celebrate

also by lauren conrad

L.A. CANDY NOVELS

L.A. Candy

Sweet Little Lies

Sugar and Spice

FAME GAME NOVELS

The Fame Game

Starstruck

Infamous

NONFICTION

Lauren Conrad Style

Lauren Conrad Beauty

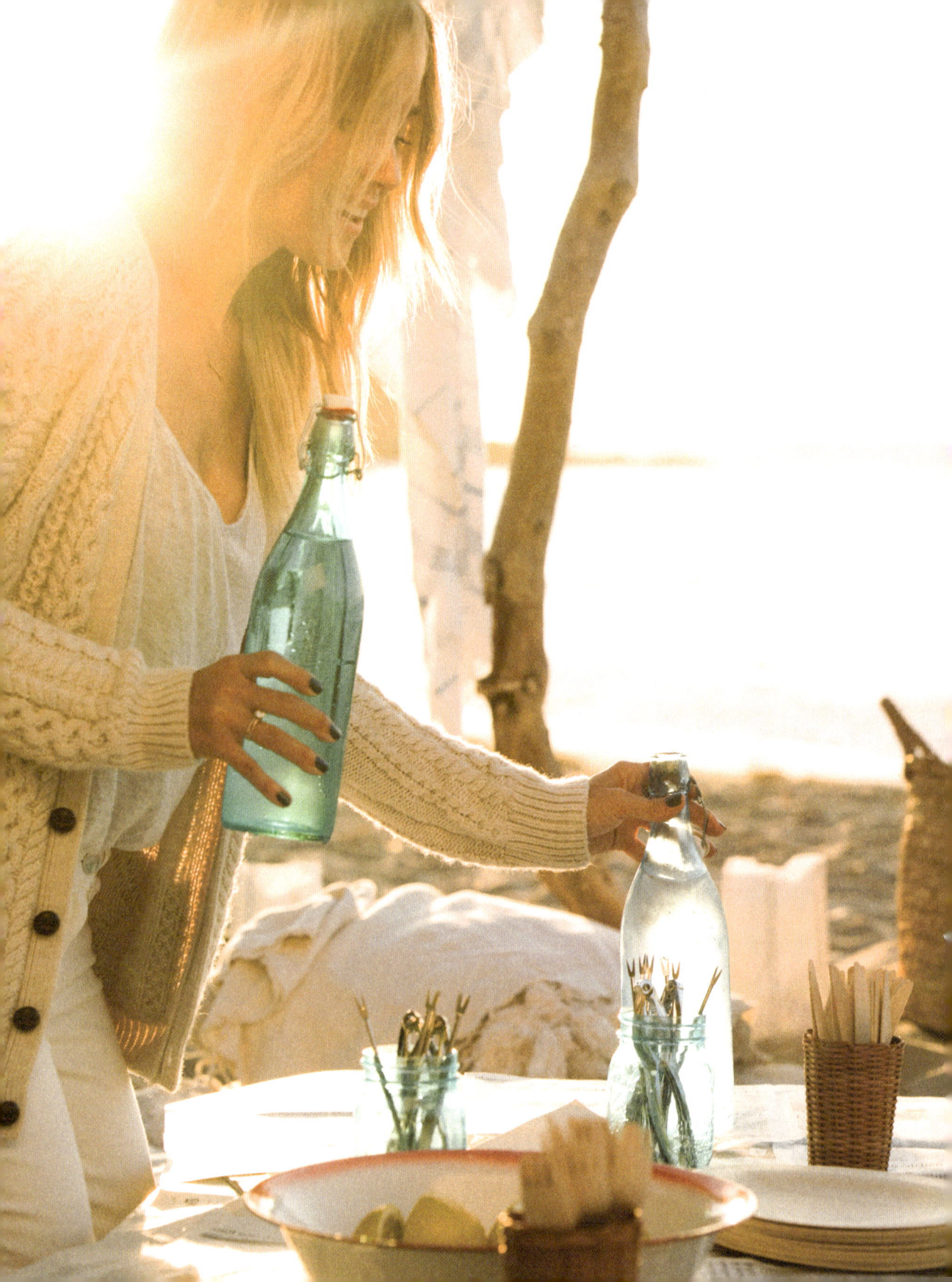

celebrate

LAUREN CONRAD

WITH

LESLIE BRUCE

DEY ST.
AN IMPRINT OF
WILLIAM MORROW PUBLISHERS

DEY ST.

CELEBRATE. Copyright © 2016 by Lauren Conrad. All rights reserved. Printed in the United States of America. No part of this book may be used or reproduced in any manner whatsoever without written permission except in the case of brief quotations embodied in critical articles and reviews. For information address HarperCollins Publishers, 195 Broadway, New York, NY 10007.

HarperCollins books may be purchased for educational, business, or sales promotional use. For information please e-mail the Special Markets Department at SPsales@harpercollins.com.

FIRST EDITION

Designed by Suet Yee Chong

Library of Congress Cataloging-in-Publication Data has been applied for.

ISBN 978-0-06-243832-4
ISBN 978-0-06-256175-6 (B&N signed edition)

16 17 18 19 20 OV/QGT 10 9 8 7 6 5 4 3 2 1

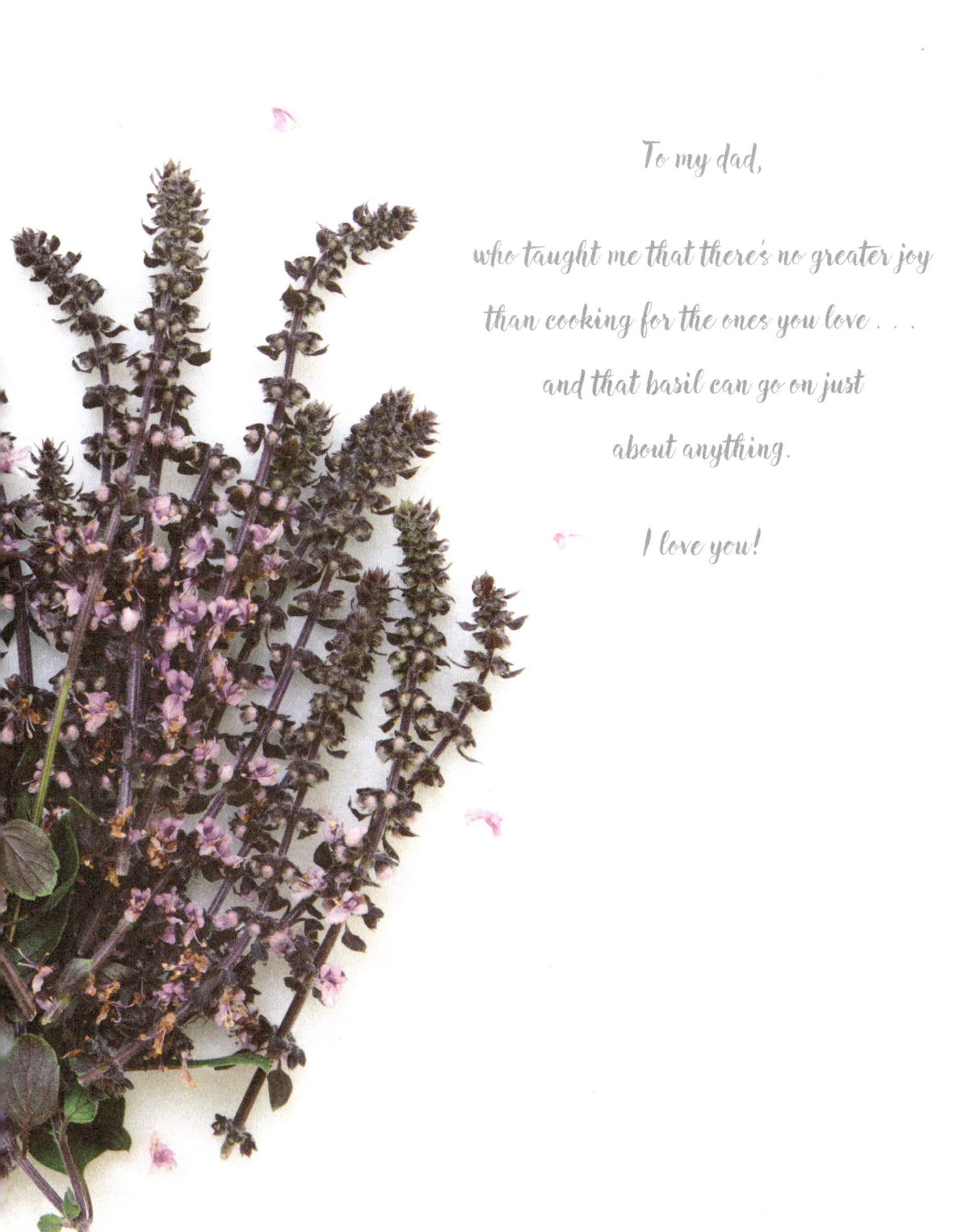

To my dad,

who taught me that there's no greater joy
than cooking for the ones you love . . .
and that basil can go on just
about anything.

I love you!

contents

THE BEGINNING 1

part 1: prep

1 THE CONCEPT 9
2 THE INVITATIONS 17
3 THE MENU 25
4 THE BAR 43
5 THE DÉCOR 61

part 2: party

6 THE BIRTHDAY PARTY 73
7 THE ENGAGEMENT PARTY 87
8 THE BRIDAL SHOWER 107
9 THE HOUSEWARMING 121
10 THE DINNER PARTY 135
11 THE BABY SHOWER 151
12 THE CLAMBAKE 165
13 THE BACHELORETTE PARTY 185
14 THE WEDDING 199
15 THE BRUNCH 243
16 THE HOLIDAY PARTY 259
17 THE NEW YEAR'S EVE PARTY 273

THE CLEANUP 287
CREDITS & ACKNOWLEDGMENTS 289
FASHION CREDITS 292

the beginning

What does celebrating mean to you?

When I began working on this project, I asked myself this question and tried to figure out what it was about a party that made it *really* special. For as long as I can remember, I've loved celebrating, so I know my obsession started at an early age. I shuffled through shoeboxes of old photos, reminisced with family and friends, and even watched crackly home movies that, as fuzzy or imperfect as they may be, possess an unfiltered charm we're incapable of capturing on our smartphones nowadays. And during these strolls down memory lane, I was reminded of some of the happiest moments of my life and how they were filled with people, music, food, and, of course, laughter. I remembered the time my dad drove my best friends and me to the mountains for a snowy slumber party to celebrate my thirteenth birthday and how my older cousin taught us all how to put on makeup for the first time. I thought about how every December, my family came together to trim the Christmas tree, listen to carols, and drink hot apple cider—only to one night catch my mother redecorating the tree after we'd gone to bed, since her small children hadn't "evenly distributed the ornaments" (apparently I am my mother's daughter). I remembered standing alongside my dad in the kitchen, in a puff-shouldered

party dress, helping him prepare appetizers before guests arrived and him reminding me: "Food only tastes as good as it looks." It was a lesson I would always remember.

The first party I recall attending was when I was five years old. It was a surprise party for my mom's thirtieth birthday, which is more than a little alarming, since I just recently celebrated my own thirtieth birthday. In the days leading up to the event, I had butterflies in my stomach. I could barely contain my excitement—bundles of balloons, a sea of streamers, and a fluffy, frosting-covered cake! The morning of the big event, my dad formulated a plan that had my mom out of the house for the day so he could spend the afternoon in the kitchen preparing and plating beautiful platters of her favorite foods. But more than anything, I remember the bubbling anticipation, knowing she would soon arrive and see all that we planned. With my thick satin headband peeking out from above the couch I was hiding behind, I waited for my cue to explode up like a taffeta-covered jack-in-the-box. When she finally appeared in the doorway, we all jumped out and shouted, "Surprise!" And then I remember seeing her face. For a moment, she appeared to be in total shock, before bursting into tears and running out of the room.

Ever since that day I've been strongly opposed to surprise parties. Can you blame me? Truthfully, I've never understood the appeal of an event where the unassuming guest of honor opens a door only to be shouted at by a large group of overexcited people. He or she is almost never appropriately dressed and always seems more mortified than pleased. It's really sort of cruel when you think about it. Needless to say, it was an event that deeply scarred me.

But memories can be a funny thing. When I retold my version of the story to my parents, they filled in a few details that my five-year-old eyes apparently missed (if I'm being honest, I was probably just preoccupied with selecting a party dress). My mother said my dad actually created a theme for the event: "a funeral for her youth," to hear him tell it. He chose all black decorations—balloons, linens, you name it—and even requested that the guests wear black, all to poke fun at my mother's mounting anxiety over turning thirty. (If you've ever spent time with my dad, this will come as no surprise. He has a *unique* sense of humor—and taught us never to take ourselves too seriously.) He cooked up the menu himself: crab salad finger sandwiches and duck liver pâté prepared in a duck-shaped mold and displayed on a bed of parsley. He later confessed that it was actually made of chicken liver to save money and therefore was more of a *faux* gras. My facial expression must have said it all, because both my parents were quick to assure me that it was a real crowd-pleaser.

Oh! I thought. Her reaction finally made sense! Who wouldn't burst into tears upon stumbling into a slightly offensive, funeral-inspired birthday party complete with fake pâté? When I said as much, she quickly corrected me.

"No," she said. "That wasn't it at all."

She told me she had started crying because when she looked around the room, she saw all these people from different parts of her life who had come together to celebrate *her* on her special day. It was such an emotional moment that she was instantly overwhelmed—and the only thing she could think to do was to run crying out of the room. She felt so lucky to be cared for by so many people—and even forgot how anxious she was about the milestone birthday. She even forgave the Grim Reaper–chic décor. Those traumatizing tears that I remember from so many years ago were actually happy ones.

And I realized she had helped answer my question. To me, celebrating is taking a moment to show those special people in our lives how much we love them. It's about creating memories, sharing laughs, and honoring the occasions in life that make everything worthwhile. How and what we celebrate isn't nearly as important as the act itself—even if that means serving chicken liver shaped like a duck.

As I've gotten older, party planning has become much more than a frilly dress (but that's not to say your celebration ensemble is unimportant!). These days, I adore any excuse that allows me to indulge in three of my favorite things: food, flowers, and friends. Living in Los Angeles and working in both the fashion and entertainment industries, I've been fortunate enough to attend some of the most decadent parties imaginable, where literally every last detail was considered and flawlessly executed. But for me, nothing compares to an evening at home, surrounded by loved ones, sipping charming handcrafted cocktails and dining on delicious home-cooked fare.

And it's not just the party I enjoy, but everything leading up to it too! I get just as much joy from planning a party as I do from hosting one. (I know, I'm strange.)

I live to create. It's what drives me. Whether it's a gracefully tailored garment or a tastefully executed tablescape, nothing gives me more joy than mak-

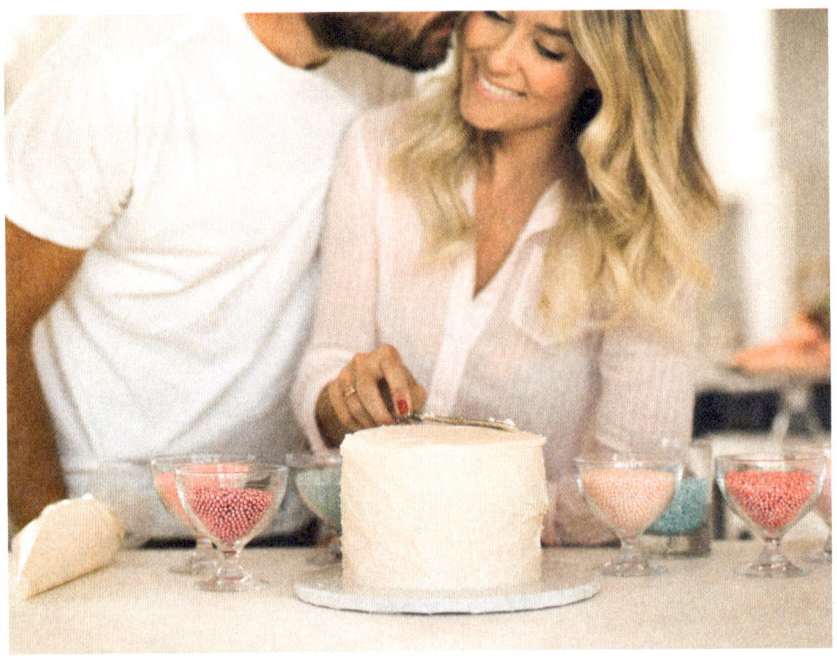

ing beautiful things. I take great pride in dreaming up a concept, and nothing is more fulfilling than seeing it realized—and that's why I love throwing parties. I can spend weeks (or, in the case of my wedding, nearly a year!) preparing for an event—and after all the planning is complete, I'm able to enjoy these special occasions with the people closest to me. What could be better?

Or it could be that I just really like cake—and a party simply isn't complete without a proper dessert.

Last year my best friend and I both got engaged, a month apart. Not long after that, another friend announced that she was expecting her first baby, while another decided she was moving across the country. Suddenly, my weekends were filled with showers, bon voyages, cocktail parties, and weddings, while my weekdays were filled with Pinterest boards, addressing envelopes, and trips to the flower mart! The truth is, I look for any excuse to host a party—whether it's my always-themed birthday party, my now annual Fourth of July barbecue, or my monthly movie night with girlfriends. No moment is too small. Life gets busy, complicated, and downright exhausting, and it becomes all too easy for days, weeks, and sometimes even months to go by without connecting with some of

my nearest and dearest, which is why I firmly believe that we must take time to celebrate all occasions, big and small.

But planning them takes time—and the more parties you host, the more time you spend. That's where *Celebrate* can help. This book should alleviate all those headaches so often associated with party planning and allow you to create a wonderful event by offering a few ground rules, some basic advice, and, I hope, lots and lots of inspiration! Think of this book as your go-to resource for the countless questions that come along with the planning process—use it as both a starting point and a reference throughout.

I recognize that not everyone wants to spend time obsessing over a color scheme and that some may even shudder at the thought of constructing a flower arrangement. The truth is, you don't need to know violas from violets to throw a successful party. You just need a thought-out plan to get you to the big day without losing your mind. (After all, if anyone should get to enjoy the party, it's the host!)

This book is divided into two parts: Prep and Party. Prep tackles the party-planning basics: from invitation etiquette and the proper place setting to sample seasonal menus and mandatory bar accessories, with the nuts and bolts broken down for a celebration of any size. In Party, I'll feature twelve events—ranging from a simple al fresco dinner to my very own wedding—and show how you can pull all those basics together into a beautifully executed soiree.

Celebrate is for every type of party planner—from the do-it-yourself maven who makes her cupcakes from scratch (including homemade sprinkles) to the last-minute Lucy who scrambles to empty grocery-store fruit salad into a glass bowl moments before the guests arrive, and everyone in between. This book will provide tips and tools for how to streamline the process of party planning so you can focus on what is most important . . . and celebrate!

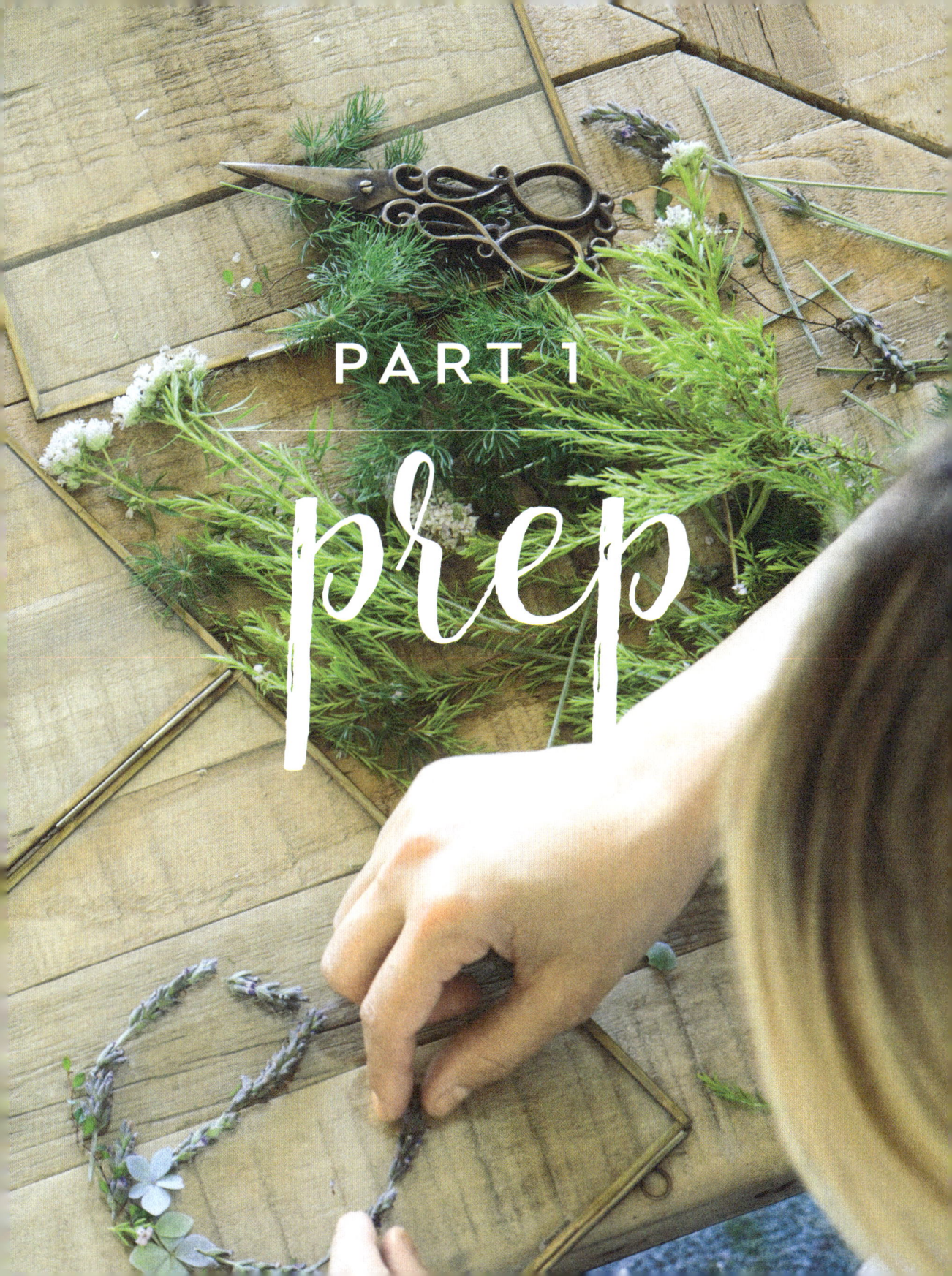

PART 1
prep

1

the concept

Finding a reason to celebrate shouldn't be too difficult. Whether you're planning a birthday, a holiday, or simply a "just because" party, a good excuse is always within reach. While weddings and showers are guaranteed to be special, memory-making occasions, sometimes a casual dinner party can be just as unforgettable.

Being a married lady with a full-time job, new house, and two dogs, I don't have as much time as I used to to spend with my family and friends, so I made a commitment to host at least one celebration per month. With that in mind, I want to make sure that as the host, I'm able to spend as much time with my guests as possible while also treating them to a truly special occasion, which means one thing: plan ahead!

the basics

Before the planning can even begin, there are lots of decisions to be made. Start by asking yourself these six questions:

- What is the occasion?
- Who is hosting?
- What is the time and date of the event?
- Where is the event taking place?
- Who is on the guest list?
- What is the budget?

After you've determined your answers, you'll probably have a good foundation for planning your soiree. (The one caveat is wedding planning, which is a huge undertaking. But we will get to that later on!)

Whether it's an autumn apple-picking party or a child's first birthday bash, you should be clear about the reason for your event. All else will grow from this: the menu, the cocktails, the guest list, the décor, and so much more.

Odds are that if you're the one planning the event, you'll most likely be hosting it too. On some occasions, however, it's customary for a party to be hosted by a handful of people. For example, bridal showers, baby showers, and bachelorette parties are often thrown by a few of the honoree's close friends and family. If you're hosting one of these events, you should always ask the guest of honor if there is anyone else who has expressed an interest in hosting. Leaving people out, even if unintentionally, can lead to hurt feelings and become a huge but totally avoidable headache. It's best not to get caught up in the "politics" of party planning.

Before securing a date, make certain all your VIPs can attend... that is, parents of the couple at an engagement party or the best friend of the bride for a bachelorette.

Next, you need to decide *when* the party will take place, as the date (both time of day *and* year) will inspire much of the ambience.

A cocktail party being held on December 31 will look and feel a lot different from a beachside bash in July. From determining the seasonality of particular

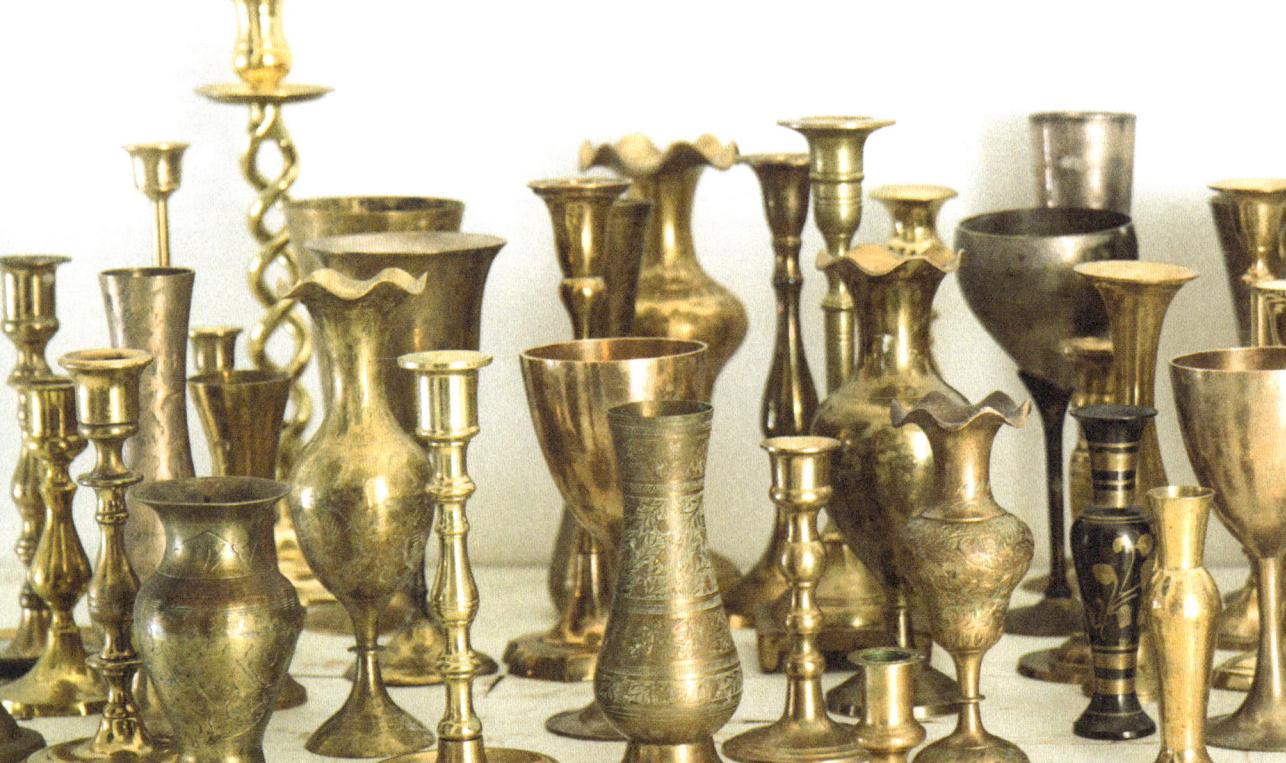

flowers to going on a wild goose chase for peaches in November, the time of year is a factor that will dictate the availability of many items. Equally as important is the time of day you choose to host the event. For example, if you're inviting people over at 5 P.M., you'll be expected to provide dinner, versus an 8 P.M. start time when light appetizers and/or desserts are more than appropriate. Generally, I follow this rule of thumb: if the start time of your event does not allow guests to reasonably eat a meal before or after, you are responsible for feeding them.

The next two questions are closely linked: where and who? Where you choose to host the event depends largely on how many people you choose to invite. If you're looking to host a dinner party in your tiny Manhattan apartment, you'll need to keep it relatively intimate. If it's an engagement soiree and your best friend has a hundred-person guest list, you better start looking at other locations.

As I mentioned earlier, I prefer hosting parties at home when the occasion allows for it. Not only is it a great way to save money on location fees, it also creates a warmer, more welcoming environment. It feels much more personal to invite people into your home rather than into a restaurant or hotel conference room—and celebrations should make your guests feel comfortable above all else.

Plus, my home office is overflowing with an admittedly ridiculous number of gorgeous, patinated brass pieces covering just about every inch of the room. That's not an exaggeration; I have roughly three hundred brass candlesticks and vases, and I'm always

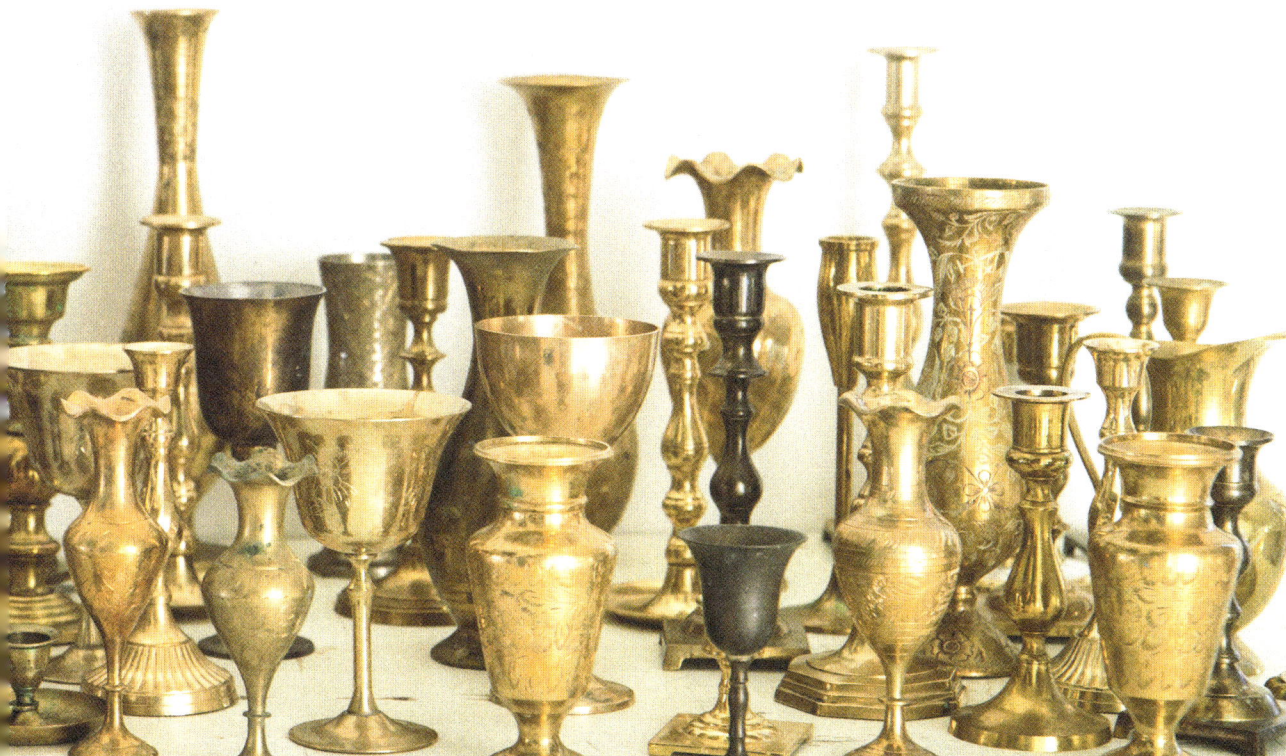

looking for an excuse to use them. But trust me, I have a very good reason as to why I have curated this seemingly absurd exhibit. During the year leading up to William's and my wedding, I began obsessively scouring eBay, flea markets, and antique shops for vintage brass for our reception tablescapes ... and I *promised* him that the collection that was rapidly taking over our home was a thoughtful investment that I would use for years to come. Let's just say that these days, it's hard to come to a gathering at our house without spotting some brass. If you're a habitual party thrower, I strongly encourage you to invest in some key items; it will end up saving you a good amount of money in the long run. It will also make you very popular when your friends are throwing parties of their own.

We'll tackle the etiquette of *who* to invite in chapter 2, but the size of the party and the details of the event (like menu, location, etc.) go hand in hand. In my opinion, celebrations with plated meals are better suited for a smaller guest list (unless it's a wedding or another bigger-budget event), while backyard barbecues—which lend themselves to premixed cocktails, beers in an ice bucket, and a beautifully set buffet of finger foods—are perfect for larger parties.

Finally, and perhaps most important, you have to establish a budget. The hardest thing about having a budget is *sticking* to it, but that's where planning comes into play. This is your opportunity to choose which aspects of the party are important to you and prioritize them. That means if a top-shelf bar is a must, then you might need to bid adieu to the live entertainment and turn on your iPod. Preparing your own food and drinks (and using in-season ingredients) is a great way to save money. Although hiring caterers and a waitstaff can take a lot of the pressure off the host (on top of setting a more formal, sophisticated tone), it will also cost you. Throughout this book, I'll offer some easy, unexpected tips on saving money where you can.

My suggestion when budgeting is to provide a 10 percent buffer. Last-minute things will always arise: a guest with a food allergy, late RSVPs, or the realization that you don't have enough glassware to serve that specialty cocktail your heart was set on. Consider

*In this book, I'm going to be offering you lots of advice and suggestions, but please keep in mind that I'm a firm believer that rules are made to be broken. Party planning is such a personal experience, and much of it depends on factors unique to you and your event. For every rule, there's almost certainly an exception to it.**

** This does not, however, apply to cash bars. Cash bars are always a bad idea. Sorry.*

that 10 percent your insurance to keep from panicking at the eleventh hour. If you end up not using it: bonus—tuck it away and start planning your next soiree!

To start, figure out a number that you (and, if applicable, your cohosts) are comfortable with and break it down as such:

	30%	menu
	30%	bar
	30%	décor
+	10%	buffer
	100%	budget

Don't be married to this formula; simply use it as a jumping-off point. For example, you might want to plan on a bigger bar budget for a New Year's Eve bash than you would for a baby shower. Consider the event and adjust accordingly.

If you are hosting an event with others, make sure you respect their input on what they're comfortable spending. It is important to be sensitive to other people's financial situations. If there is something you're dying to include that the agreed-upon budget doesn't necessarily allow for, either offer to cover the cost on your own or file away the idea for your next event.

the inventory

Before you begin the execution of the event, you should take stock of what you already have and see what can be incorporated. A smart party planner is a strategic party planner. This theory applies across the board. If you're creating a menu, check what's already in your pantry before heading to the grocery store—or you'll run the risk of being like me and always having five spice jars of cinnamon (sorry, William!). If you're someone who frequently entertains, you probably have things left over. Before calling the florist or heading to the flower mart, tally up how many vases you already have. The same goes for dishware and glassware—determine how many already line your cupboard before renting or purchasing more. And *always* account for a bit extra. Glasses so often get misplaced and/or broken, so you'll want to have some backup. A couple of years

ago I invested in a set of simple, inexpensive plates, glasses, and flatware that I use when I entertain. Since they were reasonably priced, I purchased a few more than I thought I would need, knowing that this way I would always have more than enough and that those items could easily be replaced.

Family heirlooms, however, cannot be. Unless it's a truly special occasion, you don't want to serve champagne in your great-grandmother's Depression-era antique coupes. As for the *exact* amount, only you know the answer. Ask yourself how many people you could comfortably host on average given the size of your space. For example, you don't need to get twelve place settings if you have a six-person dinner table.

In the same vein, when you're deciding on the menu, the bar, and the décor, keep in mind what you already have lying around the house. If you plan to serve your famous tomato bisque, check to make sure you have a full set of bowls and soupspoons. (If not, it's time to come up with a clever alternative like heading to the bakery for a handful of loaves to fashion into bread bowls.)

Finally, you'll need to consider entertainment. For more casual occasions—like an al fresco dinner party or a Sunday brunch—you can easily create a playlist and you're covered. For some gatherings, good company, good food, and good drinks are more than enough. However, for other events, you'll be leading games, icebreakers, or perhaps even an old-fashioned piñata party! (See chapter 9.)

Once you've determined the foundation for your event, it's time to get to planning...

I'm a huge believer in bargain shopping; I've found some of my favorite pieces through resellers, discount websites, and affordable home goods stores (like IKEA, where pretty, simple champagne glasses cost under a dollar). Whichever vendor you choose, focus on the basics: a set of white dinner plates, multiuse glassware, utensils, and a few serving platters. While many people turn to disposable dishware as a budget-friendly alternative, I've found that oftentimes it ends up being more expensive. Disposable glassware designed for more formal events isn't cheap. So if you're looking for something beyond a red plastic cup, consider investing—particularly if you plan to be a repeat party thrower.

THE ETIQUETTE

basic dos and don'ts of party planning

Modern-day party-planning etiquette can be tricky, particularly for the hostess. It feels like the general rules are always changing and usually subjective, so I've compiled *my* tried-and-true tips for hosting an event with grace and consideration.

- I try to send out invitations four weeks in advance. People's calendars fill up quickly, but sending the invitations too early risks them being misplaced or forgotten about. Obviously, for weddings and larger-scale events that may require travel, you should afford your guests additional time, while two weeks' notice is enough time for a smaller, more casual gathering.
- Make certain to properly greet and introduce partygoers, even if you believe they may have already met. Social gatherings can be intimidating, so do your best to make each guest feel comfortable. (Take a note from *Bridget Jones* and try to offer an interesting fact about each person to help spark a conversation!)
- Avoid serving fussy or antisocial foods. Keep the menu simple and familiar. Do not serve heavily garlic- or onion-infused dishes. Socializing with stinky breath is not good for anyone involved.
- Invite guests with a date, if the budget allows. It makes for a better time for everyone. If the budget is tight, be very clear in your invitation so that you don't find yourself scurrying to set an extra place setting when the guest arrives with a plus one.
- Don't invite a second-tier guest list too close to the event. People will know they were not your first choice, and no one wants to feel like the second string.
- Be prepared. Give guests as much information as possible ahead of time regarding parking, transportation, and attire; have a backup plan in case of inclement weather (see sidebar on page 182), etc. The more you anticipate and do ahead of time, the better your event will be. There are always inevitable hiccups on the day of, so it's best to eliminate or minimize the *foreseeable* bumps so you have more time to focus on the *unforeseeable* ones.

the invitations

The invitation is the first glimpse your guests will have of whatever it is you are celebrating! And everyone knows you don't get a second chance to make a first impression. Upon its opening, an invitation immediately establishes the tone of your soiree while providing guests with the necessary information. It's a pretty big responsibility!

the basics

Before you even begin *thinking* about the design direction of your invite, you need to decide *who* will be on your guest list. This decision is quite personal. Who you choose to ask into your home (or whatever the location may be) and share your time with is something you want to stop and truly consider.

Many times, the nature of the event will help determine who should be invited. Cocktail parties are adult events, while Sunday brunches are usually inclusive of the whole family. Weddings will typically be larger events, while an al fresco dinner party may be just a handful of people.

When the purpose of the party is to celebrate a particular person, you should always include him or her in deciding the guest list (unless it's a surprise party . . . in which

case, don't). Oftentimes a second cousin once removed will have to be included for the sake of formality, and no matter how close you are to the guest of honor, he or she may have friends outside your circle who should be included.

If I'm hosting an outdoor cocktail party, I usually cast a wide net if the budget and space allow. That being said, not every occasion calls for a huge guest list.

My advice is to prune your potential-invitee list with kindness. If you *must* trim down the number of guests, eliminating a group (distant relatives, work colleagues, children, etc.) is the most neutral option. Picking and choosing among individuals can get sticky. This way, it keeps explanations from becoming personal and feelings from getting hurt.

As long as it's appropriate for the event, I always make sure to include my best girlfriends and my family. There's no such thing as *too much* time spent together when it comes to these people. For more intimate events, I try to include the people I'm not able to see as much (and will often clear the date with them beforehand) and use it as a chance to truly focus on spending valuable time with one another. I also think those smaller gatherings are perfect occasions to bring together people who might not already know each other but who I think would become fast friends!

And as a general rule, if individuals are invited to an event leading up to a larger social affair, then it's best not to exclude them from the actual event. That is, if you invite a girlfriend to an engagement party, shower, or bachelorette, invite her to the wedding. All those gatherings are a buildup to the actual event, so it's best not to exclude.

the design

It's important to be thoughtful when designing your invitation. It's silly to put so much effort into an event and not send out an invite that duly represents that!

First, decide whether you're sending an electronic or paper invite. In recent years, it's become more widely accepted to send electronic invitations for events that would have traditionally called for paper. However, most of us still need a bit of guidance when determining what's appropriate.

If you happen to be a particularly eco-conscious person, you may forgo paper invitations entirely. On the other hand, if you consider yourself a bit technologically challenged, the concept of an "evite" may be totally outside your comfort zone.

Most people fall somewhere in between. Modern e-cards can be just as beautiful as

hard invites, not to mention user-friendly and cost effective. It's also the absolute easiest way to manage RSVPs and communicate with partygoers. However, there is something uniquely charming about receiving an exquisitely crafted paper invitation. When a host takes the time to create and mail a paper invite, it shows guests that he or she is taking great care—as well as cost—in the event preparation.

All that being said, when deciding whether to send an electronic invite versus a paper invite, I ask myself one simple question: Is it a once-in-a-lifetime party? If the answer is yes, I'll send a hard invitation; if it's a no, I'll send an electronic card. There are exceptions to every rule, and preference plays a large factor, but more often than not events such as a graduation party, a wedding, and a baby shower are milestone celebrations that call for more pomp and circumstance (like a paper invitation), while birthday parties, clambakes, and holiday soirees can be annual gatherings.

With that decision made, you can begin looking at designs. (Minted.com is a great online resource for ideas and inspirations.) The invitations should be a reflection of the overall nature and theme of the event. Here are some things to think about when deciding on a design:

- **THE COLORS** You want the invite to feel like a thoughtful representation of the event itself; however, keep in mind that some color combinations are more difficult to read when paired together than others (pale yellow on white, for example).
- **THE PURPOSE OF THE EVENT** It should go without saying that the design of the invite should clearly state what you're celebrating. If you're not serving sparkling wine at your event, having a champagne bottle graphic doesn't really make sense.
- **HOW CASUAL OR FORMAL THE PARTY MAY BE** It's pretty simple; if the event is a beach barbecue, don't send an invite befitting a black-tie gala.
- **FORMAT** For paper invites, don't feel restricted to the standard 4 × 6 or 5 × 7 rectangle. Play with alternative shapes and sizes.
- **CLARITY** Make sure the information is conveyed legibly. Whether using a calligrapher or a whimsical computer font, it's important that your guests can clearly read the information provided. Consider the legibility of a typeface before the design.

the essentials

With your guest list finalized and the perfect invitation style selected, it's now time to solidify the details of your event: who, what, where, wear, and when. Let's break this down:

WHO: First of all, your invitation should clearly state if the party is celebrating a special someone, which is usually the case for showers, birthday parties, and so on. Next, it should identify who is hosting the event, and if it's a paper invitation, you should let guests know to whom they should RSVP (see page 19 for more info on electronic versus paper invitations). Finally, the invitation should also clearly indicate who is invited to attend and if the person is being given a plus one. This is an important note for both the host and the attendee (see "The Etiquette: A Note for the Partygoer," page 22).

WHAT: Even though you don't always need an excuse to host a party, if there is a particular reason, this is the time to let your guests know what you are celebrating.

WHERE: Let people know where they're being asked to go! In addition to the actual location (name of venue and physical address), you should provide partygoers with any specific instructions, such as parking, gate access, and other important information.

WEAR: If there is a dress code, you must alert your guests. For semiformal and casual events, the tone of the invite will usually dictate the attire, so it's not necessary to spell it out, while weddings follow their own set of rules (see chapter 14). My one piece of advice? Don't make up your own dress code language. It just confuses people. For William's and my engagement party, our parents told guests to dress "California Chic." What does that even mean? Is that cocktail dresses and button-down shirts with ties? Or is that colorful maxis and Hawaiian shirts? We had no idea . . . and neither did our guests. (Sorry, parents!) The reason you have a dress code is so your guests are clear on the attire. Bottom line: It ensures that everyone will feel comfortable when they arrive.

WHEN: You need to provide guests with the date of the event, the start time and the end time (if applicable), and by what date they should submit their RSVP.

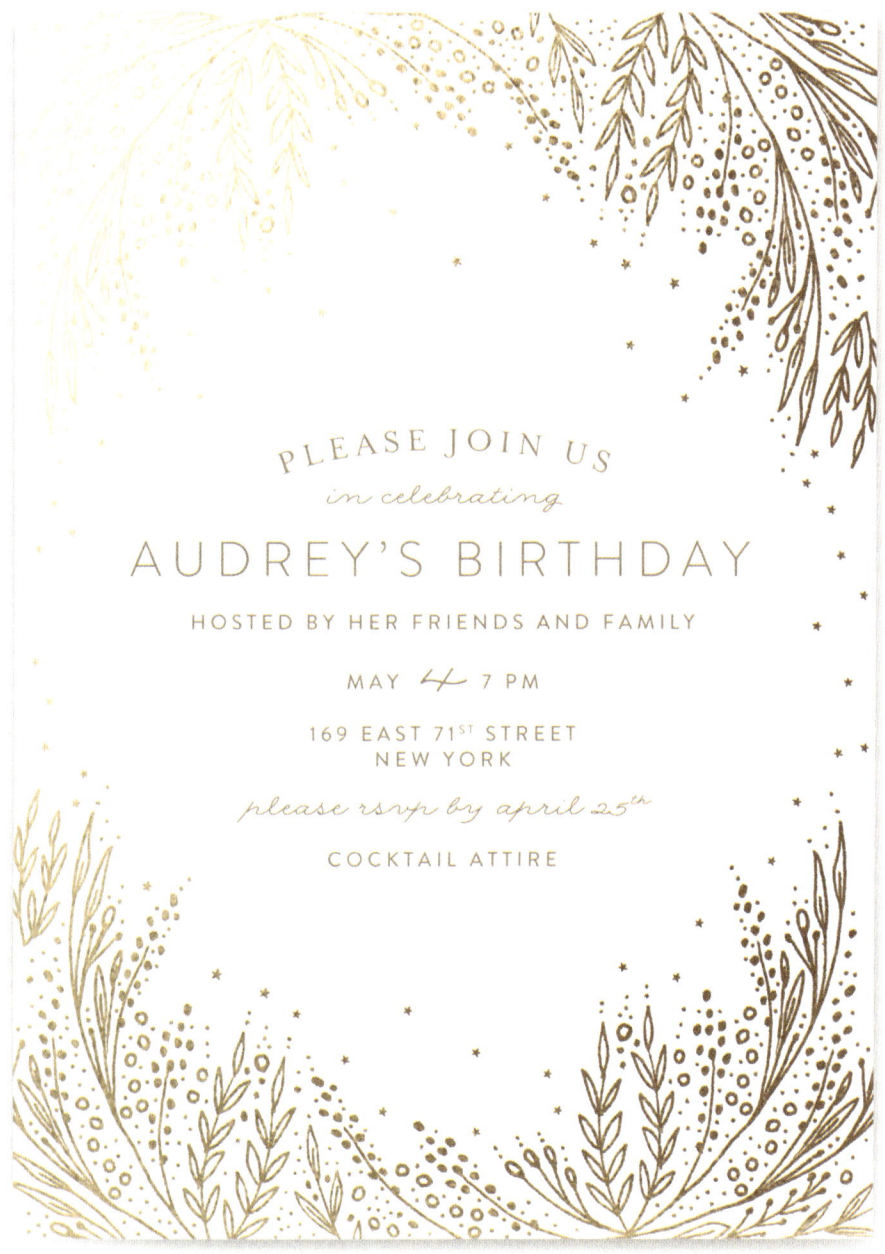

ADDITIONAL INFO: For a bridal or baby shower, the host might include a note on where the guest of honor is registered. For a food-focused event, the host might ask guests to contact him or her if they have any food restrictions. This is your opportunity to relay any other important details.

THE ETIQUETTE
a note for the partygoer

As a good host, you can prepare for just about anything and plan a dazzling event, but so much of the party mood depends on your guests. Which is why being a thoughtful partygoer is an important role.

- Reply by the RSVP due date. As a host you typically wait for a final head count before placing most orders and finalizing details, so when you're the guest, respond as soon as possible—especially if the host is someone you would like to make a good impression on. Plus, it's just the nice thing to do.
- Never cancel on the day of the event. Unless it's an emergency, it's never an okay thing to do. Be mindful of how much work he or she is putting into hosting you.
- Be on time. Do not arrive more than fifteen minutes late to a dinner party or thirty minutes late to a cocktail party. If you're going to be any later, you should call or text the host. Equally as important, do not arrive early. Oftentimes, the host is running around putting on the finishing touches. An early guest is just unwanted stress. Try your best to arrive during the first few minutes of the party.
- Don't ask if you can take home a floral arrangement, a centerpiece, or leftover food. If the host isn't offering, you can assume it's for a reason.

If you're at all unclear and the event seems casual or semiformal, it's always better to ask the host than to show up with an uninvited date. However, if it's a formal, seated occasion, do the host and yourself a favor and don't ask if you can bring a plus one.

- Follow the dress code. If the host offers one of those "open to interpretation" dress codes, just ask.
- Don't bring an uninvited guest. Here's the bottom line: The people listed on the invite or envelope are the people invited to attend. If it reads "Ms. Audrey Hepburn," you can safely assume the invitee is not being asked to attend with a guest. If it reads "Ms. Audrey Hepburn and Guest," that's an invitation to bring a plus one (but only one!). If the invite reads "The Hepburn Family," it's safe to assume the entire household is invited.
- Come bearing gifts. If you don't already know, you will soon: party planning is a big job and showing you appreciate the efforts of your host is not only considerate, it pretty much can guarantee an invitation to the follow-up get-together. (For more details, see chapter 10.)

3

the menu

Food is often at the heart of most memorable events—and like everything else, the more you plan ahead, the easier executing your menu will be. There are a few occasions where serving food isn't necessarily mandatory, but most events require that you provide guests with at least a little something to snack on.

the basics

First, you'll need to decide whether you'll be whipping up the menu yourself or calling in reinforcements. There are pros and cons to each, and honestly, it's a personal choice (and one that your budget or schedule usually decides for you). Not only is cooking the food yourself more cost effective, but for me, it's also an enjoyable thing to do, and a home-cooked meal is often appreciated by guests. On the other hand, hiring good caterers can guarantee both the timeliness and quality of the food served, as well as free you up to focus on your guests. You'll need to decide what's most important to you. And not for nothing: Be honest with yourself about your kitchen skills. A special occasion is no time to start testing out Julia Child's beef bourguignon recipe if you usually manage to burn grilled cheese.

Next, you need to determine what you would like to serve your guests. The menu

is based on a few things: the time of day, the time of year, and the size of your event. Ask yourself: What is appropriate for the occasion? It's a closely woven fabric, so all parts need to work together harmoniously.

If your party begins before noon, consider offering brunch: mini quiches, chocolate croissants, and fresh berry and yogurt parfaits. Lunch menus typically begin at most restaurants after 11 A.M., so that's a good place to start: consider a DIY bruschetta bar, a mixed salad, and panini.

Evening events are a bit trickier. I mentioned it before, but just as a refresher: if your guest can *easily* have dinner before or after the event, you're only responsible for providing light fare (although no one would fault you for having more!). A passed appetizer menu—such as Greek chicken meatballs, ricotta deviled eggs, and prosciutto-wrapped asparagus—for a late-afternoon housewarming is more than appropriate, while a Saturday night cocktail party beginning at 8 P.M. might lend itself to more dessert offerings: white chocolate-covered strawberries, blackberry pie pops, and a variety of French macarons.

If your event begins at 5 P.M. or later, you should provide your guests with dinner (see page 31 for examples). The menu depends on the size and occasion of your party. Keep in mind that dinner doesn't necessarily mean seated; the right finger foods—like skewers or flatbreads—can be just as filling.

Most important, remember that a successful party means happy guests. If you

were attending a particular event, what would you want to see on the menu? Offer your guests a sampling of treats that you would wish to see served, and it's safe to say that you've done your job.

If you're not a seasoned cook, sourcing out recipes can feel like a large undertaking, and the Internet can be an overwhelming place to start. While I prefer to cook to taste (and use recipes merely as a jumping-off point when attempting a dish for the first time), when I'm truly stuck, I have my tried-and-true resource: *The Joy of Cooking* by Irma S. Rombauer and Marion Rombauer Beck. I also suggest looking to places and people you know. Ask a friend or a relative, and in some cases, the chef at your favorite restaurant may even share the recipe for that perfectly roasted chicken.

If your guests need to use a knife to cut their food, they'll need a table too.

the seasonality

When it comes to executing the meal, be flexible. You could have your heart set on a particular menu, but when perusing the farmers' market or grocery store, you might face the earth-shattering realization that your main ingredient is unavailable. My best advice? Shake it off. Perhaps your strawberry pie becomes a pear tart. It's not the end of the world. The best food comes from the freshest ingredients . . . so pay attention to the seasonality of the food you plan to serve.

Here is a basic list of the essential fruits and vegetables for each season:

spring
- Apricots
- Broccoli
- Green beans
- Honeydew
- Mango
- Pineapple
- Rhubarb
- Spinach
- Strawberries

summer
- Bell peppers
- Blackberries
- Cantaloupe
- Corn
- Cucumber
- Eggplant
- Peach
- Plum
- Raspberry
- Tomato
- Watermelon

fall
- Apple
- Beets
- Brussels sprouts
- Carrot
- Cauliflower
- Cranberries
- Grapes
- Parsnips
- Pear
- Pomegranate
- Pumpkin

winter
- Banana
- Grapefruit
- Kiwi
- Leeks
- Lemon
- Orange
- Potato
- Sweet potato
- Turnip
- Winter squash

the anatomy of an appetizer board

In my opinion, there's nothing tastier than a well-constructed appetizer board—whether it's charcuterie, artisanal cheese, or antipasto. I prefer to assemble a board showcasing elements of all three. Not only is it a popular party favorite and easy to pull together in a pinch, when thoughtfully arranged, it also can be truly beautiful (and double as party décor). Your board can be as decadent or as simple as you want it to be and is, therefore, an appropriate offering for most occasions. Depending on the elements you choose, it can be "dressed up" or "dressed down" (particular gourmet cheeses, specialty cured meats, and even the inclusion of swanky fare like pâté can elevate your board for more formal events). My advice is to begin with the essential elements and then make it your own—tailoring it to your specific tastes and the theme or mood of the event.

THREE MEATS Try to diversify your elements, like a spicy soppressata, a sweet prosciutto, and a classic salami. When serving cured meats, I sometimes offer guests the option of whole-grain mustard on the side. The choice is yours!

A PALATE CLEANSER The idea behind an appetizer board is to offer guests samplings of different flavors, so I like to include a bundle of grapes or thin slices of pear to help reset their taste buds before trying something new.

THREE CHEESES Firm, soft, and blue. People have pretty strong opinions and tastes when it comes to cheese, so I try to keep the selection fun but familiar: Camembert or Brie, Manchego or aged cheddar, and the classic Stilton blue cheese.

BREAD I usually opt for sliced French bread, but I also really like the look of larger, grilled pieces of a rustic Italian loaf. I offer a cracker option only in addition to bread. Usually the fare requires a heartier vehicle, and there's nothing fun about a cracker crumbling in your hand when you're trying to spread it with a jam or soft cheese. Throw in a specialty breadstick (like rosemary or black olive) to diversify the flavors and textures of your board, as well as add a cool visual element to the display.

SOMETHING SWEET, SOMETHING SAVORY, AND SOMETHING SOUR The accoutrements are oftentimes the unsung heroes of a good appetizer board. My go-to basics: a honeycomb or an apricot preserve, marinated artichokes or roasted peppers, and pitted olives or cornichons.

the simple supper

When I was growing up, my dad used to come home each night and cook dinner. He didn't read off a recipe or carefully measure out the ingredients—he just cooked. It's how he would unwind from a hectic workday. As a little girl, I would watch him zig and zag around the kitchen—adding splashes of this and dashes of that—and was astonished at how quickly he could whip up the tastiest meal (without ever once cracking open a cookbook!). Every evening when he'd drop his briefcase by the front door and make his way toward the kitchen, I'd follow closely behind to play the part of his tiny, inexperienced, but ever-impressed sous chef. He gave me simple tasks like removing cilantro from its stem or peeling garlic so that I could feel involved, and always made sure to remind me just how important my dutiful work was to the dish. Once the whole meal was prepared, he would carefully assemble a plate, complete with garnish, before handing over the responsibility to me to replicate what he'd done for each additional plate. It was a daily reminder of the importance of presentation, and to be thoughtful with the details. These are still some of my fondest memories.

I guess the apple doesn't fall far from the tree, because today I find myself enjoying the same things. My favorite days are ones that allow me enough time to swing by the grocery store or farmers' market before heading home to prepare a meal for my own family (although my dogs, Chloe and Fitz, never seem too impressed!). And while I admittedly can be spotted resorting to recipes and cookbooks every so often—and I may even occasionally measure ingredients—I find a great joy in the simplicity of preparing a dish in the same way my father used to.

As a novice chef, I've realized that the key to being a good home cook means being a flexible home cook. Despite your best efforts, it's impossible to account for every last pea and carrot. Even the most seasoned party planner is bound to run into obstacles, and has most likely already survived some major event hiccups. One of the biggest mistakes that an inexperienced host can make when planning a meal is taking on an overly complicated dish. More ingredients don't always mean a better-tasting result; sometimes it just means more work. And the same goes for the amount of food. Why go crazy making a third side when two will more than suffice? Just do yourself a favor and simplify!

With that in mind, here are four seasonal menus composed of dishes using six ingredients or fewer that you can pull together in a snap (can you imagine!?).

Personally, I usually employ the trial-and-error method in my casual cooking, so I much prefer to set a menu as inspiration and then let the kitchen guide me (to be fair, it

doesn't always work out perfectly, but my track record is pretty strong). The menus I have set out below are the kind of simple recipes that can be easily improvised; that being said, if you're seeking a bit more direction, I'd suggest Pinterest, where you can scroll through countless pins featuring different ways of preparing the same dish.

spring
- Apricot and Prosciutto Crostini
- Citrus Salad with Microgreens
- Pineapple Teriyaki Chicken with Asparagus Brown Rice

summer
- Roasted Red Pepper on Ricotta Crostini
- Cucumber and Jalapeño Salad
- Chili-Lime Chicken with Avocado Couscous

autumn
- Artichoke Hearts with Parmesan Crostini
- Beet and Ricotta Salad with Pistachio
- Lemon and Thyme Roasted Chicken with Butternut Squash Quinoa

winter
- Caramelized Onion and Brie Crostini
- Spinach and Pear Winter Salad with Pomegranate Seeds
- Sage and Browned Butter Chicken with Bowtie Mushroom Pasta

dessert

In my opinion, there's nothing more charming than a homemade pie. It's a seasonless dessert that can be as simple or as intricate as you choose—from labor-intensive meringues and lattice-laced crusts to premade filling jars ready for you to pour and bake! As a rule, there's nothing posh about a pie, but what it lacks in sophistication, it more than makes up for with its incomparable comforting quality. Pies also can make for a popular (and thoughtful) hostess gift that won't break the bank. Whenever I'm invited to someone's home, I offer to bake a pie for the host to enjoy that evening or as a special treat the next day (I always check beforehand, because showing up with a dessert may throw off the existing menu and you don't want the host to feel obligated to serve it).

With that in mind, I've included my four favorite pie recipes on the following pages.

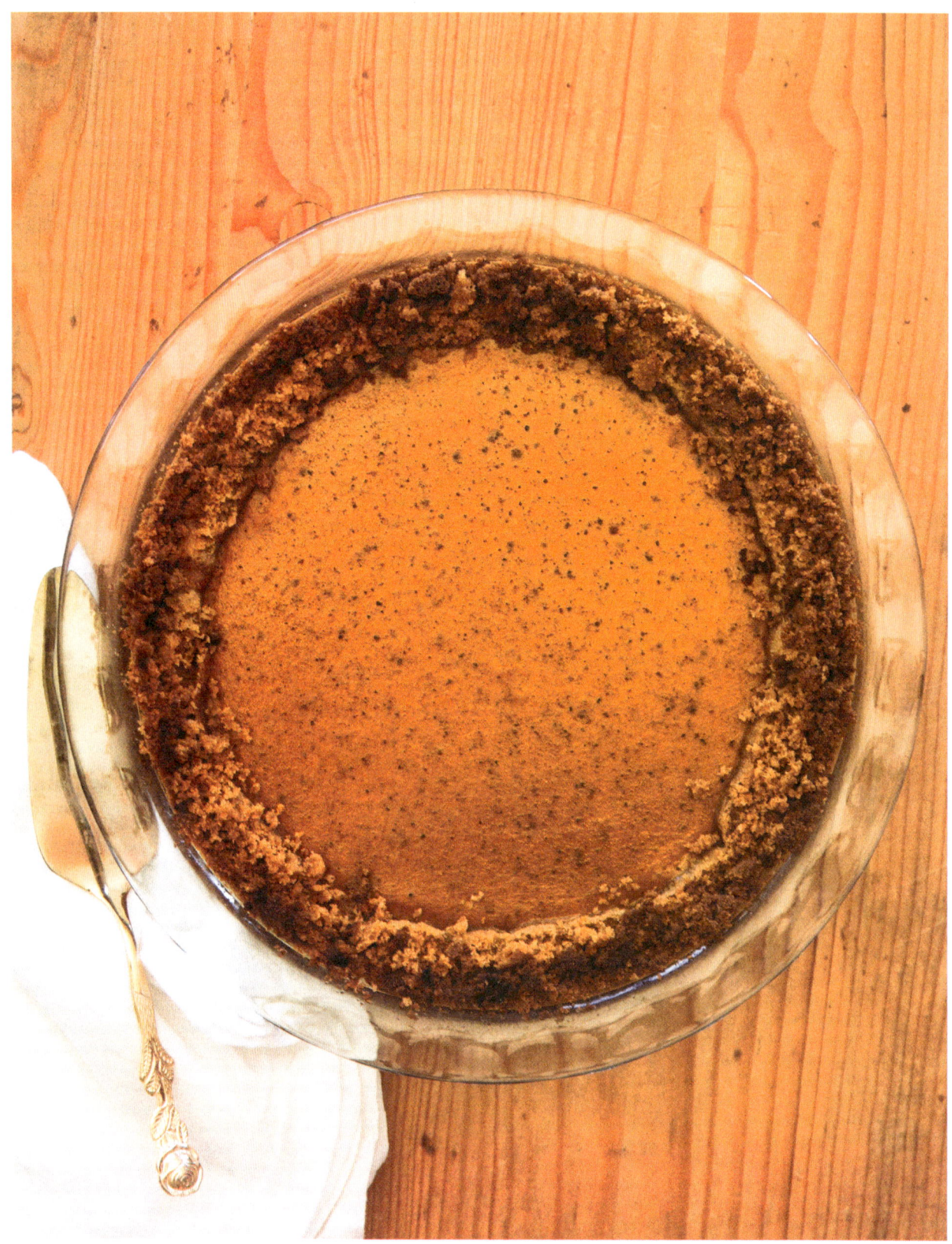

PUMPKIN PIE

I dare you to find a better, simpler pumpkin pie recipe than the one on the back of the Libby's Pumpkin can. Don't lie; you know you've used it too. It's a perennial crowd-pleaser that isn't too involved. I prefer the richer molasses flavors of brown sugar, so I substitute it for the 3/4 cup white sugar the recipe calls for. Before popping the pie into the oven, I sprinkle a bit of nutmeg over the filling. Add an unexpected twist with an easy-to-make graham cracker crust.

CRUST

1½ cups finely ground graham cracker crumbs

⅓ cup granulated sugar

8 tablespoons (1 stick) unsalted butter, melted

FILLING

¾ cup packed brown sugar

1 teaspoon ground cinnamon

½ teaspoon salt

½ teaspoon ground ginger

¼ teaspoon ground cloves

2 large eggs

1 (15-ounce) can pumpkin puree

1 (12-ounce) can evaporated milk

¼ teaspoon ground nutmeg

1. Preheat the oven to 375°F.
2. To make the crust, combine the graham cracker crumbs, sugar, and melted butter in a food processor and pulse until the mixture resembles wet sand.
3. Using your hands, press the mixture over the bottom and up the sides of a 9-inch pie pan.
4. To make the filling, in a bowl, mix together the brown sugar, cinnamon, salt, ginger, and cloves.
5. Beat the eggs in a large bowl. Add the pumpkin puree and stir to combine.
6. Add the sugar-and-spice mixture and stir thoroughly.
7. While stirring, slowly pour in the evaporated milk.
8. Pour the filling into the crust and sprinkle with the nutmeg. Cover the pie with aluminum foil to keep the crust from burning.
9. Bake for 15 minutes. Reduce the oven temperature to 350°F and bake for 40 to 50 minutes more, or until a toothpick inserted into the center comes out clean.

BERRY PIE

After a winter filled with savory sweets, I'm always eager for springtime, with its beautiful in-season berries for a fresh, tangy dessert. The berry filling isn't overly complicated and doesn't take much time. In fact, you could say it's as easy as pie!

CRUST

2 cups all-purpose flour
1 teaspoon salt
1 tablespoon sugar
8 tablespoons (1 stick) chilled unsalted butter, cubed
⅓ cup ice water

FILLING

1 cup sugar
3 tablespoons cornstarch
3 cups blackberries
4 cups raspberries
2 tablespoons unsalted butter, diced

1 large egg
1 tablespoon water

1. To make the crust, in a food processor, combine the flour, salt, and sugar. With the motor running, slowly add the butter, piece by piece. Pulse until the flour and butter form pea-size pieces.
2. Slowly add the ice water until the dough begins to collapse onto itself.
3. Turn the dough out and form it into two disks. Wrap the disks in plastic wrap and refrigerate them for 1 hour.
4. Preheat the oven to 400°F.
5. Unwrap one disk of chilled dough and roll it out into a circle. Gently transfer the dough to a pie dish, leaving a little extra overhanging the edges.
6. To make the filling, in a large bowl, mix the sugar and cornstarch. Toss the berries in the mixture to coat.
7. Pour the berry mixture into the pie dish and dot the top with the diced butter.
8. Unwrap the second disk of dough and roll it out to the same thickness as the first. Cut the dough into long strips about 1 inch wide. Weave the strips of dough together over the filling to create a lattice top for the pie. Secure the ends of the strips to the edges of the pie and trim off any excess dough around the pie dish.
9. Beat the egg with the water to make an egg wash and brush it over the dough. Cover the pie with aluminum foil to avoid burning.
10. Bake for 45 minutes, or until the crust is golden brown and the filling has been bubbling for more than 5 minutes. Let cool before serving.

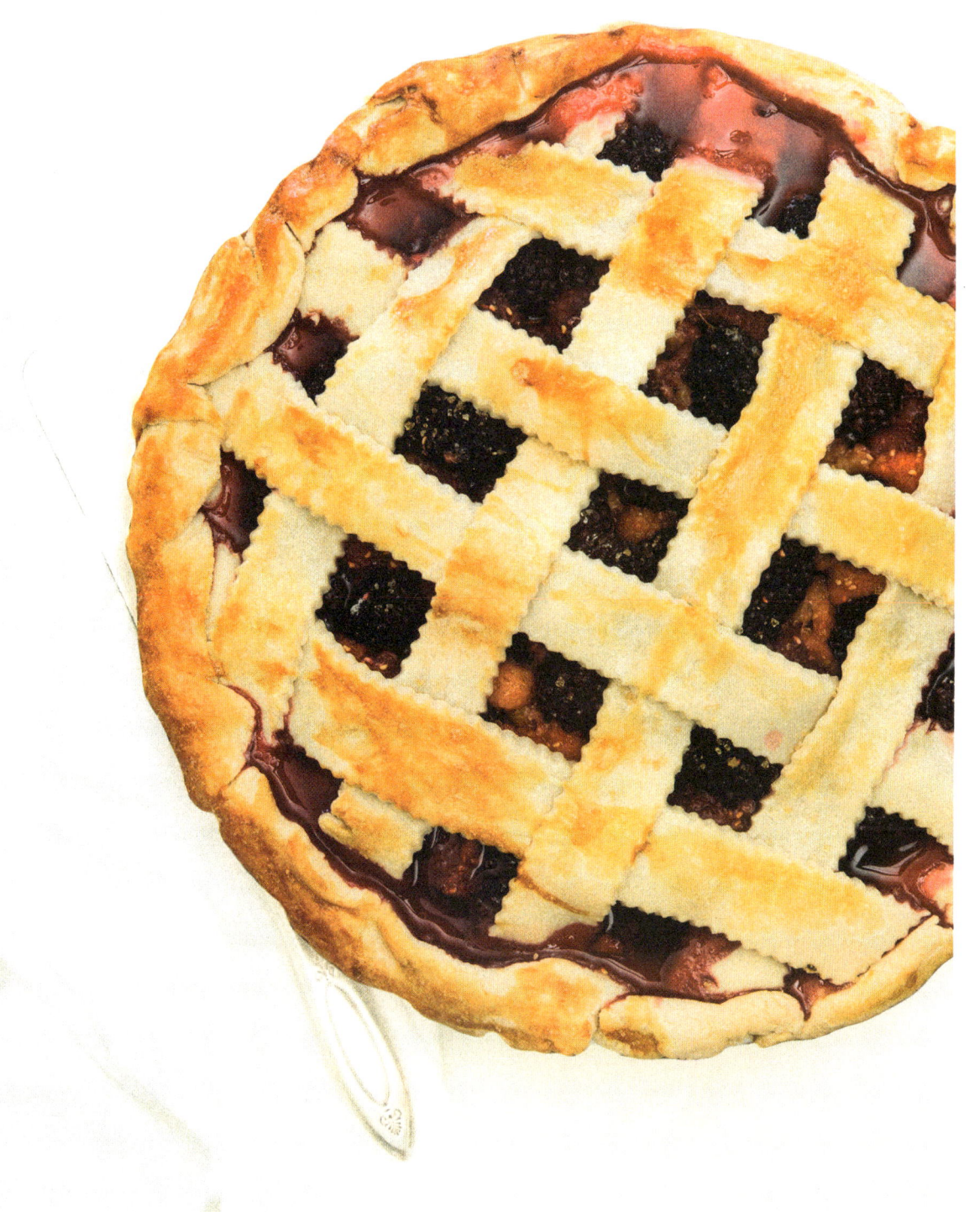

Don't cry over burnt crust! Coconut crusts can easily burn, so in the event that it does burn simply remove the darker bits once the crust has cooled.

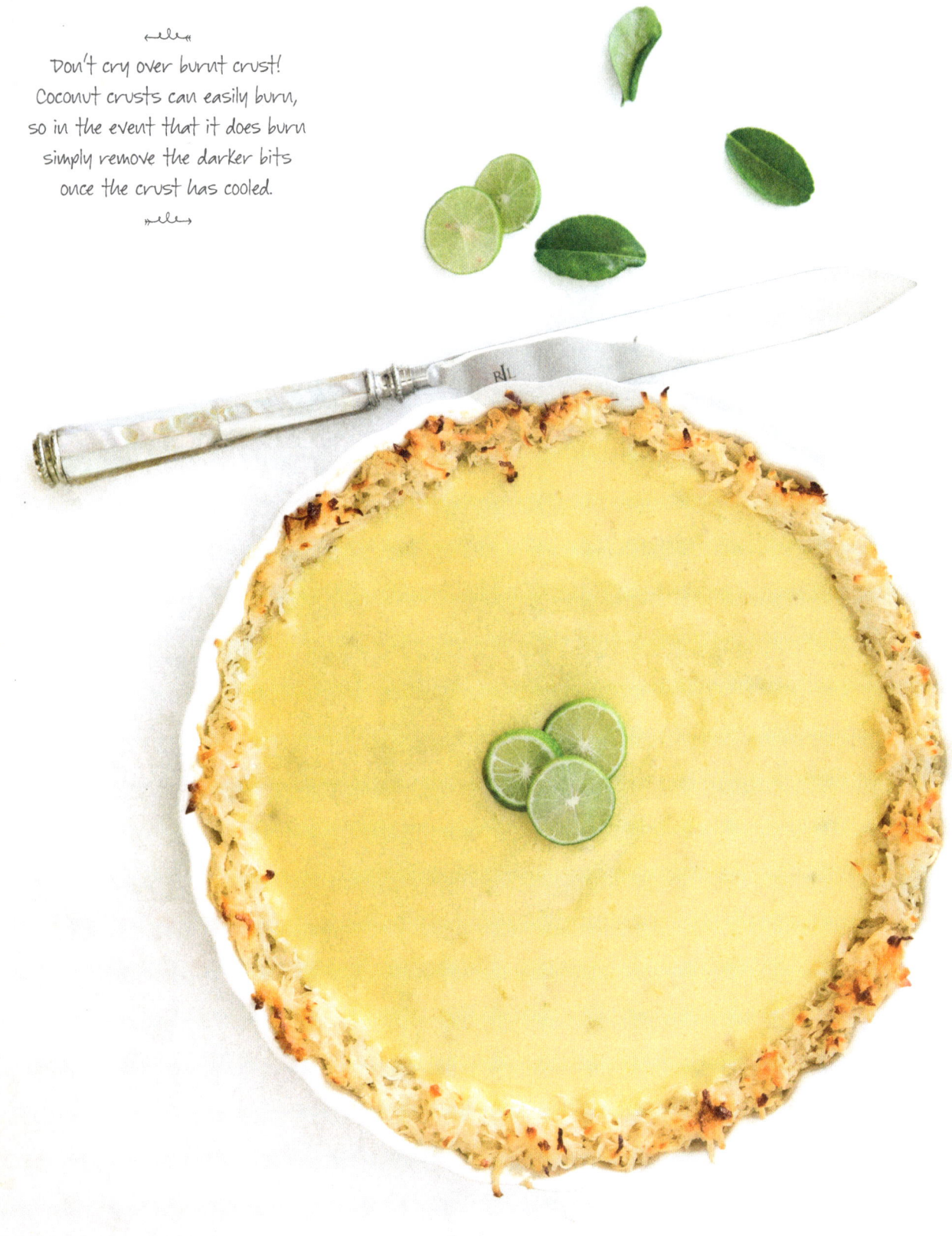

KEY LIME PIE

This light, zesty dessert is such a lovely departure from the more traditional pie offerings and is the perfect way to round out a summer dinner party. For the coconut crust, I use the macaroon recipe from my old copy of The Joy of Cooking.

CRUST

2/3 cup sweetened condensed milk
1 large egg white
1½ teaspoons vanilla extract
⅛ teaspoon salt
3½ cups sweetened flaked coconut

KEY LIME FILLING

1 (14-ounce) can sweetened condensed milk
4 large egg yolks
Zest of 1 large lime
½ cup fresh lime juice

1. Preheat the oven to 350°F. Grease a pie dish with butter or baking spray.
2. To make the crust, combine the condensed milk, egg white, vanilla, and salt in a mixing bowl and stir in the coconut until well mixed. Using your hands, press the coconut mixture into the bottom and up the sides of the prepared pie dish.
3. To make the filling, whisk the condensed milk and egg yolks together in a bowl. Add the lime zest and juice and whisk to combine.
4. Pour the filling into the crust and cover the pie with aluminum foil so the crust doesn't burn. Bake for 15 minutes.
5. Let the pie cool, then refrigerate for a minimum of 1 hour before serving.

APPLE PIE

This is a version of the apple pie recipe I used for William's and my wedding. I decided to mix it up by splitting the ingredients and making three smaller pies, and forgoing the lattice crust on top. Instead, I formed the apple slices into rosettes, added fresh rosemary to the crust, and topped the pies with sprigs of rosemary.

CRUST

2 cups flour

1 tablespoon granulated sugar

1 teaspoon salt

8 tablespoons (1 stick) chilled unsalted butter, cubed

1 tablespoon chopped fresh rosemary, plus 3 sprigs for garnish

1/3 cup ice water

FILLING

8 Granny Smith apples, peeled, cored, and sliced

1/2 cup brown sugar

1/4 cup granulated sugar

3 tablespoons all-purpose flour

1 tablespoon ground cinnamon

CARAMEL SAUCE

8 tablespoons (1 stick) unsalted butter

3 tablespoons flour

1/4 cup water

1/2 cup granulated sugar

1/2 cup brown sugar

1. To make the crust, in a food processor, combine the flour, granulated sugar, and salt. With the motor running, slowly add the butter, piece by piece. Pulse until the flour and butter form pea-size pieces. Add the chopped rosemary and pulse to combine.
2. Slowly add the ice water until the dough begins to collapse onto itself.
3. Turn the dough out and form it into three disks. Wrap the disks in plastic wrap and refrigerate them for 1 hour.
4. Preheat the oven to 425°F.
5. To make the filling, mix the apples, sugars, flour, and cinnamon together in a bowl. Let the mixture sit for 30 minutes.
6. To make the caramel sauce, melt the butter in a saucepan over medium heat. Add the flour and stir to form a paste. Add the water and sugars and bring the mixture to a boil. Turn the heat down and simmer for about 10 minutes. (You want the sugars to dissolve and the mixture to not be grainy anymore.) You don't want to turn this into a dark caramel sauce—just a good sugar-butter mixture that caramelizes once baked.
7. Unwrap each disk of chilled pie dough and roll them out into rounds. Fit each round into a 6-inch pie pan. Divide the apple filling among the pans. You can choose to place the apple slices in a rosette formation (as shown) or you can simply pour the mixture into the crust. Drizzle the caramel sauce over the top of each.
8. Bake for 15 minutes on the lowest rack, then reduce the oven temperature to 350°F and bake for an additional 15 to 20 minutes. Let cool before serving and garnish with the remaining rosemary sprigs.

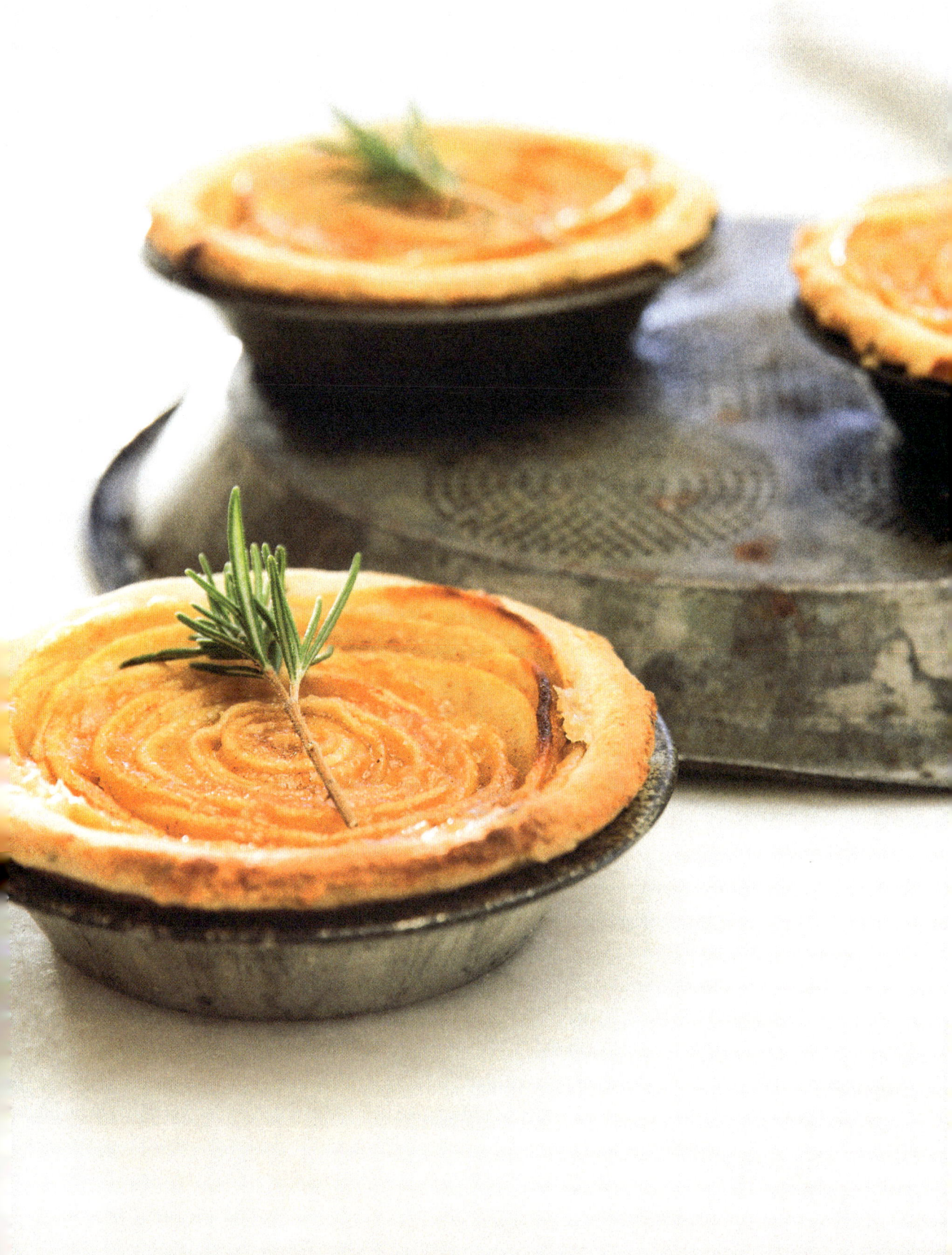

THE ETIQUETTE
table manners

I'd like to believe that, as adults, most people have a pretty good idea of what constitutes proper table behavior . . . but a refresher course couldn't hurt. As society continues to shift and change, so do our guidelines for modern-day etiquette and table manners.

Traditionalists have very strict opinions when it comes to dinner-party decorum, but since my life isn't an episode of *Downton Abbey*, I'm a bit more lenient with my guests and in how I conduct myself.

- Sit down when invited, not before. The host or hostess may require a few moments of last-minute prep, and a table filled with expectant guests can be anxiety inducing.
- Once you're seated for dinner, you should immediately put the napkin (assuming one is provided) on your lap.
- Elbows on the table. This particular topic is ripe for debate. Here's my two cents: before and after, but not during. If dinner has yet to be served or has already been cleared and you're engaged in a conversation with someone across the table, then sure. During the meal? No. Plus, I can't imagine it's that comfortable (or easy) to eat from a plate in front of you with your elbows propped up.
- Remember what your mom taught you: chew with your mouth closed.

- Even Julia Roberts had trouble figuring out how to navigate a place setting. When it comes to silverware, start from the outside in. If you're pausing during the meal, place them perpendicular on your plate; when you're finished, lay them parallel. Your bread plate is on the left and your glassware is on the right.
- Don't reach for a platter; always ask for it to be handed to you. And yes, salt and pepper should always be passed as a pair. Not only is it proper etiquette, it's also inconvenient to have them on opposite ends of the table.
- No cell phone. Nope. Not ever. We have very few occasions in life to unplug, and a dinner party interrupted with buzzing cell phones is distracting for everyone. If you're awaiting an urgent call, speak with the host or hostess about it ahead of time. However, before doing so, you should ask yourself: Can it wait? I bet it can.
- Food restrictions should be addressed prior to the meal, but in the event that they haven't been, it's not polite to announce them at the table. Not only will it make the host uncomfortable, it would likely make the other guests feel awkward as well.
- On that note, don't feel pressured to eat something you can't or prefer not to. Eat around it, but don't make a scene.
- Compliment the host or hostess. He or she has likely worked very hard preparing your meal.

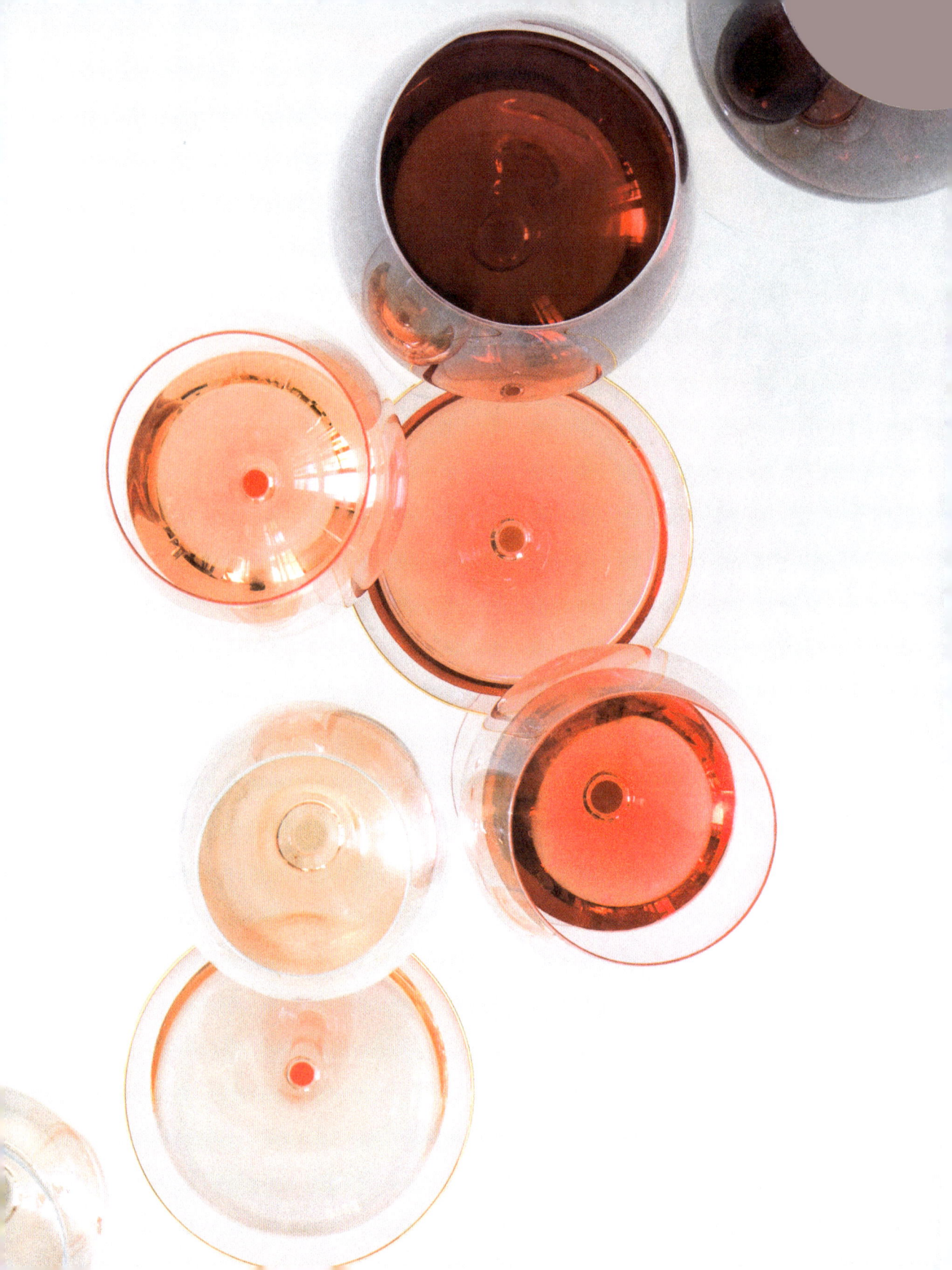

4

the bar

Perhaps even more important than the food you serve at a party are the drinks! After all, what good is the perfect cocktail dress without, well, a perfect cocktail?

the basics

By this point, you've established your budget, finalized the guest list, and pulled together menu ideas. So you're probably ready for a drink! Deciding on the bar presentation for your soiree is the next step in party planning. With all those big decisions now made, you can more easily determine *what* you want to serve and *how* you want to serve it.

Much like the food menu, the bar can be as low maintenance or elaborate as you want. If you're planning a more casual gathering, go easy on yourself and offer a few bottles of wine and a selection of craft beers. There's no reason for the bar to be unnecessarily fussy. For more formal events, blow your guests away by lining your liquor cabinet with specialty spirits and hiring a seasoned mixologist to craft both modern and vintage cocktails.

I typically fall somewhere in the middle. My appreciation for themed parties extends to the drinks being served, so when I have reason to celebrate, my bar usually

includes both a basic bar setup (wine, beer, and clear and dark spirits with complementing mixers) as well as a specialty cocktail to honor that particular occasion (anything from a pitcher of spicy margaritas to my famous spiked apple cider). It's important that as the host you're familiar with the beverages being offered. For instance, if you're a wine drinker, don't feel the need to serve the coolest, most on-trend craft cocktails (like The Commonwealth, which is made using seventy-one ingredients!); and if your Vienna-style lager education is limited, your guests will happily make do with more classic beer options (no one gets mad at a Corona). The short of it? Don't feel pressured to venture too far out of your comfort zone. Stick to what you know *and* to what you like. Establish a bar that complements both the event and your personal knowledge.

When it comes to setting up a bar, you can go in several directions. The goal should be to make it easy on yourself and convenient for your guests (while remaining within budget). For daytime events, you want to have a good balance of both alcoholic and nonalcoholic beverages, particularly if children will be present. And if you plan to offer whimsical-looking cocktails, make sure they're kept beyond the reach of little fingers!

Since morning and afternoon soirees aren't typically liquor-heavy events (save for the bachelorette party!), chances are you'll be covered with a basic bar setup. If your gathering is more than twenty people, you might want to consider premium beer, good wine, premixed drinks, and/or a self-serve cocktail bar (Bloody Mary, mimosa, margarita…the sky's the limit). Plus, a well-dressed beverage buffet can double as festive décor, as well as an activity for your guests. Make cocktail crafting part of the festivities!

However, for evening events with a sizable guest list, you should budget for a bartender—particularly if you plan to offer a full bar. Most partygoers won't turn down handcrafted cocktails. Not only are they delicious, but a properly made beverage can help elevate the overall aesthetic of your event.

Without a bartender, you'll most likely spend the entire party either making drinks or cleaning up after partygoers helping themselves to your liquor cabinet. While it can be done, I don't recommend it. A bartender will also keep your glassware cleaned and in rotation, which, otherwise, can be an unex-

pected party hassle. If you're serving specialty cocktails, you need to consider that each new cocktail means a fresh glass; so without a bartender, plan on having a new glass for each guest for each hour of the event. For example, if you're hosting twenty people for three hours, you'll need approximately sixty glasses (or a pair of rubber gloves to wash the ones you have throughout your party).

the alcohol calculator

For most hosts and hostesses, the biggest headache is always determining *how much* alcohol to buy. Many things factor into this decision (like who is on your guest list, what food you are serving, who likes what mixers, and what you are celebrating), but I've come up with a pretty standard formula to help you avoid making those frantic last-minute beer runs. Stick with me here! It's not as complicated as it looks.

First, determine the average number of drinks you expect each guest to drink per hour (cocktail party guests may drink 2.5 drinks per hour, while baby shower guests may drink only 1 per hour) and then multiply that by the number of hours your event will last. That will determine the drink count for a single guest. Keep in mind that the average mixed cocktail contains 1½ to 2 ounces of alcohol. Remember to be realistic with your estimate and round up if you are unsure. Better a little booze left over than running out while the party is still going.

Take the estimated drink count number per guest and multiply it by the number of guests you're hosting; the result will be the number of drinks your guests will consume. Finally, take that number of drinks total and multiply it by 1.20 (this will account for a 20 percent overage to avoid running out!). The final total is the amount of drinks you believe will be consumed at the event, with a 20 percent safety buffer.

(AVERAGE # of DRINKS × # of Guests) × 1.20 = Total Drink Count
(including safety buffer!)

Now that you have the number of drinks you will be serving, you just have to figure out what those drinks will be. (This is where things can get tricky!) Following is an example of how we estimated the appropriate amount of alcohol to purchase for the birthday party detailed in chapter 6....

- Average number of drinks per guest: 4
- How many guests: 15

Now I use the equation shown on page 45...

(4 × 15) × 1.20 = 72 Total Drinks

Now I know that I will be serving roughly 72 drinks to these party animals. The question is how much alcohol do I need to buy?

At the birthday we offered pink champagne, a signature cocktail, beer, and clear liquors. I wanted a pretty even assortment of drinks, so I estimated the average guest would consume:

1 glass pink champagne (standard bottle serves 6)
1 signature cocktail (containing 2 ounces tequila)
1 beer
1 basic cocktail (1½ to 2 ounces of alcohol, and in this instance I'm planning on offering additional tequila-based drinks, as well as vodka and rum)

With the 20 percent buffer, I am going to be shopping for 18 guests instead of 15. As we move on to what to buy, it's also important to note that alcohol is sold in milliliters, but most cocktails are measured in ounces. The standard 750-milliliter bottle equals just a splash over 25 ounces. So, after the necessary math, here is my shopping list:

3 bottles of pink champagne
3 six-packs of a variety of beers
2 (750-ml) bottles of tequila
1 (750-ml) bottle of vodka
1 (750-ml) bottle of rum

I had to overbuy on the tequila because one bottle wasn't quite enough, and I'd rather have extra left over for my next party than not enough for this one.

If for some reason you find your bar running low while the party is still in full swing, don't worry... technology to the rescue! Apps like Minibar and Instacart are available in most major cities and, depending on local laws, can deliver wine, beer, and liquor to your front door provided you are of legal drinking age and can show a valid ID (and are willing to pay a nominal service charge).

the bar necessities

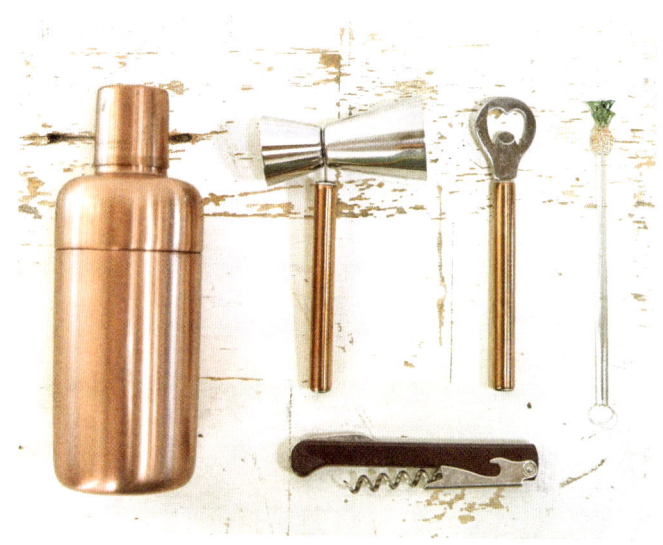

THE JIGGER Both a unit of measure in making cocktails and the tool used to craft them. The traditional hourglass shape provides two measures common to mixed drinks: the large side holds 1½ ounces (which typically equates to one shot or jigger, hence the name) and the smaller holds a fraction of that, often ¾ ounce.

THE SHAKER Besides being a barware essential, a proper cocktail shaker can also give you serious street cred. From James Bond to Holly Golightly, the coolest kids knew the power of a properly shaken cocktail.

THE DRINK STIRRER When whipping up cocktails with light mixers or using distilled spirits (like whiskey or gin), professional mixologists suggest stirring your beverage, so a well-prepared host should have both a shaker and a stirrer on hand.

THE BOTTLE OPENER Since most premium beers are rarely "twist off," it's important to keep a few bottle openers available for partygoers—particularly if you want to avoid anyone trying to get creative with your countertops and house keys!

THE CORKSCREW Although screw-top wine bottles are becoming more and more popular (even among the finest winemakers), no bar is complete without a proper corkscrew. These can range anywhere from $3 to more than $700, but my advice is to land somewhere on the lower end. Avoid cheaply made plastic openers and save yourself the headache of spooning pieces of cork out of your glass. Pick up a sturdy, easy-to-handle waiter's corkscrew from a home store (such as Crate and Barrel or Williams-Sonoma) for around $20.

THE BAR 47

the glassware guide

When it comes to glassware, the possibilities are endless, from copper mugs and margarita glasses to hurricanes and mason jars. At the end of the day, there are really only eight basic glass types you'll need in order to serve most cocktails.

THE SHOT Typical for one serving of any liquor consumed in one, well, shot. Bottoms up!

THE HIGHBALL Typical for mixed drinks with a lot of ice and a larger proportion of mixer to alcohol, such as a mojito, vodka soda, or tequila sunrise.

THE OLD-FASHIONED Like the highball, it can be used for mixed drinks served over ice, such as a margarita or its namesake, the old-fashioned, as well as top-shelf liquor served without a mixer (think: whiskey on the rocks).

THE PINT Typical for beer and cider or a really decadent Bloody Mary.

THE MARTINI Typical for mixed drinks served "up," like a cosmopolitan, Manhattan, and, of course, a martini.

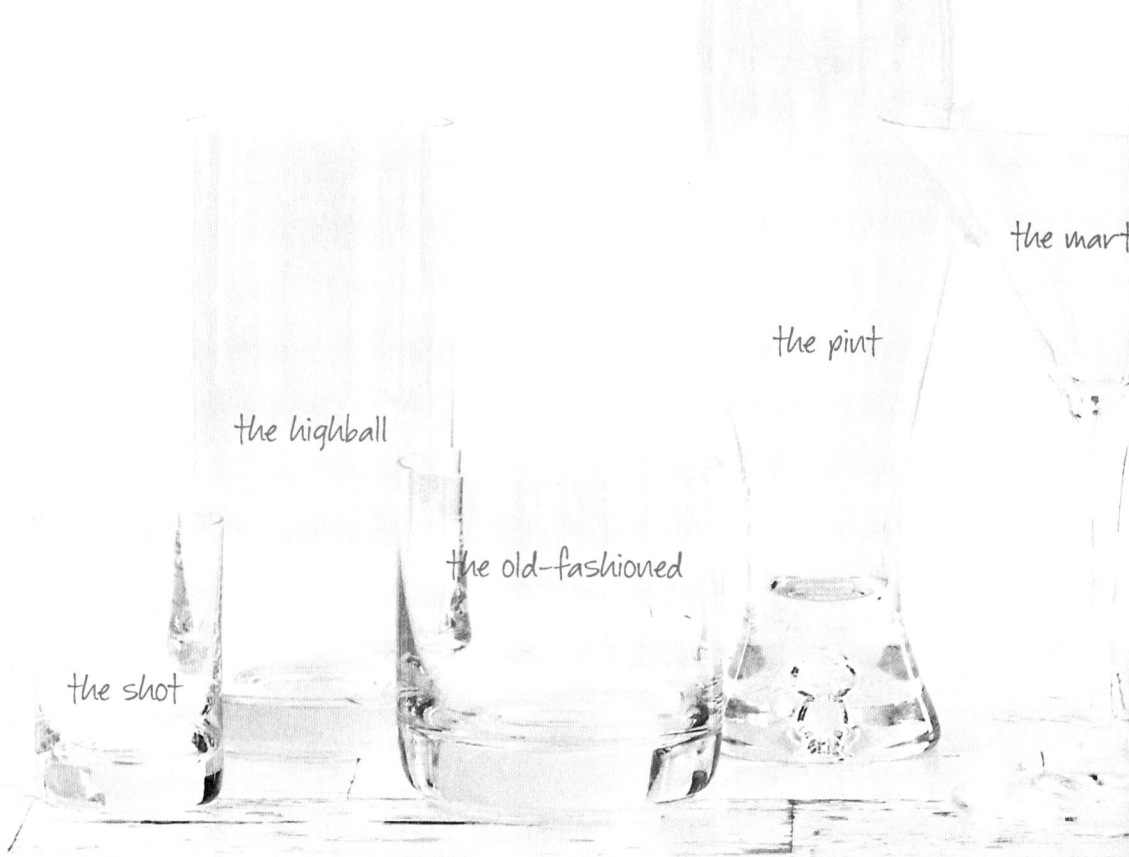

THE CHAMPAGNE FLUTE Typical for sparkling wine like prosecco, champagne, or champagne cocktails.

THE BORDEAUX Typical for red wines, this wineglass is known for its wider bowl, which aids in aerating the wine and enhancing its flavor.

THE CHARDONNAY Typical for white wines, this glass is similar to the Bordeaux but smaller and narrower, which helps to retain the wine's cooler serving temperature.

Wine enthusiasts are adamant that each varietal requires its own shape of stemware, but for more casual wine drinkers, a standard red and a standard white will cover all the bases.

the champagne flute

the bordeaux

the chardonnay

the booze basics

Pay attention, party people! For those in need of a refresher course, here's an overview of the standard types of alcohol you will find in a bar, along with the drinks in which they are most commonly used.

vodka

Usually distilled from fermented grain or potatoes (although it can actually be made from anything capable of being fermented—grape vodka, anyone?), this colorless alcohol is the base for many mixed drinks. It's the most popular spirit in the country, so you'll probably want to have it as an option at your bar.

DIRTY MARTINI

3½ ounces vodka
¾ ounce dry vermouth
2 tablespoons olive brine

Shake
Garnish with: olives
SERVE IN: martini glass

BLOODY MARY

2 ounces vodka
4 ounces tomato juice
2 dashes Tabasco sauce
1 teaspoon prepared horseradish
2 dashes Worcestershire sauce
Pinch celery salt
Pinch ground black pepper

Pour over ice and stir
Garnish with: celery and lime
SERVE IN: pint glass

MOSCOW MULE

2 ounces vodka
3 ounces ginger beer
Juice of ½ lime

Pour over ice and stir
Garnish with: sprig of mint
SERVE IN: copper Moscow mule mug or old-fashioned glass

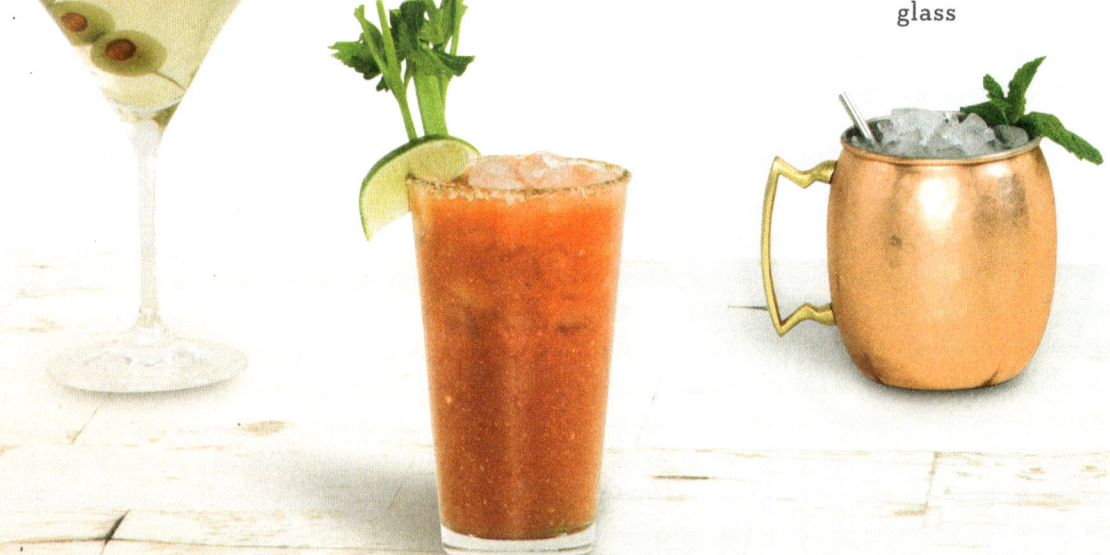

tequila

Made from the agave plant and originating in Mexico, this spirit comes in different forms ranging from clear to golden. If all you know about it involves dive bars, salt, lime, and a hangover, be prepared to welcome it back into your life. Sipping a delicious citrus-infused tequila cocktail can be the most refreshing way to spend a warm summer night. But, that being said, never underestimate the temptation of a well-executed tequila shot!

MARGARITA
1¼ cups ice cubes
1½ ounces tequila
1¼ ounces fresh lime juice
1½ tablespoons agave syrup

Blend
Garnish with: lime wedge
SERVE IN: margarita glass

TEQUILA SHOT
1½ ounces chilled tequila

Garnish with: lime wedge and pinch of salt
SERVE IN: shot glass

TEQUILA SUNRISE
1½ ounces tequila
4 ounces fresh-squeezed orange juice
Dash grenadine

On the rocks
Garnish with: orange slice and cherry
SERVE IN: highball glass

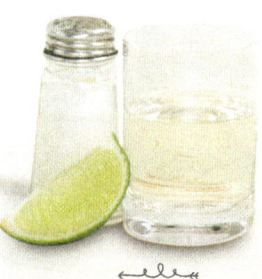

Salt, shot, then lime.

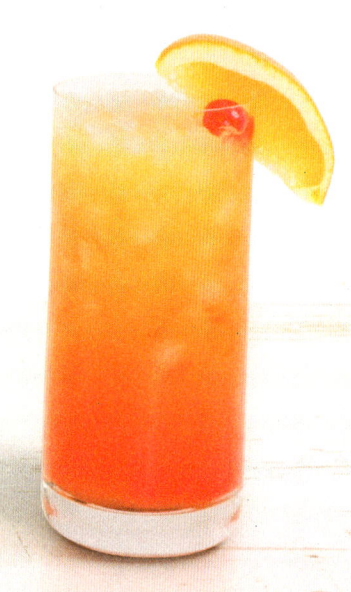

gin

Ah, gin, the preferred spirit of hip mixologists everywhere. Unlike vodka, this clear liquid flavored with juniper berries has a taste all its own, although not all gins are alike. Some are floral and flavorful while others are crisp and clean. But they all make for a satisfying cocktail base. I suggest beginning with a simple gin like Hendrick's and seeing how your palate develops from there.

GIMLET

2 ounces gin
2 ounces sweetened lime juice

Shake
Garnish with: lime twist
SERVE IN: martini glass

TOM COLLINS

2 ounces gin
1 ounce lemon juice
½ ounce simple syrup
3 ounces club soda

Pour over ice and stir
Garnish with: orange twist and a maraschino cherry
SERVE IN: highball glass

NEGRONI

1 ounce dry gin
1 ounce Campari
1 ounce sweet vermouth

Shake
Garnish with: an orange twist
SERVE IN: old-fashioned-glass

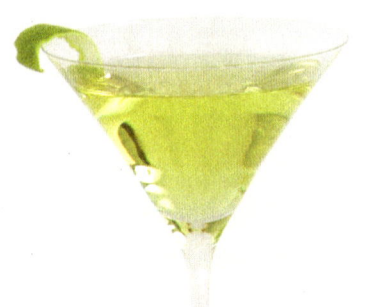
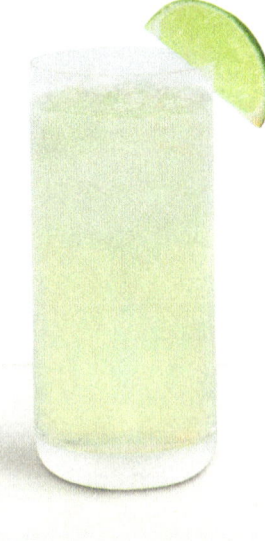

whiskey

Made from fermented grain, this distilled drink has a strong flavor and makes for a hearty and sweet cocktail. Both scotch and bourbon fall under the whiskey category as specialty offerings of the brown spirit. Scotch is made specifically from malted barley and must be produced in Scotland to bear the label, while bourbon is primarily corn based (more than 51%) and produced entirely in the United States. As common sense would suggest, rye whiskey must contain rye to be labeled as such (for American rye it must be more than 51%). Brown spirits are the trickiest to understand because of the specifics of the distilling process, but having a basic handle on the topic could prove a useful party trick!

MANHATTAN

2 ounces rye whiskey
½ ounce sweet vermouth
1 dash bitters

Stirred over ice, served up
Garnish with: maraschino cherry
SERVE IN: martini glass

MINT JULEP

2½ ounces bourbon whiskey
2 sugar cubes
6 mint leaves
1 cup crushed ice

Muddle sugar and mint, add crushed ice and whiskey, and stir
Garnish with: sprig of mint
SERVE IN: mint julep cup

OLD-FASHIONED

2 ounces rye whiskey
¼ ounce simple syrup
2 dashes bitters

On the rocks
Garnish with: orange twist
SERVE IN: old-fashioned glass

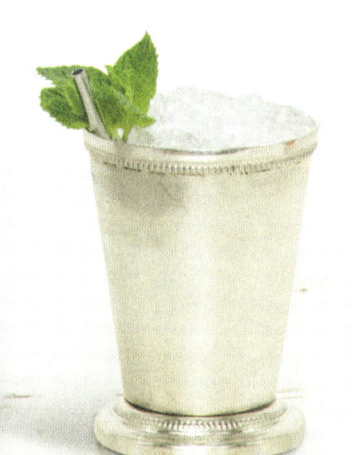

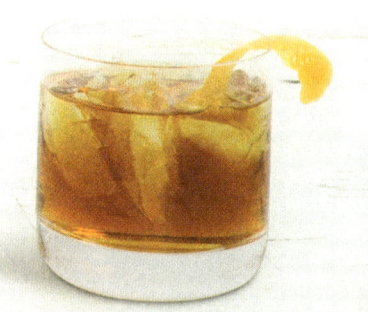

rum

If you want to offer sweet cocktails to your guests, rum is the way to go. It's an alcohol distilled from sugarcane or molasses, and therefore ranges in color from clear to golden amber to deep coffee. And since a majority of the world's rum is produced in the Caribbean, cocktails made with the candied alcohol pair nicely with little umbrellas and sunscreen.

PIÑA COLADA

1½ ounces light rum
2 ounces coconut milk
2 ounces pineapple juice
1 cup ice

Blend with ice
Garnish with: slice of orange and a cherry (and umbrella, if you're feeling festive)
SERVE IN: hurricane glass

DAIQUIRI

2 ounces light rum
1 ounce fresh lime juice
1 ounce simple syrup

Blended with ice
Garnish with: lime wedge
SERVE IN: daiquiri glass

MOJITO

1½ ounces rum
6 mint leaves
1 ounce simple syrup
1 ounce fresh lime juice
1½ ounces club soda

Muddle mint, syrup, and lime juice, then add ice, rum, soda, and stir
Garnish with: sprig of mint
SERVE IN: highball glass

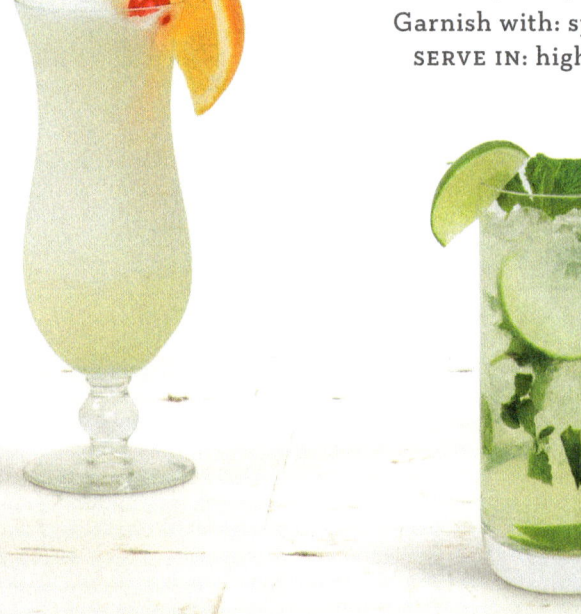

beer or wine

If you're looking for something simple on the drinks front with no assembly required, offer only beer and wine at your party. To make sure all your guests find something they like, provide options. For example, don't buy five cases of the same beer. Pick at least a few different styles—some dark, some light, some ales, or some stouts. When it comes to beer, the craft trend has really taken booze culture by storm. Now more than ever, the region where you live plays a huge role in what beer is available, so do your research. If you happen to live near a Whole Foods Market, chances are they've done the research for you. The grocery chain is a huge distributor of both nationally recognized beer manufacturers as well as local breweries—and prides itself on having an in-house beer specialist.

If you're choosing to serve only wine at your gathering, you've made your hosting duties significantly less complicated. But as they are with cheese, people are very particular about wine. If you're a novice wine drinker, stick to the basics and get some direction from a trusted wine-store expert. If you're a wine enthusiast, offer a selection of more interesting and unique wines, but remember that not everyone will be as adventurous as you, so plan on offering familiar options as well. On pages 56–57, I've outlined a few things to know about some of the most popular wines, as well as some more interesting varietals (your knowledge on these less familiar wines could make great party conversation!).

REDS

PINOT NOIR This is the world's most universal wine, with countless varying styles (depending on its region of origin). It's basically the party guest everyone likes. Given the endless number of options available, you can find a pinot to complement whatever you're serving, but most often it's paired with salmon and game meat.

SYRAH One step up in depth from the pinot noir, some varietals of this red are known for their peppery and smoke-infused qualities, while others are more jammy in flavor. This is a perfect complement to a backyard BBQ!

BEAUJOLAIS This is a fun and playful, light-bodied French wine that's high in acidity and pairs beautifully with a traditional holiday dinner, and is best enjoyed with good stories and good laughs.

WHITE

RIESLING Oftentimes this aromatic wine is earmarked as being a sweeter drink, but it can also be quite dry. It's a nice beverage to serve with a cheese board.

SAUVIGNON BLANC A crisp white usually brimming with both citrusy fruit (like lemon and grapefruit) and herb flavors, this wine is great with poultry and white fish, as well as dessert.

CHARDONNAY The queen of white wines! People usually have pretty strong opinions about the trademark oaky flavors and buttery richness of the popular California chardonnay. They either love it or hate it, but it's still widely considered a "must have" when hosting an event. It pairs best with heavier seafood dishes, like scallops.

SPECIALTY WINES

ROSÉ Nothing says summer quite like a bottle of this blush-colored wine. Unlike the other wines listed, rosé isn't from a particular region or made from a specific grape. It's a type of wine (like red or white). An agreeable, medium-bodied wine, it goes well with just about anything—especially sunshine!

CHAMPAGNE Bubbles define just about any party! If it's a particularly special occasion, splurge on a vintage. It's important to note that sparkling wine can only bear the name "Champagne" if it is produced in the Champagne region of France. This delightful beverage goes best with cocktail dresses and strawberries or lazy Sundays and orange juice.

SHERRY Once a forgotten wine and commonly thought of as an after-dinner drink, sherry is having a bit of a renaissance. It's traditionally dry in flavor, but some varieties are known for sweeter or nuttier qualities. Reacquaint yourself with sherry during your next shellfish meal.

mocktails

A proper host will always have nonalcoholic options available. While sparkling water and craft sodas are good alternatives, it's easy for your non-drinking guests to feel "left out" of the fun, so it's a thoughtful gesture to offer a festive specialty mocktail. Elevate the simple soda and fresh juices by adding additional elements with a kick (like fresh ginger, sugared rims, blackberry purees, or crushed jalapeños . . . the possibilities are endless!).

THE ETIQUETTE
how to give a proper toast

A well-delivered toast should accomplish two things: welcoming your guests and recognizing the cause of the celebration (whether that be a person or an event). Sometimes an occasion—like a wedding—calls for a more thoughtful toast, but the same rules apply.

1. Do some prep work. You should have a rough outline in your head (or on a note card) of what you'd like to say. If you're ill prepared, you'll end up stumbling through your speech—and that isn't fun for anyone.
2. Keep it short and sweet. No one wants to hold up his or her glass for fifteen minutes while you spout inside jokes that no one else understands. Don't talk just to talk! Everything you say should have a purpose.
3. Remember to introduce yourself, particularly if it's a large gathering. Don't assume everyone will know you (even if you are the host).
4. If you aren't the one throwing the party, take a moment to thank the hosts for including you.
5. Feel free to share a personal anecdote, story, or a joke, but keep it tasteful and familiar. It's a celebration, not a roast. And if it's a commonality everyone can relate to, even better! If you're feeling iffy about a particular story, skip it.
6. Don't be afraid to bring your speech with you, but be mindful to interact with your audience (and avoid reading your speech verbatim). Guests would much rather you have a deliberate toast than listen to you fumble for your words, but also want to feel engaged.
7. Keep it light. You're celebrating, so have fun with it!

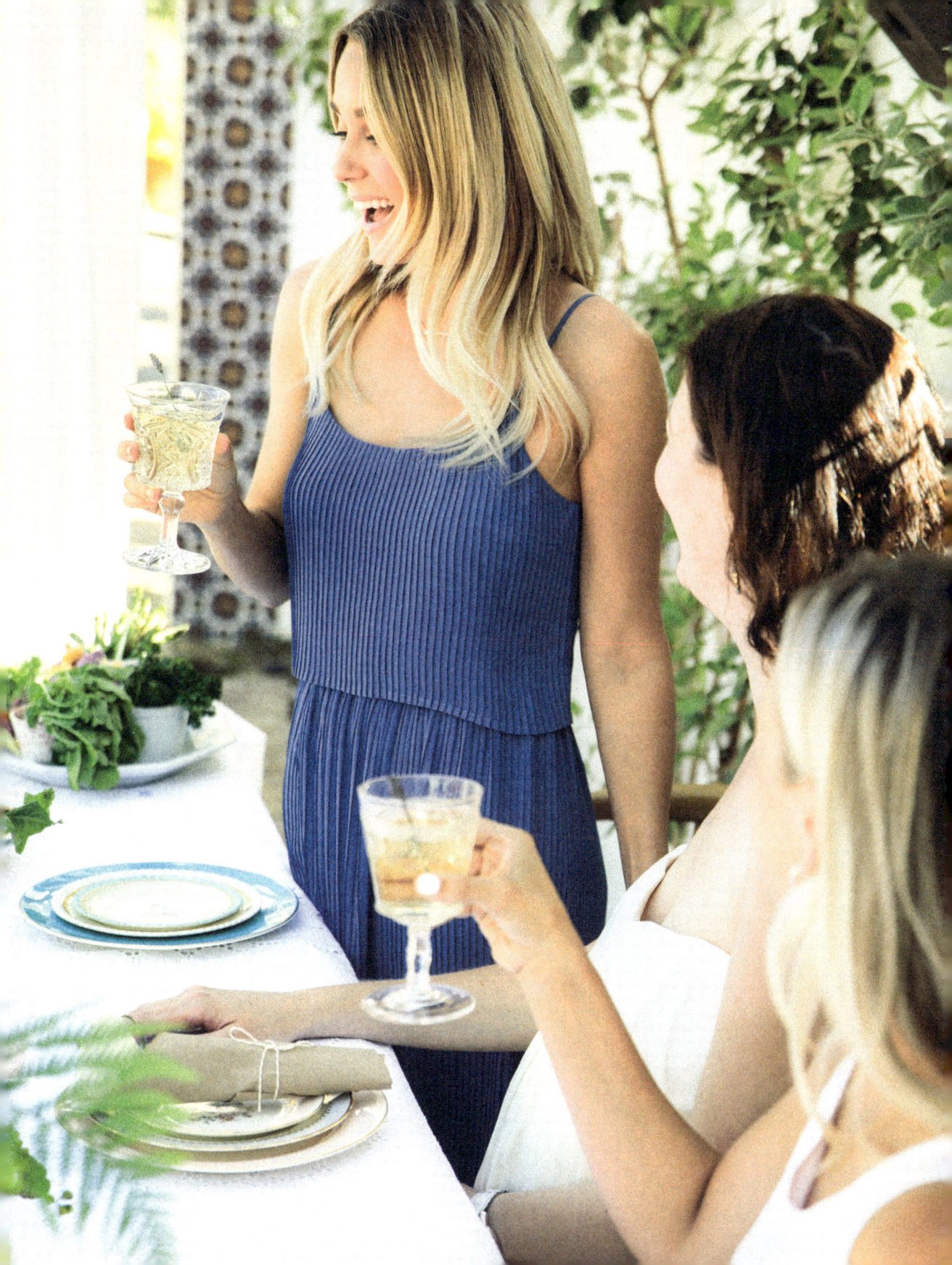

5

the décor

During my early party-planning days, I stuck with tried-and-true crowd-pleasers: a bundle of bubblegum-pink balloons, buckets of colorful confetti, and delicious, sugary, sprinkles-covered cake. Occasionally, I'd throw my guests a curveball and opt for magenta or blush when deciding on a color palette, but I typically stayed within my wheelhouse. Sometimes I'd feel especially creative and toss in some festive homemade signage designed with Crayola markers and art paper or fill a store-bought piñata with an assortment of my favorite drugstore candies.

To be fair, I was also twelve years old, so I didn't have much to compare it with.

Nowadays I have a much more involved process when it comes to event décor, beginning with a thoughtfully arranged inspiration board and ending with a bash that puts my childhood birthday parties to shame. For the record, I have totally banned confetti smaller than an inch in diameter from any party I host, along with glitter and small children. (Just kidding about the kids! Well, sort of . . .)

As I've become a more experienced entertainer, I've found that when you're throwing a party, you're not just hosting an event; you're creating an experience—and décor is a critical piece of the puzzle. You're inviting guests into a moment, and a well-

designed affair can truly leave a lasting impression. It's what separates sharing a simple glass of wine with friends from a thoughtfully executed cocktail party. You have taken the time to elevate every other aspect of the occasion, from the shoes on your feet to the appetizers being served, so it would be silly to overlook the one thing in the planning process that ties them all together. After all, you wouldn't pick out the perfect birthday present and arrive to the party with it unwrapped, right? When planning the décor, you must consider all aspects of your celebration and ask yourself: What does this event call for?

Every component should serve a purpose and/or elevate the experience for your partygoers. Although I'm always in favor of surrounding your guests with pretty things, sometimes more stuff is just more stuff. The objective of your décor shouldn't be to mask the existing environment (unless you're being forced to host the event at the

tragically eighties-inspired home of someone's aunt Barb); it should be to create an atmosphere befitting the soiree. Hand-painted signs can gently guide partygoers around the festivities, and a large woven basket full of cozy, carefully wrapped blankets can keep people warm after sunset. Even the small details—like little chalkboard signs identifying the different cheese offerings or tiny potted-succulent party favors—should feel cohesive with the overall aesthetic. The design will dictate the mood of your event, and nothing should feel forced.

For an old-fashioned birthday party (see chapter 6), large confetti, oversized balloons, cotton candy, and even streamers can serve a carefully designed purpose, particularly when the goal is to create a nostalgic, lighthearted atmosphere. Sometimes the food and drink *are* the stars of the party, so let them shine (see The Dinner Party, page 135, or The Clambake, page 165). However, while you don't need much in terms of additional design elements, your tablescaping game better be on point.

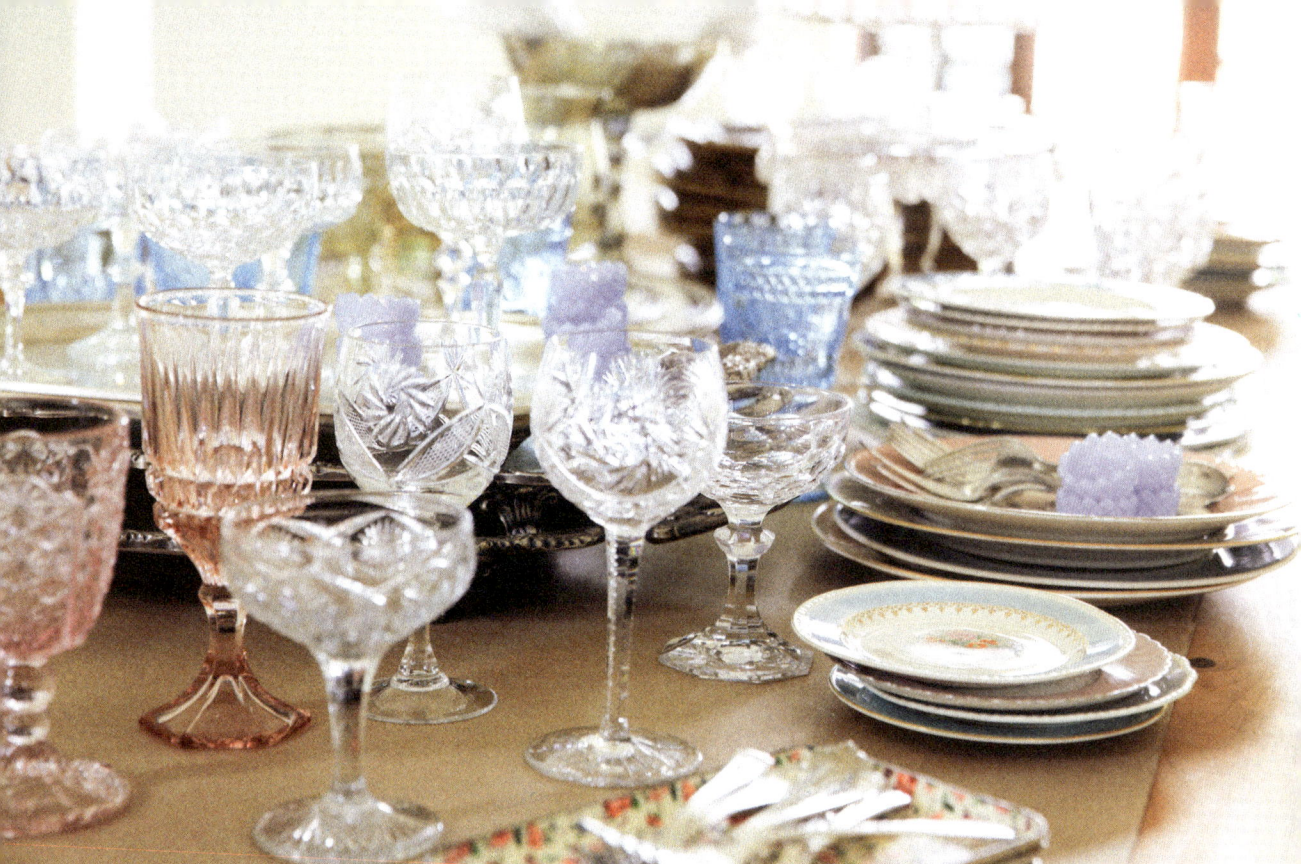

the basics

Before you even begin planning your party décor, you need to determine where the event is being held. It's better to work with your surroundings and the existing color palette rather than fight against it. Making the environment work in your favor can help you avoid creating a design that feels inauthentic. Think of it in the same way as you would when applying makeup. It's best to highlight and work with your existing features instead of trying to cover it all up, which can end up being a total disaster. Plus, chances are that you're actually going to like the look of the space you've chosen (unless it's at Barb's house), so showcasing some of the existing style elements shouldn't be a bad thing.

Next, what is the cause for celebration? If it's a baby shower for a new little girl, then pink (and lots of it) is usually a safe bet. If there is a guest of honor, you'll want to make sure his or her favorite food, drinks, and games are taken into consideration. In my opinion, if you're hosting a bachelorette party, feel free to be a bit more tongue-

in-cheek with some of your decorations (after all, bachelorette parties demand kitschy party favors).

When sourcing goods, you'll need to do some homework. What you'll need and where you'll go depends on the type of event you're throwing, but begin by scouring flea markets and bargain retailers as well as online marketplaces and resellers. For the basics, like balloons and streamers, your local party supply retailer should do the trick, while more specialty items may take a bit of hunting. Etsy can deliver just about anything you could dream up, from personalized cake pans to perfectly hued party-favor boxes, but keep in mind that his process may take a few extra days. Amazon.com is a great resource when you're looking for a specific item (like pink-and-white polka-dot paper straws or 3-inch miniature terra-cotta pots). Remember, there is no one-stop shop for party planning. As the host, you'll be required to do the work. Let's face it: if being a fabulous hostess were easy, everyone would do it.

the inspiration board

At the beginning of every party chapter, I start with an inspiration board. When the possibilities are literally endless, it's easy to get off track. Creating an inspiration board helps keep me focused, and my party looking cohesive.

First stop: Pinterest. It's an incredible resource that I use as a digital bulletin board to catalog everything from tasty pie recipes I'm dying to try to ideas for organizing my closets and drawers. If you're a bit more traditional, pick up a few magazines or a design book and start dog-earing pages. While you're out and about, take photos of a color story that really speaks to you, or make note of a cool idea for displaying your glassware. In this initial step, you can't go overboard. Collect all your ideas first, and then you can begin the editing process.

Next, pick a theme . . . and stick to it! If you're hosting a backyard summer BBQ, you're not going to need fine table linens and crystal candlesticks. If you are hosting a nice dinner party, it's probably best to skip the disposable plates and utensils (see chapter 12 for the exception to this rule!). Those are pretty obvious examples, but the point is to stay in line with your vision. If you're hosting an autumn dinner party showcasing hearty passed dishes, you will want your tablescape to have a similar feeling by including other harvest-inspired elements like a textured burlap runner or a centerpiece composed of white gourds and succulents. All parts should flow together seamlessly.

the rules of arrangement

Designing your own floral arrangement may seem daunting, but I assure you, with a little practice, you can easily become your own florist. Not to mention, it will end up saving you boatloads in the long run. Los Angeles has a spectacular flower mart, both downtown and near the airport (which is a great place to see the freshest blooms just hours after they land), but I know that not everyone lives near a big city. In that case, you should try to locate where the florists in your area source their products and go there!

Take it upon yourself to whip up a bouquet. Here are some basic guidelines to help you create your own elegant (and easy!) arrangement:

- **MIX SCALE.** If you select a larger single bloom like a rose, peony, or tulip, it's nice to offset it with a flower that clusters together a bunch of smaller blooms, like a hydrangea, a lilac, or paper whites.
- **USE COMPLEMENTING COLORS.** Pick flowers that make sense together, and stay within that color story: all cool tones, all warm tones, variations of pink, and so on.
- **PUT LIKE FLOWERS TOGETHER.** The flowers in your arrangement should feel like they've been plucked from the same garden, or, at the very least, gardens that exist in the same state. If you're featuring yellow cymbidium orchids, do not pair them with dusty miller. Bright tropical blooms just wouldn't sit with soft, romantic greens.
- **PICK A GREEN AND STICK WITH IT.** My biggest flower-arranging

pet peeve is when the the greens on the flower don't match the greenery you've chosen for the arrangement (e.g., silver dollar eucalyptus or fern), so either choose elements that complement one another or strip the bloom from its stem.

- **GET CREATIVE WITH YOUR VESSEL.** You don't need to always stick with the standard glass vase; feel free to experiment with distressed-wood boxes, old mason jars, or even a hollowed-out pineapple (see page 192). Don't be afraid to mismatch (different-size glass bottles or vintage containers in varying sizes), just as long as containers are within the same category. If the occasion calls for it, forgo the vessel altogether. There's something lovely about a living display artfully arranged on a textured tabletop.

- **USE A GUIDE.** Some containers are too wide or shallow to simply arrange and be done. Whether it's florist foam or making a tape grid across the top of your vessel, it's crucial to employ a system to keep your stems in place—especially if they are being transported.

- **DON'T BE AFRAID TO KEEP IT SIMPLE.** Sometimes a tall vase with tulips or roses stripped of their leaves can be just as chic (if not more) than a meticulously arranged display. If you're party planning on a budget, try using all greens for your arrangement. Don't be fooled by its simplicity. Rich, textured greens are beautiful. See chapter 7 for more details!

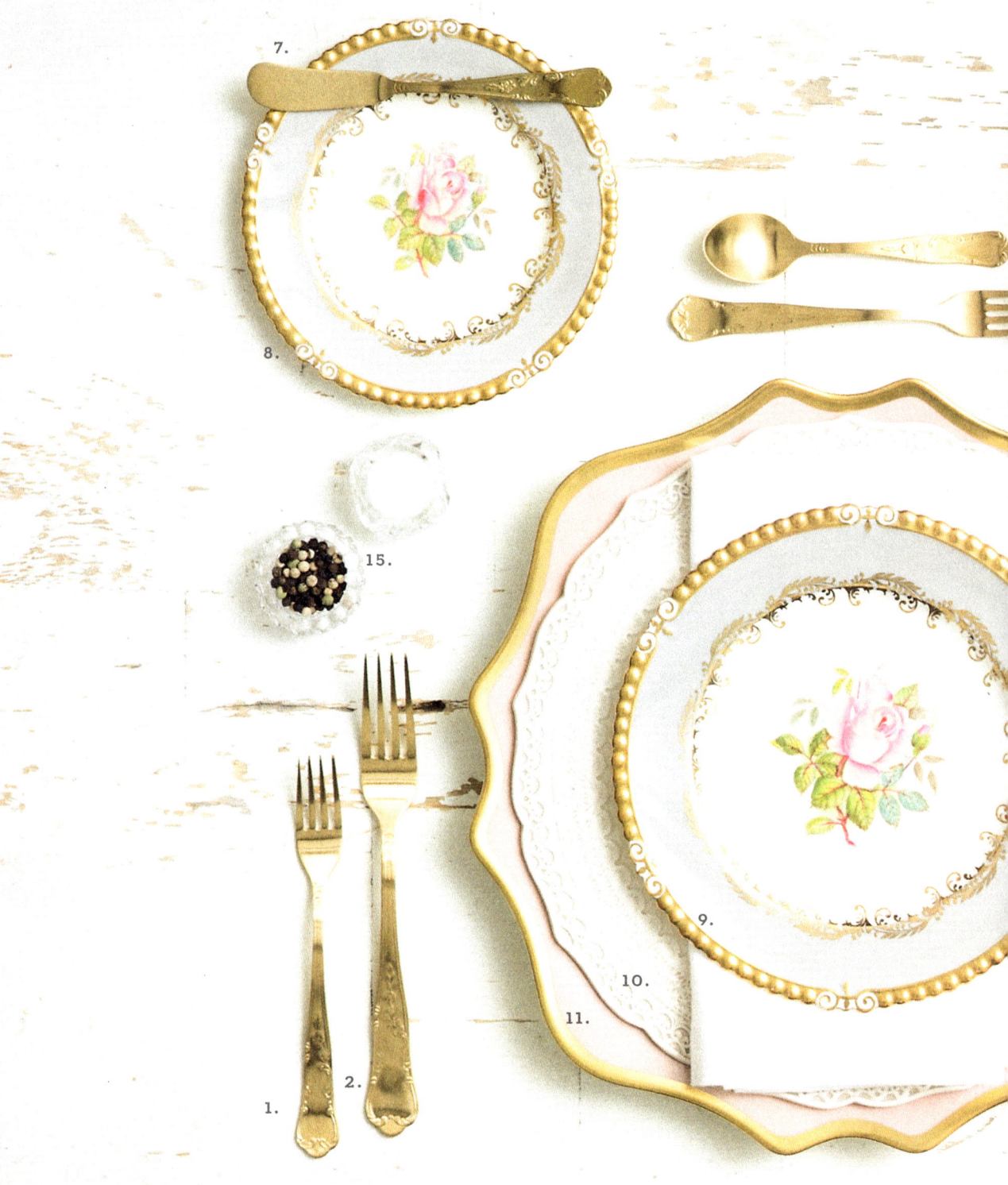

THE ETIQUETTE
the proper place setting

There aren't too many occasions that require a traditional, formal table setting—unless you're attending a wedding or black-tie event, or dining at a Michelin-star restaurant. When hosting a dinner party at home, you don't need to set your table with five glasses and twelve pieces of flatware. Since I prefer more intimate, less formal gatherings, I typically call upon a basic place setting (that falls somewhere between informal and formal) and adjust the setup accordingly to complement the meal (e.g., soup spoons, cake forks, champagne flutes, etc.).

THE ELEMENTS OF A BASIC PLACE SETTING

1. Salad fork
2. Dinner fork
3. Salad knife
4. Dinner knife
5. Dessert spoon
6. Dessert fork
7. Butter knife
8. Bread plate
9. Salad plate
10. Dinner plate
11. Service plate
12. Water glass
13. Red wine glass
14. White wine glass
15. Salt and pepper cellars

PART 2

party

6

the birthday party

the overview

Ever since I can remember, I have counted down the days to my birthday. Literally.

As a little girl, I would pop out of bed each morning to cross out yet another box on my calendar with wide-eyed anticipation. Usually this ritual lasted for a few weeks, beginning right after New Year's until February first *finally* arrived.

These days, I'm able to practice a bit more restraint, but the same excitement remains: I *love* my birthday. But it's never actually been about the day itself or becoming another year older (particularly recently); it's always been, for me, about the celebration. There is nothing quite like a good, old-fashioned birthday extravaganza. As a frequent entertainer, I can host a rustic, al fresco dinner and a chic, bohemian brunch (both of which you'll see later), but when it comes to a birthday party, I always feel like it should be a bit of a whimsical nod to our childhoods: bundles of colorful balloons, endless loops of perfectly crinkled streamers, presents wrapped in shimmery paper topped with piles of glittery, curly ribbon, and, of course, a sugary birthday cake smothered in fluffy frosting and candied sprinkles.

Most important, it's about spending time with my favorite people, reflecting on

the year that's passed, and setting intentions for the year to come. I'm fortunate that some of the people closest to me are able to be part of my everyday life, but many of my friends have scattered off into different directions: living in different cities, traveling the world, succeeding in business, getting married and having families, and so on. It's not often we can all come together, but I know that every year, I have the opportunity to see as many of them as possible at my annual themed birthday soiree. I should confess now that I'm *incredibly* partial to a theme—I'll happily embrace any reason to get dressed up! One year I hosted a Roaring Twenties bash at an old Hollywood speakeasy; the next year was a sultry masquerade party in a dimly lit cocktail lounge (masks were required). For the last several years, my husband and I have shared the event (our birthdays are only one week apart!) and have thrown a western hoedown complete with cowboy hats, haystacks, and our friend's bluegrass band.

The moral of the story: not a year goes by where I don't celebrate the occasion with

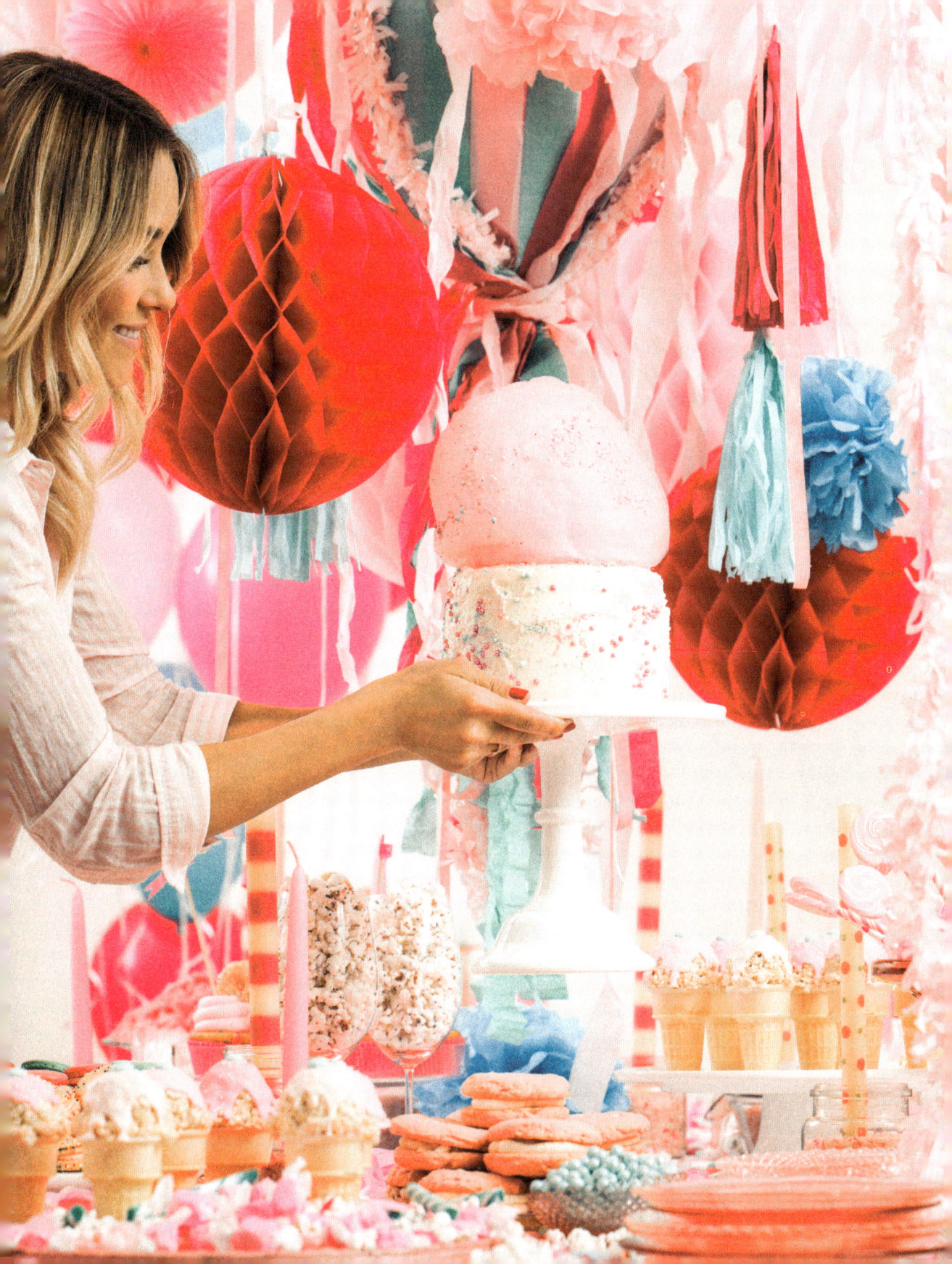

some kind of gathering, large or small. So you can imagine my surprise when I learned that there are certain crazy people in this world who don't absolutely *adore* celebrating their birthdays. They're the type of people who would prefer to let the day come and go without anyone noticing or an ounce of ceremony. For the record, I do *not* understand these totally insane people . . . one of whom happens to be one of my best friends, Maura. If it were up to her, she'd never have another birthday party ever again. (I know, right? What is wrong with this woman?)

Despite her continued reluctance, Maura's husband and I have always managed to trick her into some sort of soiree (because she's a pretty fantastic person who *must* be celebrated).

That's why I took it upon myself to plan Maura's candy-coated twenty-ninth birthday—the last hurrah before thirty!—by embracing the best elements of a traditional childhood birthday party: giant balloons, pillowy tissue paper pom-poms, and even oversized confetti (there are very few people for whom I would break my no-confetti rule, and Maura happens to be one of them).

Because Maura wasn't comfortable with a huge bash, we compromised on a small but festive gathering. We came up with the idea to skip the standard cocktail party fare and invite a handful of her friends for cocktails and confections! This way, we'd start the party a bit later, which meant less time focused on the birthday girl, but still plenty of time to focus on the best part of any birthday party: the desserts! We asked guests to arrive at 8 P.M.—it gave them the chance to eat beforehand (we made sure to note on the invitation that the party was strictly a "drinks and desserts" get-together).

With a less formal soiree, don't be married to any rules! Get creative with your décor and unique elements—like unconventional serving ware. This is the type of event where Pinterest can really come in handy.

My inspiration was "Candy Land Chic." I chose a cheerful array of bright and beautiful pinks, from a vibrant raspberry to a soft rose petal. But as much as it pains me to admit, a party can't be all pink. In order to break up the palette just a bit, I incorporated pops of turquoise. Since it was meant to be a sugary throwback, I wanted to incorporate play-

ful elements like sprinkle-rimmed glassware, a cotton candy–layered cake, and even old-fashioned party favors! It needed to be nostalgic, but it was important that it still have all the luxuries of a grown-up event.

the menu

It's important to know that calories do *not* count on your birthday. I'm also pretty sure they don't count on your best friend's birthday either—which is why I put together a fabulously over-the-top dessert buffet. I wanted the dessert table to be the star of the show (after Maura, of course), overflowing with colorful, sugar-coma-inducing treats. While I took care of most of the decorating myself, I'm fortunate to have a friend who is a phenomenal baker and who graciously handled all the baking. By displaying all the desserts on a buffet, guests could serve themselves and nibble on the treats throughout the party. Cocktail parties are

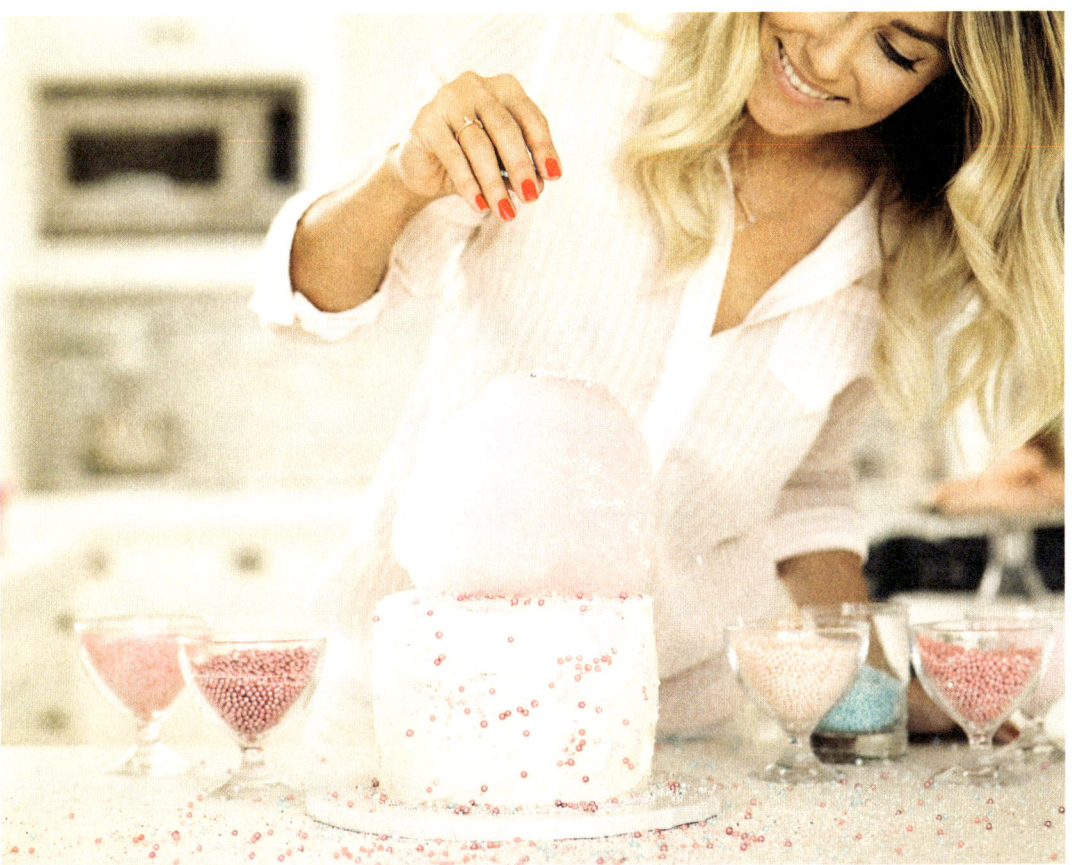

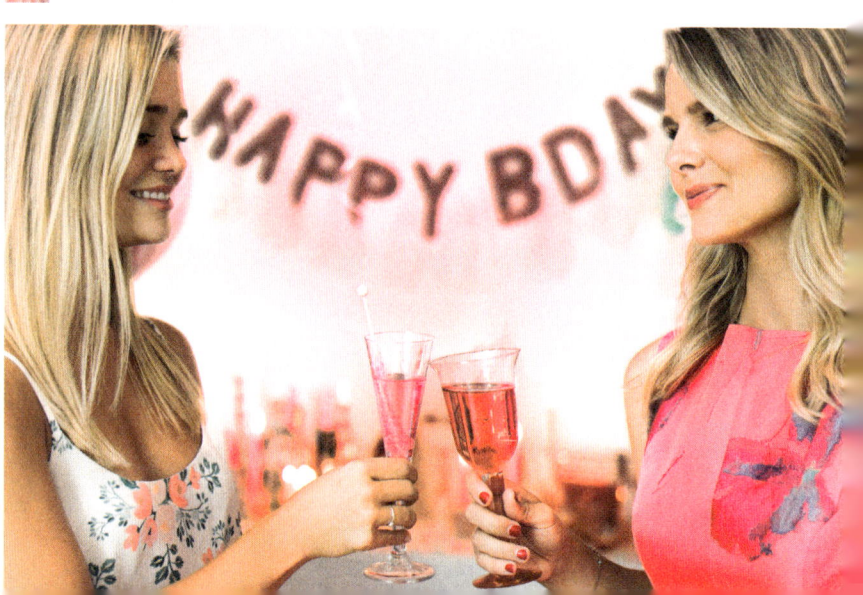

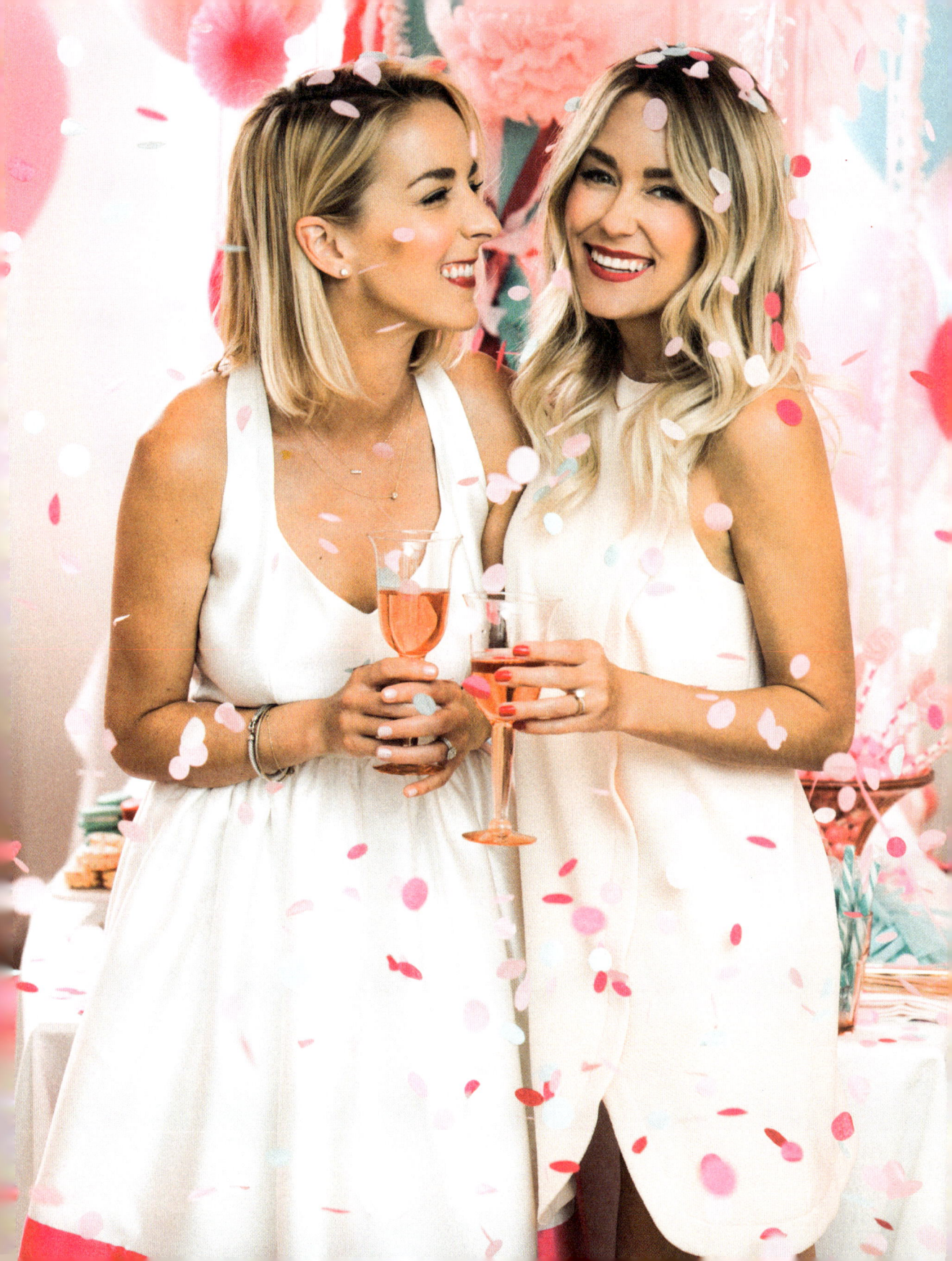

one of the few social gatherings that allow guests to come and go with more leniency, so a "serve yourself" element affords people flexibility.

The birthday cake was a no-brainer; it was the highlight of the dessert table and needed to be absolutely perfect! I chose a strawberry-lemonade-pink ombré layer cake smothered in creamy frosting, covered in shimmery iridescent sprinkles in shades of pink and aqua, topped with sugary, fluffy cotton candy, and served on a tall milk glass cake stand so it could sit above the rest of the table and really shine!

We had a pretty big table to fill, so we dreamed up a deliciously insane menu: pink-glazed éclairs dipped in confetti sprinkles; Rice Krispies Treats shaped like retro ice cream cones; strawberry-white chocolate chip cookie sandwiches filled with frosting; and Funfetti cupcakes covered in pink buttercream and topped with malted milk balls. There were piles of light, creamy macarons—in flavors like cake batter, raspberry, and old-fashioned doughnut—and heaps of candy in shades of pink and aqua covering the entire tabletop. White chocolate popcorn and white chocolate-dipped pretzels—all coated in rainbow sprinkles, because . . . why shouldn't they be?—overflowed from rose-tinted wineglasses.

While most of the goodies were small bites, we needed plates and utensils for the cake. Keeping with our feminine and frilly theme, I chose vintage pink glass cake plates and rose gold flatware, as well as a variety of crystal and milk glass serving ware.

the bar

From the moment guests walked through the door, I wanted the vibe to be celebratory and whimsical, so I made sure each guest was greeted with a silver platter of champagne flutes garnished with swizzle sticks of pink and blue rock candy (which slightly tinted the bubbles into appropriately festive hues!).

For the beverage bar, I made a spicy watermelon-and-jalapeño punch (a pink twist on Maura's favorite drink, a jalapeño margarita). I served it in a traditional etched punch bowl (these are found in just about every grandmother's house, so make good use of them!). Surrounding the bowl were rows of pink-tinted crystal teacups—a fun way to sip on a drink!

Since this was a cocktail party, I thought guests would like

Don't feel beholden to the champagne flute; try alternative glassware if it feels appropriate. A tulip-shaped wineglass is a playful way to enjoy a champagne cocktail!

to have the option of mixing their own drinks as well. On a separate display, I offered a basic bar setup. Word to the wise: Giving people free rein over your bar can be dangerous, so I suggest exercising caution. Not only can it get messy (and no one wants their kitchen to look like the aftermath of a fraternity party), it also gives your guests license to be a little heavy-handed with their pour.

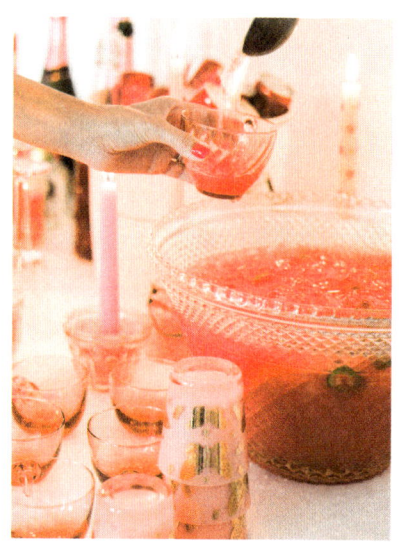

Keeping the options limited is a good way to curb any eager partygoers. I chose to offer three clear liquors—vodka, tequila, and white rum (clear alcohol looks neat and makes for a much easier cleanup). And because the theme of the party was "Think Pink," I chose three fuchsia-tinted mixers: cranberry juice, grapefruit juice, and sparkling pink lemonade. To round out the bar, I added a jigger, a bucket of ice, a few rows of pink-tinted glassware, and a collection of drink stirrers.

the décor

This party was all about going back to the basics: giant balloons virtually filling the entire space, a cascading Chinese lantern and tissue paper garland hanging over the center of the dessert buffet, and large, handmade confetti sprinkled everywhere. When filling a room, you want to start from the ground up. Since I wanted guests to feel like they were swimming in a sea of pink balloons, I used weights to set the balloons at different heights throughout the room and used tissue paper garland to create a skirt for a few of them. Some I let roll around on the floor, while others floated up to the ceiling. It needed

to be ridiculous and over the top for it to work—and luckily balloons are some of the most wallet-friendly party decorations. The suspended chandelier was constructed of different elements, including fringed garland, paper fans, and tissue poms with streamers woven throughout and pouring over the sides. When putting the table together, I decided to deconstruct the traditional candy buffet. Instead of having the malt balls and gummies in glass apothecary jars or fish bowls, I scattered them over the tabletop to make it appear like the remains of a very pink piñata. Candy buffets are a popular party trick nowadays, but that doesn't mean you should avoid it! Good ideas often become popular ones; just make it your own by putting a creative spin on it. Creating candy chaos on the dessert table was an unexpected twist.

Since our cake topper was freshly spun cotton candy, it didn't make sense to peel it off and stick in twenty-nine candles (and I'm not sure Maura would have appreciated that!). But every birthday girl needs a candle to blow out! Candlelight is such a beautiful way to warm up a room, so I wanted candles flickering throughout the party. Traditional candleholders didn't seem to evoke the right vibe, so I decided to get a little

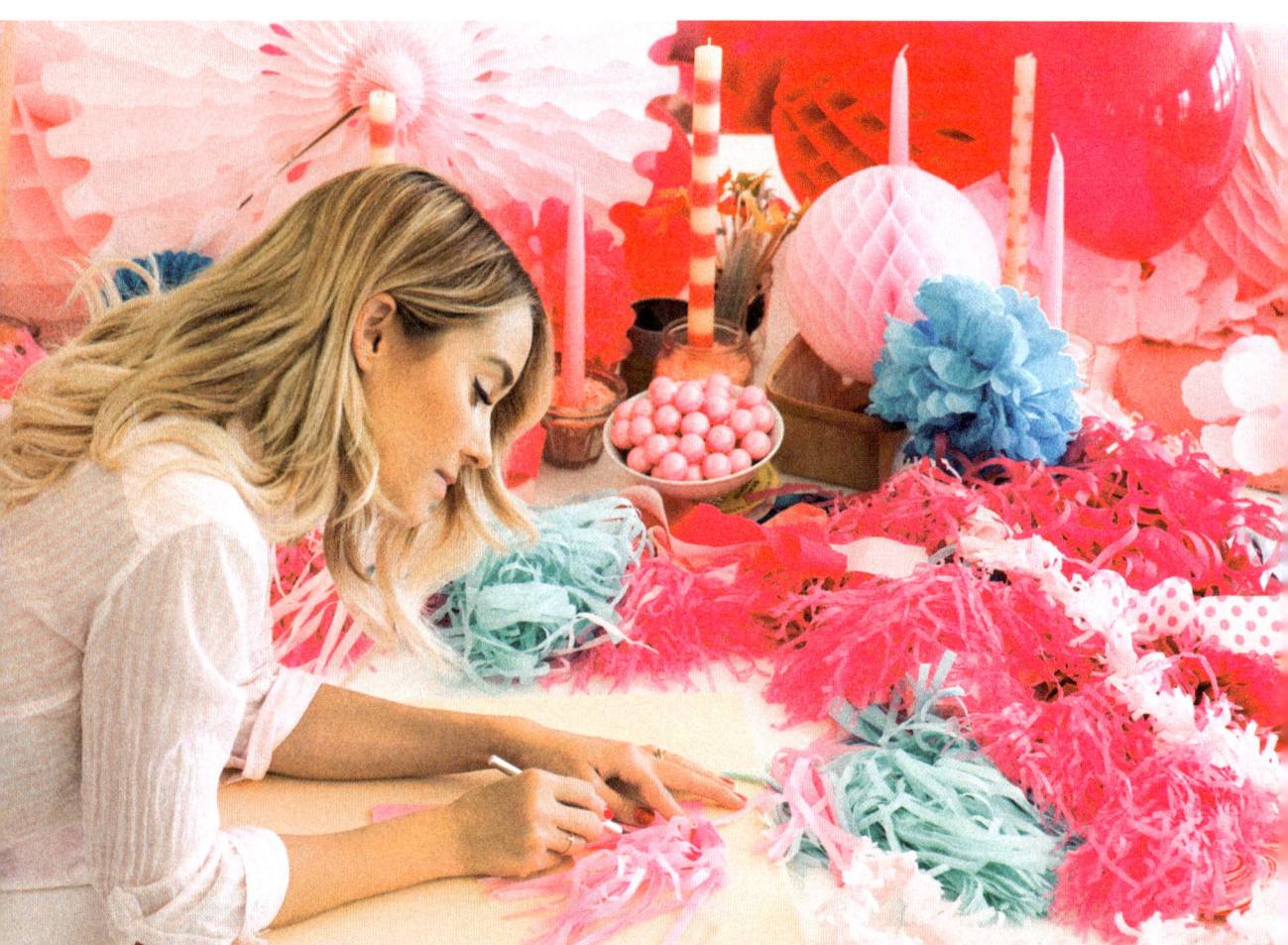

crafty and fill mason jars with pink rice (which I dyed with food coloring) and place an assortment of pink tapered candlesticks in each one.

I'm a sucker for festive signage, so I had my mind set on a sprinkle-covered "Happy Birthday" banner for the soiree. While I could have easily found one, it was the easiest DIY imaginable: cardboard letters (I used boxes I had lying around), Elmer's glue, and buckets of rainbow-colored sprinkles. Voilà!

the details

As a little girl, I never wanted the party to end, but I could hardly contain my excitement when my eyes fell on the brightly decorated favor bags. I couldn't wait to jump into the car and pour the contents out on the backseat: lip gloss, a necklace, candy, a noisemaker . . . you get the idea. To celebrate Maura's birthday, we wanted to offer the women and the men fun, festive party favors to thank them for coming.

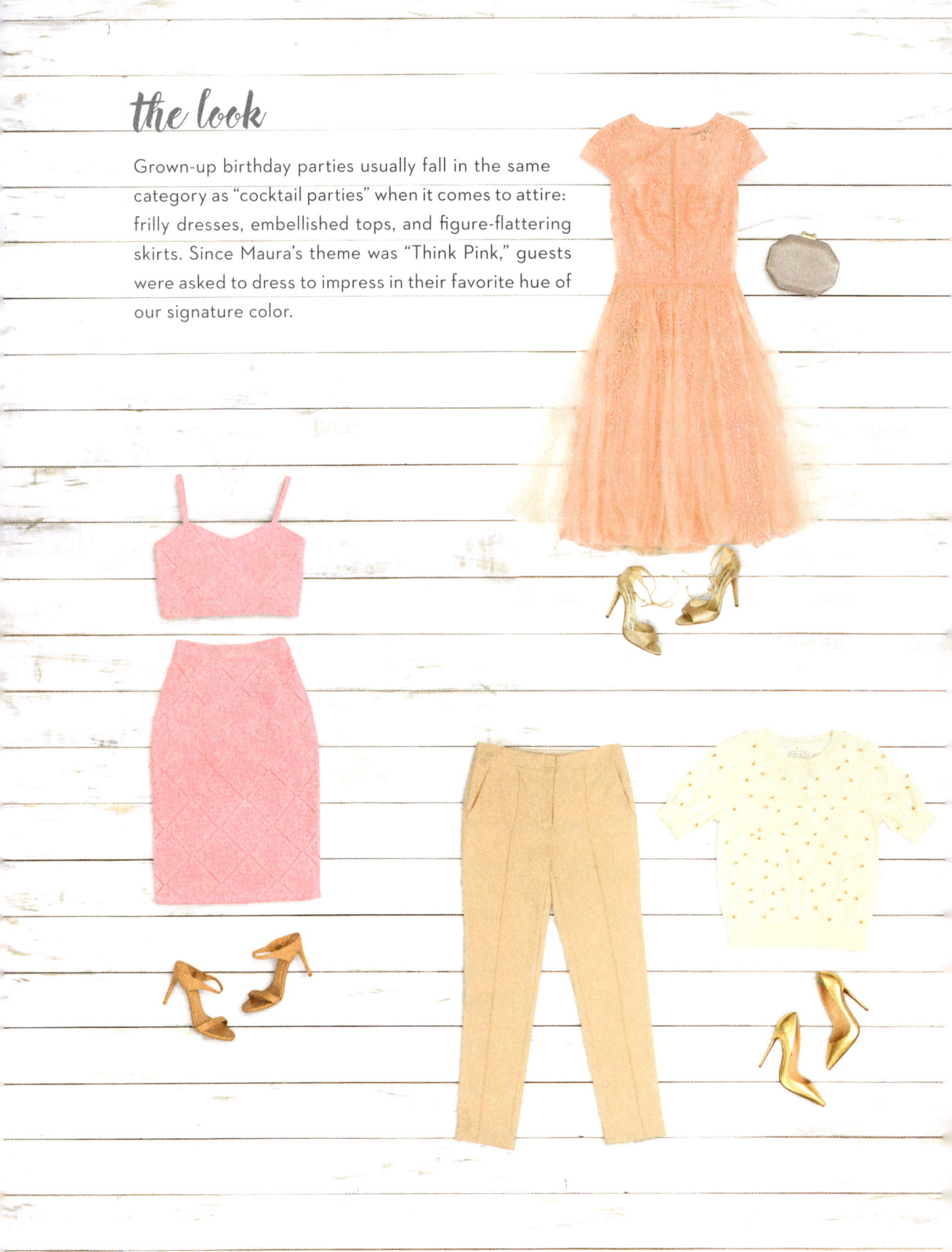

the look

Grown-up birthday parties usually fall in the same category as "cocktail parties" when it comes to attire: frilly dresses, embellished tops, and figure-flattering skirts. Since Maura's theme was "Think Pink," guests were asked to dress to impress in their favorite hue of our signature color.

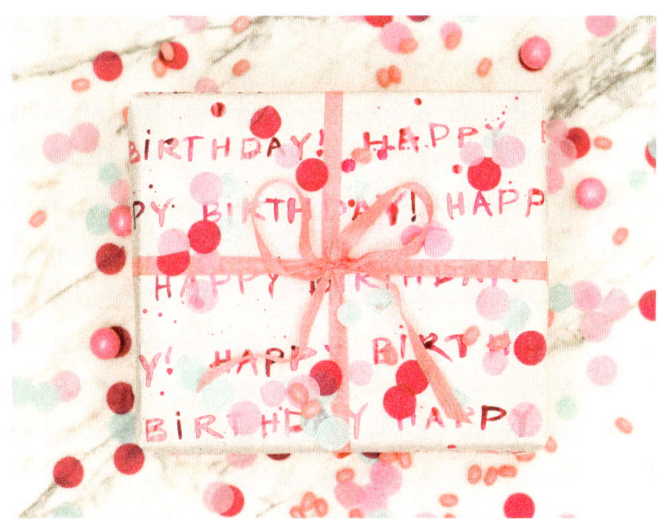

THE ETIQUETTE
the birthday present

Never arrive empty-handed to a birthday party. It's a huge no-no. Even if you're the guest of a guest, proper etiquette suggests that you bring a small token—even if that's just a card. You don't have to break the bank to be thoughtful (think: a stack of quirky coasters, a box of gourmet chocolate, or a beautiful set of playing cards). And if all else fails, bring a bottle of champagne. Nothing says "birthday" quite like bubbles!

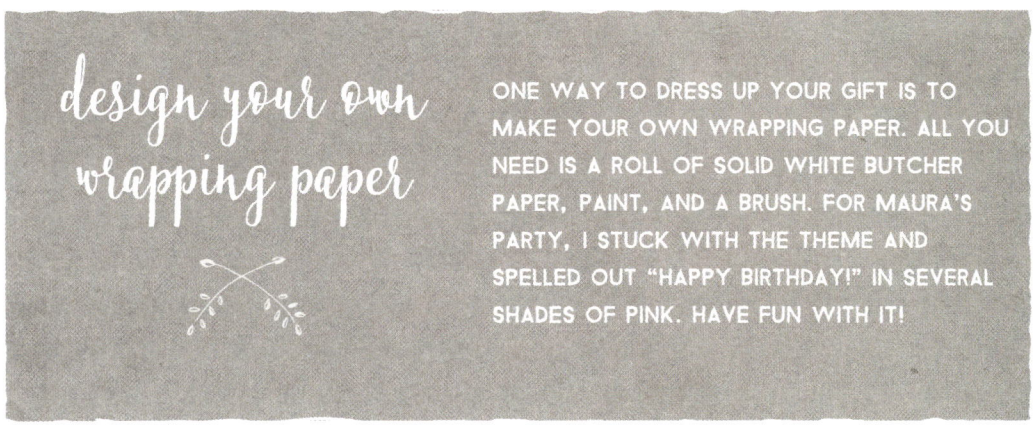

design your own wrapping paper

ONE WAY TO DRESS UP YOUR GIFT IS TO MAKE YOUR OWN WRAPPING PAPER. ALL YOU NEED IS A ROLL OF SOLID WHITE BUTCHER PAPER, PAINT, AND A BRUSH. FOR MAURA'S PARTY, I STUCK WITH THE THEME AND SPELLED OUT "HAPPY BIRTHDAY!" IN SEVERAL SHADES OF PINK. HAVE FUN WITH IT!

Engagement party
February 1

Tori + Eric

PLEASE JOIN US FOR APPETIZERS AND DRINKS
THE TELL RESIDENCE
PACIFIC PALISADES, CALIFORNIA
5:30 pm

hosted by THE TELL AND SALVATORE FAMILIES

the engagement party

the overview

When I married William, I didn't just get a wonderful partner, I welcomed an entire second family into my life—including two lovely sisters-in-law: Tori and Alex. And when Tori announced that she and her longtime boyfriend, Eric, were engaged, we could not have been more excited that our family was getting even bigger. Not long after we received the good news, William and I offered to throw an engagement party.

For a traditional engagement party, the bride's parents host the immediate family and bridal party to toast the newly engaged couple, but these days it's equally common for friends or other family members to host this special occasion. It's an opportunity for relatives to get acquainted, if they haven't already, and for the bridesmaids and groomsmen to get to know one another before the festivities begin. (When William and I got engaged, our parents were already close friends and decided to host a party together—we're both the oldest children and I think they were just anxious to start celebrating.) I wanted to make certain that everyone felt included, so I reached out to

my mother-in-law, Anna, to help plan the food. She is a fantastic cook and always ready to lend her creativity when organizing an event. I knew we would have so much fun putting together a menu for this party.

Tori's father comes from a large Italian family, so we decided to host a romantic, Tuscan-inspired engagement party in our backyard. Even though it was going to be a larger gathering, we still wanted the party to feel intimate and cozy, which meant rustic candles, lush textures, and warm, delicious food. Growing up, most of their family celebrations revolved around a large Italian meal, so we borrowed a few of Tori's grandmother's famous recipes to complete the menu. Lucky for us all, Grandma Anna offered to come help us prepare the meal the day of, so we all learned from a real pro.

In order for our sixty guests to be able to enjoy the sunset, we suggested that people arrive at 5:30 P.M. For the color palette, we chose shades of green—from light sage to deep forest green with hints of aged terra-cotta to evoke the feeling of Tuscany's rolling hills and leafy vineyards.

the menu

Since it was a larger event, we wanted to make sure guests had a few opportunities to eat. We chose to serve bite-size food that could easily be eaten with one hand, since we weren't providing seating for all guests. While it was technically not a dinner party, we did create a hearty menu of passed hors d'oeuvres, as well as an Italian-inspired appetizer board. We chose to have the party start on the early side (so guests could feasibly enjoy a meal afterward), but we wanted people to feel comfortable staying the entire the evening. Plus, it was a hugely celebratory event, and when drinking is involved, it's always better to offer filling food.

It's important to remember to keep an eye on any food or beverage buffet throughout the course of the event to make sure it's being refreshed as needed.

First, we put together a mouthwatering antipasto spread piled high with savory fare: cheeses (Brie, Parmesan, and manchego), spicy salami, cornichons, figs, Marcona almonds, apricot jam, red grapes, raspberries, apples, and dried persimmons. Serving it as a buffet—on a large, vintage wooden dough board—would allow guests to graze throughout the evening.

Around the party, servers offered guests large platters of one of the six passed hors d'oeuvres on vintage silver serving trays. I knew that bringing in a serving staff would elevate the gathering, as well as take some of the pressure off. I much preferred the idea of allowing guests to nibble on appetizers throughout the night. For smaller parties, an appetizer buffet would have been perfect, but with sixty people it can get tricky. We would have needed to have enough food out to ensure everyone could make a plate, and with that many guests, it would have been a lot. And without proper dining tables, where would they have sat to eat from their plates? Of course, I could have easily managed refreshing a buffet and bringing in tables, but I really wanted William and I to enjoy this special moment with our family. For sixty guests, I hired one bartender, one kitchen helper (for cleanup and plating), and two servers. It was the perfect ratio.

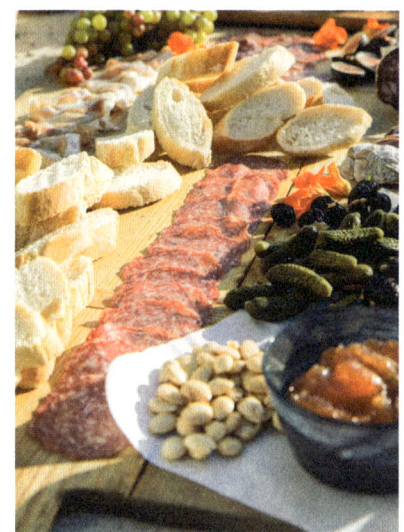

As a family, we really appreciate a good pun (and are routinely mocked for this) and decided to

give each appetizer a "romance-inspired" punny name (see page 93). William's favorite joke is: "Why do melons have big weddings? Because they cantaloupe!"

Enough said.

For dessert, we chose miniature cannoli, a Tuscan olive oil cake, and individual tiramisu bites with fresh berries.

Grandma Anna is famous for not only her tiramisu (which happens to be so exceptionally delicious that it requires no pun) but also her scrumptious meatballs. She offered to prep both of these ahead of time and bring them the morning of the party. How could I argue with that? As it turns out, cooking for sixty people is a lot of effort, but this is where thoughtful planning can really work to your advantage.

I knew the raviolis were going to be time-consuming, but I was determined to make them all on my own (and from scratch!). Fresh, homemade pasta is just about as delicious as it gets. My husband, ever the romantic, recently surprised me with a present: a food vacuum sealer for all my freezing needs. (I joke, but it's probably the gift I use the most!) The week before the party, I decided to spend an afternoon in my kitchen with a rather large bowl of butternut squash puree, bags and bags of flour, and my dog Fitz (who attempted a short-lived career as my sous chef before retiring to

tori + eric's engagement party menu

"Tying the (Garlic) Knots"

"You're One in a Melon" Prosciutto Bites

"Love You from My Head Tomatoes" Caprese Skewers

"Don't Go Bacon My Heart" Wrapped Dates with Parmesan

"Butternut Forget About Me" Squash Ravioli

"Let's Canoodle" Individual Spaghetti and Meatballs

"I Cannoli Be Happy with You" Pistachio Cannoli

"Olive You Forever" Olive Oil Cake with Orange and Ricotta

Anna's Famous Tiramisu

take a nap). It took me most of the day, but I managed to prep more than two hundred raviolis and freeze them. Okay, *fine*, I may have taste tested one or two. The morning of the event, I pulled them out and dropped them in a pan when we were ready to start cooking!

The dates were also an easy "prep ahead" appetizer, as were the caprese skewers. When it comes to a menu this large, the main concern needs to be fridge space. Luckily, we have a second fridge in our garage, which made food storage much easier to manage.

With Grandma Anna; my mother-in-law, Anna; and myself in the kitchen, we were able to tackle the remaining appetizers without incident. Except for some accidentally overcooked spaghetti that Grandma Anna quickly tossed before taking over stovetop duties. (I honestly believe everyone deserves an Italian grandmother.) Don't be afraid to take up friends and family on their offers to help. Like the saying goes, many hands make light work, and I was lucky to have them there. Not to mention, some of the best memories are made in the kitchen.

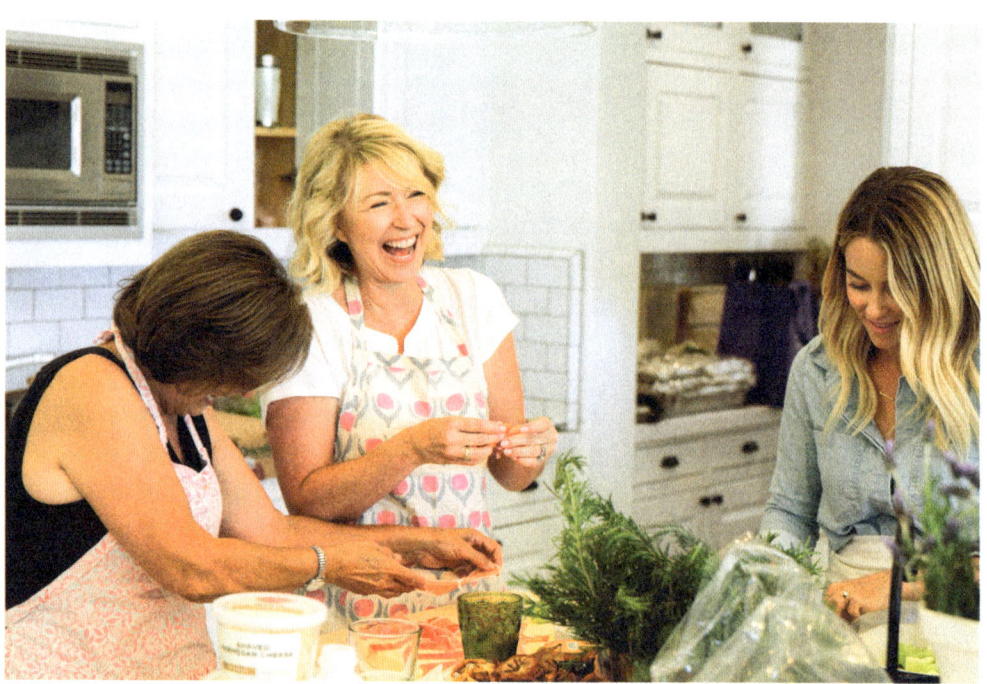

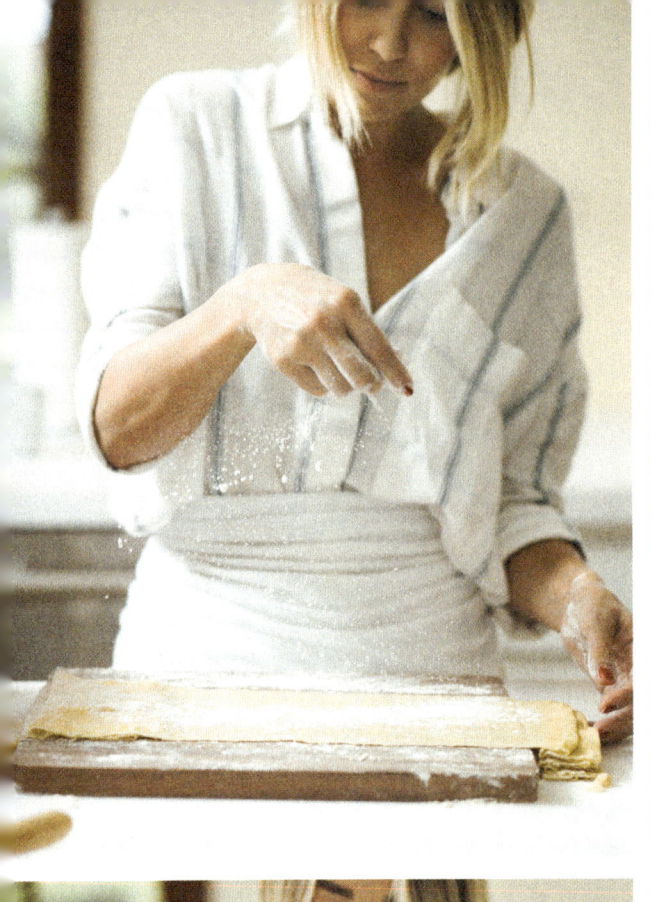
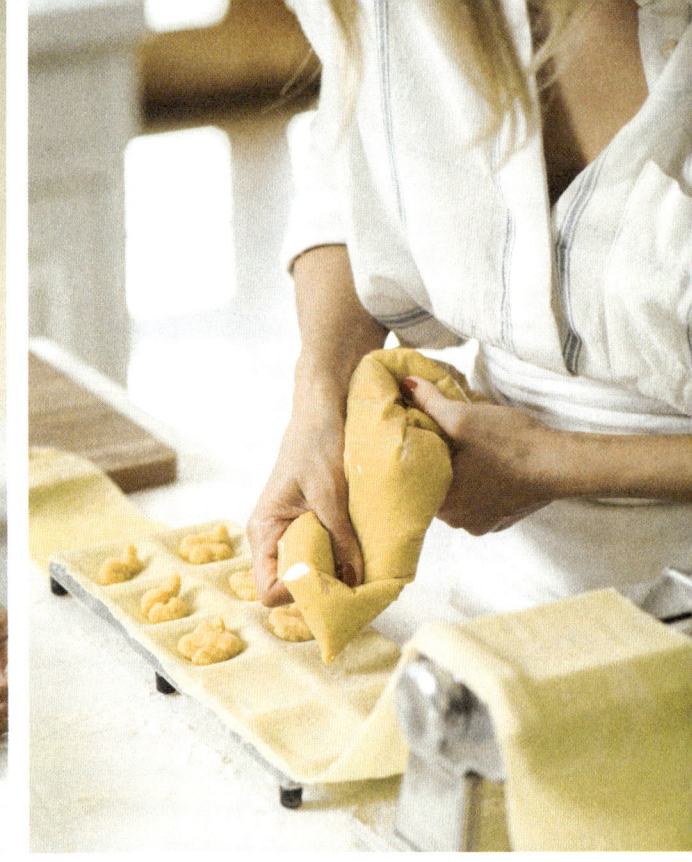
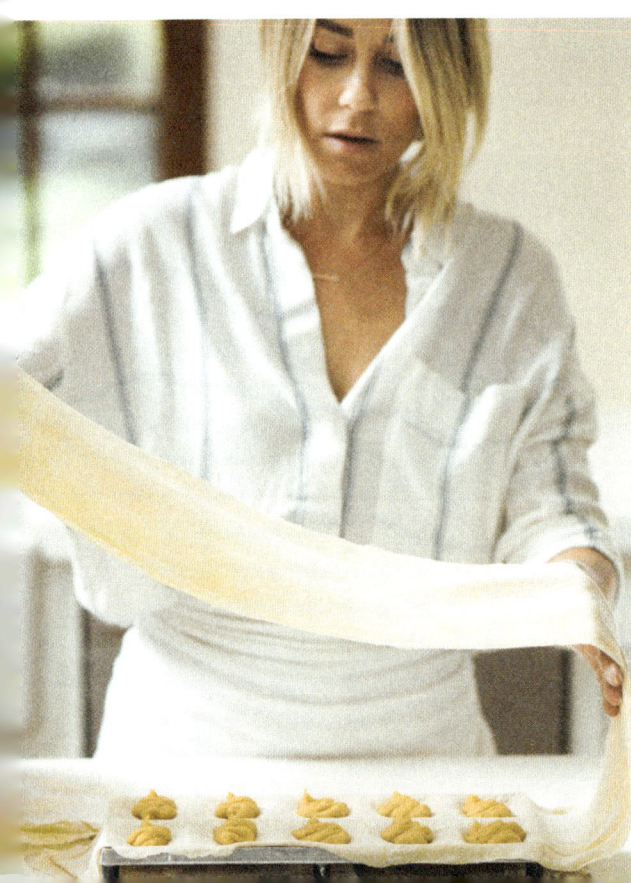
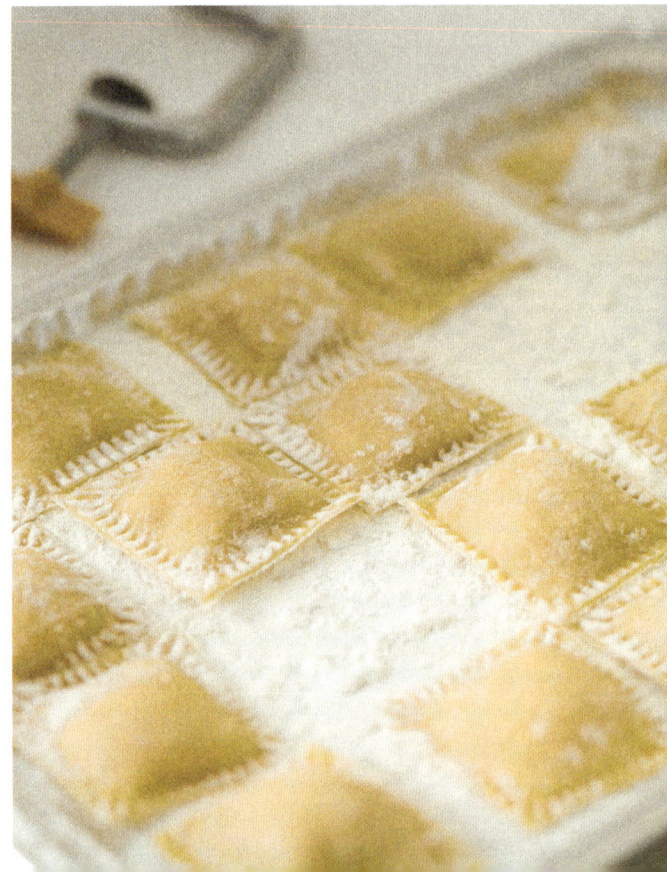

the bar

Next to a good pun, my second-favorite thing is a signature cocktail! In addition to a full bar and bartender, servers passed "Rosemary Me, Honey" greyhound cocktails served in beautiful etched crystal goblets, and garnished with a sprig of fresh rosemary. This was going to be a serious celebration, so we needed a fully stocked bar with most alcohol and mixer options, and a variety of wine and beer.

Despite popular belief, Southern California evenings can get a bit cool (particularly in winter), so we set up a "Love You Latte" coffee bar for guests with freshly brewed coffee in beautiful gold-etched glass mugs, bowls of brown sugar cubes, and creamer.

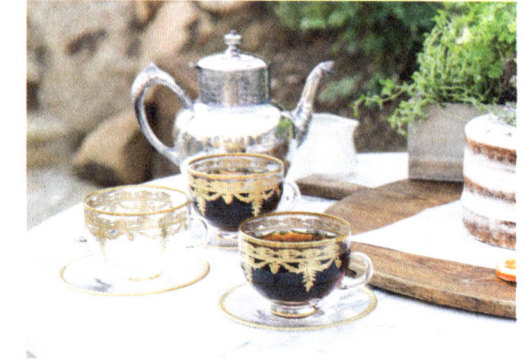

the décor

As I've said, working with the existing décor is not only the smartest way to party plan (especially on a budget), but it's also the easiest. Our backyard has a Mediterranean feel with rosemary, lavender, white roses, and fruit trees, so a Tuscan theme was the perfect complement.

I've always been keen on the idea of live arrangements—especially for a winter affair—because they last so much longer than the celebration. For this particular event, it also felt appropriate to have centerpieces that would continue to grow and flourish long after the guests have gone. Aged terra-cotta pots were the perfect vessel, but authentic ones can cost you a pretty penny. I chose to hand-age the pots myself with the intention of sending them home with guests. A few weeks before the party, I found a large selection at a local craft supplies store. To create that sunbleached, antique finish I used a medium-size paintbrush to lightly coat each pot in a combination of white and gray milk paint. Afterward, I left them to dry in a bright corner of our backyard.

For the party, we covered our Carrara dining table in seasonal greens (lavender, basil, rosemary, sage, marjoram, and thyme) planted in a large, reclaimed-wood planter box

as well as a smattering of the faux-aged terra-cotta pots to create an elegant, living, breathing table runner. The remaining pots were placed throughout the yard to continue the décor and mimic the lush Tuscan landscape.

For a party of this size, we needed to call in some décor support. During my wedding-planning process, I discovered an exquisite Los Angeles–based company called Found Rentals that specializes in vintage goods, so I didn't hesitate to enlist their services again. We brought in a charming button-tufted heavy-linen settee and armchairs upholstered in the same fabric to offer guests a place to relax; a beautiful, oversized rustic wood bar (which was a perfect tie-in to our Tuscan theme); and antique metal cocktail tables with zinc tops and saber legs.

Most wedding-related events—from the bridal shower to the rehearsal dinner—are covered in stylized floral arrangements, so the engagement party was a nice departure from this.

the details

In the beginning of the planning process, we asked Tori and Eric if they had any special requests. They had two: bocce ball and ginger beer. William searched online and found a yellow-gold bocce set for the yard, which ended up being a natural inclusion to the party since the game is Italian in its origin. It didn't take long before all the guys started a friendly, but high-spirited game. (And, of course, the bar was fully stocked with plenty of ginger beer.)

 Music is a huge part of most festive gatherings, especially when you happen to be married to a musician. And while I can definitely appreciate the appeal of live entertainment, it's not always ideal for events that don't call for dancing. It also can be a large expense, so you need to determine how important it is and if it's within your budget. For Tori and Eric's engagement party, I put William on DJ duty and asked him to come up with a playlist befitting the occasion. Of course, he didn't disappoint. He compiled a great collection of some tried-and-true classic oldies from singers like Frank Sinatra, Jerry Vale, Dean Martin, and Nat King Cole.

the look

An engagement party follows the same rules as a cocktail party (unless otherwise noted on the invite). It's technically a family affair, so keep that in mind when choosing your ensemble—lean toward stylish but elegant. If you're on the fence about a particular look, ask yourself if you would wear it in front of your grandmother. If the answer is no, you know to save it for the bachelorette. Think of an engagement party like it's the Oscars; unless you're nominated for best lead actress, there's no reason to toe the fashion line. Upstaging the bride is never a good idea, even if done unintentionally. And on that note: no white. Some people say that this is an antiquated rule, but in my opinion, wearing white is a nonstarter. Even if the bride is choosing to wear a different color, guests need to respect that she corners the market on all white, ivory, and cream-colored dresses for every designated wedding event.

THE ETIQUETTE

when to valet

I think everyone can appreciate complimentary valet service, particularly when wearing heels. There are no real rules as to when it's expected that you as a host should provide valet for your guests. However, nothing tells your guests that they'll be taken care of like seeing a professional tuxedo-clad valet attendant when they arrive. Formal celebrations, like a wedding or black-tie gala, would most likely be held at venues already offering valet services, such as a hotel or restaurant. It's a bit different when hosting a party at home. If your neighborhood offers ample street parking, then there's no real need. If parking options are limited or confusing, having a valet can help bypass any inconvenience and help you avoid the headache of a dozen missed calls and texts. Some neighborhoods also require that valet attendants be brought in to help with the crowding of the streets and general flow of traffic.

Another thing to keep in mind is that valet services set a particular, more formal tone. If it's a casual gathering, it might give the wrong impression. If you choose to hire a valet, the experts suggest one attendant for every forty guests. That being said, different companies may suggest a different ratio. Also, make sure the valet company pulls the proper permits for parking and curbside drop-off in your city (if needed).

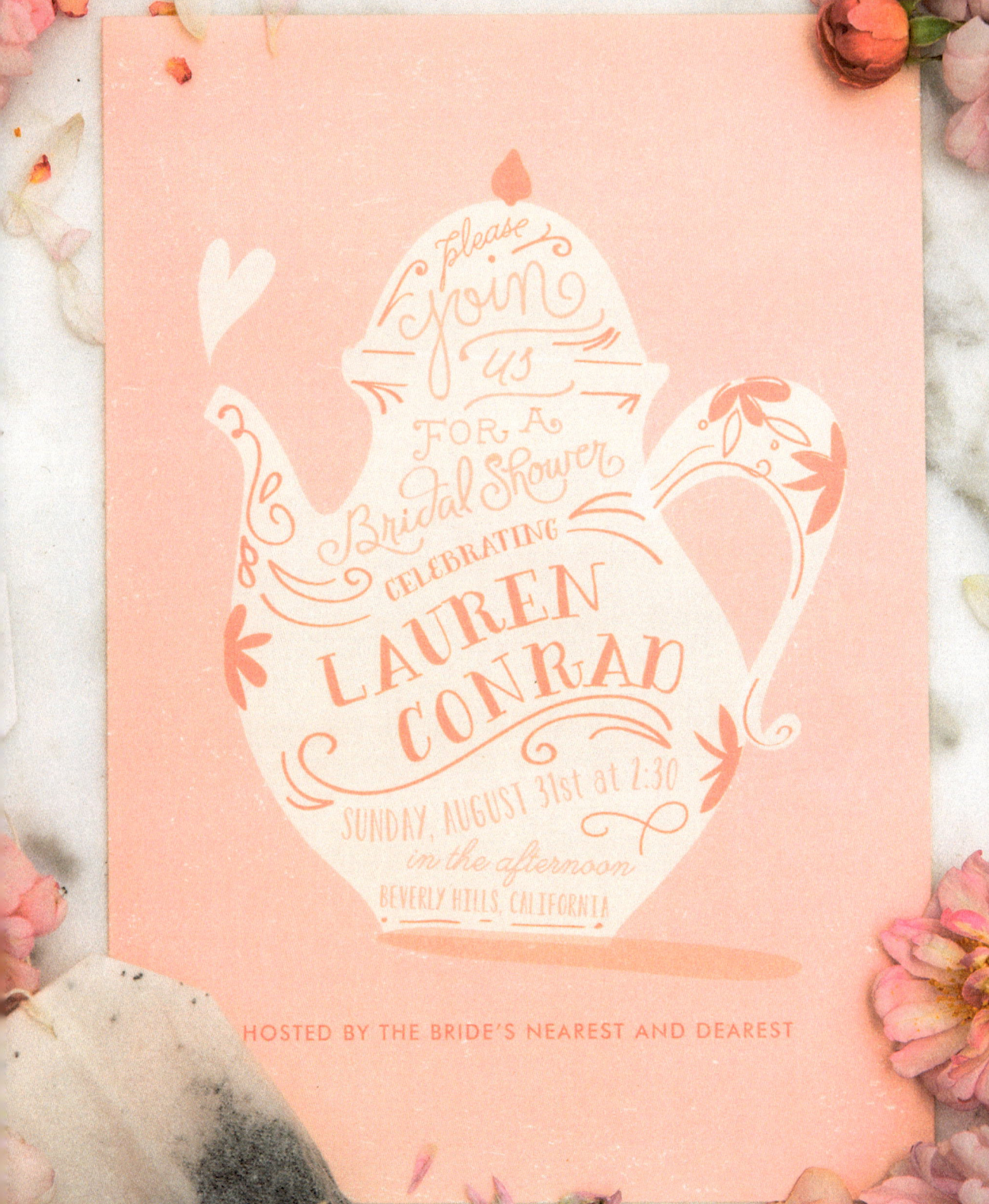

8

the bridal shower

the overview

Although it's not necessarily customary for a bride to help plan her own shower, I couldn't help myself. My bridesmaids were scattered all over the country and our schedules rarely align, so planning my shower was a chance for us all to take a break from our busy lives to do something fun *together*. I couldn't handle the thought of my girlfriends making Pinterest boards, deciding color stories, and DIY-ing without me. Not to mention, it was a welcome distraction during the busy months leading up to the wedding.

The theme was a no-brainer. I adore a superfeminine party and have been collecting antique teacups and floral dishes for years, so I jumped at the chance to put them to good use. What's more feminine than a tea party? Dainty bites, beautifully painted cake plates, soft floral arrangements . . . it's my version of wonderland. We chose a palette of soft pastel hues inspired by my collection: feathery lilac, antique lace white, and shades of pink from hushed blush to deep rose. When it came time to decide on the location, I immediately offered my Los Angeles condo to host forty of my nearest and dearest for the shower (we chose a 2 P.M. start time, because tea is always *after* lunch). As the bride,

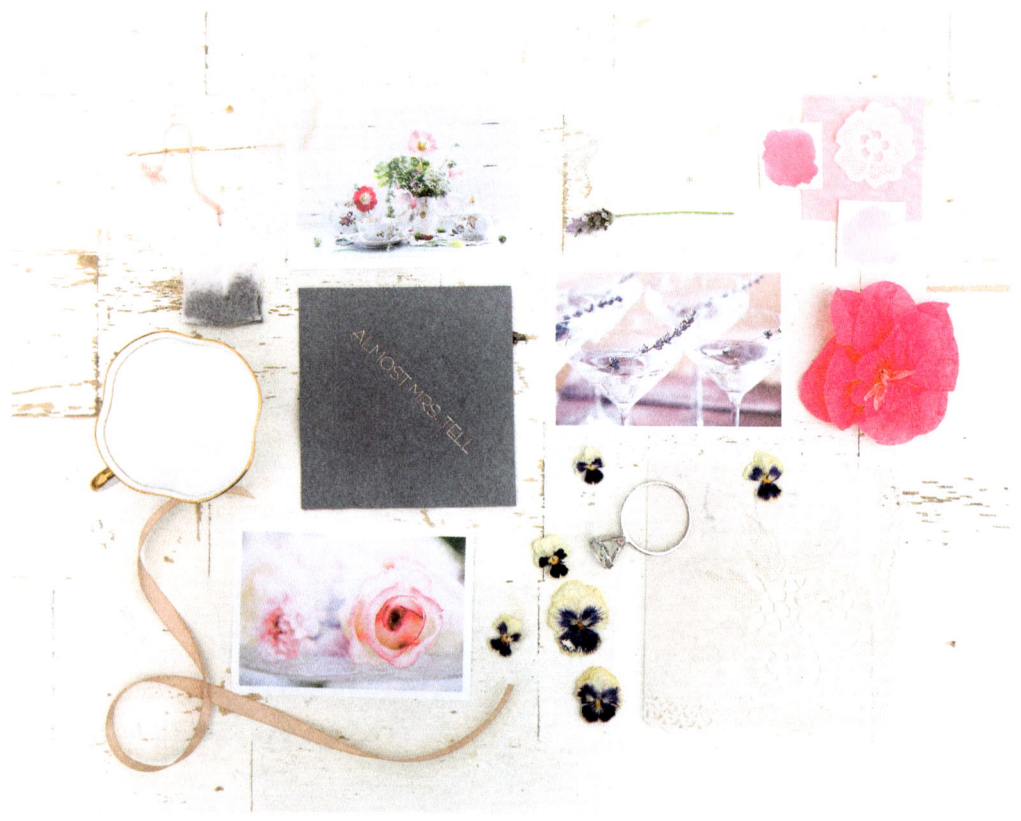

I was already asking so much of my close friends (airfare, hotel rooms, and time away from their lives), and I didn't want them to take on the added cost of a venue when my home was the perfect entertaining space for a luncheon—complete with a large outdoor patio! It's also where we felt most comfortable letting our hair down and spending time together—and that's what was most important.

the menu

When you have multiple party hosts, decisionmaking can be a bit tricky. Fortunately, our theme pretty much decided the menu for us. Tea parties aren't technically intended to be a full meal, but we wanted to make sure guests had enough to nibble on. We chose to offer a variety of tea sandwiches—prosciutto, Parmesan, and mashed pea; salmon, cucumber, and dill cream cheese; and caprese made with heirloom tomatoes—stacked high

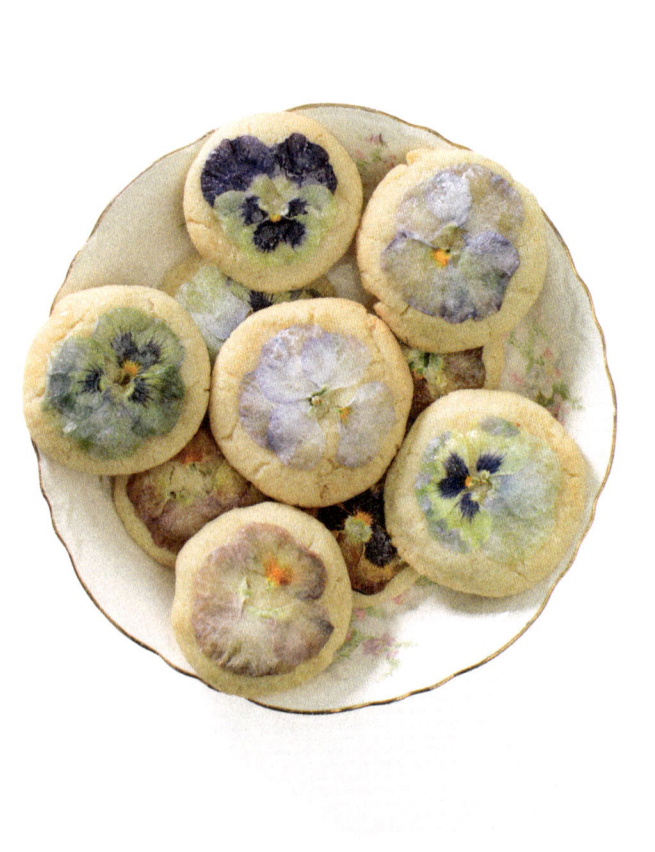
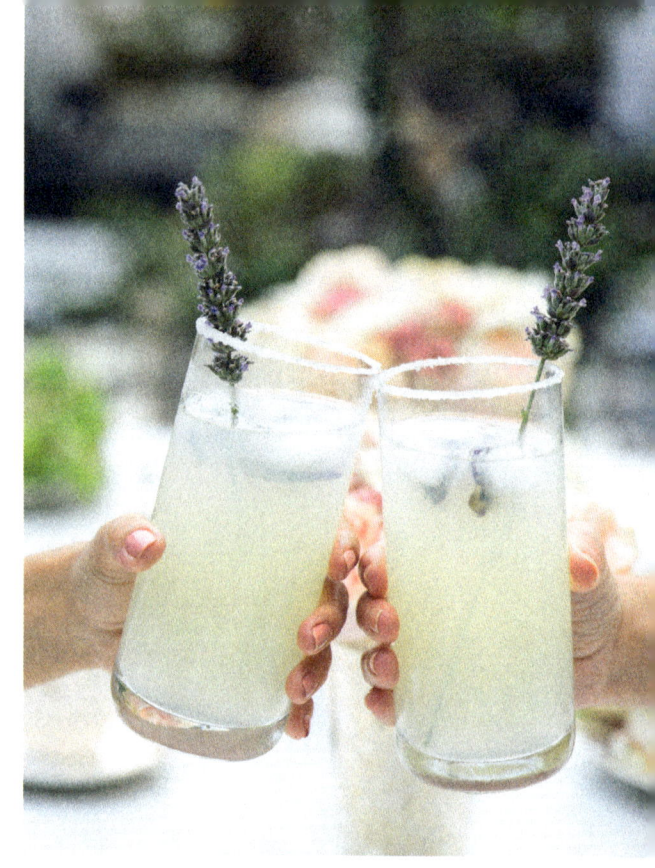
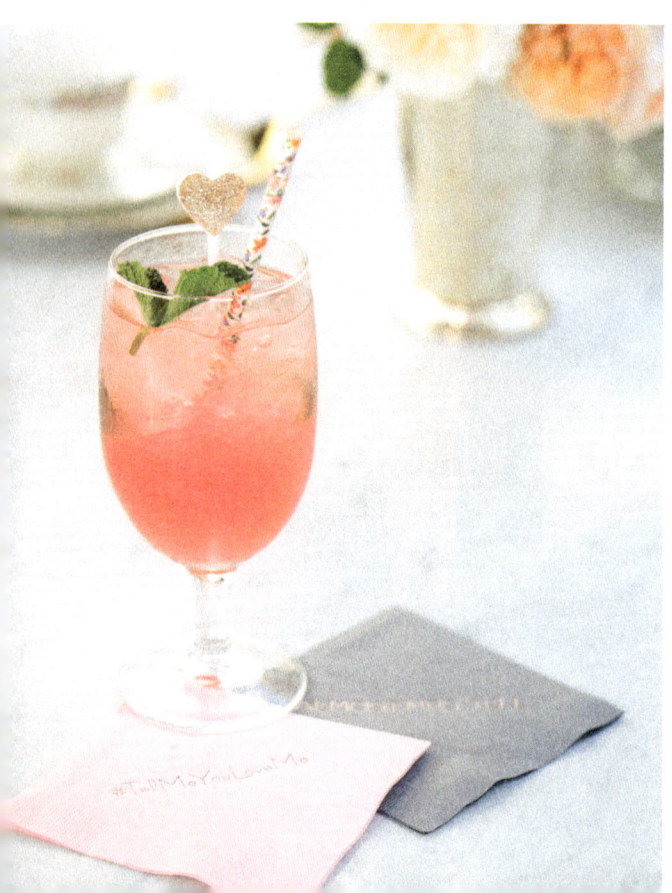
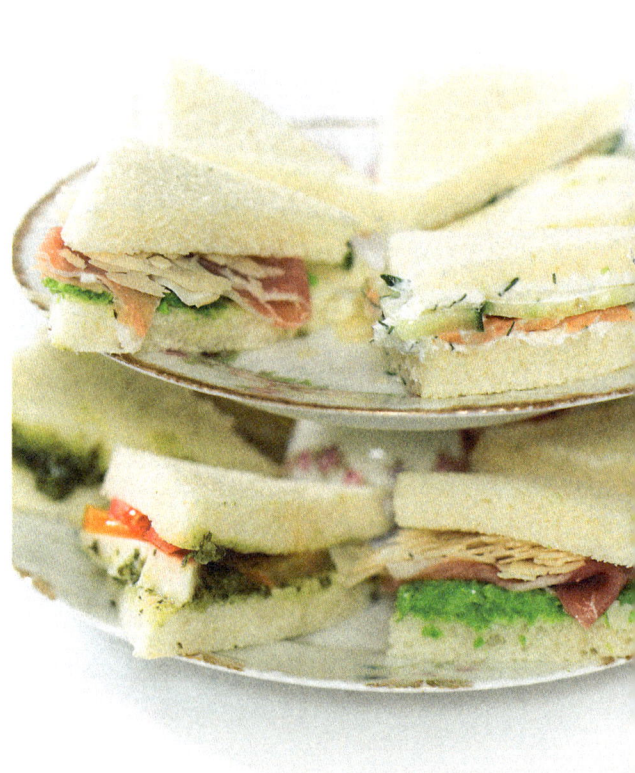

on two-tier dessert trays. To accompany the sandwiches, we wanted a light, refreshing side, so we put together a grapefruit avocado salad with edible pansies and microgreens tossed with a champagne vinaigrette. Because I'm absolutely smitten with anything petite, we also served mini crudité (think: tiny, adorable carrots and itty-bitty radishes).

We whipped up soft-baked sugar cookies decorated with edible flowers as well as lemon-blueberry tarts topped with beautiful sugar roses to serve with the tea. The real star of the dessert course was a buttery layer cake, frosted in passion fruit buttercream and covered in hand-painted watercolor roses. The yellow cake layers were filled with passion fruit pastry cream and apricot preserve.

the bar

As luck would have it, the shower ended up falling on one of the warmest weekends of the year, so, in addition to serving pots of Earl Grey and glasses of lavender lemonade, we wanted to offer a refreshing champagne option to keep guests cool (and one can only have so many spiked lemonades). My bridesmaids and I came up with the idea of creating homemade ice pop mimosas. We froze three fresh fruit purees (peach, grapefruit, and tangerine) in ice pop molds and, before guests arrived, placed them in champagne-filled wineglasses.

Since this particular event was at my home and we were so rarely all together at the same time, the tea party eventually transitioned into a small cocktail party. For that reason, we chose to offer a basic bar (tequila, vodka, and mixers), with a bartender mixing beverages as the afternoon became the evening. My condo had a small bar off the sitting room, so serving drinks from there was the obvious choice.

the décor

All wedding-related events should feel fairly cohesive. While you don't want them to be mirror images of one another, you do want them to feel like they all fall under the same umbrella (except for the bachelorette party, of course!). The engagement party, the bridal shower, the rehearsal dinner, and so on should all capture the same general tone. For instance, William and I had decided that our California vineyard wedding would be rustic and intimate, and the color palette would be softer, so I wanted my bridal shower to possess that same sort of feeling and charm.

Given that I host a lot of parties, it was important that this one feel different. Bridal showers are one of those watershed events in life that tend to be well documented by family and friends, so we had the idea of building a photo wall to provide a fun and unexpected backdrop to take pictures against. Plus, I've long been obsessed with alternative ways of decorating with flowers. We chose an area

that would have the best afternoon glow (I've taken my fair share of photos, so I know the importance of good lighting) and got to crafting! Choosing tissue paper in pinks and peach, we constructed oversized blooms to cover the wall.

I have been collecting vintage embroidered napkins for some time, picking them up whenever I stumble upon a beautiful batch at flea markets or online. My bridal shower was the perfect occasion to pull them out. We rolled the napkins

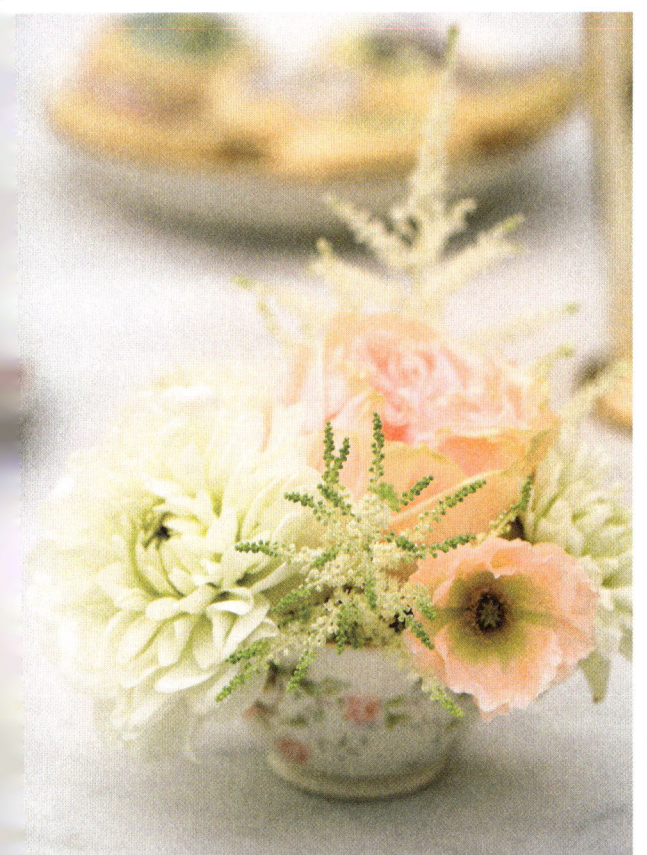
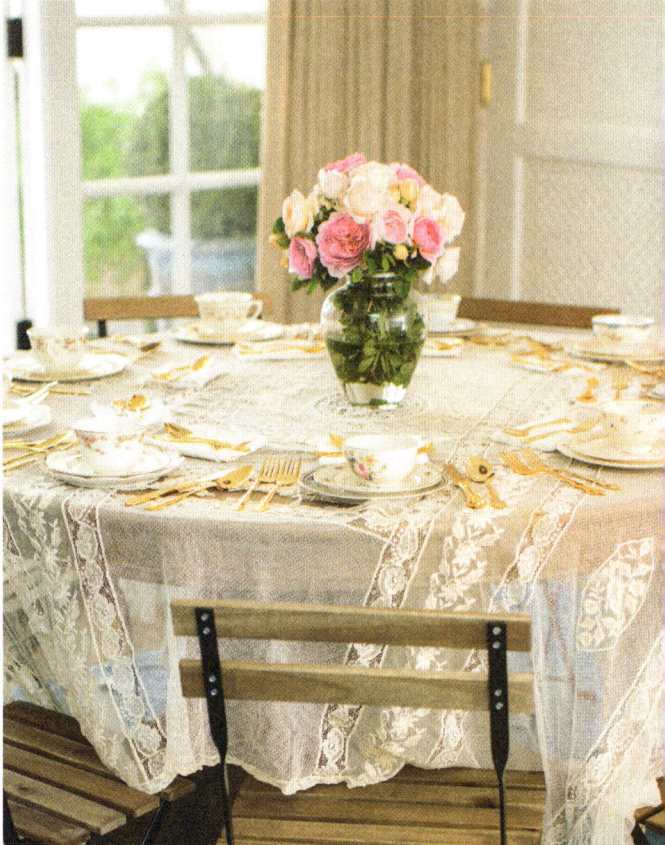

and tied them with a soft twine and piled them on an antique serving platter. My girlfriends also surprised me with personalized cocktail napkins: "Almost Mrs. Tell" and "#TellMeYouLoveMe." It was a cute play on my soon-to-be married last name, and a clever way to incorporate a hashtag so I could see all the photos my friends shared on social media.

We covered each table in antique lace—Alençon and Chantilly—and used a mix of floral china for the place settings to establish a romantic feeling. For an unexpected pop, we chose bright gold, etched tableware. The centerpieces were simple: English garden roses we picked up that morning from my favorite fragrant rose vendor at the farmers' market in cream, pale rose, and French pink. We clustered them together in tight, plush bouquets with minimal greenery and included astilbes, poppies, and mums in a few arrangements. In addition to traditional vases, we included mint julep cups and teacups as vessels. Since the décor was made to feel like a thoughtful collection of vintage odds and ends, we wanted to do the same for the floral arrangements.

the details

When people think of "shower games," it's usually coupled with a cringe. But when it comes to a bridal shower, they're basically obligatory. My advice is to do something you think is fun and engaging and will encourage guests to get to know one another (since many of them might be meeting for the first time!).

For my shower, we chose "Ring on a String." Each guest received a fuchsia engagement ring tied to a ribbon and was asked to wear it around her neck. During the party, guests were instructed to NOT use the words *bride*, *groom*, or *wedding*. If someone said one of the words, she was obligated to hand over her ring to whoever caught the slip! Whoever had the most rings at the end of the party won. Anna, my mother-in-law, took the prize, although I almost beat her. I totally forgot that the word *bride* was in the word *bridesmaid*. Rookie mistake.

the look

I've spent years curating a closet filled with feminine, flowy dresses. A bridal shower is the perfect event to showcase your most ladylike ensemble. From pastel color blocking to flowery frills, the only requirement, as we've already noted, is absolutely no white. And much as for the engagement party, you want to be tasteful, but it's still an occasion where champagne is being served, so feel free to have fun with your attire.

THE ETIQUETTE
to open or not to open

It's becoming more and more commonplace for brides-to-be to skip the tradition of opening gifts in front of their shower guests. If you're not the type of person who enjoys being the center of attention, your bridal shower can already be a pretty overwhelming, and even emotional, day (in a really good way!). However, tradition is tradition for a reason, and some of your guests might be hoping to see you unwrap each place setting and help count the number of ribbons you break. At the end of the day, the decision is yours to make. If you'd like to open gifts without an audience (or perhaps with your husband-to-be), that's totally acceptable . . . just make sure the hostess knows this ahead of time. If a particular guest is eager to see you open the gift he or she gave you, you can choose to share that moment with him or her at the shower, and save the rest to open later. Being a bride comes with its fair share of perks, and being able to decide what traditions you choose to follow is one of them!

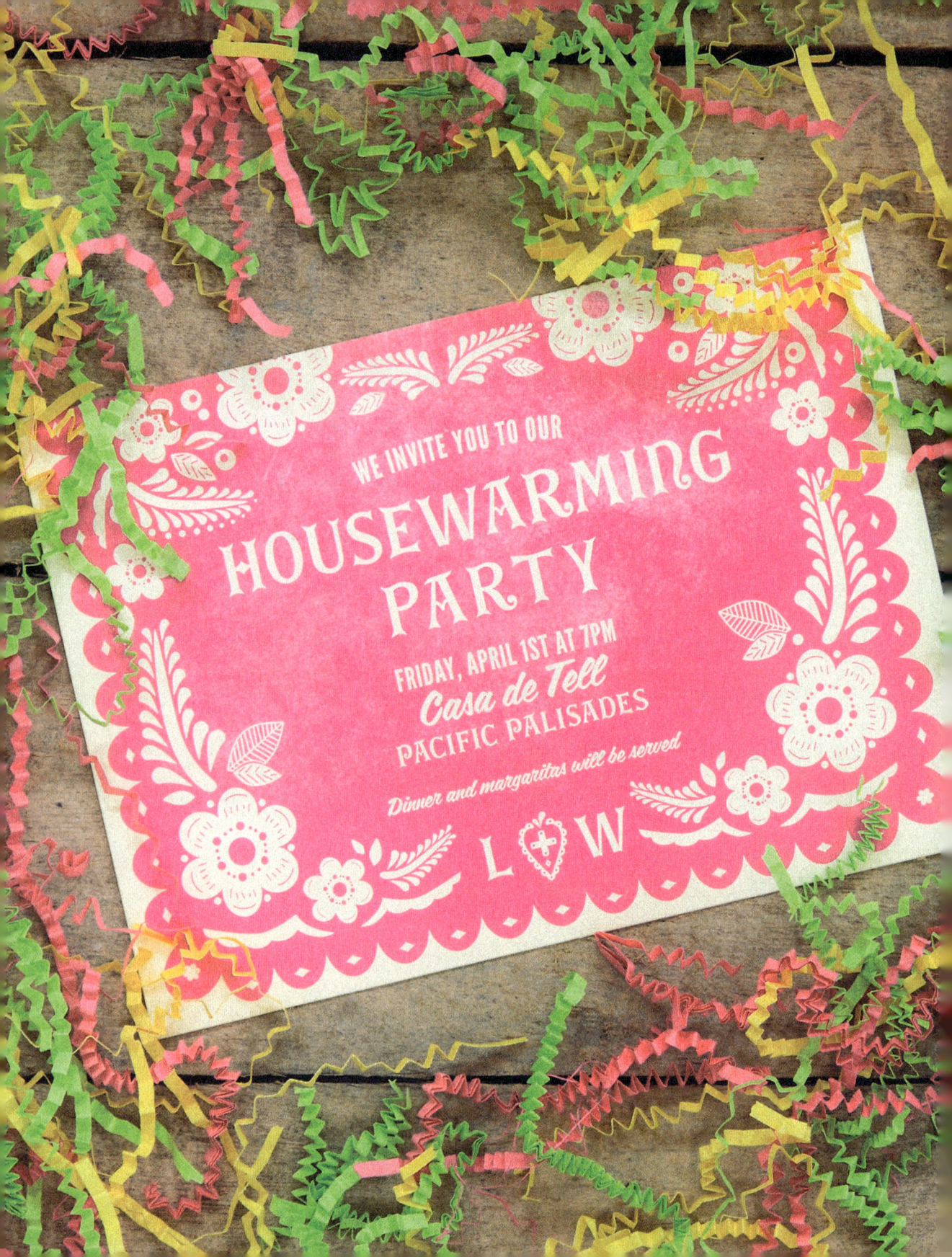

9

the housewarming

the overview

Every time I've moved into a new home—eight times since arriving in L.A. a little over a decade ago—I've dreamed about the spectacular housewarming party I have every intention of throwing. Unfortunately, it's never happened. Not even once. The closest I've ever gotten was pizza and champagne, which wasn't terrible, but it was hardly a proper party. By the time the pictures are hung and the kitchen is organized, I'm ready to move on (pun intended). My most recent condo took over a year to renovate and was the first place that I actually finished decorating—but having a housewarming party so long after moving in seemed silly (and unnecessary since most of my friends had already been there many times).

When William and I found our first house together—as newlyweds—it felt like the perfect opportunity to host my (or our) very first housewarming party. Moving into a new home can be such a huge life event that we really wanted to mark the occasion with a cheery, festive, over-the-top bash.

We decided we would celebrate our first home by paying homage to our first date. William and I have a soft spot for delicious *authentic* Mexican food. We met on a blind

date at a popular Mexican restaurant in West Hollywood and immediately bonded over our mutual respect for a proper salsa verde. So what could be a better housewarming theme for our first home together? Plus, it gave us an excuse to serve pitchers of delicious, colorful margaritas.

Since housewarmings are such celebratory events, I wanted to use bright primary colors, like true reds, and yellows, with bursts of hot pink and electric orange. Of the events I've hosted, this felt like the truest "party," where we were hosting forty people for an open house. (Regardless of how polite your guests may be, plan for a pretty major cleanup the next morning . . . or bring in reinforcements.) One of the reasons we chose this house was because of the amazing backyard, which we immediately wanted to put to good use for the party. We asked guests to arrive at 6 P.M., so the sun would still be up. This was the first time many of our friends were seeing our new home and we wanted the yard to still be bright!

the menu

This had to be one of my favorite menus to put together—any occasion that lends itself to *queso* is okay by me! Since the tequila would be flowing (more on that later), we wanted to make sure we had some pretty filling dishes for our guests; however, since we couldn't offer seating for everyone, the food needed to be easy enough to eat with one hand (think: tacos, tamales, chips and salsa). One of the best pieces of advice I can give you as a party planner: Know your limitations. For me, it's Mexican food. I know my way around a kitchen and have prepared what I consider to be some memorable meals, but I also know that when it comes to a particular regional cuisine, there are people with far more experience than me. Our dear family friend Martha is the most amazing cook I know when it comes to Mexican food and recently started catering events, so I immediately reached out and asked her to cater our celebration.

We discussed the details of the event and came up with a tasty, festive menu that would work for the number of people as well as the seating available.

We set up a buffet in our kitchen on a large center island. The menu called for hot plates, and we didn't want to compromise Martha's wonderful cooking, so we used traditional steel chafing dishes to ensure that the food stayed warm as guests grazed. While I usually try to incorporate unique and surprising elements in every aspect of an event (including the serving ware), sometimes a little kitsch is perfectly appropriate. A bright red serape blanket added a pop of color to the white countertops, acting as a table runner. In that same vein, we lined the bottom half of restaurant carry-out boxes with parchment paper (both of which can either be recycled or disposed of, making for much easier cleanup) and stacked them next to the buffet.

The fresh grilled corn and sweet corn tamales were plated on crisp white serving platters alongside rows of bright, colorful linen napkins. Although the food didn't necessarily require utensils, we still wanted to offer them for those guests who don't necessarily like eating with their hands.

For dessert, it was important we served a sweet that would keep on an outdoor food display, so we chose cinnamon churros, Mexican hot

THE HOUSEWARMING

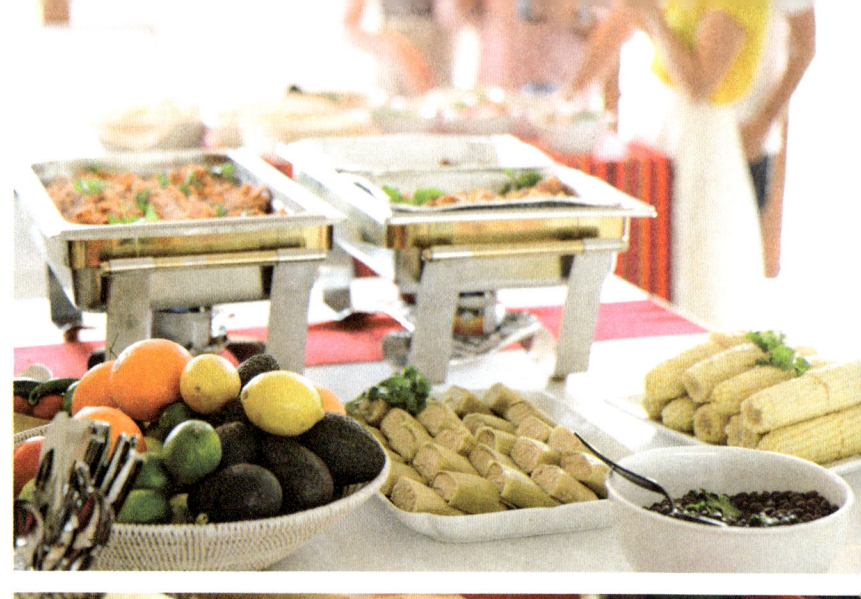
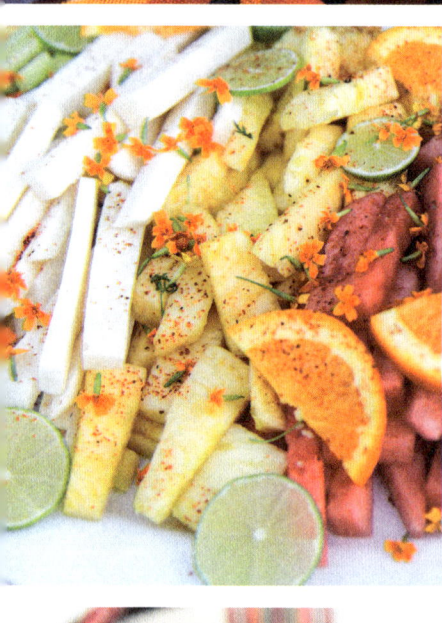

housewarming menu

Small Tacos
(Chipotle Chicken, Pork
Carnitas, and Cumin-Spiced
Potatoes)

Queso con Chorizo

Sweet Corn Tamales

Grilled Mexican Street Corn
with Cojita and Lime

Chips, Salsa, and Guacamole

Sliced Fruit with Chile Powder
and Lime

Lime-Cured Onion and
Habanero Salad

Cinnamon Churros

Mexican Hot Chocolate Cookies

Horchata-Flavored Popcorn

chocolate cookies, and horchata-flavored popcorn, as well as platters of freshly sliced in-season fruit.

I knew that given the reason for the event, people were expecting to see our new home. With Martha there to take the lead in the kitchen, I had the freedom to address any last-minute housekeeping items. Plus, having her there to focus on prepping the food, setting up the buffet (and refreshing as needed), and doing some light kitchen cleanup allowed William and me to focus on our guests.

the bar

Who doesn't love a specialty margarita? We decided to skip the bartender, and invited guests to help themselves to a serve-yourself margarita bar. We premade batches of four specialty margaritas—jalapeño lime, watermelon mint, cucumber lemon, and mango habanero—and displayed them in clean, contemporary glass pitchers alongside rows of gorgeous blue-tinted Little Market margarita glasses.

Because salt or no salt happens to be a very personal

For a larger party without a bartender, serving cocktails that can easily be made in batches beforehand will save you from spending most of the evening in your kitchen mixing drinks.

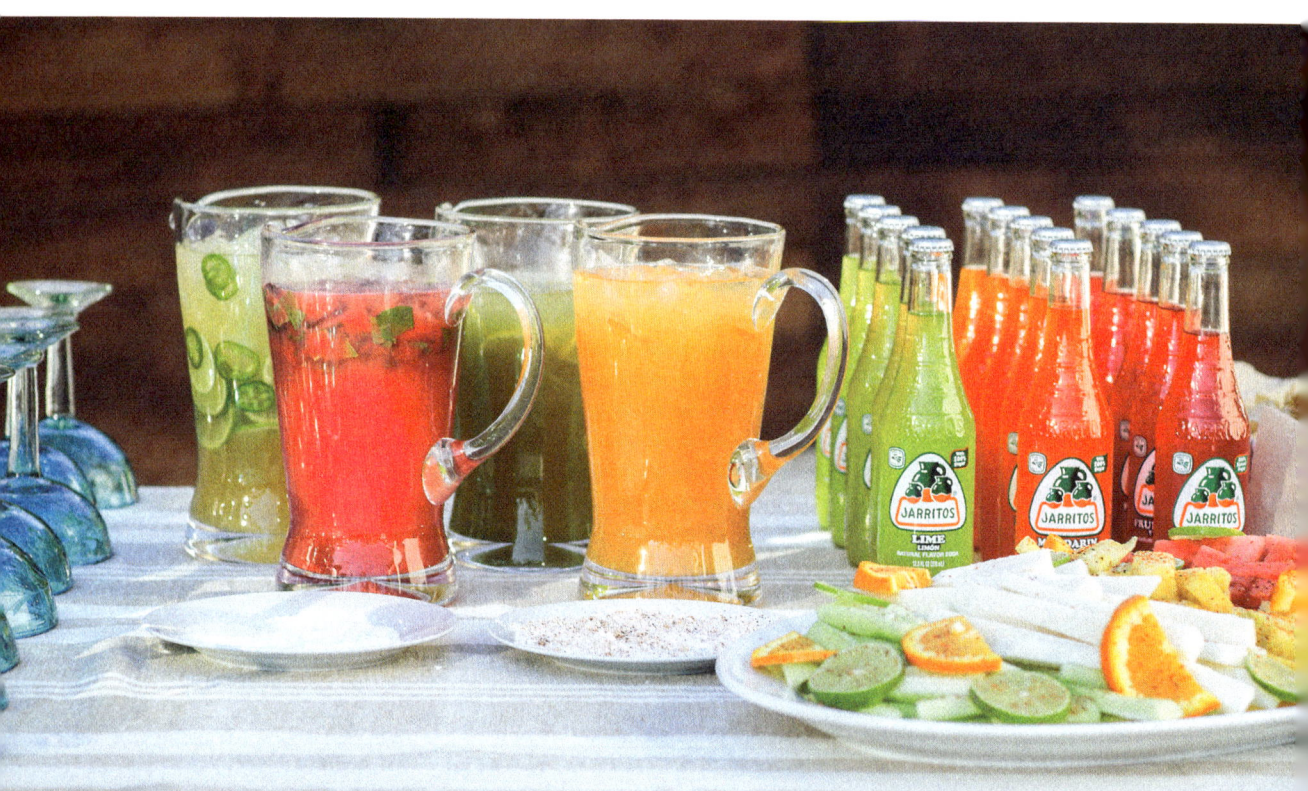

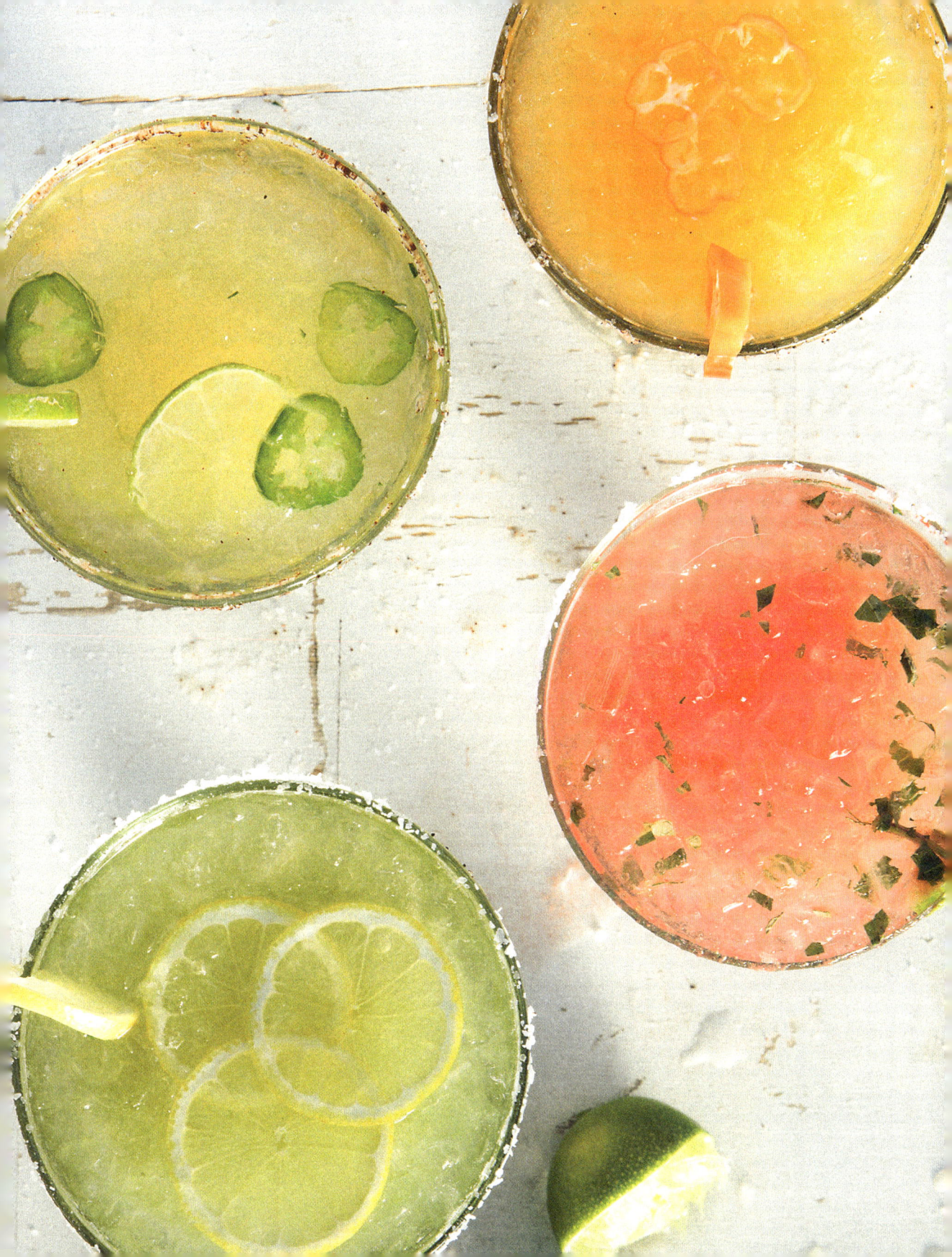

decision, we provided limes to rim the glasses and two kinds of salt: pink Himalayan and chile salt. In the move, I discovered an antique tabletop drawer set that I had picked up at a flea market a while back. It was the perfect quirky decorative element to hold the garnishes.

We also set up large beverage tubs filled with ice to offer some of our favorite Mexican beers: Pacifico, Corona, Sol, and Negro Modelo.

For the nondrinkers, I lined up rows of brightly colored Jarritos Mexican soda in a variety of flavors: Tutifruti, Toronja, Guayaba, Jamaica, and Limón. On top of being sugary and delicious, they're also so much fun to look at!

During a house party, bottle openers have a way of growing legs and walking off. I suggest tying one to the bucket or table with a ribbon.

the décor

Initially, I had the idea of filling the soiree with big, bright blooms, but immediately changed course when I stumbled upon these adorable, colorful miniature cacti. Moon cactus, as they're called, offer unexpected color—and look like they have been plucked from outside the most amazing dollhouse. After painting a couple dozen small pots with bright white paint and allowing them to dry, I planted each of the tiny cacti. (A word to the wise: They may be cute, but the spines still prick!) I arranged them on different surfaces and tables around the yard, then invited guests to take them home at the end of the evening.

Our yard was still a bit of a blank canvas when it came to décor, so we draped colorful, traditional woven fabric serape blankets on benches and chairs throughout for guests to lounge on. I had stocked up on a bunch of the woven blankets during a recent trip to Central America for the Little Market and had fallen in love with their simplicity and beauty.

the details

Last, but certainly not least: the piñata. Sometimes a brightly colored, candy-filled piñata is all the entertainment your event needs. Because I can't turn down a good craft project (and moving into a new home apparently wasn't enough of one), I chose to construct my own house-shaped piñata for our backyard party—and being surrounded by moving boxes assured me I'd have more than enough supplies if I needed a few practice rounds. It turns out piñata crafting isn't as arduous as it may seem. Don't be intimidated; it's actually a lot of fun and I've since extended my now expert piñata-making services to all my friends!

First, you need to determine the shape of your piñata. We wanted a house, so I used one of the countless cardboard moving boxes we had stacked in our garage. If you're in need of something round, papier-mâché a balloon and start from there.

THE HOUSEWARMING

~~~ When an event has a very specific theme, I try to get a lot of mileage from the décor elements, since odds are I won't be using them again. With the leftover tissue paper from the piñata, I decided to put together a garland of brightly colored fringed tissue to hang behind the margarita bar. ~~~

Remember to leave an opening at the top. Could you imagine constructing the perfect piñata only to realize you had no way of filling it with candy? I left the roof off my house while I began decorating the base with fringed tissue paper. This is probably the most time-consuming part of the process. I cut rows of hot pink tissue paper into strips and fringed one side, leaving about an inch uncut along the top. (You need an area to apply the glue.) Once the base and roof were covered with fringe and I had filled the box with our favorite candy, I brought the top flaps of the box to meet at the top into an A-frame-shaped roof.

When the time came for guests to take a few swings at the piñata, breaking it proved more difficult than it looked. I guess I built a pretty sturdy house! After a few failed attempts by partygoers, my friend and makeup artist Amy Nadine had no problem crushing the house. It was wonderful to see it explode with a shower of yummy candy (although I have since considered that perhaps some of my piñatas should just be décor and not actually swatted to smithereens).

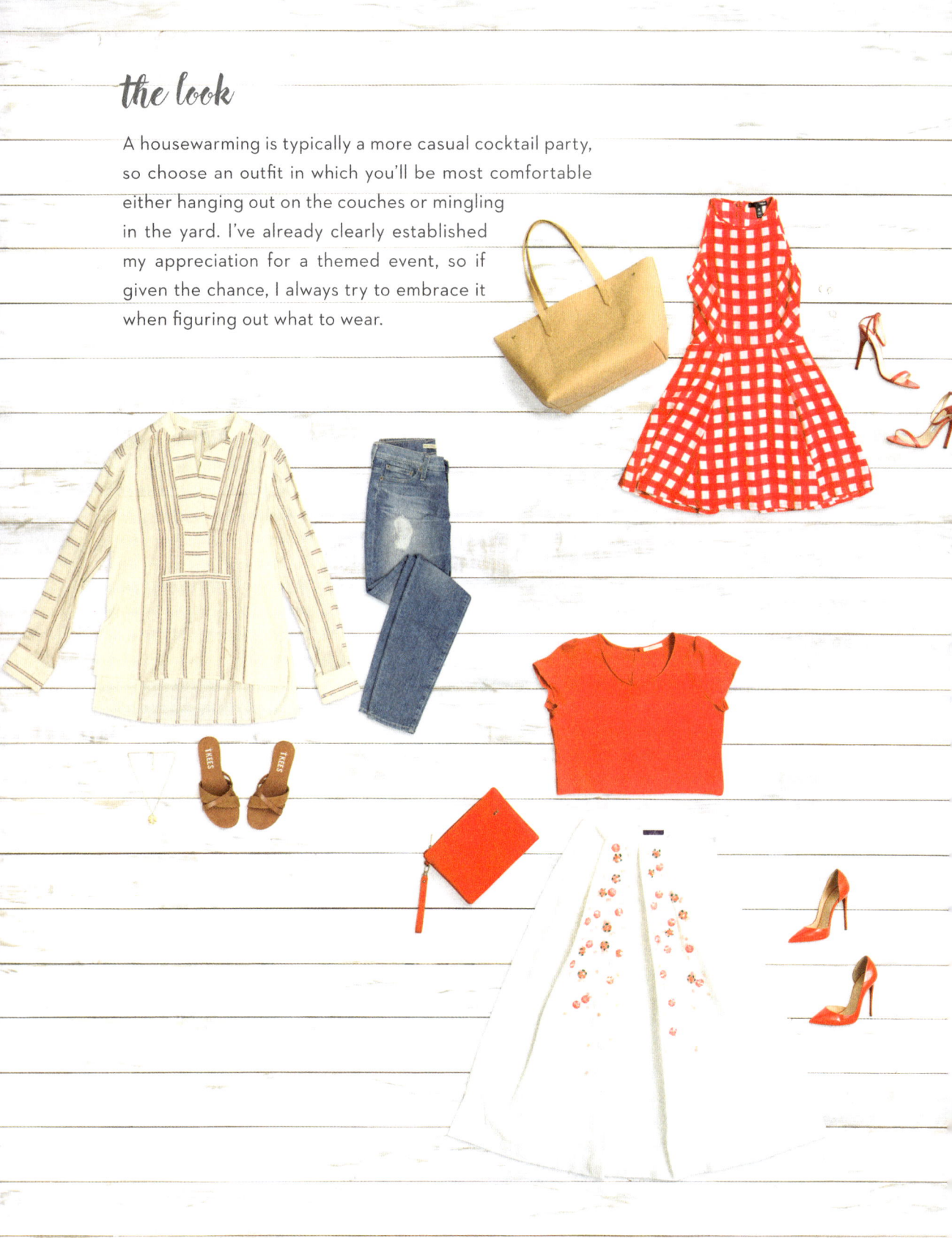

# the look

A housewarming is typically a more casual cocktail party, so choose an outfit in which you'll be most comfortable either hanging out on the couches or mingling in the yard. I've already clearly established my appreciation for a themed event, so if given the chance, I always try to embrace it when figuring out what to wear.

## THE ETIQUETTE
### the art of small talk

If you're a seasoned partygoer, chances are you're not always going to know everyone in the room. It's your responsibility to introduce yourself and socialize... after all, that's sort of the point of social situations. For some of us, making small talk is a bit of a struggle; there's a serious art to holding a conversation that's both lighthearted and nonintrusive. In my professional life, I'm constantly meeting new people, so I've learned a thing or two and have developed a few pointers for how to effectively make small talk.

- Never ask "What do you do?" If you'd like to offer an interesting anecdote about your career, that's fine. The other person may share something about his or her profession, but as a rule, limit work talk.
- Don't ask someone if he or she is married or has children. It can be a sensitive subject for some and you don't want to risk making things awkward. Offer information about yourself and hopefully the fellow guest will take the cue and return the gesture.
- Find common ground and keep things positive. Sure, misery loves company, but a party isn't the proper venue to bond over shared complaints.
- Make a connection over current events—but remember to keep things light: new films, good reads, interesting art exhibits, and so on. By any means necessary, avoid politics!

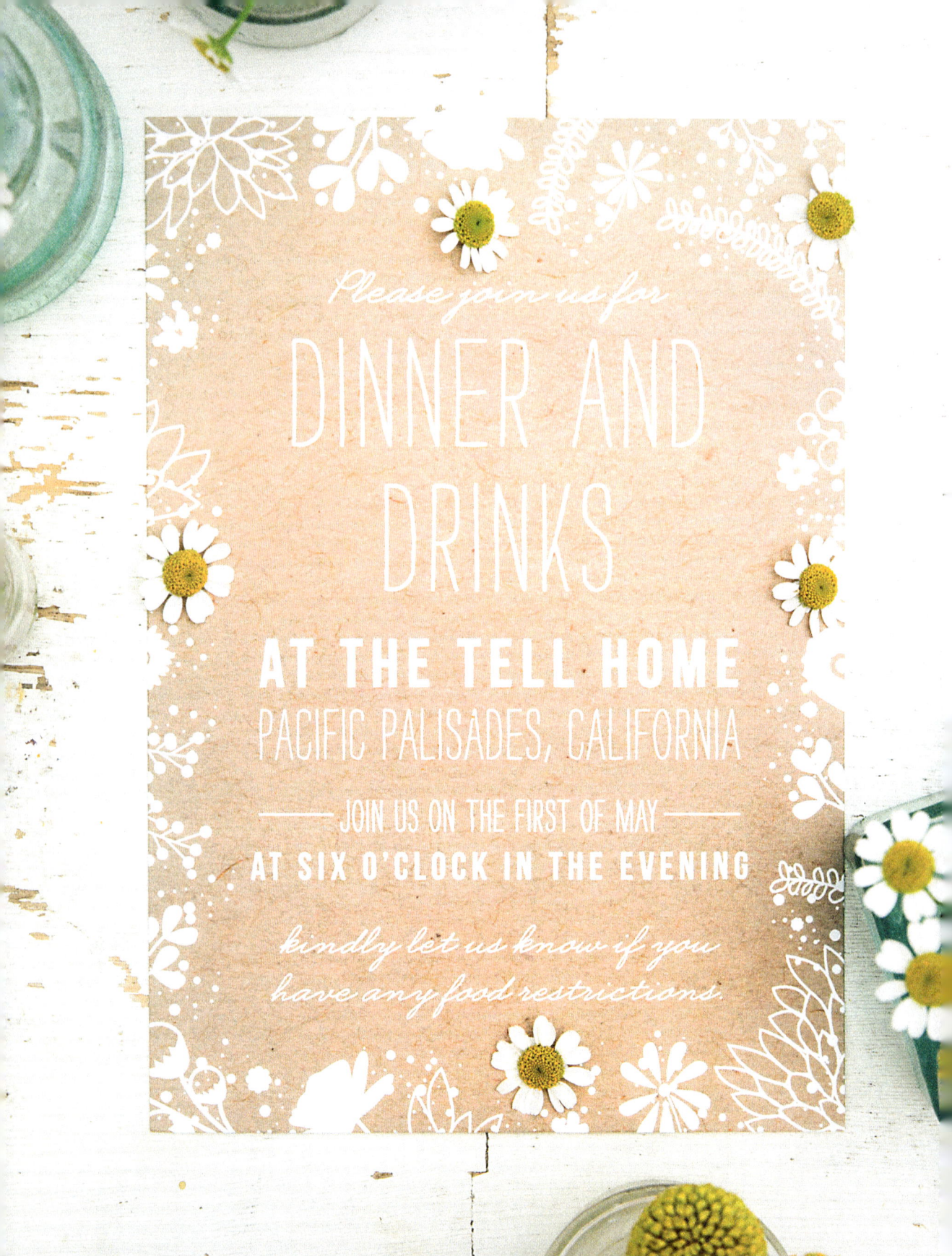

# 10

## the dinner party

### the overview

Nothing says "welcome to your adult life" quite like hosting a dinner party. It's such a grown-up thing to do, right up there with paying the gas bill on time and folding your laundry. For many of us, it's a rite of passage. We have that aha moment where we say, "You know what? I'm going to throw a dinner party." And it's almost always a small disaster. Whether it's undercooked chicken and overcooked sides or too few place settings and empty bottles of wine with no backup, it can be a real trial-and-error process.

For me, my main goal at the first few dinner parties I hosted was simple. Do *not* give people food poisoning. It may seem like I set the bar pretty low, but you'd be surprised at how quickly things can turn sour. One mislabeled or misused ingredient can transform your entire celebration into a nightmare. If people left my house without getting sick, it went down in my book as a real success.

I've hosted my fair share of events over the years, but I didn't dare tackle my first dinner party until I was in my midtwenties. (Confession: In my first apartment I had a foldaway card table in the dining room, so I wasn't hosting any formal soirees until I had a table I was confident wouldn't collapse under the weight of a Caesar salad.) When I

finally abandoned apartment living and moved into an actual house, I purchased my first dining room table and was ready to host friends for a proper dinner. Of course that plan changed a couple of weeks later when my friend Maura returned from her summer in Europe and was searching for a place to stay; the table was promptly replaced with a futon.

So it wasn't until Maura, Lo (our other best friend from home), and I moved from our house in Hollywood into our condo in Westwood that we once again had a formal dining room. I enlisted the design services of a close friend who decorated houses as a side job, and he did *not* disappoint. He found a vintage ebony wood dining table with brass accents and surrounded it with chairs he reupholstered in a canary yellow. It felt like a very grown-up achievement, so we celebrated by doing something equally as mature: hosting a dinner party. It had all the typical hiccups you'd expect and, frankly,

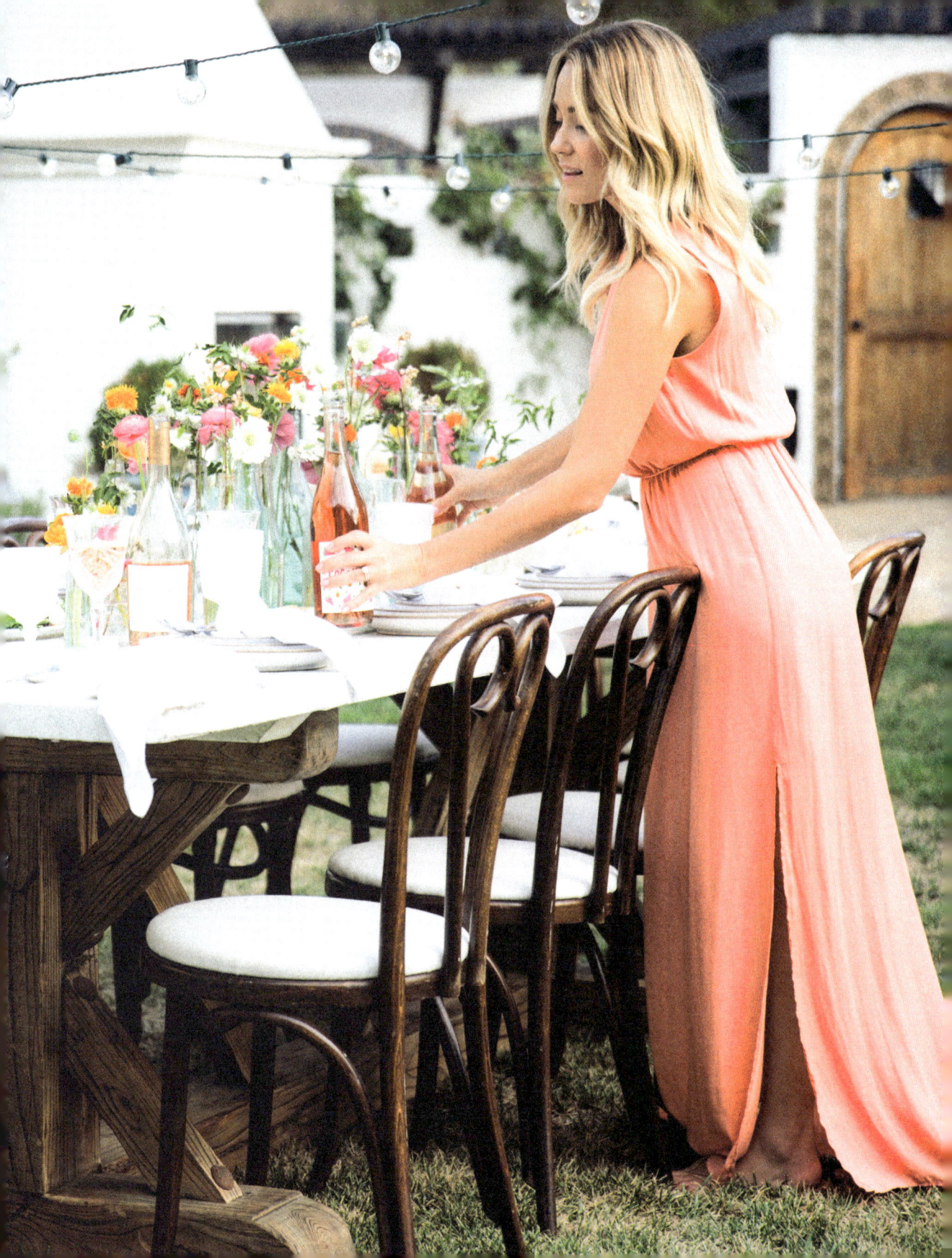

wasn't entirely memorable—but I do know no one came down with food poisoning, so I'll consider that a win.

Any occasion can be a good occasion for a dinner party—whether you're celebrating a particular life event or just hoping for some quality time with friends. It's a sit-down meal, but it's not fussy. By nature, it's intended to be personal, warm, and relaxed—big bowls of fresh tomato sauce and angel hair with shaved Parmesan, toasty homemade garlic bread, and a few bottles of earthy pinot noir littering the table. While I much enjoy going out and trying new restaurants with friends, it's far more personal to cook for them. You're welcoming people into your home, so there's no rush to leave the table when dinner is over, not to mention the awkward reaching for the check at the end of the meal.

William and I had recently met a sweet couple who moved from New York to Los Angeles. Moving to a new city can be overwhelming, so we wanted to welcome them and introduce them to some of our close friends with whom we thought they'd hit it off. Since it was summertime, we wanted to create a rustic al fresco vibe—weather permitting—and to showcase in-season citrus tones: blood orange and pink grapefruit with pops of spring green.

*As you become more of a seasoned dinner party host, you'll learn which of your dishes are most reliable, swap out the paper napkins for proper linen ones, and, eventually, stop buying wine based solely on the labels you like—although I can still be guilty of this from time to time, including for this event; however, the wine ended up being absolutely delicious!*

## the menu

I've said this before, but the seasonality of the food you serve is really important. Using the freshest ingredients will not only help you avoid spending your entire budget at the grocery store, it also lends itself to the best-tasting meal. When products are in season, they *always* taste (and look) better. And if you have access to a farmers' market, that's ideal.

Since a dinner party is one of those events that revolve solely around the meal, I planned our menu first and let the food dictate everything else, from drinks to décor. Even though William and I

would be hosting only seven guests, I didn't necessarily want to do a fully plated meal, so we decided serving it family-style would be our best bet. Whipping up individual servings requires a lot of time and attention, and I wanted the focus to remain on spending the evening with our guests. Plus, serving a meal family-style forces everyone to get friendlier a lot faster.

We chose a 6 P.M. arrival so that dinner could begin promptly at 7 P.M. to make certain we'd be enjoying our meal during sunset (which in May in Southern California is around 7:30 P.M.). Traffic is as much a part of L.A. culture as the Beach Boys and palm trees, so I always like to provide a bit of buffer. Inevitably life happens, whether you realize your gas tank is empty or you forgot to send a last-minute e-mail, so I don't want my guests to feel stressed. I also want to save myself the panic of dishes going bad.

At 7:30 P.M., William invited our guests onto the patio for appetizers (coconut shrimp and pancetta-wrapped peaches), while I put the finishing touches on the main course and sides. (Teamwork makes the dream work, people!)

Our menu featured an aromatic baked Mediterranean sea bass (the recipe can easily accommodate a substitution, like chicken) with seasonal sides. (See "The Etiquette" in this chapter for a full breakdown for prepping and timing your dinner.) The food was served on crisp, white platters, and each seat was set with natural white Heath ceramic plates and pickled wood flatware.

For dessert, I wanted to keep with our citrus theme and remembered William's mom makes a delicious lemon–poppy seed cake (which turned out to start with a box cake mix, giving me one less thing to worry about!). I added my own spin by covering it in lemon buttercream icing and decorating it with thin, brightly colored citrus slices and mint leaves.

THE DINNER PARTY   139

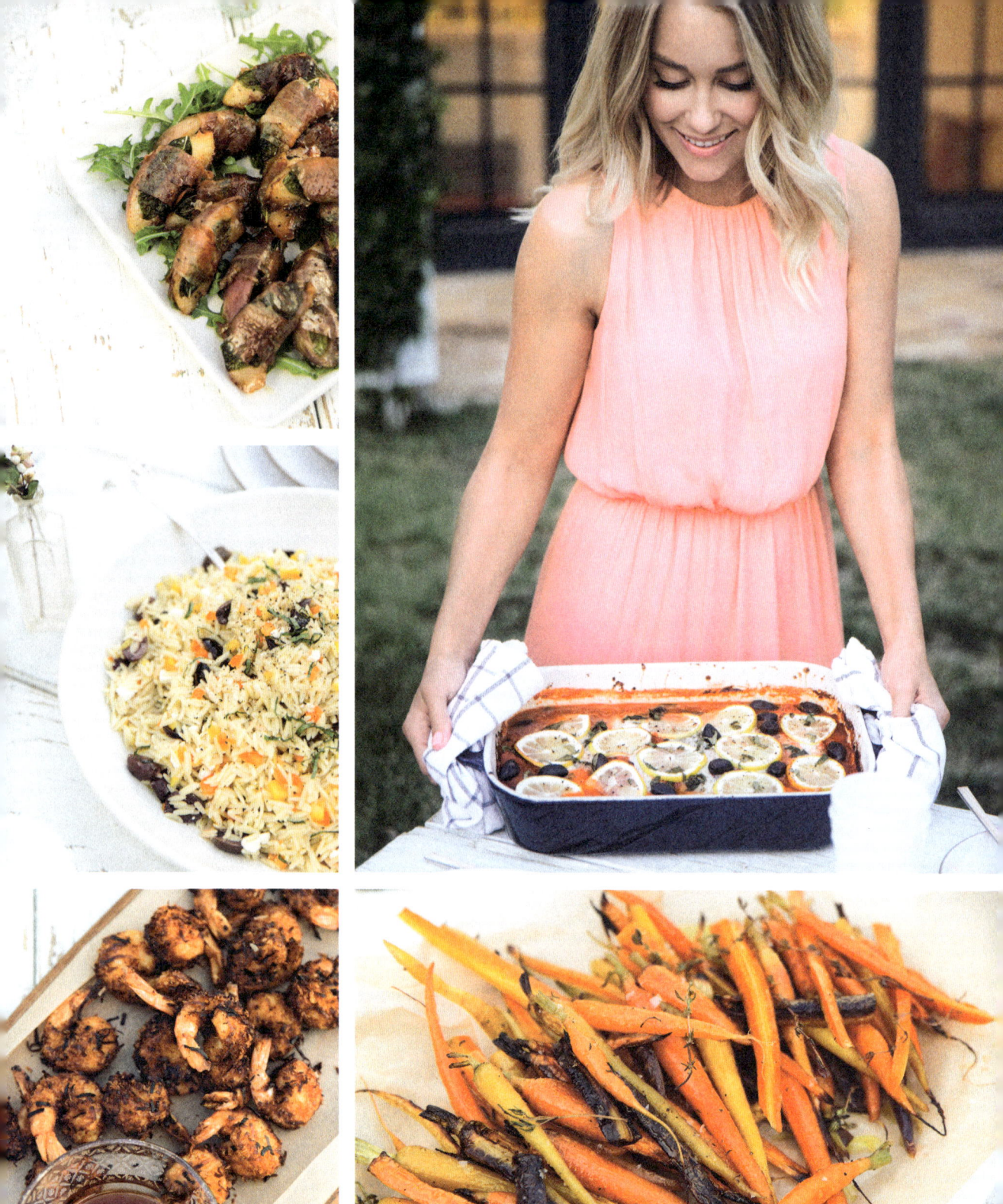

# dinner party menu

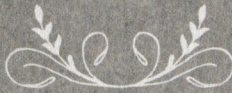

Coconut Shrimp

Pancetta-Wrapped Peaches

Mediterranean Sea Bass with Tomato, Olives, and Lemon Slices

Roasted Rainbow Carrots

Feta and Pepper Orzo Salad

Beets with Fresh Burrata

Lemon-Poppy Seed Cake

## the bar

To complement the rustic menu, we kept the bar relatively simple. Southern California summers can be hot, so I wanted to offer guests a chilly, citrus-infused beverage. Shortly before our friends were set to arrive, I mixed up a glass pitcher of apricot mojitos to offer them during our cocktail hour.

Given the more relaxed, intimate atmosphere of the dinner party, we chose to serve a selection of wine (rosé and white) to play off the acidic, citrusy flavors of the meal. Each table setting had a standard crystal wine goblet, which could be used for either offering, and I placed a few bottles on the table so guests would feel comfortable pouring for themselves. William is a beer guy, so we chose two premium beers as well: Peroni and Leffe Blond.

Oftentimes your guests will arrive with a bottle of wine in hand. Since it's not always clear whether they intend to share the bottle or if they brought it as a host or hostess gift, just ask whether you should open it up or save it. When in doubt, always ask. You don't want to open up a pricey bottle if you aren't sure it will be consumed. Also, some red wines (particularly younger ones) need at least an hour to aerate before being served, so you want to make sure you allow yourself time to decant it.

*In the weeks leading up to the event, save a few wine bottles, soak them in hot water, and give them a good scrubbing to remove the labels.*

Most people prefer to have water with their meal (in addition to a libation), so I filled a few clear, empty wine bottles with filtered water and scattered them on the table.

## the décor

At a dinner party, the food is the star of the show—consider everything else a backup dancer. Luckily, beautifully roasted dishes and carefully arranged platters are pretty nice to look at. The remaining décor just needed to support our al fresco vibe, in hopes of making guests comfortable and helping to avoid the fuss of more formal gatherings.

I collect old glass bottles—it's sort of a passion/obsession. I'm an avid flea market

shopper, so I'll scour booths looking for antique glass bottles. You'd be amazed at the beautiful vessels that were used in the past to package everyday products. From Listerine to baby formula, I have a pretty fun assortment of unique and interesting bottles in different shapes, sizes, and shades (they can also be wonderful conversation starters . . .). For our dinner party tablescape, I chose a variety of tinted glass bottles and filled them with wispy, brightly colored wildflowers like ranunculus, cosmos, marigolds, and oregano flower. I set them around the table in places that felt natural, keeping in mind that I didn't want it to look "too done." Since the sun would set during our meal, I needed lighting that was both complimentary and functional. I adore the look and feel of exposed vintage-style lightbulbs, so I ordered a few strands of carnival lights and strung them above the table in our backyard. The table itself was made of reclaimed wood and was surrounded by French bistro chairs.

For this event, the table was enough without a linen, but I do usually prefer the look of a "dressed" table. It's a simple detail that can dramatically elevate your table—without breaking your budget. In fact, it can be a really inexpensive way to make a boring table look incredibly chic. Simply measure the length of your table plus two feet, for overhang, and go to a fabric or craft store and choose a textile that really appeals to you. To make it easy, make a runner by choosing a fabric that's about one-third the width of your table. I'd also suggest going with a material like a rustic linen or a bohemian-looking lace so you can leave the edges undone and raw.

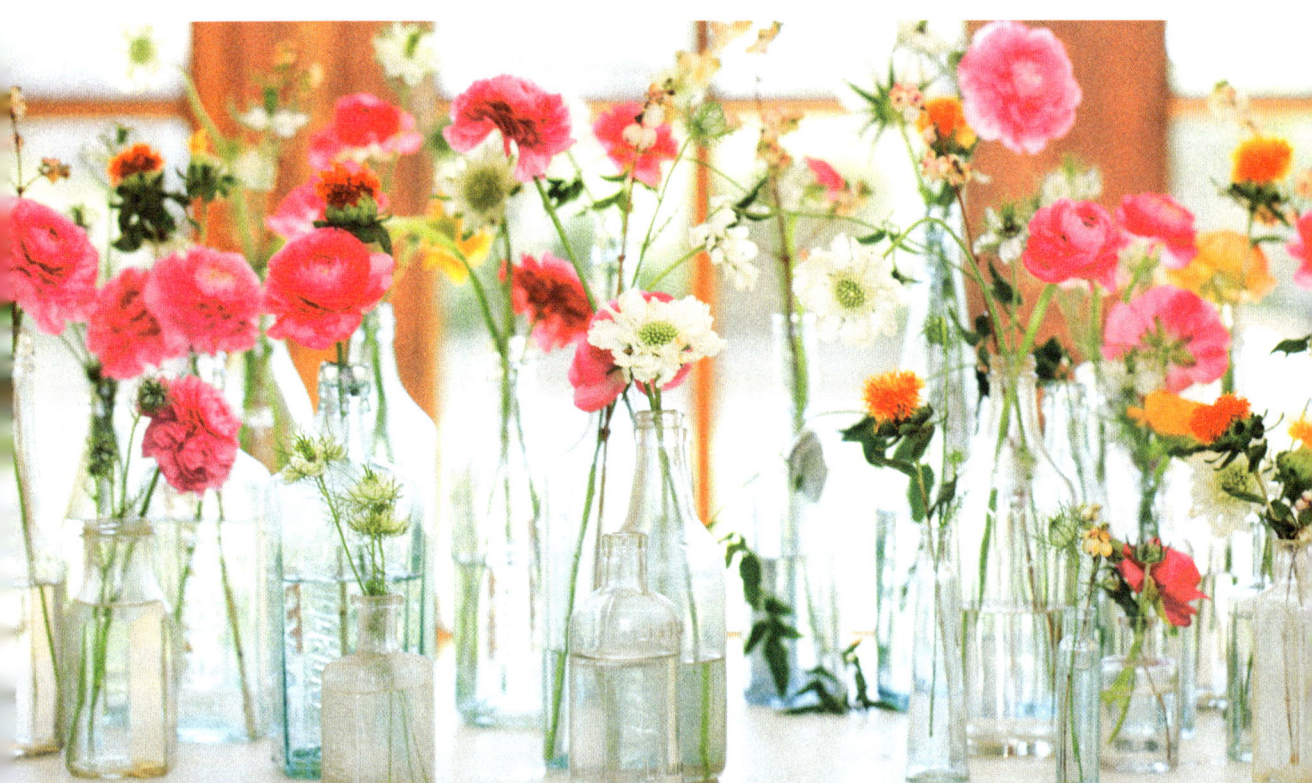

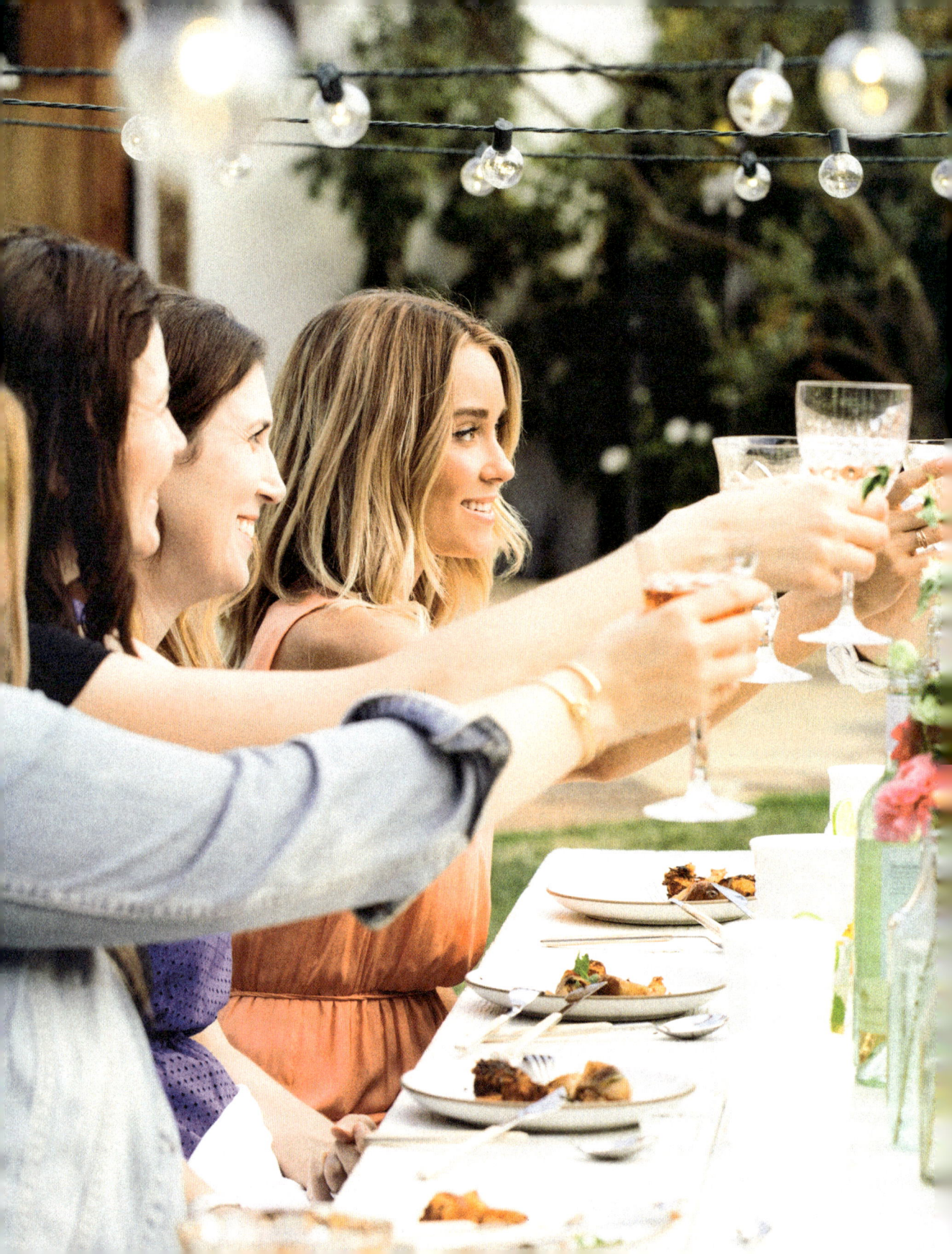

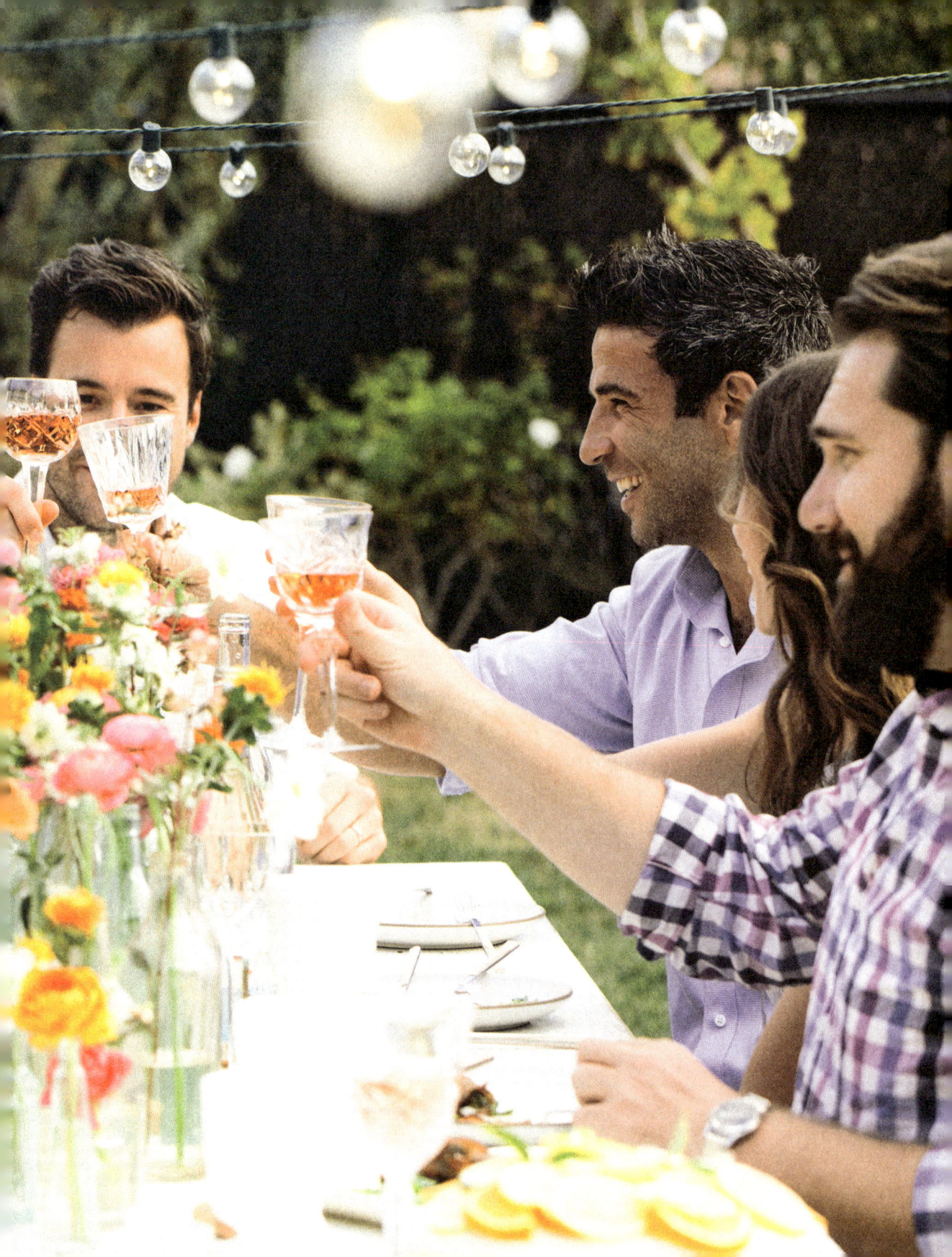

## the details

As a guest, you're obligated to ask, "What can I bring?" The host will almost always say, "Nothing." But when you're invited into someone's home for a dinner party, it's always a good idea to arrive with a gift in hand. Here are a few gift ideas that are both practical and thoughtful:

- A bottle of alcohol or wine
- A scented candle
- A pretty bottle opener
- A small cocktail recipe book
- A bouquet of flowers

## the look

Dinner party attire can vary greatly. From a sophisticated Manhattan gathering to a comfy Southern barbecue, a dinner party can range from ultraformal to casual and elegant. My advice is to take your lead from the style of the invitation and err on the side of slightly more elevated if you're still unclear.

## THE ETIQUETTE
## *the well-timed dinner party*

We're all guilty of this, but how many times have you played host or hostess and spent the entire evening in the kitchen? Guilty! You spent so much time planning the event, you deserve to enjoy it! Your guests will feel guilty or uncomfortable watching you run in and out of the kitchen all night. If you're relaxed, everyone will be more at ease and able to appreciate the get-together. That said, the way I have learned to avoid this situation is by following a good old-fashioned schedule. For example, here's the step-by-step forty-eight-hour schedule I used while preparing my dinner party menu to ensure I was serving a fresh, tasty meal that I actually got to enjoy with my guests!

### THE WEEK OF

→ Finalize your menu, print out any recipes you need, and create a shopping list.

### DAY BEFORE

→ Do your shopping. Keep in mind that this might require multiple stops and you may not be able to get everything you need the day before. For example, I wanted to serve the freshest fish available, so I made an early-morning trip to the fish mart on the day of the event.

### NIGHT BEFORE

→ Take care of any nonperishable prep. For this party I boiled, cooled, peeled, and diced the beets, then placed them in the fridge, as well as baked the cake.

→ Clean and polish the serving ware, flatware, and glassware (especially if it's "special occasion" tableware that may have collected a bit of dust or rust).

⇢ If you're serving the meal indoors, set the table and press the linens, if you're using them. It's one less thing to worry about.

⇢ And while you're at it, do your own personal prep: put together your hostess ensemble and be sure to tidy up around the house.

## DAY OF

⇢ Start your morning by picking up any last-minute ingredients, as well as the floral elements or any other items where freshness is a factor (i.e., the shrimp and fish).

⇢ Put together floral arrangements and address any final elements needed for your tablescaping.

⇢ Frost and decorate the cake.

⇢ Time to start cooking! Begin by making dishes that will hold up best throughout the day (for example, the orzo salad). Next, prep ingredients for any of the baked dishes so that they're ready to pop into the oven before the dinner (like the carrots or peaches).

⇢ The oven and stovetop are prime real estate when hosting a dinner party. My approach is to cook and bake dishes based on the order in which they will be served. If at all possible, I try to tweak recipes to allow them to bake at the same temperature at the same time. For example, I usually roast carrots at 400°F, but in order for them to cook at the same time as the fish, I chose to bake them at 375°F and just kept them in for 10 minutes longer. But beware of overcrowding your oven, as it could affect the cook time.

⇢ While the items in your oven are baking, you can turn your attention to the stovetop. Luckily, chances are you have at least four burners and can whip up a few dishes at once. For this party, the peaches were prepped and ready to be grilled so I could focus on battering and frying the coconut shrimp.

⇢ Shortly before guests arrive, prepare drinks, fill water glasses, plate appetizers, and add any last-minute touches to the table.

⇢ Take off your apron, slip on your big-girl shoes, and pour a glass of wine. It's time to enjoy a beautiful meal with your guests.

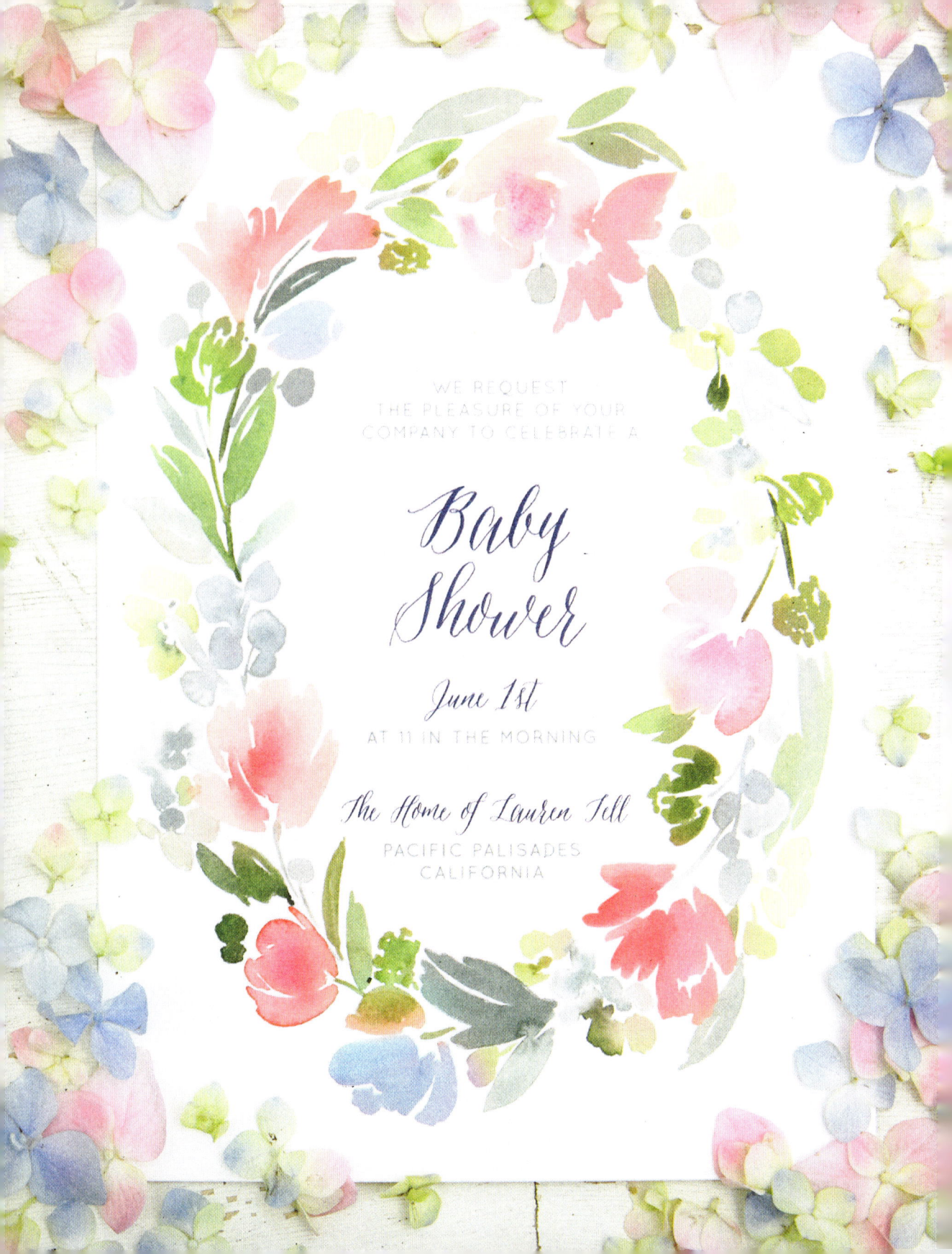

# 11

## the baby shower

### the overview

It's like clockwork. Just when you start to see a lull in the bridal shower luncheons and fewer bachelorette party invitations, your mailbox will start overflowing with pink rubber ducks, powder-blue elephants, and tiny hooting howls. I'm at the age where many of my friends have caught some serious baby fever. It's not unusual for my weekends to be filled with mocktails, DIY onesies, and diaper cakes. When my close friends share any news befitting a proper party, I'm always quick to host a celebration. So while I haven't yet boarded the baby train myself, I've happily enjoyed quite a few tiny people parties. Oftentimes, baby showers are more intimate celebrations, so this particular event had a smaller guest list. We invited eight ladies to "shower" the guest of honor with a Provençal-inspired fete. The French countryside is famous for its breathtaking landscapes, and showcasing those delicate, pastoral elements felt like a natural theme when celebrating a glowing mama-to-be . . . and because it gave me the perfect opportunity to use the term *bébé*. Baby showers can be big days for expectant moms and are oftentimes quite tiring, so while I don't usually put end times

on invitations, I made sure to let guests know the party would be about three hours.

It's become popular to wait to find out the baby's gender until the day of birth. While I'm not sure the planner in me would ever be able do this, many couples choose to be surprised, so I opted to host a gender-neutral baby shower. Although some people feel limited by a gender-neutral event (all yellow everything), we decided to embrace the unknown! Instead of avoiding gender-specific color, we wanted to incorporate both the traditional baby girl and baby boy palettes. I used the foundations of true whites and bright greens with pops of rosy pink, pastel blush, baby blue, and periwinkle, which lent itself nicely to the soft rustic aesthetic I was hoping to achieve.

Since oftentimes pregnant women don't always feel their best, I wanted this to be a slightly more formal occasion, but *not* stuffy. Baby showers can give the mama-to-be a fun excuse to get dressed up and feel gorgeous.

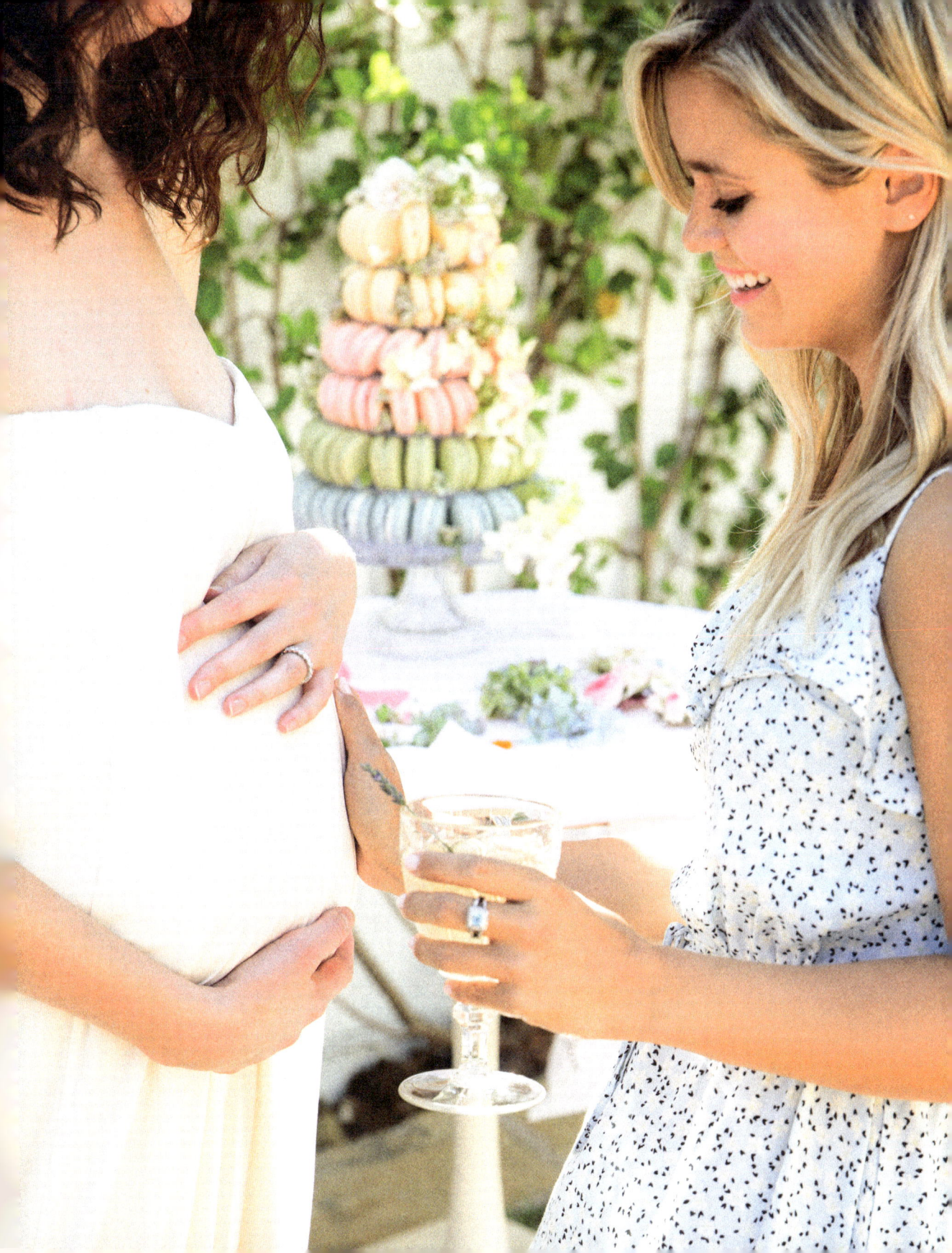

## the menu

When planning a baby shower menu, it's important to be sensitive to any dietary restrictions the guest of honor may have. Depending on whom you talk to or what website you read, expectant women are discouraged from eating quite a few foods (such as deli meats, sushi, soft cheeses, and runny egg yolks).

In keeping with the theme, I cooked up a family-style Provençal-inspired lunch menu of traditional French offerings.

A major perk of pregnancy is never having to pass on dessert, so obviously we needed plenty of options. In addition to a beautiful flower-adorned dessert tower of pastel-washed macarons, I served mini French apple cakes dusted with powdered sugar and wrapped in parchment paper, multicolored white cake petit fours, and a homemade crepe cake with raspberry mascarpone frosting (talk about a labor of love!). As a thank-you, each guest took home a fluffy chocolate croissant in a wax paper favor bag.

*I suggest talking to the mama-to-be before setting the menu. Not only are there certain things pregnant women should avoid, expectant moms tend to have lots of aversions—as well as cravings!*

## the bar

It's a baby shower . . . so chances are your guests won't be expecting a fully stocked bar and bartender (but it'd sure be amazing if there was one!). Of all the events you'll host, a baby shower is perhaps the lightest on alcohol consumption. That being said, it's still a celebration! I decided the best bet for this party was to keep it simple, offering proper French champagne as well as French 75 cocktails (a champagne cocktail made with lemon juice, gin, and simple syrup) garnished with fresh sprigs of lavender.

The nonalcoholic drinks needed to feel just as special as the cocktails. I wanted the guest of honor to have a delicious, beautiful beverage to go along with her meal—no one wants to toast with a water cup—so I created a "Craft Your Own Soda" station. Guests could choose from four infused simple syrups to enhance their soda water: rosemary, mint, lavender, and rose. Tying a sprig to each bottle is a fabulous way to indicate the syrup's flavor.

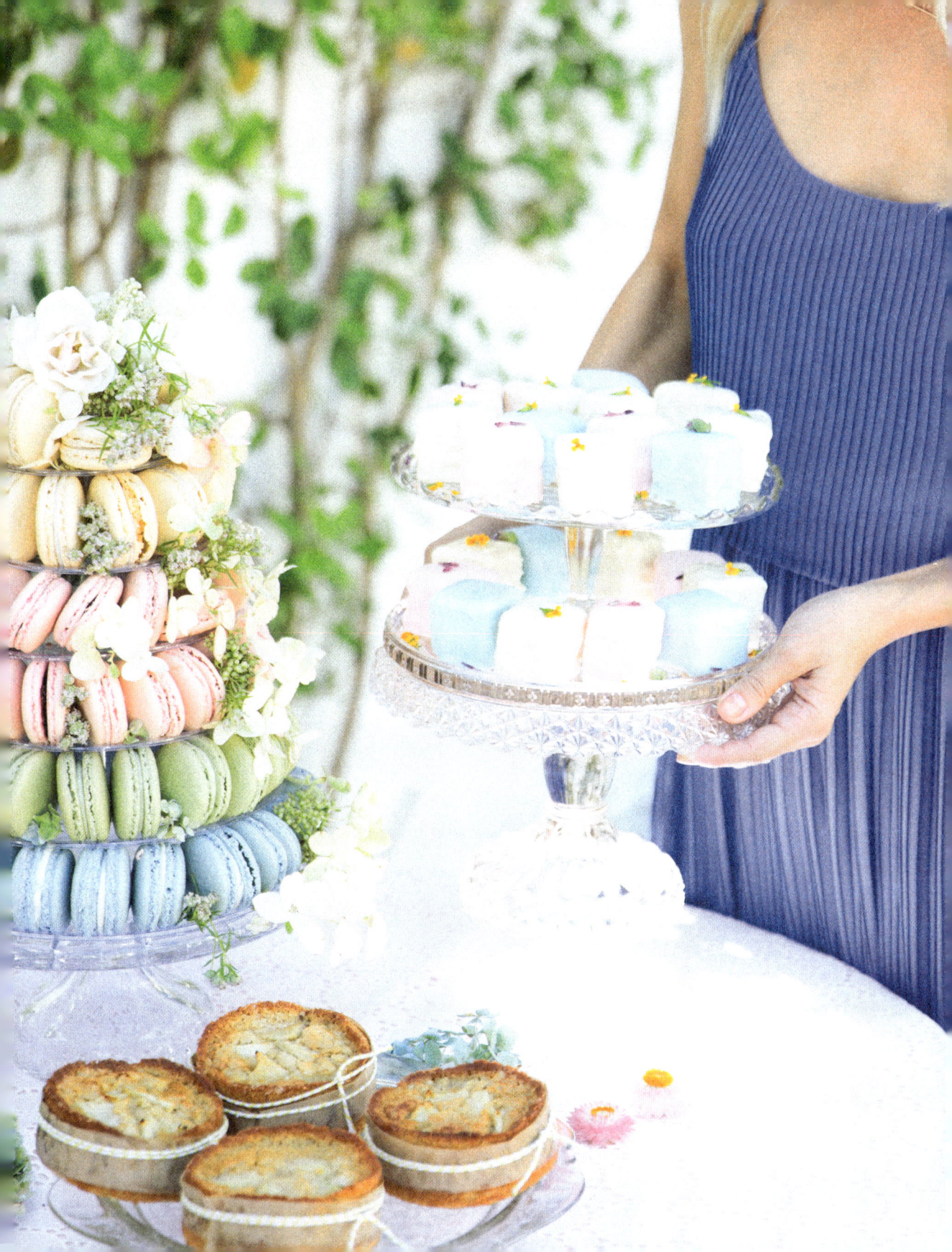

# baby shower lunch

### Organic Crudité
*Baby radishes, mini carrots, traditional and purple cauliflower, asparagus with cucumber yogurt dip*

### Salade Niçoise
*Heirloom tomatoes, fingerling potatoes, green beans, and quail eggs with tuna (cooked, not seared) and olives*

### Baguette Sandwiches
*Carved ham on miniature baguettes with either Gruyère or Brie wrapped in parchment paper and twine*

### Quiche
*Leek and goat cheese topped with sliced tomatoes and tri-mushroom Parmesan*

### Crepe Cake with Raspberry Mascarpone Frosting

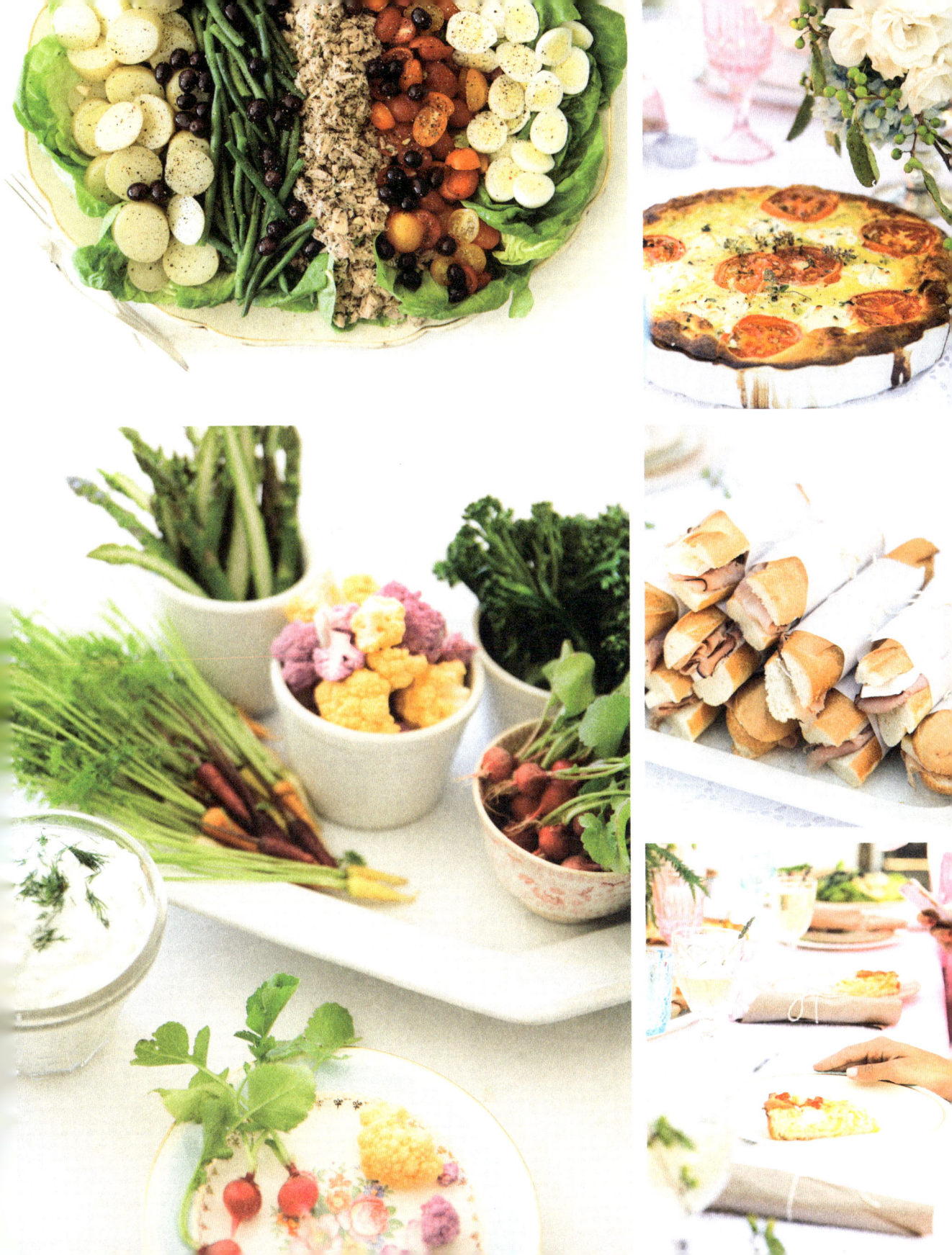

## the décor

I wanted each décor element to feel rustic and earthy, but still feminine. I didn't want the floral arrangements to feel overly manicured, so I chose delicate, soft blooms for the centerpieces: garden roses, multicolored hydrangeas, and vines. I arranged them in organic, textured shapes in mismatching gold stone urns and placed them around the white lace-dressed farm table. Each place setting featured a different piece of vintage dishware—alternating between the soft pink and pale blue hues, and cotton eyelet detailing—and we topped each setting with a small rose wrapped in craft paper.

Everything needed to feel organic and natural. For a fun, unique element, I put together four brass specimen frames, strung them on a piece of blue silk ribbon, and hung them over our DIY floral hair comb activity table (more on this next). Using dried wildflowers, I trimmed and shaped individual pieces to create the letters to spell out *bébé*.

## the details

During the party, guests were invited to create a live flower hair comb. The project was interactive, but not overly time-consuming or messy. Plus, who wouldn't appreciate a table filled with beautiful spray roses, hydrangeas, lavender, straw flowers, silk ribbon, and gold hair combs? They're easy for guests to make, and I chose flowers that would dry beautifully so the ladies could take them home to place on a perfume tray or in a jewelry box.

    I'm not opposed to a fun shower game, but I like to be thoughtful about what I'm asking guests to participate in. Maybe it's just me, but I've never been a fan of any game that puts candy in a diaper, and I can't imagine any pregnant woman who would want someone guessing how big her belly is. When it comes to baby shower games, my advice is to keep it simple and elegant. I've listed a few examples on page 161.

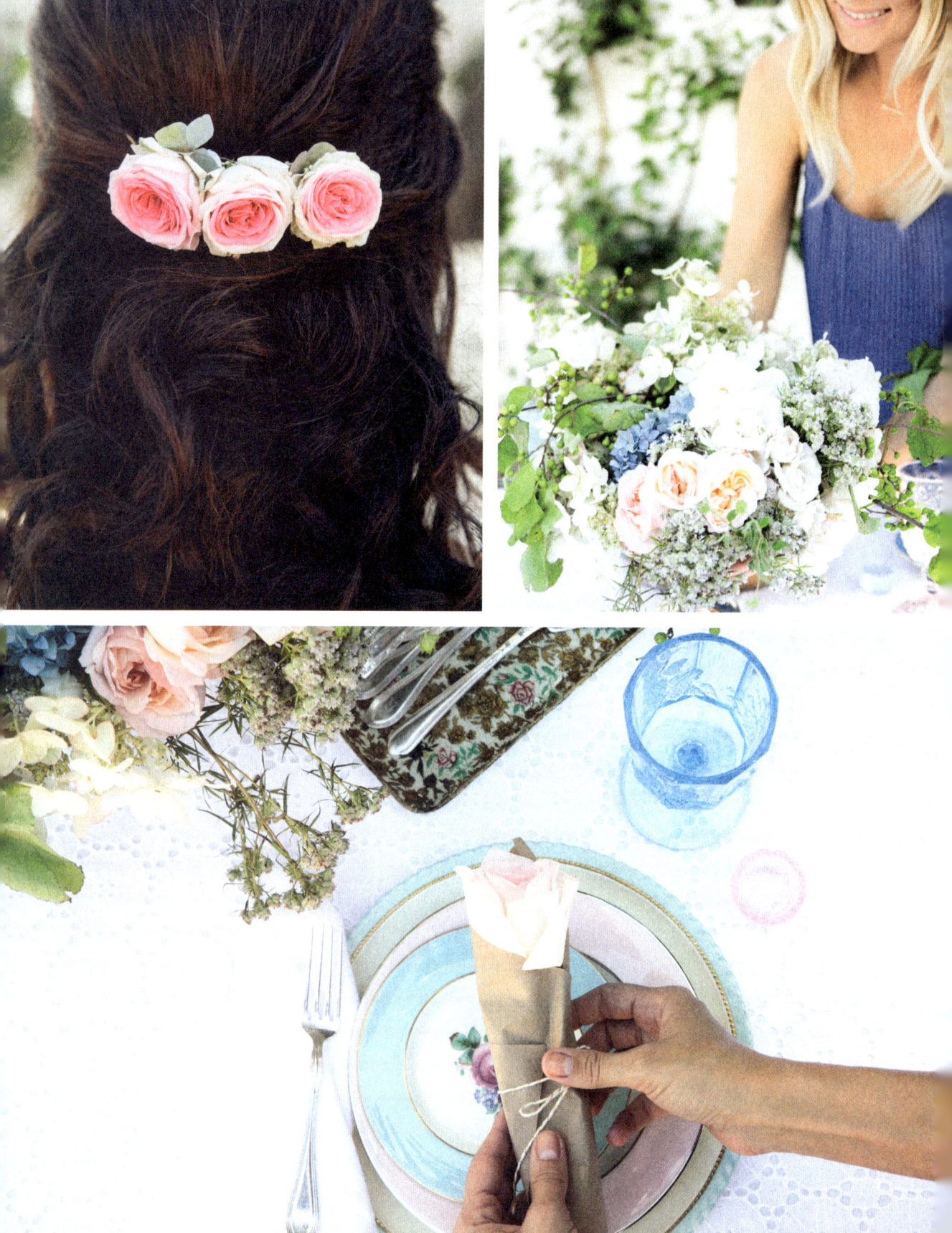

- **BABY PHOTO WALL.** Before the event, ask guests to send you a baby photo of themselves. Display each photo during the shower with an assigned number (you can drape it across the wall like a banner or attach each photo to a beautifully framed pin board) and ask the mama-to-be to figure out which baby photo belongs to which guest, and have her reveal her guesses.
- **WISHES FOR BABY.** At each table setting, place a small "Wishes for Baby" card. Each line is a different hope to fill in, like "I hope you never forget . . ." and "I hope you laugh . . ." Ask guests to fill in the blanks with their hopes and well wishes for the new little one.
- **BABY'S FIRST YEAR.** This one is particularly good for first-time moms! Guests are invited to write short notes to the new parents offering words of wisdom or advice for the baby's first year. The hostess collects each card in a beautiful fabric-covered vessel for the guest of honor.

## the look

Finally, a party you can wear white to! Much like the bridal shower, this is the perfect event for your most feminine and dainty ensembles (think: flowery, flirty dresses and structured lace two-pieces). Keep in mind, the guest of honor will probably be further along in her pregnancy and not feeling quite like herself, so I would avoid the bold backless maxi or saucy crop top.

# THE ETIQUETTE
## the sprinkle

A traditional baby shower celebrates parents who are expecting their very first little one. It's an event that brings together the couple's nearest and dearest to "shower" them with presents and well wishes as they prepare for their new arrival. When a couple announces that they're expecting baby number two (or three or four), it's now common for friends and family to host a "sprinkle" to celebrate the newest addition—and since the "shower" helps a family prepare by gifting them with all the baby essentials, the "sprinkle" is intended to be a more casual gathering. It's assumed that the couple already has the changing table, diaper pail, and stack of baby-friendly board books, so this party should just be about celebrating the new little one. Proper etiquette suggests not registering for a second shower, but inevitably people will *want* to bring gifts. Suggest that guests bring baby essentials that can't be passed down: diapers, wipes, shampoos, and lotions. Not only will these items definitely be put to good use, but they are also relatively cost-effective gifts (since odds are these are the same friends who helped you celebrate baby number one). If the guest of honor still feels uncomfortable, ask guests to bring a baby item that will be later donated to a specific children's charity, like Baby2Baby.

PLEASE JOIN US FOR A

# CLAMBAKE

JULY 1ST AT SUNSET
MUSSEL COVE
LAGUNA BEACH, CALIFORNIA
COME READY FOR SURF, SPIRITS, AND SEAFOOD!

# 12

## the clambake

### the overview

Few things are more charming than a good old-fashioned clambake. Surf, sand, and seafood—what's not to love?

It's a delicious example of an event that revolves exclusively around the food being served. You don't need much in the way of décor or activities. The meal itself is both the party *and* the entertainment!

A few summers ago, I spent a week in Nantucket with my husband (then boyfriend) and his parents. I've always been a beach-town girl, but this little island was unlike any place I'd ever seen. From the crushed white-seashell walkways and quaint quarter-board signs to the wood-shingled cottages weathered gray and engulfed by gorgeously overgrown hydrangeas, the town seemed to have been plucked right out of the pages of an old book and dropped thirty miles off the coast of Massachusetts. While there, I was invited to my very first clambake. I'd never actually been to one before and was excited to properly round out my New England experience.

Something about drinking crisp, cold sauvignon blanc out of a paper cup is incred-

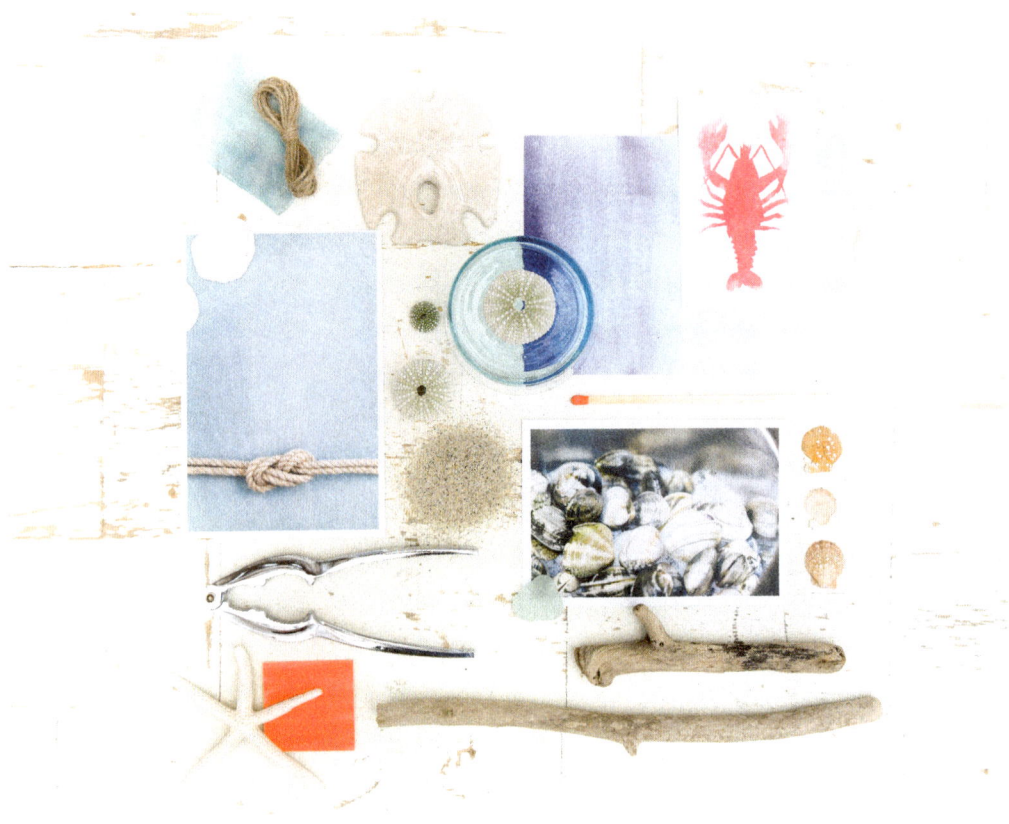

ibly romantic. It's a major party faux pas every other time, but it's practically a requirement at any self-respecting clambake. With the steely-gray Atlantic Ocean as a backdrop, I buried my feet into the sandy beach and cozied up with the best clam chowder I'd ever tasted, savoring each spoonful. While we waited for dinner to bake over an open fire, our chef taught me the art of shucking a clam and how to then shoot it like a tiny oyster. He had over thirty years of professional experience and shared with me that the secret of any well-executed clambake is to avoid overcooking the seafood.

When the next summer rolled around, I found myself daydreaming about my days on the island and, particularly, about that delicious clambake. I kept going on and on about it until William said, "Why don't we just have one here?" Of course! Sure, clambakes are typically more of an East Coast tradition, but why couldn't we have one? It didn't seem that difficult to pull off. After all, we have seafood, beaches, and paper cups in California, too. And by the way, the beach is totally optional. Who says you can't host

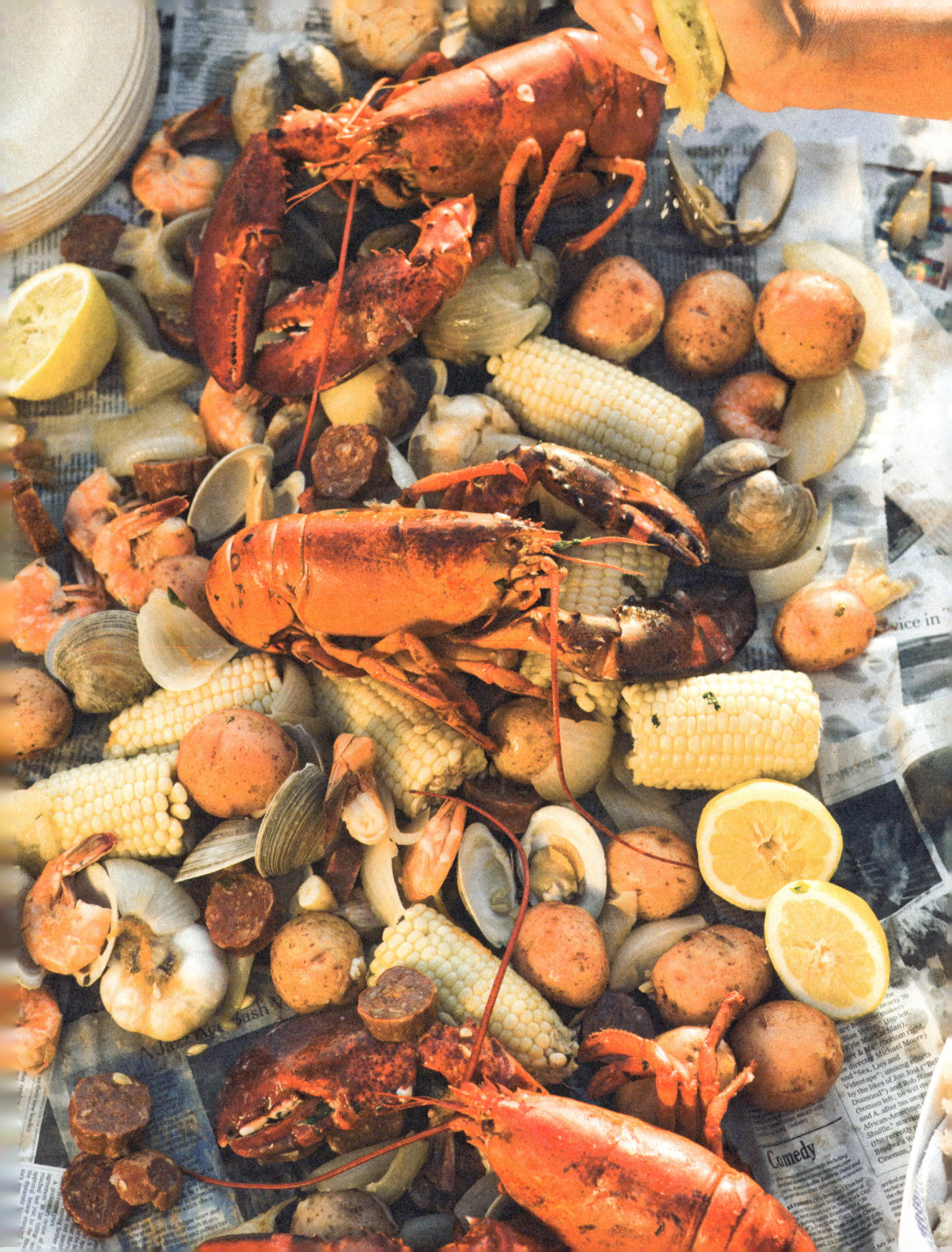

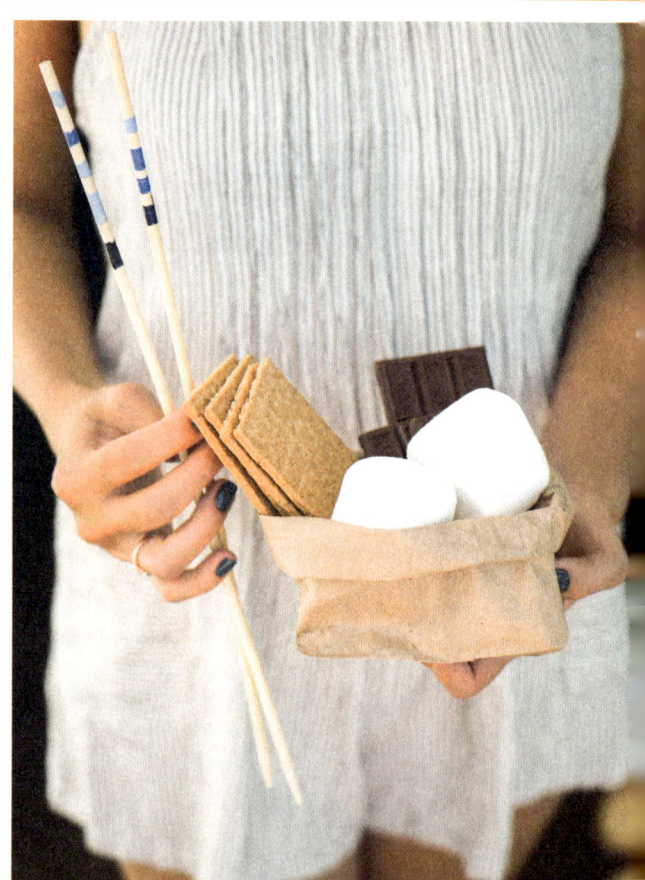

a clambake in your own backyard or even on an apartment rooftop? You just have to get a little creative.

We decided to test the idea on some friends who were coming to stay with us in Laguna for the weekend. Immediately, I went online and ordered the largest stockpot I could find (which was surprisingly enormous). The décor was simple. We were hosting it at our beach house, and when you have the ocean as your backdrop, there really isn't much else to be done. Typically, I'm not a big fan of disposable dishes and utensils (probably because, as you know, I collect vintage dishware and use it every chance I get), but this occasion was the perfect opportunity to break out those paper plates. And thank goodness I did...

I spent the day preparing the meal, beginning with an early trip to a salty, floating fish market to pick up freshly caught clams, shrimps, mussels, and a few lobsters (I prefer to get the freshest seafood possible, especially when serving it to a group of people). Since I had already done all the prep the day before, I just added the layers of food to the pot (see directions on page 173) and was able to enjoy time with our friends. As soon as the clams were opened and the delicious, buttery seafood flavors wafted through the air, everyone gathered around the farm table in our dining room to serve themselves from the platters piled high with steaming jumbles of fresh, lemony lobster; corn; linguiça sausage; fresh clams; and potatoes. We toasted with our paper cups and everyone got to cracking! I was pretty pleased with myself that I seemed to have pulled off a respectable West Coast clambake. Right as I was about to give myself a well-deserved pat on the back, my victory party came to an abrupt halt when a friend started shouting from across the kitchen for me to come quickly. A large pool of water was forming in the doorway to our guest bathroom. It didn't take us long to realize that a pipe had burst (I have a weakness for old homes with loads of charm and unreliable plumbing). William immediately ran outside to shut off the water. Slightly deflated, I made the command decision that I refused to let this ruin my inaugural clambake. Lucky for me, the paper plates and Dixie cups turned out to be a smart decision. After dinner, we just tossed everything into the trash and recycling bins and headed outside for a bonfire.

We called the plumber first thing the next morning, but it was more bad news: the pipe needed to be replaced and the water in the house had to remain off... for the next few days. With a sink full of dishes (from all the prep and serving) and a house full of sandy guests returning from a day spent at the beach, we did the only thing we could think of. We stripped down to our bathing suits, carried the dishes outside, and turned on the hose (and some music)! It was a far cry from a dishwasher and a hot shower, but it was the best we could do—plus, it ended up being a pretty hilarious memory.

My next time around, I chose a soft nautical color scheme: lobster red (naturally) and a cascade of blues, ranging from true navy to soft robin's-egg blue. I decided to host it down at the beach and kept the invite list fairly small (ten people) since seafood can get pretty pricey and that's one place where you don't want to cut corners. The invite asked guests to arrive at 6:30 P.M. sharp, so we planned for a 7 P.M. dinner. I always want to give my guests a buffer and I wanted to ensure that everyone would be there to enjoy the meal when it was piping hot with sunlight to spare. No one wants to get stuck with cold clams in the dark.

So much of what I enjoy about a clambake is its simplicity: toss everything into a huge pot; cover a table in some craft paper or newspaper; throw a few pillows and blankets on the ground; kick off your flip-flops; and voilà! Instant affair! Oh, and don't forget: paper plates are highly recommended.

# the menu

Good news! Once you've decided that you're hosting a clambake, you're basically done with menu planning. Guests aren't showing up expecting barbecue or roast chicken—it's pretty much obligatory that you serve delicious, buttery seafood with traditional clambake accoutrements: linguiça sausage, potatoes, and corn (however, no guest will ever complain about a side of homemade macaroni and cheese). I was inclined to grab a few loaves of freshly baked sourdough bread at the market and offer the soft roasted garlic from the pot as a spread.

The biggest job on your party prep list will be getting all the supplies to pull off this feast! While I'm a huge advocate of purchasing items you'll get to reuse over and over, a giant aluminum clambake pot is pretty much only good for one thing. That being said, it's a necessary purchase. Newspaper and paper cups and plates aren't going to break the bank. A good clambake pot starts at about $60. I suggest comparing prices online to find the best deal.

When it comes to serving, the host at a traditional clambake pours the contents of the pot directly onto a table—covered in craft paper or newspaper—before handing guests a pair of lobster crackers and a bib. That's a terrific, kitschy option (not to mention interactive) for your soiree, but I do savor the way the perfectly steamed heaps of seafood look on white porcelain platters (it's also less of a mess). The choice is yours.

The clambake itself is an art. It's not difficult, but it *is* involved. And depending on who you've talked to and what you've researched, it's safe to say you've found some different theories on the order, the time, and, perhaps, the ingredients. I've experimented with a few different recipes and through trial and error pieced together my favorite clambake prep. Feel free to make it your own by playing around with the ingredients.

If all goes to plan, your clambake should be wrapping up right around sunset, which, of course, makes it the perfect time for s'mores. A beach party isn't really complete without this quintessential summer dessert. Like the meal itself, your dessert can become part of your décor. I chose to offer guests premade s'more kits with a Hershey's chocolate bar, two marshmallows, and four graham crackers wrapped in brown paper bags. And if you ask me, a double-decker s'more is the *only* way to go.

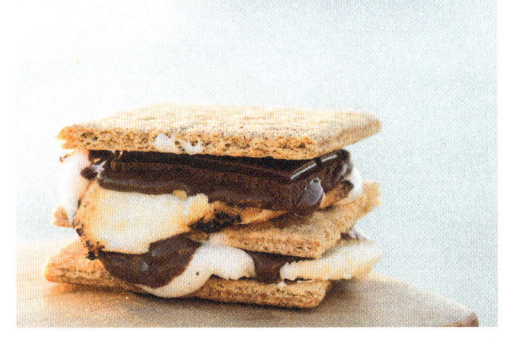

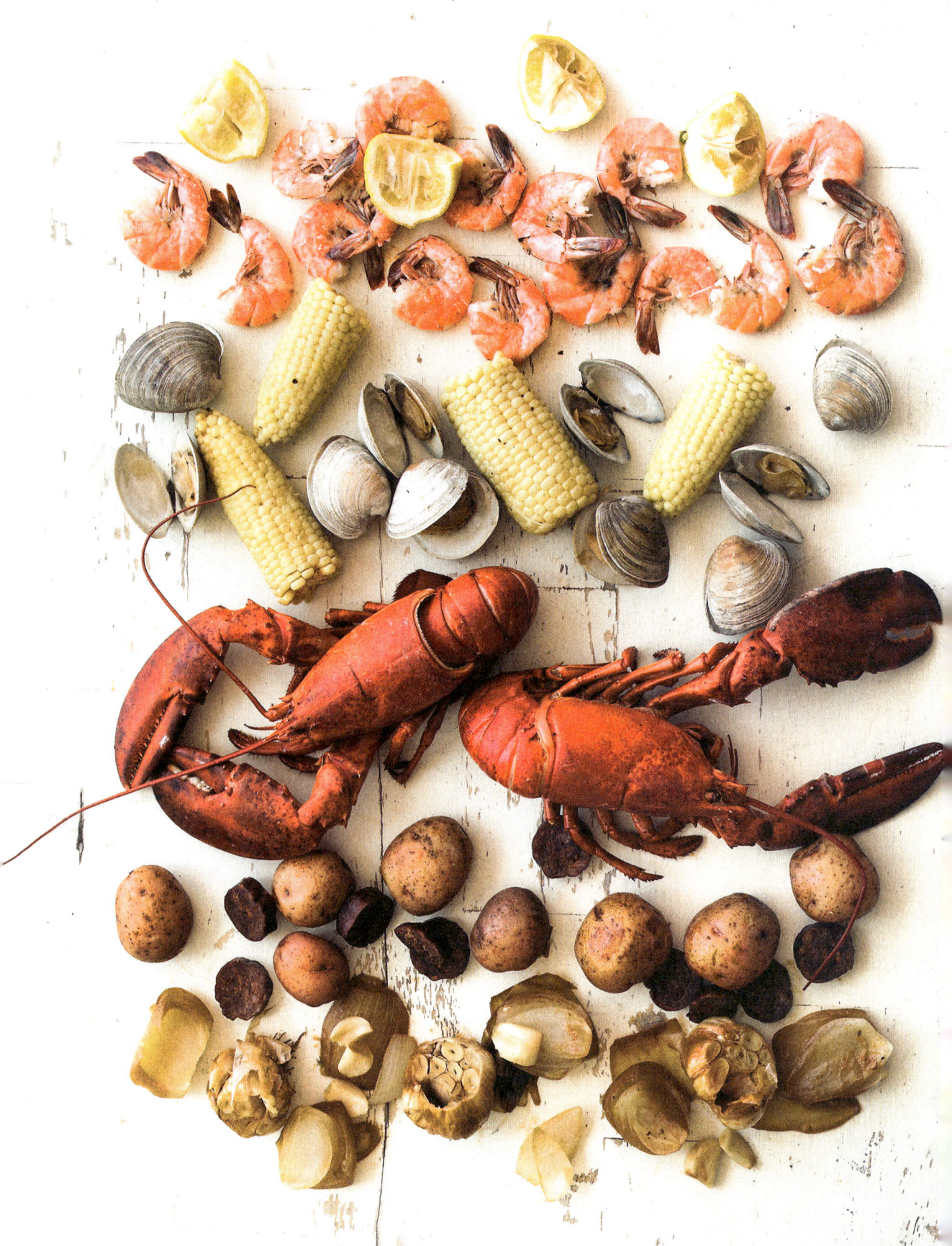

# LAUREN'S KITCHEN CLAMBAKE RECIPE

*Many clambake recipes will have you boil the potatoes with the meal, but the best way to be certain they are fully cooked through is to prep ahead of time. After cooking, remove them from the heat and let cool for at least sixty minutes, or up to twenty-four hours. Preparing the potatoes ahead like this also helps them to absorb the delicious clambake flavors when they are added to the pot on the day of your event.*

---

**SERVES 8**

- 1½ pounds baby red potatoes
- 1 pound littleneck clams
- 2 cups water
- 4 tablespoons (½ stick) salted butter
- 2 large yellow onions, cut into eighths
- 8 garlic cloves
- ½ bottle dry white wine
- 1¼ pounds linguiça pork sausage
- 3 lobsters (each 1½ pounds or larger; if smaller, I'd suggest grabbing an extra lobster)
- 5 medium ears of corn, husked and snapped in half
- 1 pound shrimp, peeled and deveined
- 8 lemons, quartered, for serving
- Melted butter, for serving
- Sourdough bread, for serving

1. Place the potatoes in a large pot and cover with warm water. Bring to a rapid boil and cook over high heat for 6 to 8 minutes (or until tender).
2. Fill a large bowl with cool, salted tapwater and submerge the clams for 30 to 45 minutes (the clams will purge any remaining sand they've collected). Scrub the shells to remove any particles and discard any clams that are open and will not close when gently tapped on.
3. Bring the 2 cups water and the butter to a light boil in a large stockpot over medium-high heat. Add the ingredients in this order, stacking them on top of one another: onion, garlic, wine, potatoes, and sausage. Bring to a boil and cover. Cook for 5 minutes or until fragrant.
4. Add the lobsters; cover and cook for 6 minutes.
5. Add the corn and clams; cover and cook for an additional 6 minutes. Add the shrimp; cover and cook for another 6 minutes. Check to make sure the shrimp is fully cooked and discard any clams that remain unopened.
6. Pour onto a newspaper-covered table and serve with the lemons, melted butter, and full loaves of fresh-baked sourdough bread. Enjoy!

*I suggest keeping lobsters in the refrigerator until ready to cook. Since not overcooking them is essential, keep an eye on the color. A lobster is cooked when it turns a bright, glowing red. A 1½-pound lobster takes between 15 and 20 minutes to cook, depending on the strength of your stove.*

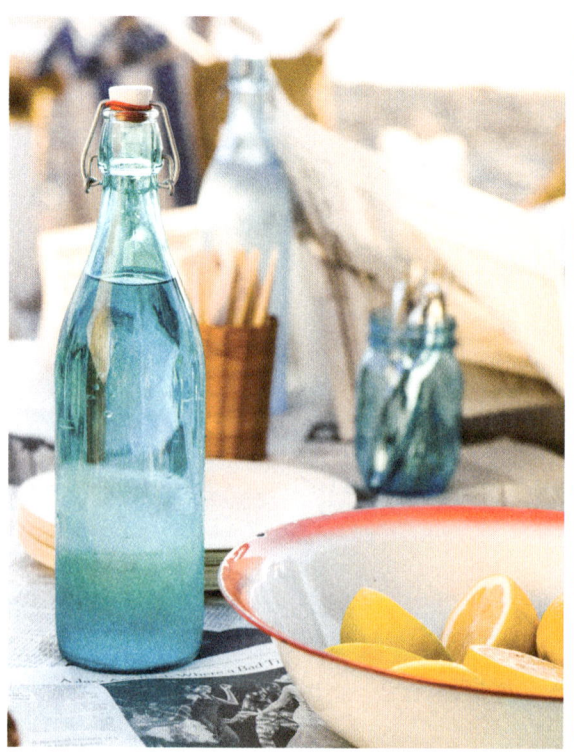 

## the bar

We've long since established my love of a signature cocktail, but some occasions just don't call for one. For the clambake, I chose to keep it simple and offered guests a selection of wine and beer, as well as French glass table bottles filled with flat water. To complement the seafood, I'd suggest offering lighter beverages: a crisp sauvignon blanc, a fruit-forward rosé, and a few craft beers like an IPA and a wheat-based hefeweizen (especially with a lemon or orange wedge).

    This was a beach party, so I grabbed a large galvanized tub (I've picked up a few at flea markets over the years) and filled it with ice and drinks. If you are hosting this soiree in a public setting (like a beach), ensure that alcohol is permitted. Also, don't forget a corkscrew and bottle opener! Not remembering those until you're already set up down at the beach is a real bummer. I chose clean, white paper cups to serve the wine in (glass containers are forbidden at most beaches without the proper permits).

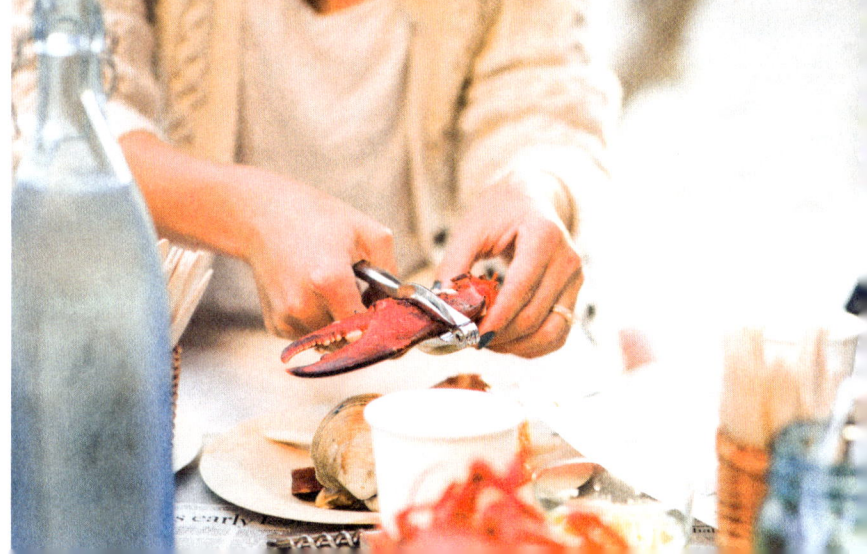

## *the décor*

Clambakes, historically, have pretty upper-crust roots, which is ironic because they're actually one of the least fussy events to host. The majority of your budget will go toward the pot and the seafood—which accounts for most of the event décor.

I covered a rustic wood tabletop that I have with a few layers of newspaper. Like I mentioned earlier, you can easily pour the contents of the pot out on the table and invite guests to dive in. A good clambake is deconstructed by nature.

Since the feast is intended to be very hands-on, I wanted to provide everyone with a way to wipe their hands, so I filled woven apple baskets with wet linen hand towels rolled and wrapped with twine and sprinkled with lemon juice.

I picked up some oversized tan pillows at IKEA for some comfy beach seating, in addition to a few vintage indigo woven pillows and cozy beach blankets in shades of blue that I had around our house (skipping anything that might require dry-cleaning after). I also picked up some blue-and-white-striped fringed Turkish towels that I laid out on the beach, and kept a few rolled up in Moroccan straw baskets in case guests got chilly after sundown.

Because we planned on dining thirty minutes before sunset, I wanted to scatter around some luminary bags for light after the sun set. I filled them with sand to weigh them down, and placed small tea lights inside.

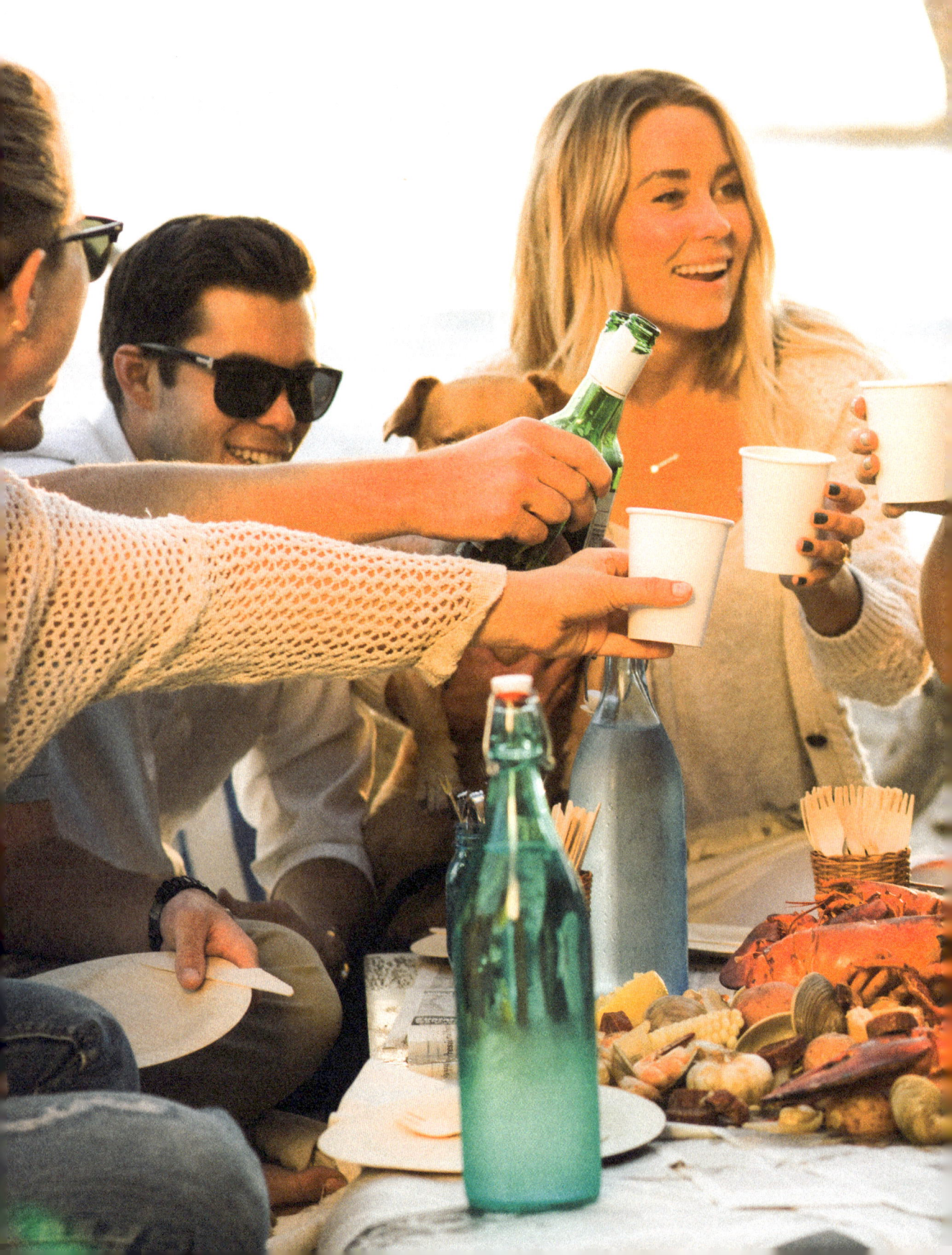

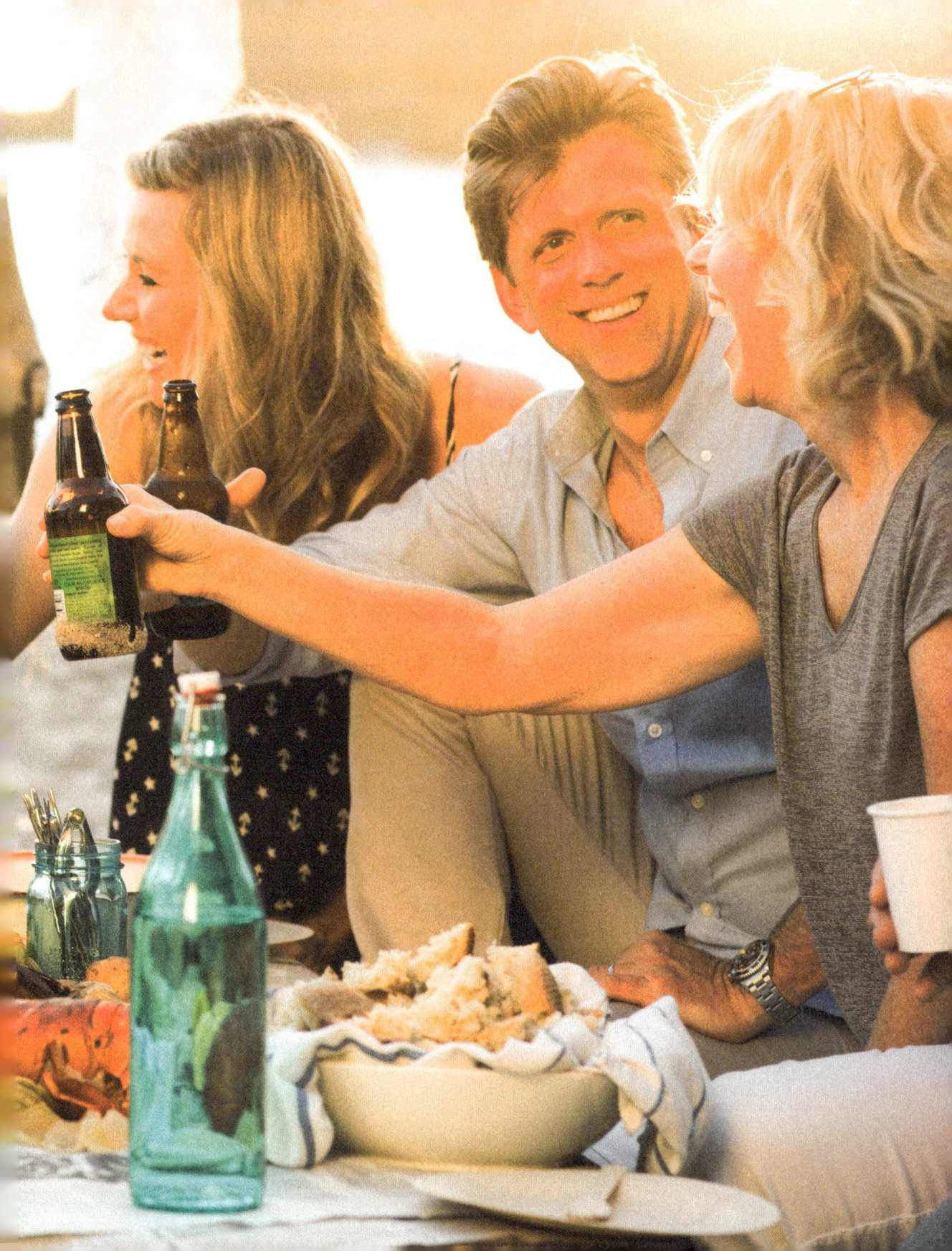

## the details

When prepping for the clambake, I was surprised to find that if you do a bit of digging around at party stores or online, you can find some really beautiful disposable dishware options and ways to elevate it just a bit. Keep in mind you'll want to invest in sturdier plates. Lobsters and corn can be heavy—and it would be a shame to see them covered in sand because your plates were too flimsy. I stumbled on some bamboo plates and utensils that were not only lovely and a bit more refined than a traditional paper plate, but also are more environmentally friendly and hardier.

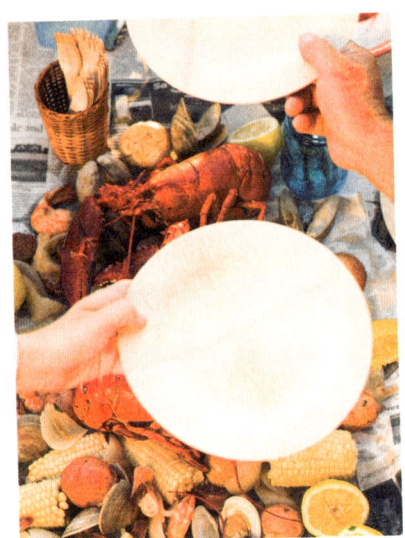

# the look

Beach chic happens to be one of my favorite looks—and nowhere is that look more appropriate than at a clambake. While there's always a place for flirty dresses and spectacular heels, I'm never opposed to an event that invites me to wear a chunky sweater, denim, nautical stripes, and flip-flops. Bring the whole look together with a casual summer hat to keep away those rays!

# THE ETIQUETTE
## *the art of the backup plan*

When hosting a party, it's possible to account for every last detail, but you can never plan for the weather. Mother Nature has a mind of her own, so it's important to always have a backup plan—especially if your event is outdoors. Do as much as you can to think ahead and have rainy-day plans.

First, when you begin planning an outdoor party, check the weather patterns in that area for the last few years (if it's a heavy rain month, perhaps rethink the location). Leading up to the event, keep an eye on the weather. If rain seems plausible, it's time to call on your "rainy day" budget. When hosting an outdoor event, you should always set aside a just-in-case fund for tenting (including flooring, so guests don't sink in grass or sand) or have a good option to bring the party indoors. Remember that even indoor events sometimes are affected by the weather—plan to have a few umbrellas on hand to help guests from their cars, and a few towels!

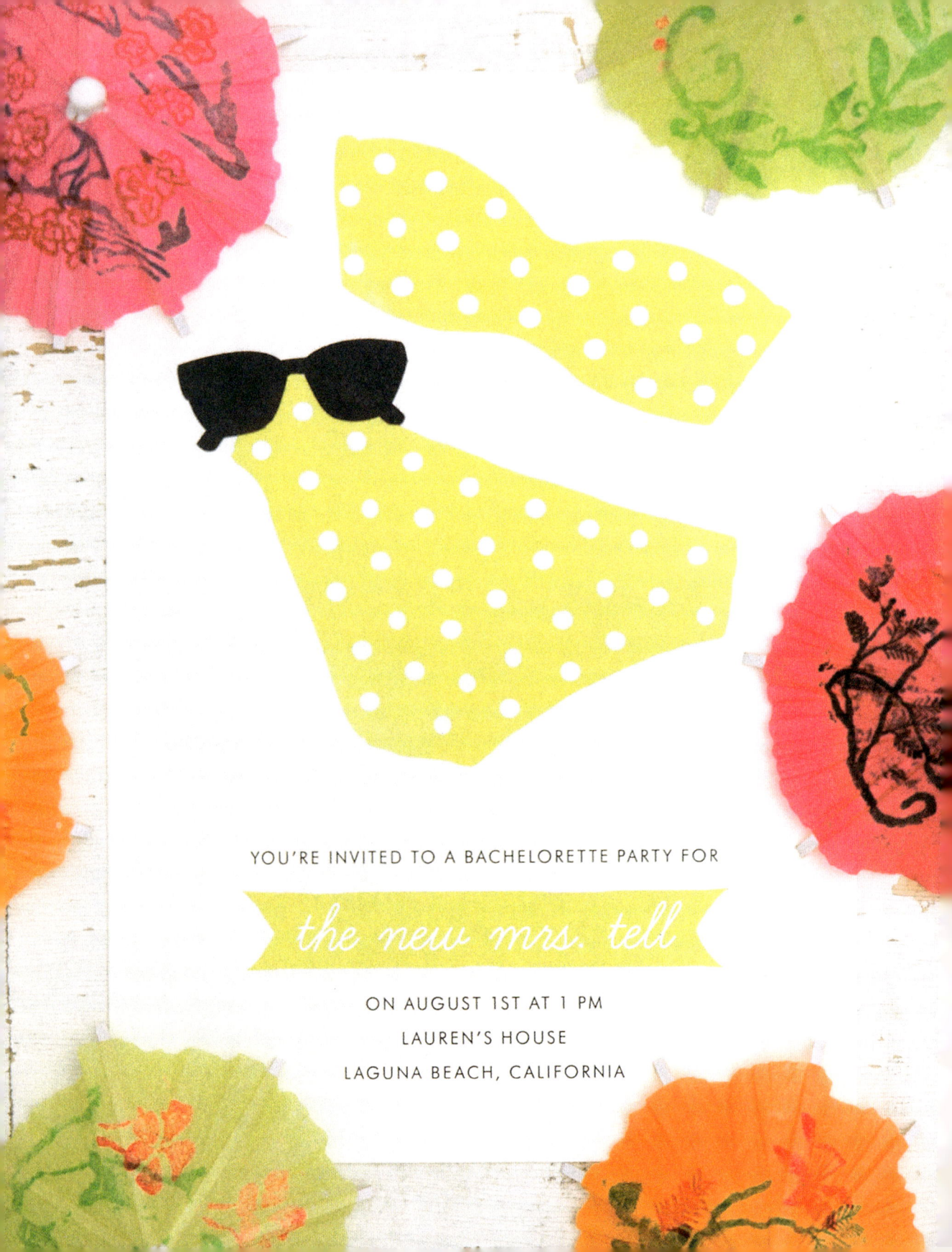

# 13

## the bachelorette party

### the overview

My bachelorette party was absolutely perfect, except for one small thing: I was too sick to enjoy it. Together with all my bridesmaids, I flew to Cabo San Lucas for a long weekend of sunshine, beaches, margaritas, and dancing. We stayed in a villa at my favorite resort, which the girls had outfitted with all the obligatory bachelorette favors: veils, ice cubes shaped like wedding rings, cookies with my soon-to-be married name, and so much more. They really went all out!

Between wedding planning and work, I was desperate for a little rest and relaxation... and this trip was just the thing.

On our very first night in Mexico, we all went out for a fun dinner to kick off our weekend and before I could even order my first margarita, I started to feel sick. I figured I would go home early and nip it in the bud. I had hoped that after a good night's sleep, I would feel better. By the next morning, I had a full-blown stomach flu. I tried to put on a good face for my bridesmaids who had done so much to make this a special weekend, but I could barely drink a club soda (tequila shots were out of the question). I spent most of the weekend curled up on a lounge chair. Regardless of how I'm feeling,

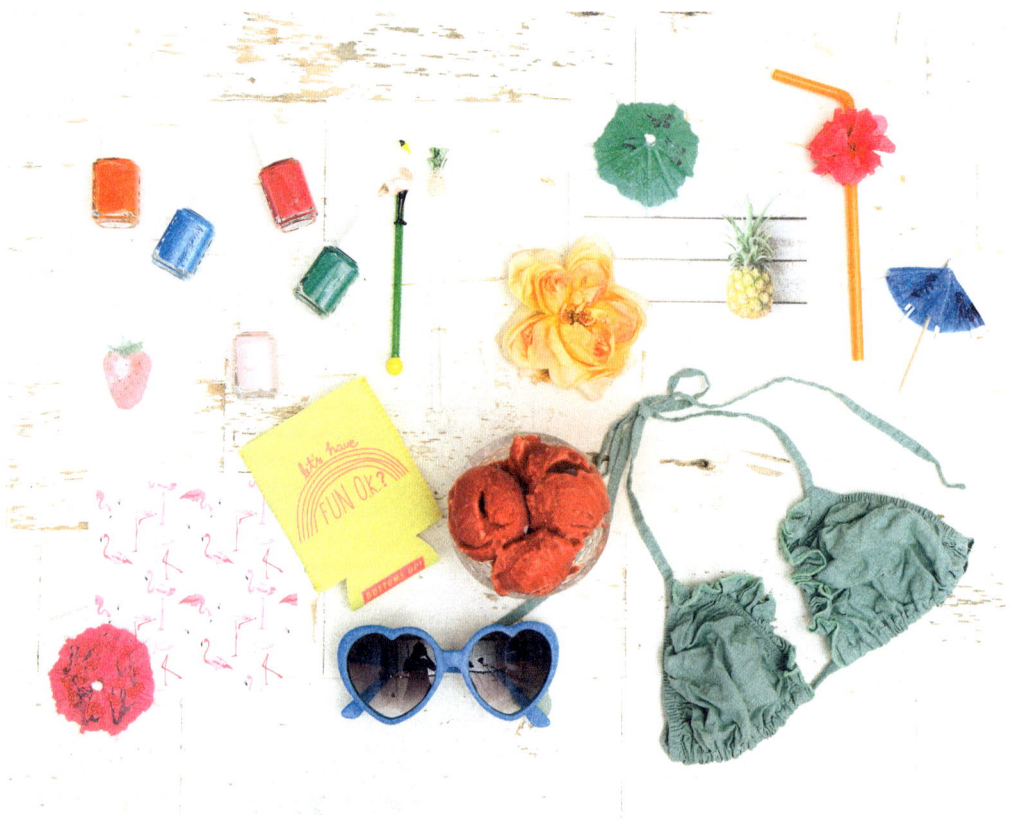

I always cherish time spent with my girlfriends and it was perfect in so many ways . . . but because I was sick, I didn't end up having the *party* I had always imagined.

That's why I needed a "do-over." I admit I totally used *Celebrate* as an excuse to have a second chance at my bachelorette party. (I mean, if you're going to have a redo of any celebration, why shouldn't it be your bachelorette!?)

I couldn't ask everyone to sneak away for a weekend in Mexico again, but I still wanted to treat the do-over like a getaway. I invited a group of local girlfriends for a tropical beach day bash at my home in Laguna, complete with fruity cocktails, silly games, and pampering. Because I wasn't trying to totally replicate my first bachelorette, I leaned toward a Hawaiian theme (think: pineapples, palm trees, and flamingos!) and chose vibrant colors like tangerine, aqua, raspberry, bubblegum pink, and papaya. Everything needed to be playful and bright!

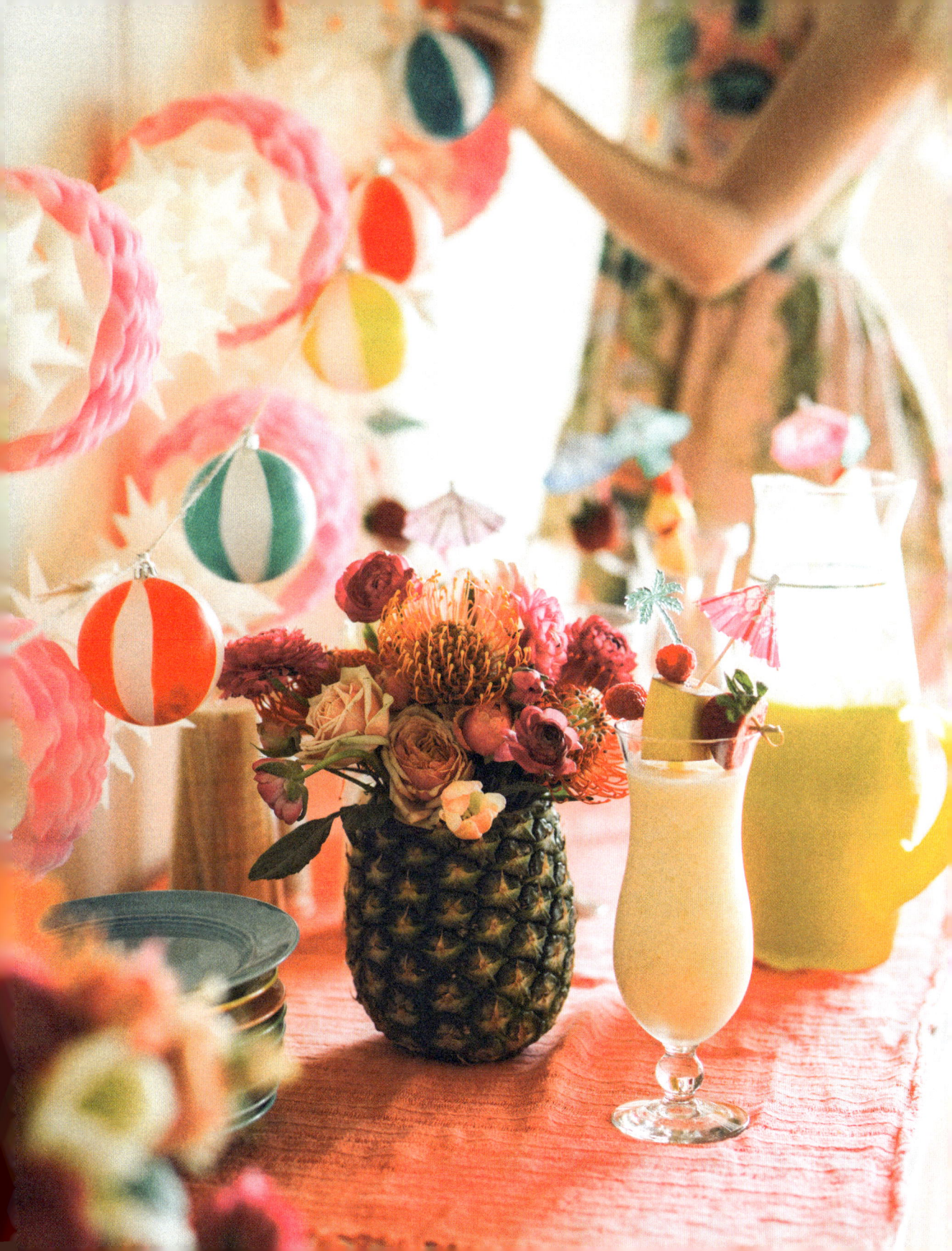

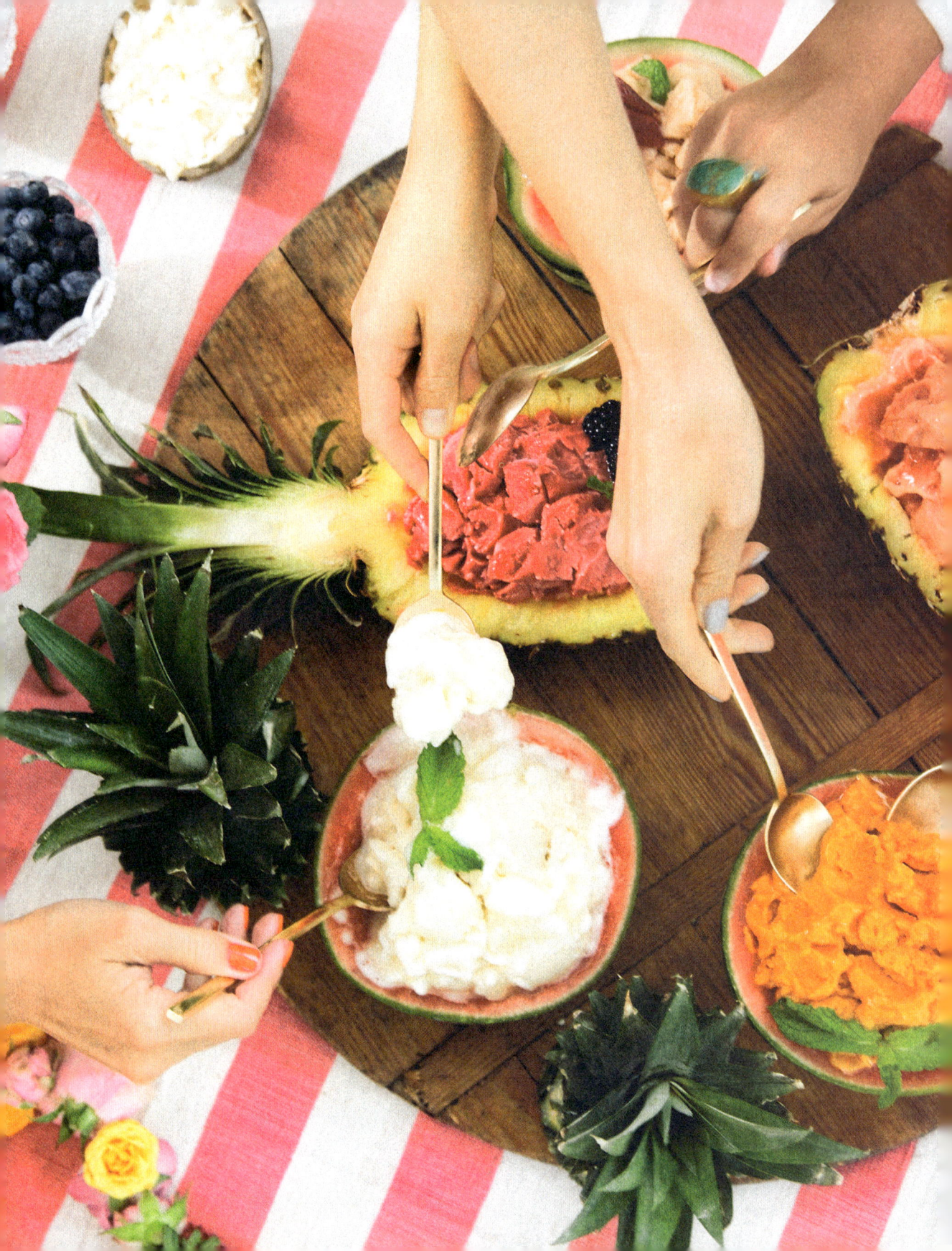

## the menu

The absolute best way to top off a sunny beach day is a scrumptious, towering ice cream sundae. I wanted to offer my guests a refreshing treat, so I put my own twist on the tradition and created a colorful sorbet bar.

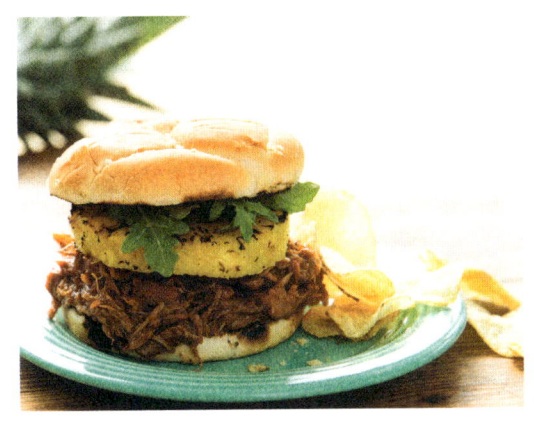

To serve, I made bowls out of pineapples and mini watermelons by halving them, hollowing out the core, and shaving enough down on the sides so they could rest flat. Then I filled them with raspberry, apricot, coconut-kiwi, peach, and lemon gelatos. For the toppings, I found halved coconut shells from an online party supply store and filled them with fresh berries and shredded coconut. Because sorbets would quickly melt in the sun, I prepped everything ahead of time in frozen, halved pineapples and kept it in the freezer (the frozen fruit helped keep the sorbet cold once on display), then set everything out on an oversized vintage dough board when all the girls arrived. I invited everyone to help themselves to fill coconut shells with their favorite sundae combo!

After an afternoon in the sun, I knew we'd all be craving something yummy (and filling) for dinner: Hawaiian BBQ pork sandwiches with tangy grilled pineapple and arugula. Before the party, I started slow cooking a BBQ pork shoulder so it would be ready by the time we were all hungry. Just add some classic Hawaiian potato chips and enjoy!

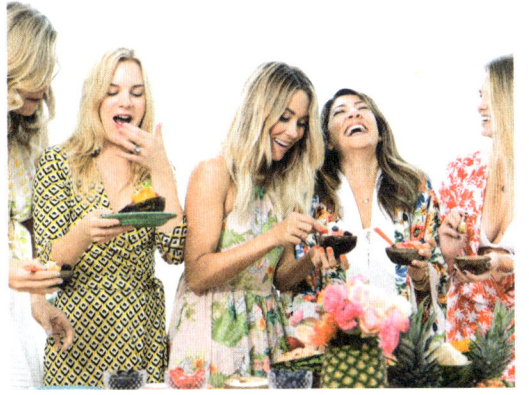

## the bar

Okay, so it may have been my second bachelorette party, but it still required a well-stocked bar! I wanted to re-create the sort of delicious, cheerful drinks you'd find on the cocktail menu at your favorite tropical resort: piña coladas, strawberry

daiquiris, and spicy tequila sunrises topped with festive umbrellas, kitschy straws, and fresh fruit skewers.

I premade the cocktails and kept them in pitchers in the freezer. (Making the drinks ahead of time also allows you to control how much liquor is being served in addition to making sure you don't spend all afternoon in the kitchen.) I removed them from the freezer a few minutes before guests were scheduled to arrive.

And just for fun, I dreamed up a specialty shot for the occasion: "The Itsy Bitsy Teeny Weeny Yellow Polka Dot Bikini." It's a dangerously delicious mix of rum, ginger, and passion fruit. (The black seeds of the passion fruit mimicked polka dots.)

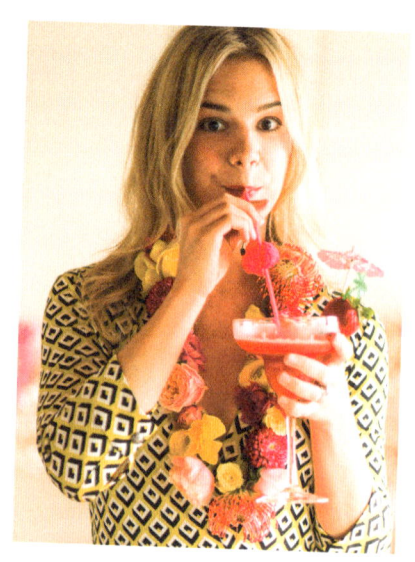

## the décor

Bachelorette parties need to be just the right amount of cheeky—and the bright, fruity sorbet bar and whimsical cocktails were a great start. A day at the beach practically demands a beach ball. To dress up the beverage bar, I made a garland using white Christmas ornaments I had ordered online and painted to look like tiny colorful beach balls. Using twine, I strung them across the wall (it took a few tries to find the right adhesive to hold them). And by happy accident, I stumbled upon a beautifully designed pink-and-white garland, and I have to be honest, it took me a minute to realize it was shaped like pineapples (because, why not!?). To hold the sandwiches, I used vintage Fiestaware plates and retro brass flatware.

   I wanted to brighten the room with cheerful, pillowy flowers that just made people feel happy: ranunculus, pincushion protea, spray roses, and astro daisies in coral tones, bright and pale pinks and roses. Instead of a traditional vase, I decided to use cored-out pineapples for the arrangements to complement the tropical theme. Since I had a fair share of sizable blooms left over, I fashioned them to create some rattan Hawaiian

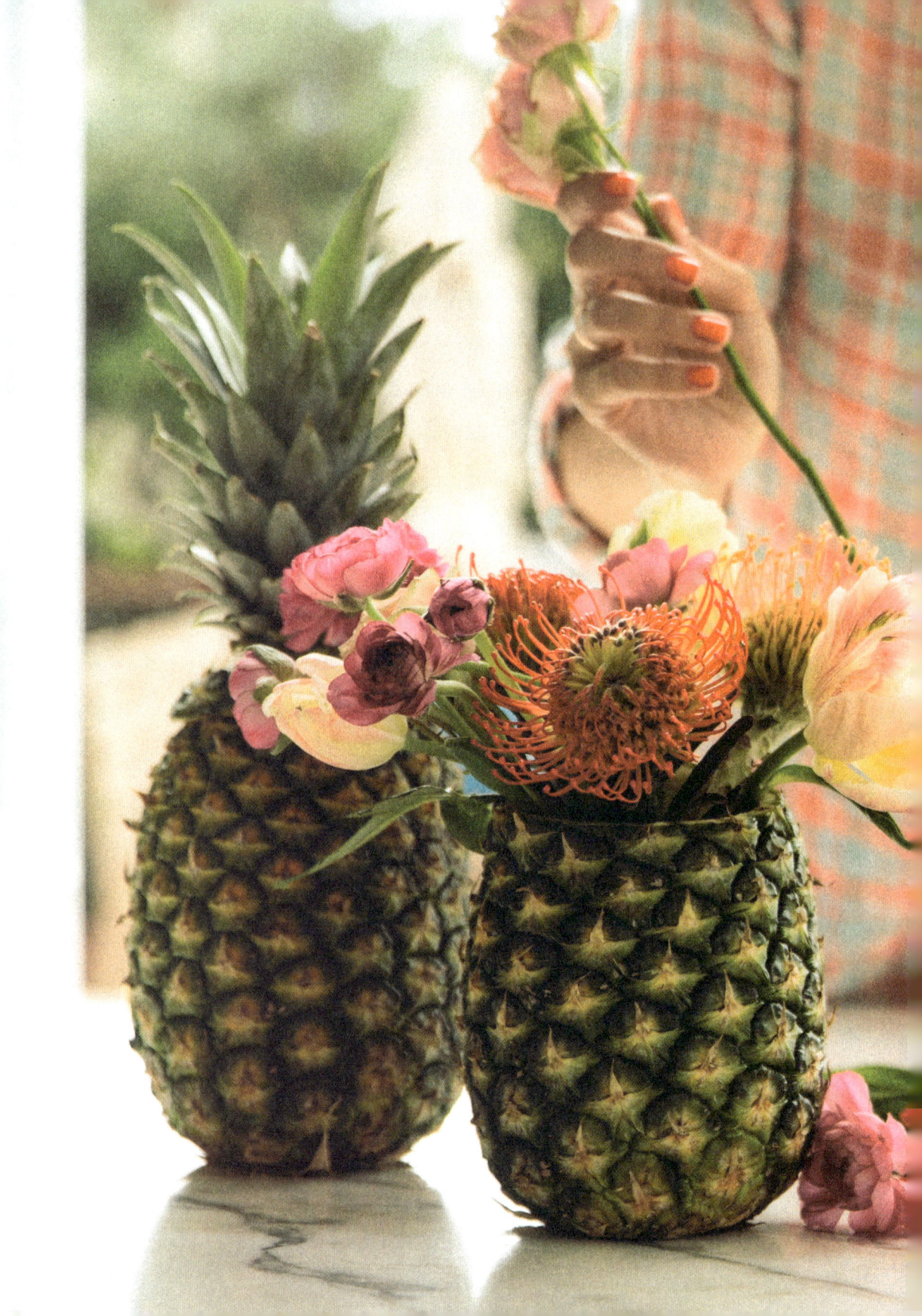

fans and even crafted up some homemade leis using sewing thread. Last, but not least, I tossed in some bright beach towels and heart-shaped sunglasses, and we were all set! Inflatable flamingos aren't mandatory for a bachelorette, but they're *highly* encouraged.

## the details

As a thank-you to my girlfriends for celebrating yet another bachelorette party for me, I put together beach bag favors. I chose lightweight striped canvas totes and filled them with my favorite summertime essentials: sunglasses, beach towels, flip-flops, bikini bags, and big, floppy sunhats.

Since oftentimes a bachelorette party is a way for a bride and her bridesmaids to get a little pampering before the big day, I decided it would be a unique, special treat to bring in a manicurist to give the girls mani-pedis!

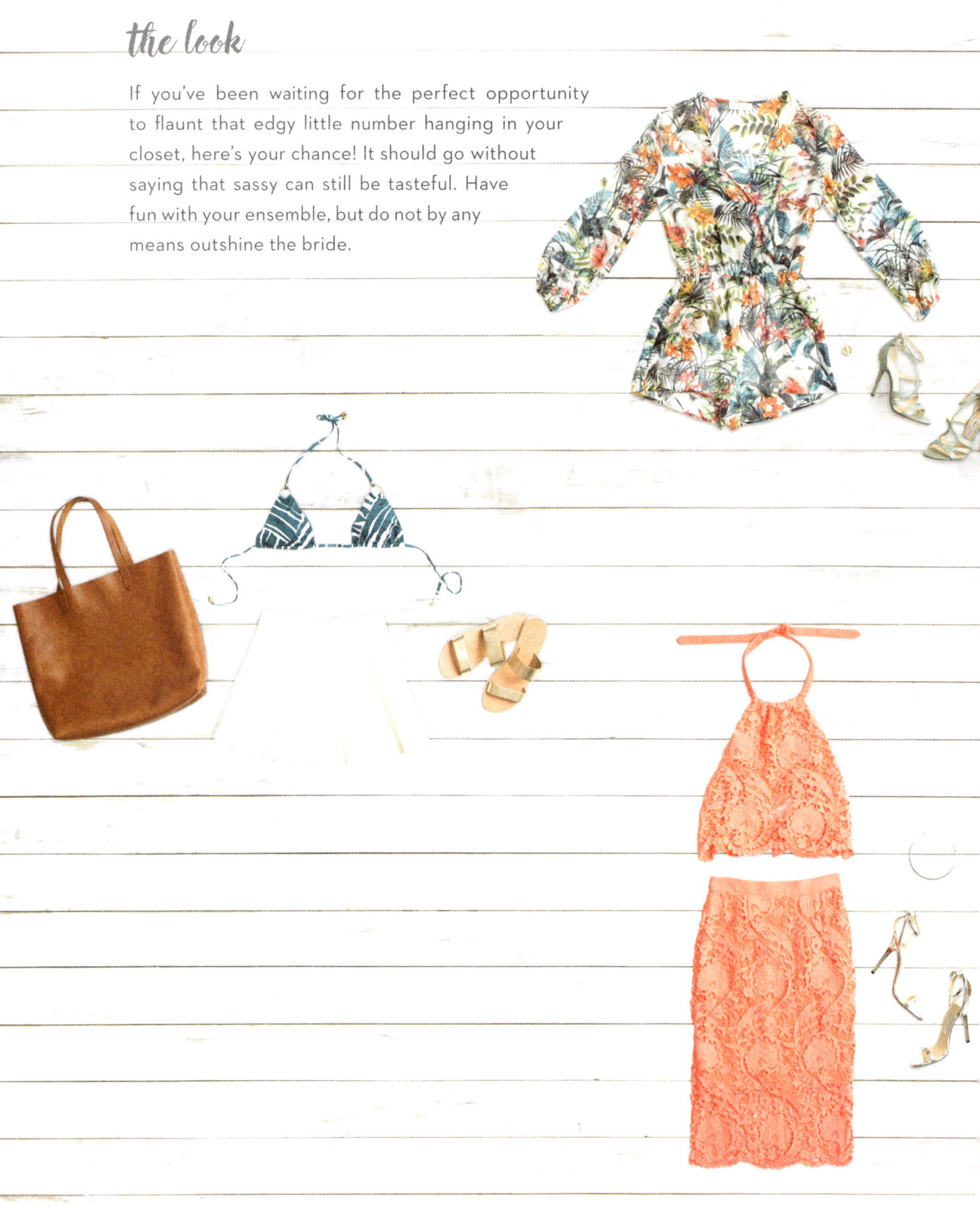

# the look

If you've been waiting for the perfect opportunity to flaunt that edgy little number hanging in your closet, here's your chance! It should go without saying that sassy can still be tasteful. Have fun with your ensemble, but do not by any means outshine the bride.

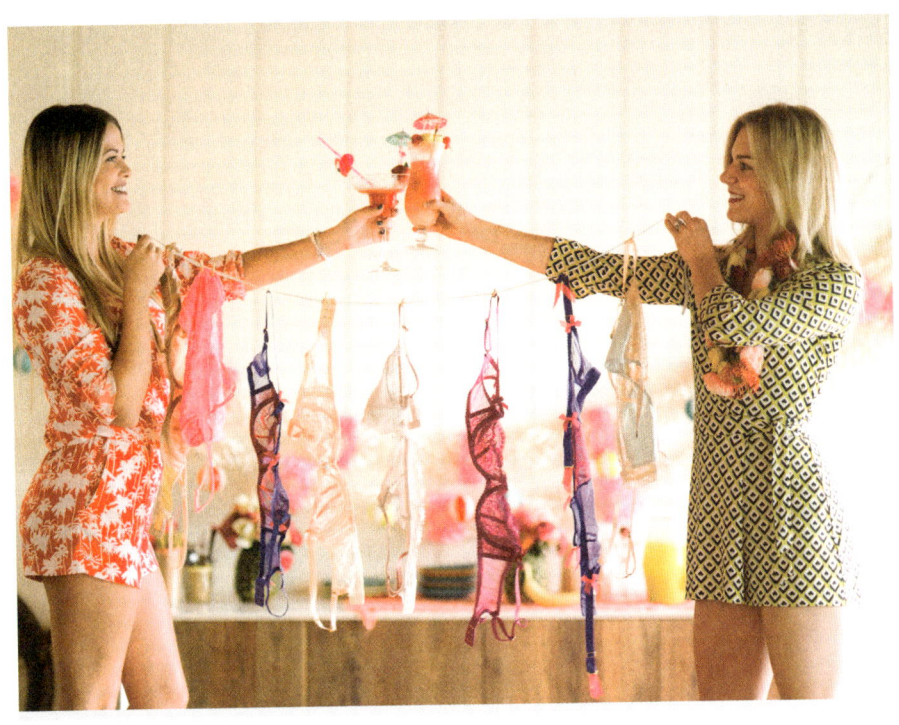

## THE ETIQUETTE
### the lingerie shower

Bachelorette parties are supposed to be a little sassy, so what better way to celebrate the Miss becoming a Mrs. than a lingerie shower! Depending on the group of girls, this could be tame, wild, or anywhere in between. Whoever is hosting the "shower" should first check with the bride to make sure she's comfortable with the idea and then ask for her sizes so the partygoers can make sure the undergarments fit (it's not like buying a sweater; you don't really want to guess someone's bra size). As a guest, make sure you feel out the crowd. If the bride's mother and soon-to-be mother-in-law are going to be in attendance, perhaps keep it a bit more tasteful. Use your best judgment, but the most important thing is to have fun!

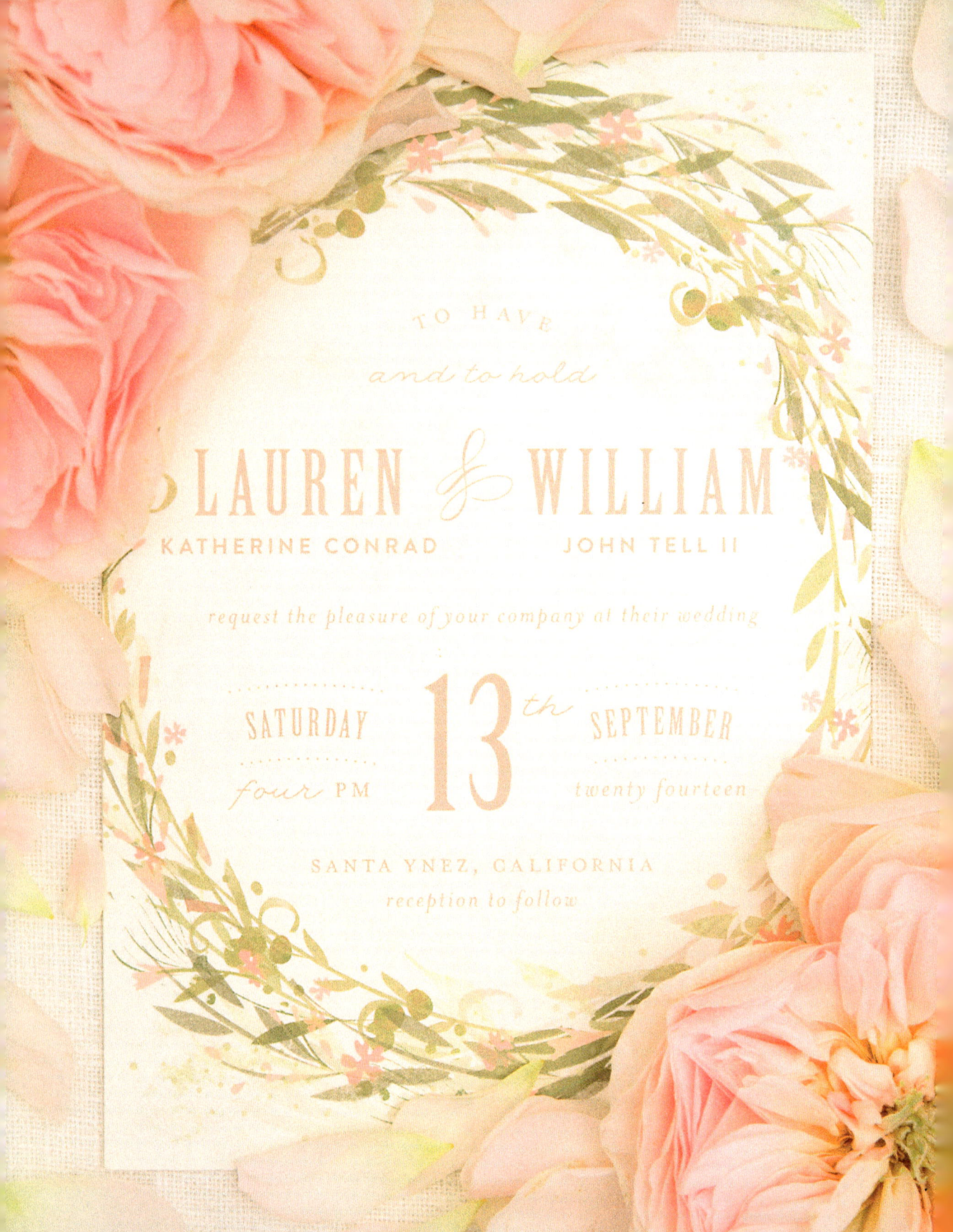

# 14

## the overview

The first thing people ask when you get engaged is: "Did you have any idea it was coming?"

William and I had been dating for a couple years and talked a lot about the future, but I didn't imagine we'd become engaged until the following year. Don't get me wrong, I knew that William was "the one," but I was never one of those tick-tock kind of girls, tapping the face of my watch and waiting for a ring. I knew he'd propose when the time was right . . . I just didn't realize that it was *right* then.

We were spending the weekend down in Laguna. It's an amazing retreat from all the craziness that goes along with city living, so we tend to keep our weekends there pretty casual (think: sandy feet; cozy, oversized sweaters; and minimal makeup). Before leaving L.A., William told me that we were invited to a business dinner on Saturday night for his stepdad's work and I should bring something nice to wear. (My soon-to-be fiancé had the good sense to know that I'd want to be appropriately dressed for such a momentous occasion.)

Looking back now, of course, there were signs (like how a ten-minute errand to

"drop off" something at his friend's house mysteriously turned into a two-hour production), but on that October afternoon I had no clue what was about to happen.

Forty-five minutes before we had planned to leave for the "work dinner," I excused myself from a lazy afternoon of lounging around to go upstairs and get ready. To his credit, William played it totally cool. He kept his nose tucked in his book as if it were any other Saturday afternoon. Little did I know that he was about to transform the lower level of our beach cottage into a twinkly, romantic garden.

I had been in New York the previous week for work, so William used my absence as an opportunity to do a test run, setting everything up to make sure he could do it in the thirtyish minutes it would take me to get ready. He also used it as a chance to meet with my parents and get their blessing—which they happily gave, but not before reminding him that I could "be a handful." (Thanks, Mom and Dad.)

As soon as he heard the shower turn on, he rushed to the coat closet where he had hidden everything and started stringing exposed carnival bulbs, lighting candles, and covering the patio with gorgeous white roses (which were apparently sold out all over Laguna that particular day, hence his two-hour expedition). He pulled out a little bistro table and chairs so we could have dinner together; he even borrowed proper china and candlesticks from his parents to serve us shrimp enchiladas with verde sauce from Javier's Cantina (my absolute favorite dish!).

Per usual, I was running a little bit late and just finishing my makeup when I heard William whistle for me. (He grew up with a "family whistle" that his parents and siblings would use to find one another in crowds—it's actually sort of genius, but when I'm already behind schedule, it isn't necessarily my favorite sound.) I quickly strapped on my heels, grabbed my purse, and hurried down the stairs of our split-level home.

At first, I was totally confused. *Who set up a candlelit pathway in our living room?* Standing in the French doorway that led to our patio in a full suit and tie was William, with his hands in his pockets and a wide, bright grin spread across his face. A beautiful cover of Queen's "You're My Best Friend" (our song) came trickling through the speakers as I came down the stairs. I was still sort of disoriented, trying to process what was going on. I needed my brain to play catch-up! I figured he had just prepared a romantic evening for us. I looked toward the table, where my favorite champagne was chilling in a silver ice bucket. *Wow,* I thought. *He's really going for it.* When I turned back toward William, he was getting down on his knee, and my heart skipped a beat. It *finally* dawned on me. It all happened so quickly and I was so totally surprised that I let the moment get

the better of me and interrupted his proposal . . . twice. Poor guy. (My parents may have been right . . . )

After accepting (obviously), we popped the champagne and I quizzed him for a few minutes on his elaborate, surprising, and totally wonderful proposal plan (Who had he told he was proposing? Everyone, apparently. How long had he been planning it? Months. Where did he really go that afternoon? Florist. How did he choose the ring? He knew what I liked. Where did he stand on the idea of a "barn" wedding? He would need convincing . . . ). We finished our glasses of champagne and called our families to share the news. Since I was the only one seemingly in the dark, they had all been eagerly awaiting "the call." They convinced us to meet them for drinks so we could toast our engagement, but truthfully we didn't need much encouraging. I was anxious to begin celebrating and talking shop with our parents. I expected lots of lovely wedding talk, but instead they immediately started guessing how long until they could expect grandchildren (with my father leading the charge).

So, yes, I was completely surprised. And even though, as a rule, I absolutely hate surprises, I wouldn't have had it any other way.

The second thing people ask is: "So . . . when's the wedding?"

When it came to planning, there was no time to waste. My enchiladas hadn't even cooled before I pulled out my iPad to unlock my secret "I Do" Pinterest board (and thereby giving my new fiancé just a few moments to experience "cold feet").

Given my schedule, I knew that I'd need help pulling off such an event—and there was only one choice: Cassandra Herschenfeld. Cassie and I had been friends for a while, so I already knew that she was a brilliant wedding planner with an amazing eye. Shortly after becoming engaged, I asked her to be our planner. (I waited a few weeks before laying the news on her that she'd have to do double duty . . . as a bridesmaid.)

Many brides prefer to go the course without a planner, but I knew that with my commitments, having one would be essential. And while it may seem to some like an unnecessary added cost (particularly for those Pinterest-y brides), I actually think that many wedding planners can *save* you money.

When dealing with vendors, a bride is a onetime customer (hopefully), where a wedding planner is a repeat client, which may incentivize vendors to give him or her the best deal. Planners are also well versed in the piles of contracts, banquet event orders, and so on that you'll be reviewing. A coordinator can help you navigate these documents, as well as find loopholes and areas in which you can save (for example, a good planner knows the

# WEDDING PLANNING TIMELINE

If you're anything like me, you started "planning" your wedding long before you ever got engaged. Maybe you stumbled onto some dress websites or found yourself in the magazine aisle flipping through *Brides*—we've all been there. But as much as you've dreamed about it, nothing can actually prepare you for the work it takes to pull off a wedding. Putting together a backyard barbecue can be overwhelming; planning your *wedding* can be maddening. My advice is to plan wisely. Create a timetable to manage your ever-growing "to do" list, and be realistic in your planning expectations. Don't try to nail down every last detail in those first few weeks . . . but don't wait until a month before to book your caterer. Seriously.

    Use this twelve-month timeline as a reference. While it should help, don't feel beholden to it. Most of these are just suggestions, but do note that some of them you'll want to pay more attention to (like ordering your wedding dress eight to ten months before the big day to avoid "rush" charges, and drafting your guest list before you book a venue).

## 12 MONTHS

- **PREPARE A GUEST LIST.** It's the very first thing you and your partner should do. *Who* you want to be at your wedding will largely influence so much of your planning.
- **PUT TOGETHER A BUDGET.** Decide how much you're able to allocate for your big day. After you have that number, slice off one-third. You will undoubtedly go over budget (it's inevitable), so having a safety net is the best way to avoid major headaches.
- **BOOK A WEDDING PLANNER.** If you choose to hire a planner, you should do so early. If you choose not to enlist a full-time planner, you can opt for a "Day Of" planner who will be on-site the day/weekend of your wedding to help execute everything you've already designed.
- **START AN INSPIRATION BOARD.** Begin pulling photos, ideas, colors . . . anything that catches your eye!
- **BOOK A VENUE.** Once you know your head count, find a venue that you and your partner love. Popular locations book early, so it's important to check this off ASAP.

## 10 MONTHS

- **SELECT AN OFFICIANT.** This can be whomever you would like it to be—the most important thing is that you both are comfortable with this person.
- **CHOOSE YOUR WEDDING PARTY.**
- **TAKE ENGAGEMENT PHOTOS.** This really is an important step. Not only does it allow you both the opportunity to get comfortable in front of the camera, it's also a trial run with the photographer.
- **START RESEARCHING VENDORS.** Do not feel pressured to book the first florist, caterer, DJ, and so on that you meet. It's easy to get caught up in the wedding hype. Start early to get a few quotes. Prices can get crazy. My first flower quote was staggering. I ended up finding an amazing florist for less than a third of the cost.

*Photograph by Elizabeth Messina*

## 8 MONTHS

- **ORDER YOUR DRESS.** If you are planning to buy a designer dress, do it early. Most boutiques will estimate six months for your gown to be made and shipped.

- **BLOCK HOTEL ROOMS.** If you have a number of out-of-town guests or it's a destination wedding, you should negotiate a block at two or three hotels in different price ranges.

## 6 MONTHS

- **HAVE THE "SHOULD WE JUST ELOPE?" CONVERSATION.** By now you're in the thick of it and are looking for an escape route. Do not fear. All of us have had the same thoughts: *Is it too late to run off to Las Vegas? How much of the deposit would we lose?* It's real and happens to the best of us. Keep in mind that those feelings will pass; having the conversation is a rite of passage.

- **BUILD A WEDDING WEBSITE.** It can be minimal or decadent, but having a destination with all wedding-related information is a convenient resource.

- **SEND OUT SAVE THE DATES.**

- **BOOK YOUR HONEYMOON.** Decide where you want to go, and book your travel and hotel. However, don't start planning activities or meals yet. Whenever you need an escape from planning, do something for the honeymoon. Reminding yourself that after the guests leave and the final song is sung, you get to escape somewhere together is a wonderful way to de-stress.

- **ORDER YOUR BRIDESMAID DRESSES.** By now you have chosen your colors, so you can select what you would like your bridesmaids to wear. Another option is to let them pick their own dresses within a particular color scheme (if you're feeling generous . . . or brave).

- **START WEDDING BAND SHOPPING.** To be honest, William and I went into a store and picked our wedding bands out of the jewelry case two weeks before our wedding, but that's not normal. Most people spend time shopping around and finding exactly what they want. After all, you are going to be wearing it for the rest of your life.

## 4 MONTHS

- **DO HAIR AND MAKEUP TRIALS.** Start playing with your wedding day look! Pull photos for inspiration and don't be afraid to be picky. It's your day to look and feel your absolute best.

- **SELECT GROOMSMEN ATTIRE.**

- **CONFIRM VENDORS.** By this time, you should have all your major vendors in place. Make sure the contracts are signed, the date is held, and that all deposits have been paid.

## 2 MONTHS

- **MAIL YOUR INVITATIONS.**
- **PLAN THE CEREMONY.** Whether this means writing your vows, choosing the readings, or establishing the order of the wedding party processional, it's time to finalize your program.
- **PURCHASE "DAY OF" ACCESSORIES.** This is everything from jewelry to nail color. It's also a good time to plan for something old, something new, something borrowed, something blue, and, if you're feeling traditional, a two pence for your shoe.
- **CONFIRM YOUR DAY OF TRANSPORTATION.** Make sure you have your car, trolley, taxi, limo, or horse-drawn carriage reserved for you, your spouse, and the wedding party. If needed, it's also a good time to arrange guest transportation.

## 1 MONTH

- **REVIEW MUSIC LIST.** I suggest compiling a "Do Not Play" list for the band or DJ. If "Endless Love" was your and your ex's song, it's probably a pass.
- **START THE SEATING CHART.** No one can prepare you for how tedious this can be. William and I got a piece of poster board and drew up mock tables. We wrote every guest's name on a Post-it and began placing and replacing them at tables until we found an acceptable arrangement (this took over a week and more than a couple of martinis).

## 6 WEEKS

- **APPLY FOR A MARRIAGE LICENSE.**
- **PRINT ALL PAPER GOODS.**

## 1 WEEK

- **FINALIZE HEAD COUNT AND SEATING CHART.**
- **STUFF WELCOME BAGS.**
- **PAMPER YOURSELF.** If you need a last-minute trim or root touch-up or want to indulge in a facial, now is the time to do it!

## 2 DAYS

- **GET A MANICURE/PEDICURE.**
- **WRAP BRIDAL PARTY GIFTS.**

## DAY BEFORE

- **REHEARSAL DINNER.**

## WEDDING DAY

- **GET HITCHED!** Enjoy this amazing occasion, celebrate with loved ones, and don't forget to stop and smell the roses (or peonies, or ranunculus, or lilacs!).

tricks of the trades and can point out little details that add up—like an event contract that may include a served champagne course, even though you're hosting a full open bar).

Brides also have the option of hiring a "Day Of" planner who will come help manage the flow of the day: streamlining photos, coordinating the first dance, cueing the cake cutting, making final payments to the vendors, and so much more. Having a good planner to go through your checklist is extremely helpful. (For our wedding, poor Cassie diligently coordinated all the bridal party photos before jumping in at the last minute to pose.)

The first thing Cassie told me was to create a guest list. We couldn't begin any of the planning until we knew how many people we'd be inviting.

William and I went back and forth on this. On one hand, we daydreamed about an intimate ceremony barefoot on a beach; on the other hand, we couldn't imagine getting married without including everyone we know and love. We decided to start by drafting a list of every person who had to be there. When that list got to be over a hundred names, we knew that exchanging vows in a small seaside ceremony was no longer an option. We're blessed to have so many people in our lives we couldn't have our wedding without—so we chalked it up to champagne problems and moved on. After that, all bets were off . . . we wanted to celebrate this day with all the people we hold dear. And looking back, we are so glad we did.

Once our guest list was settled, William and I began researching venues. It was important to us that our wedding felt like a getaway, but also close enough to get home if a guest needed to. We knew two things for certain: we wanted it to be coastal (or relatively coastal) and we wanted to go north. Whenever I imagined my wedding ceremony, it was always outdoors, so I began researching venues all around Santa Barbara that could accommodate us getting married outside (which ended up being complicated when I later had to tent the altar for privacy purposes).

For some reason I got super attached to the idea of hosting the reception in a barn, so every location I wanted to look at featured a barn. But William never warmed to the idea. He told me that barns were full of spiders . . . and I *really* don't like spiders.

I began pulling images for inspiration and found that everything I was drawn to evoked a rustic, romantic feeling: floral arrangements in organic, unmanicured shapes; soft palettes and muted hues; and Provençal details like craft-paper-wrapped bread and soft lace on distressed wood. It felt intimate and really beautiful.

In my experience, many grooms tend to be more hands-off in the wedding planning process (not for lack of interest, but because most brides have pretty concrete ideas of what they want . . . and what they don't). William didn't want a lot of input when it came

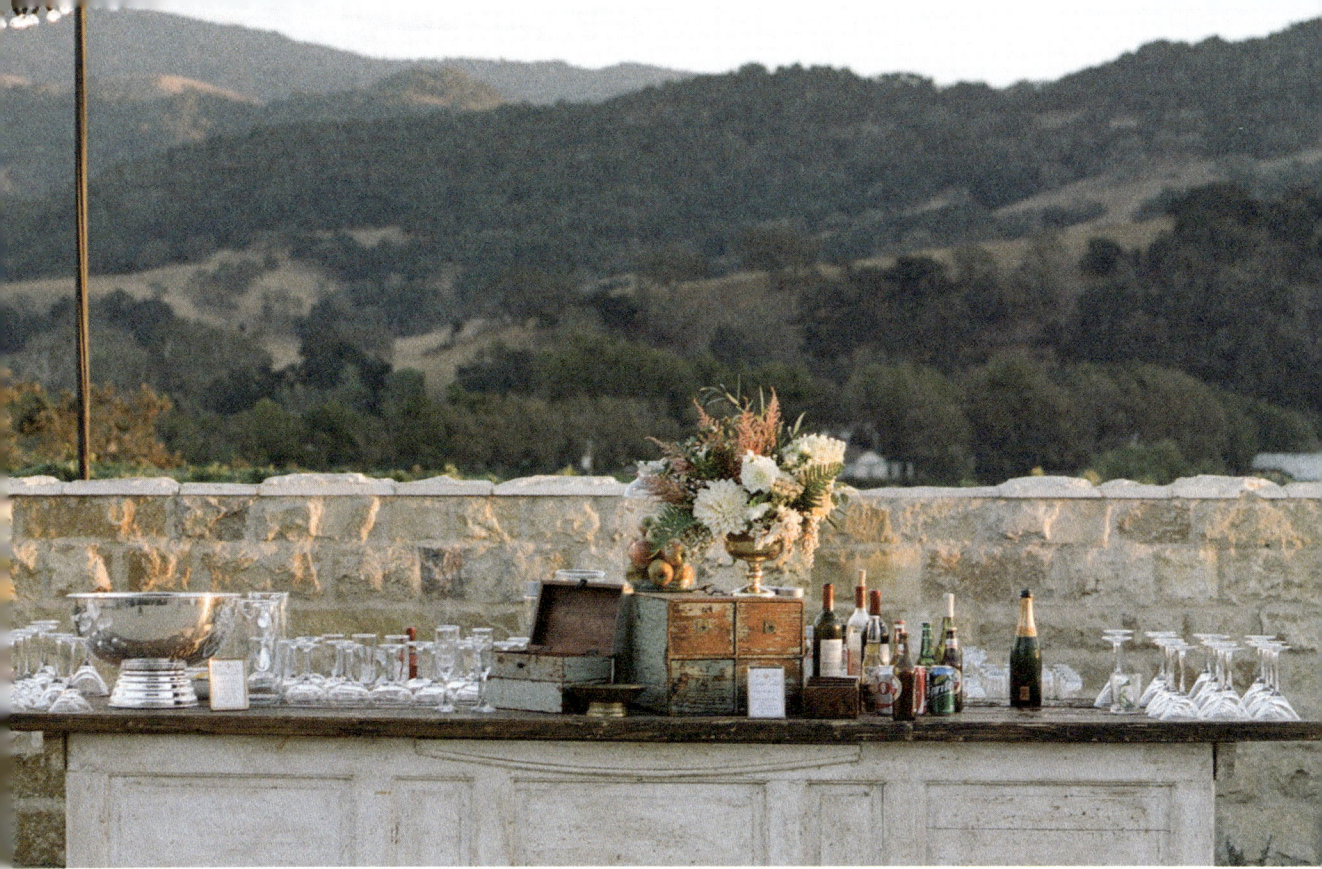

down to brass tacks, but he did invoke his veto power when he felt particularly passionate about something (like making sure we offered heartier fare during the cocktail hour, to avoid overly spirited guests). But mostly, he just asked for the wedding to not be *too* pink.

    We drove up the coast in October and our first stop was a gorgeous vineyard estate that my friend Lo suggested. Our search ended before it ever really began. Despite being only a few hours from L.A., it felt like we were light-years away from the city—with gorgeous rolling hills reminiscent of the countryside. The grounds also included an exquisite five-bedroom stone villa that looked like a nineteenth-century French château that had been dropped in the middle of Santa Ynez. It was perfect: quiet, secluded, charming, and romantic. Out of sheer obligation, we toured the rest of the locations we planned to see, but booked the dream vineyard the very next day.

    In my head, I really wanted a year for wedding planning, but options were limited as apparently a few other brides had already beaten me to the punch. September 13 was the only date left, so we took it!

    That's when the real planning began . . . let me say this: wedding planning is not for

Photograph by Elizabeth Messina

the faint of heart. Before we got down to it, Cassie gave me some really valuable advice about what aspects of a wedding (both good and bad) guests will always remember.

- **THE TEMPERATURE** Guests will always remember if it's too hot or too cold (which means emergency reinforcements might be necessary if hosting a wedding outdoors, like tents and fans or heat lamps).
- **THE DRINK SITUATION** If it's a cash bar, guests will remember they had to pay for their drinks—or that they had to borrow cash to do so.
- **THE FOOD** This is one where you don't get credit for good food unless it's amazing. People will, however, always remember if it isn't so tasty or if there wasn't enough.
- **BAD SPEECHES** Unfortunately, there isn't a ton you can do about this, besides gently and politely reminding those giving toasts that you'd prefer they keep it short and sweet.

That being said, don't get obsessed with the details. Despite all our prepping and planning, some things didn't turn out exactly how I imagined them, but nobody knew the difference!

The next thing Cassie told me was to choose my battles wisely. She was right. Weddings are bigger than two people, so there will be plenty of opinions and suggestions about how you should celebrate your special day. You need to accept, from the beginning, that some people will get their feelings hurt. And while unintentional as it may be, it's also inevitable. You are not going to be able to make everyone happy.

You should definitely consider their feelings, but remember, this is your and your future spouse's day—and that should be your focus and priority. Every wedding should represent the couple. You don't need to follow every rule—and some were just made to be broken.

Take my suggestions at face value and decide what is best for you and your partner. What works for one couple may not work for the next. For example, I decided not to have a maid of honor because every member of my bridal party was important to me in different ways. Traditions are lovely if they mean something special to you, but don't feel obligated to follow them just because. I've always adored the silly anticipation of a bouquet toss, so I wanted to be sure to include it, but we skipped the garter toss. I also broke a huge tradition and saw William before the wedding. In my mind, it's such an important day and I didn't want the very first time I saw him to be at 4 P.M. We woke up and had a quiet, cozy breakfast together in the morning before saying, "See you at the altar!"

## the rehearsal dinner

The evening before the wedding, William's parents hosted forty people, including our closest family members and the wedding party, for an intimate rehearsal dinner at the estate. It was so picturesque, I couldn't imagine going anywhere off-site. The estate itself is like a piece of art—all the wood finishes had been brought in from a lavender farm factory in France, and the limestone structure had all been shipped in from Italy. It was a little Tuscan dream.

It was a very elegant but understated evening. I wanted it to be a relaxing time—the calm before the storm (including a downpour of lavender and lace). A few of our close friends and family members made speeches, which could be a bit more candid and personal (since it wasn't in front of 230 guests!).

*Prior to the dinner, our planner, Cassie, did a run-through of the ceremony that lasted about fifteen minutes where she basically directed all of us on when to walk, where to go, and what to do. A lot of it is common sense, but with all the day-of jitters and chaos swirling about, it was nice to go over everything ahead of time so there wasn't any confusion.*

Photographs by Elizabeth Messina

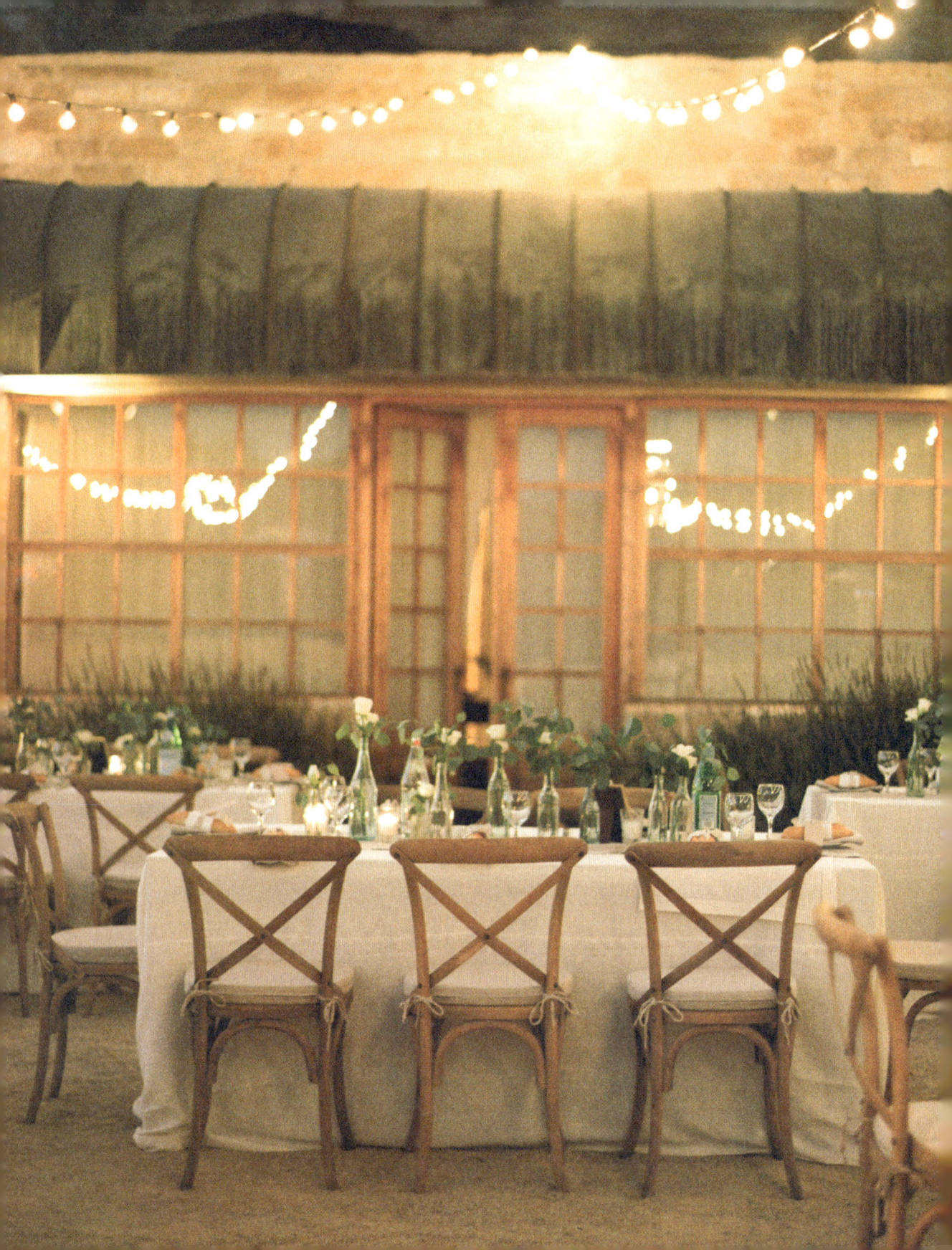

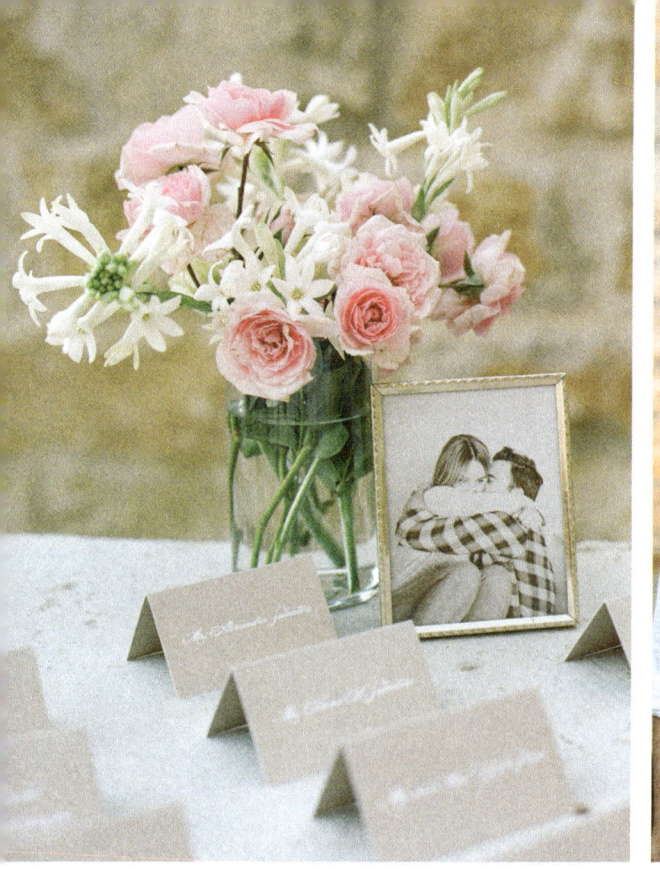

Photographs by Elizabeth Messina

# rehearsal party menu

### APPETIZERS

Appetizer Board of Italian Meats, Assorted Cheeses, and Marinated Olives

Arugula Salad with Lemon and Olive Oil Dressing

Caprese Salad

### MAIN COURSE

Classic Beef Meatballs

Linguini Marinara

Penne with Mushrooms and Sausage

Chicken Breast with Lemon and Herbs

Homemade Pizza with Choice of Toppings

### DESSERT

Tiramisu with Mixed Berries and Whipped Cream

### *the menu and the bar*

Originally William's mother and I had the idea of cooking up a big Italian meal ourselves for the rehearsal dinner (with the help of Grandma Anna, of course). While it sounds like a pretty big lift the day before our wedding, I'm definitely the kind of person who thinks anything is possible with a little elbow grease (even when it's maybe not). However, when it got down to it, we realized it was just going to be too much work, so we had a big Italian feast catered in. William's parents hosted a full premium bar with a bartender.

Photographs by Elizabeth Messir

## *the décor*

We didn't want it to feel too formal, so we kept things pretty simple. We used the same distressed wood tables and cross-back chairs for the rehearsal that we were using for the reception as well as the white porcelain plates and etched crystal goblets—I saw no point in bringing in different rentals when the ones we were using for the wedding were already so beautiful. I used my collection of vintage glass bottles (like you saw at the dinner party in chapter 10) that I packed up and brought with me.

Confession: I actually put up a pretty big fight to design my own floral arrangements for the wedding, but Cassie told me it was absolutely out of the question. We went back and forth on it for a while. I knew what I wanted and was convinced it would be easy to pull off, while Cassie insisted that it was just too much work on a day where I would already be overwhelmed. She was right and I finally forfeited the battle, but our compromise was that she let me handle the arrangements for the rehearsal. The morning of the rehearsal dinner, Cassie and I went to the Santa Ynez farmers' market to pick up bunches of silver dollar eucalyptus and white roses. We arranged simple bouquets

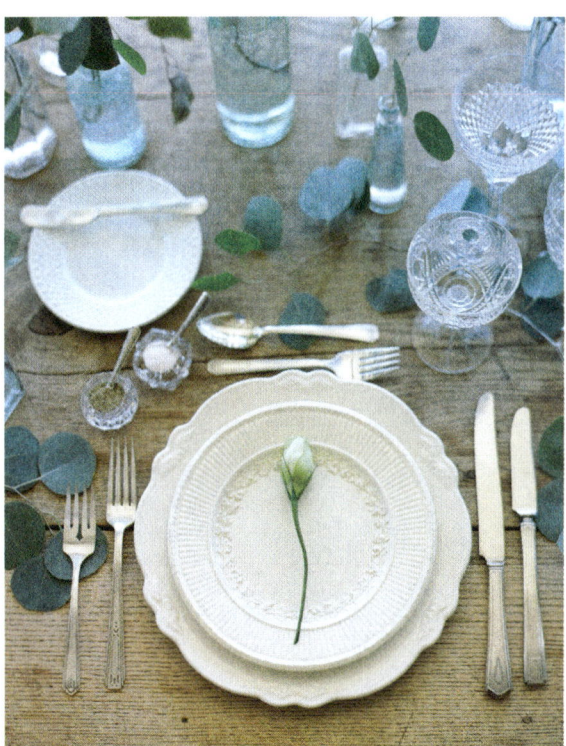

in the glass bottles and placed them on the table with a few scattered eucalyptus leaves.

## *the details*

### PLACE CARDS

We used fresh baguettes wrapped in parchment paper, tied with butcher string, and adorned with little name tags.

### BRIDAL PARTY GIFTS

This is your chance to show your thanks and appreciation for all their help and support. Here's what William and I gave our wedding party:

*bridesmaids*

- Vintage monogrammed handkerchiefs with their initials
- Dainty rose gold and diamond bar necklaces by Dana Rebecca
- Painted petal jumpers and robes by Plum Pretty Sugar
- Adorable sleeping masks with cat ears and bows by Naomilingerie

*groomsmen*

- Customized bocce ball sets

## *the look*

For the rehearsal dinner, I wanted to be comfortable but still feel sophisticated. Since the event was more understated than a typical formal dinner, I wanted a dress that felt less serious, so I chose a white crepe maxi dress from our Paper Crown line. Since I would be wearing my hair down for the wedding, I decided to pull it back in a loose, low side bun with a delicate gold and mother of pearl hairpin.

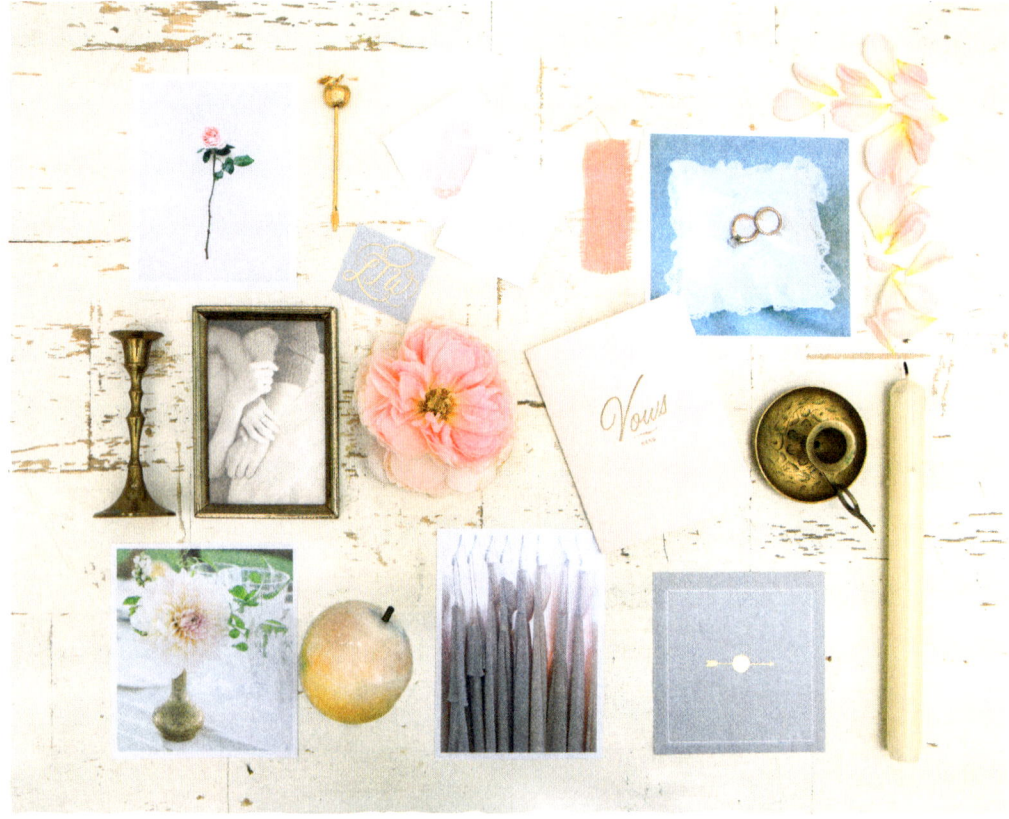

## the wedding inspiration

Our wedding venue really captured the aesthetic I was hoping to achieve: rustic chic. For our colors, I knew I wanted a soft palette and to play off the beautiful natural flora on the property—lavender bushes and grapevines. We chose a palette of blushes, peaches, feather grays, and dusty blues with aged mixed metals, ivory lace, and muted woods.

While I'm clearly partial to a theme, we decided that for our wedding it should be understated. When William and I started dating, I began a new collection: apples and arrows. (My husband shares his name with the folk hero William Tell, who famously split an apple off the top of his son's head using a single arrow.) Apples and arrows felt like the natural elements to weave throughout a September wedding weekend.

## the food

Wedding food is so often a punch line to a bad joke because it can really easily go wrong. When a vendor is preparing that many meals at one time, it's hard to ensure the quality, temperature, presentation, and so on. Cassie and I found a catering service that came very highly recommended. On the day of William's and my menu tasting, I requested to try every option they had . . . literally. It was an impressive spread. Now, I'm a girl with an appetite, but I couldn't keep up. By the time we got to the entrée sides, I started walking laps around the building, trying to work up an appetite for the late-night snack options like chicken and waffles, macaroni and cheese, and mini BLTs.

The good news was everything tasted delicious—which also ended up being the bad news. We had so many favorites that we had trouble agreeing on a menu, so we just sort of ended up ordering all the things! It also eliminated the task of determining a guest's dinner preferences ahead of time.

## cocktail hour

Since our guests would be standing during cocktail hour, we wanted appetizers that would be easy to eat, but I had one strict stipulation: nothing on a stick! It was our wedding, so I wanted things that were delicious and simple but also elevated.

## cocktail hour menu

### PASSED APPETIZERS

Miniature Potato Tacos

Smoked Salmon
with Crème Fraîche

Nectarine Bites

Prosciutto Wrap
with Fresh Basil

Crispy Haricots Verts
with Black Truffle Oil

Chicken Parmesan Bites
with Marinara and Fresh Mozzarella

Ahi Tuna Tartar
on a Wonton Crisp

We offered guests bite-size portions along with hearty, cloth-feeling paper napkins designed with either apples and arrows or William's and my initials in gold foil.

## reception menu

In addition to the entrée options, we offered guests family-style sides, which helped to create a more intimate feeling and encouraged guests to interact with others at their table. On each table, we had a big, overflowing basket of fresh baked breads. It looked beautiful and also kept people from getting too tipsy too early.

To capture the harvest theme, we decided to serve homemade apple pie. And I mean . . . *homemade*. It felt different from anything I'd seen at a wedding, and an unexpected personal touch. I dream of the smell of cinnamon and warm apples, and the idea of it wafting around our wedding reception sounded so delightful that I was determined to make it happen.

Plus, I happen to make a pretty tasty apple pie (see page 38).

*It's definitely an added expense to allow guests to choose their entrée during the reception, but it's a nice way to make them feel taken care of, if the budget allows.*

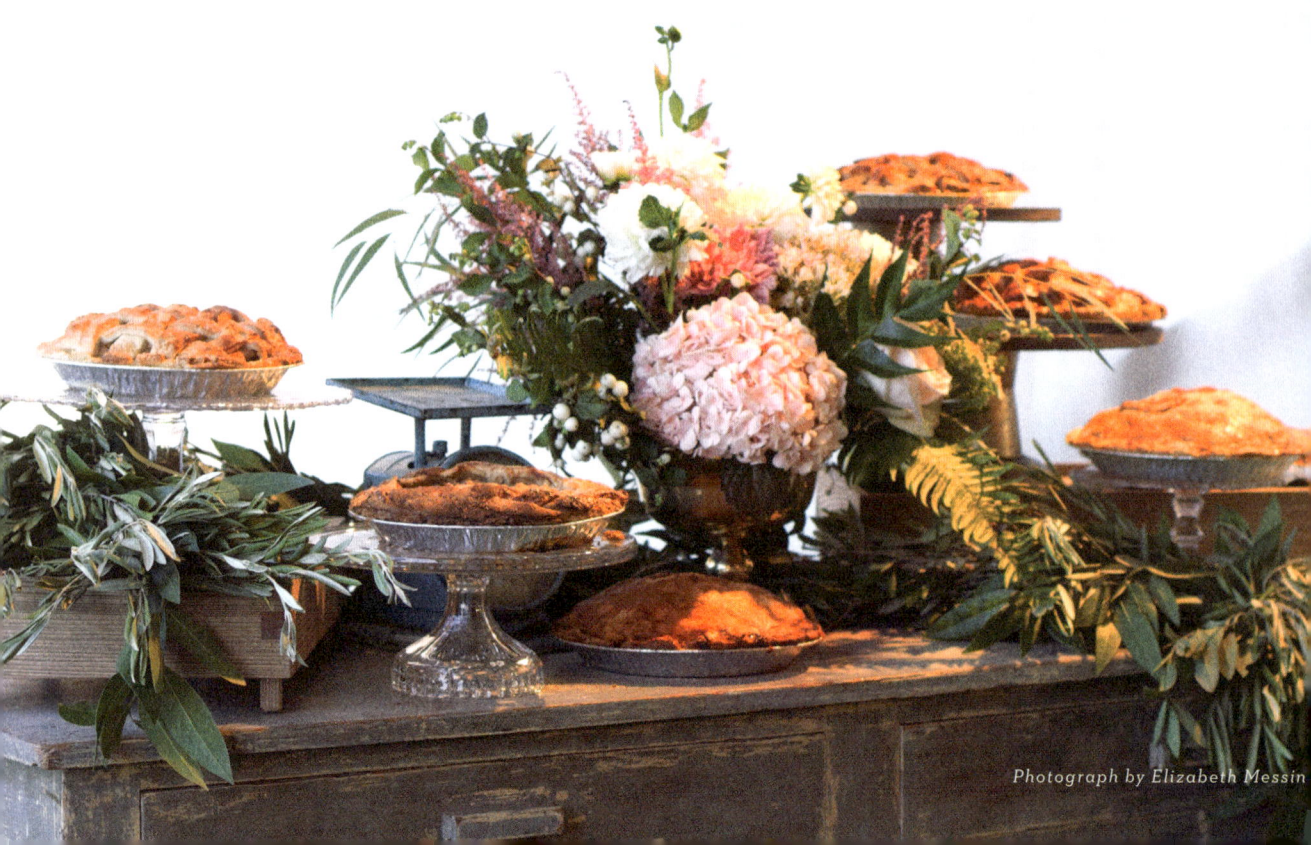

Photograph by Elizabeth Messin

# reception menu

## BREAD

Cumin Cheddar Cheese Coins, Cheese Toasts and Twists, Seeded Flatbreads

## FIRST COURSE

Heirloom Tomato, Peach, and Burrata Salad with Butter Lettuce
and Champagne Vinaigrette

## CHOICE OF ENTRÉE

Black Striped Bass with Lemon,
Kalamata Olive, and Tomato Confit Served
with Ribbons of Zucchini

Beef Tenderloin Tournedos
with Chimichurri Sauce Served with Green
and White Asparagus Bundle

Tuscan Roasted Organic Chicken Breast
Marinated with Lemon and Herbs Served with
Haricot Vert Bundle

*Vegetarian Alternative:*
Wild Mushroom Parcel with Farro, Sautéed
Shallots, and Tarragon Served with Green and
White Asparagus Bundle with Chive Tie

## FAMILY-STYLE SIDES

Homemade Pumpkin Ravioli with
Brown Butter Sage Sauce, Pumpkin Confetti,
Crispy Sage, and Parmigiano-Reggiano Cheese

Olive Focaccia Bread, Italian Country Bread,
Breadsticks, Extra-Virgin Olive Oil, and Aged
Balsamic

Roasted Fingerling Potatoes with
Crispy Herbs and Sea Salt Horseradish Sauce

## DESSERT

Vanilla Wedding Cake
with Buttercream Frosting

Homemade Apple Pies
with Vanilla Bean Ice Cream

Two weeks before the wedding, I locked myself in an industrial kitchen space with two girlfriends and 280 Granny Smith apples. My friend Lauren is a baker and has access to a huge kitchen space, with a giant freezer. We peeled, cored, and sliced the nearly three hundred apples over the course of about four hours. We prepped and assembled fifty pies and stored them, uncooked, in the freezer. The day of the wedding, Lauren drove them up to the reception site. They defrosted during the day and the caterers began popping them in the oven during dinner service. During the reception, Cassie arranged the pies on a rustic wood table, using an apple crate to stagger them at varying heights to resemble a charming little pie stand at a country fair. Who doesn't enjoy some edible décor? Servers offered guests fresh, warm slices along with a big scoop of vanilla bean ice cream.

I didn't want to forgo the tradition of cutting the cake with my new husband, so we ordered a small twelve-inch vanilla wedding cake to cut. We actually had two different cake toppers: a pair of antique brass swans and a vintage porcelain 1950s bride and groom for photographs.

*Photographs by Elizabeth Messina*

# late-night snacks

**Gourmet S'mores:**
Classic and chocolate-dipped graham crackers and an assortment of large and small flavored marshmallows (lemon curd, peanut butter, and Nutella), caramel sauce, and Hershey's bars

**Salted Caramel Brownies**

**Warm Chocolate Chip Cookies** with Chilled Milk Shooters

**Waffle Bites with Fried Chicken Breast, Berry Jam, and Maple Crème Fraîche**

**Tomato Soup Shooters** Served with Miniature Sharp Cheddar Grilled Cheese

## late-night snack

When it gets later into the evening, people start to get hungry again. If you're eating, drinking, and dancing, it's nice to put something in your stomach. For this second food service, we invited guests to indulge in some delicious comfort foods.

## the bar

September in Southern California can still be pretty toasty, so we planned to serve a variety of refreshing beverages as guests entered the vineyard.

Flat and Sparkling Water

Lavender Hibiscus Lemonade with Lavender Sprigs

Champagne

Vodka-Spiked Lemonade

It's called cocktail hour for a reason. William and I wanted guests to have options! This was the kickoff to the biggest celebration of our lives, so we needed to start off on the right foot. When 230 people head toward a bar, it can get a little crazy, so we wanted to offer a few ready-made cocktails and passed champagne to mitigate bar traffic. In addition to two full premium bars, we had servers offering guests three of our favorite cocktails (Moscow mules, jalapeño skinny margaritas, and dirty martinis) as well as a specialty

cocktail created for the wedding (The Apple of My Eye) arranged on beautiful vintage metal trays (each of the drinks were also available at the two bars):

### THE APPLE OF MY EYE

*Apple brandy, hard apple cider, simple syrup, fresh lemon juice, apple juice, red, yellow, and green apple slices*

> People have differing opinions of what constitutes a full bar. I would count on offering vodka, gin, white rum, dark rum, tequila, bourbon, scotch, beers, wines, champagne, soda, mixers, and flat and sparkling water.

# the décor

## ceremony

As I mentioned, I daydreamed of having an outdoor ceremony set against a breathtaking backdrop of the rolling hills and grapevines. Unfortunately, that plan got scrapped. Not only was the afternoon sun going to be too warm, we also were battling some privacy issues. Luckily, Cassie had a tent on retainer in case of emergency (of course she did!), which she had brought in along with a mobile air conditioner to cool down our guests.

When you entered the tent, guests could approach a wooden frame filled with rows of beautiful, vintage hand-sewn handkerchiefs. For guest seating, we used vintage reclaimed-wood benches. William was concerned that benches would be too uncomfortable for some guests, so he thoughtfully suggested mixing in some chairs for our grandparents in the first two rows, which were reserved for immediate family. Lining the aisle were distressed gray clay pots filled with lush greens and white delphinium and lisianthus (with pops of blush). We wanted the ceremony to feel slightly different from the reception, but still cohesive. Because the wedding was happening outside we needed an aisle runner to cover the exposed ground. A simple white runner felt too stark, so instead we laid down a cream linen runner and sprinkled the aisle with both natural and gold-painted eucalyptus leaves.

At the altar, we had rustic wooden branches woven into a large arch and covered in a floral drape of hydrangea, garden roses, peonies, and bunches of beautiful greenery, as well as trees that had been handmade from olive branches.

I wanted the bridal party bouquets to feel like a natural extension of our reception centerpieces: peonies, dahlias, ranunculus, anemones, winter berries, and garden roses

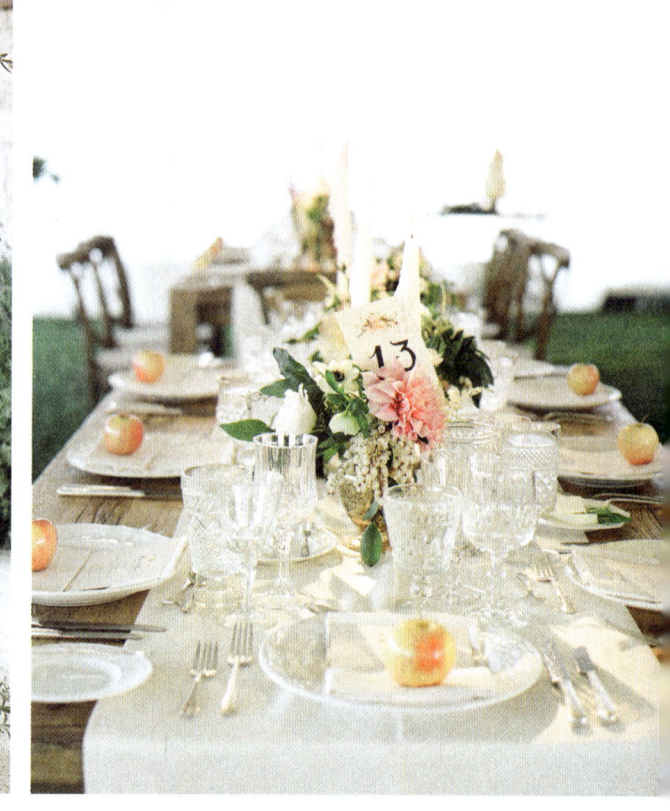
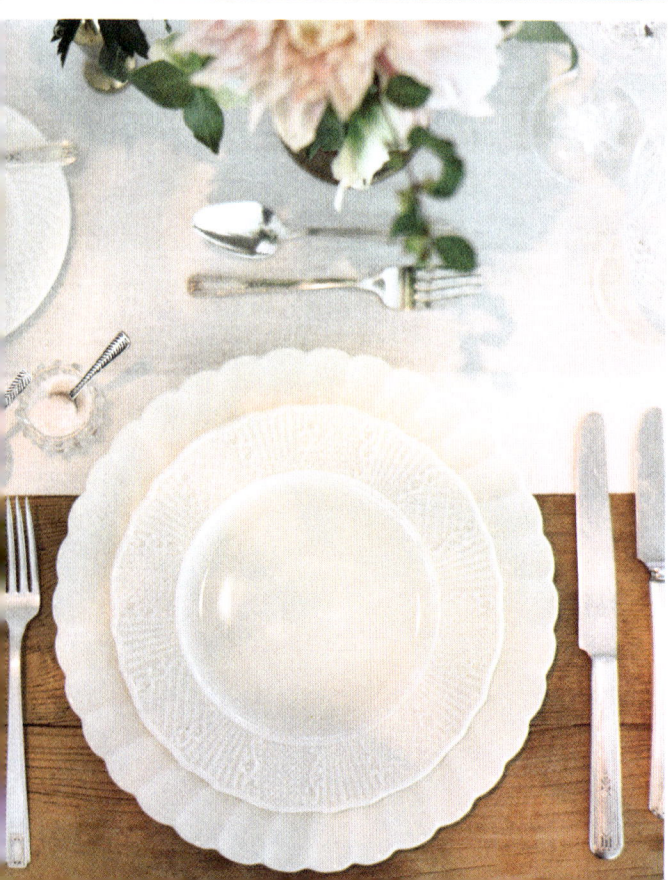

Photographs by *Elizabeth Messina*

wrapped in a blush-colored silk ribbon. To complement the bouquets without being too fussy, the boutonnieres were simple white blooms wrapped in twine.

    I had trouble deciding between bringing in wood tables for the reception or simply covering standard tables in beautiful linens. Cassie and I went back and forth, but eventually decided that since the mood we were trying to evoke was casual sophistication, the covered tables felt a bit too formal. We were already bringing in vintage pieces through Found, a furniture rental company that specialized in remarkable, one-of-a-kind pieces. They offered beautiful, paint-chipped farm tables that were quaint and rustic, but incredibly elegant. The distressed wood immediately added a warm texture to the general tablescape inspiration. For the seating, we chose cross-back wooden chairs. For the bridal party (and their dates), we brought in a king's table large enough for thirty-one guests, as well as a tufted linen wingback settee for William and me at the center of the table.

    Next came the brass pieces. Depending on the size of the table (each table varied), we used anywhere from ten to twenty-five brass vases, goblets, and candlesticks to display the flower arrangements, pulled together with the same flowers from our bouquets. The small brass pieces also kept the arrangements low, so they didn't block anyone's view. I filled the brass candlesticks with classic tapered white candles.

    We rented the dishes and china from Casa de Perrin, a beautiful tabletop rental

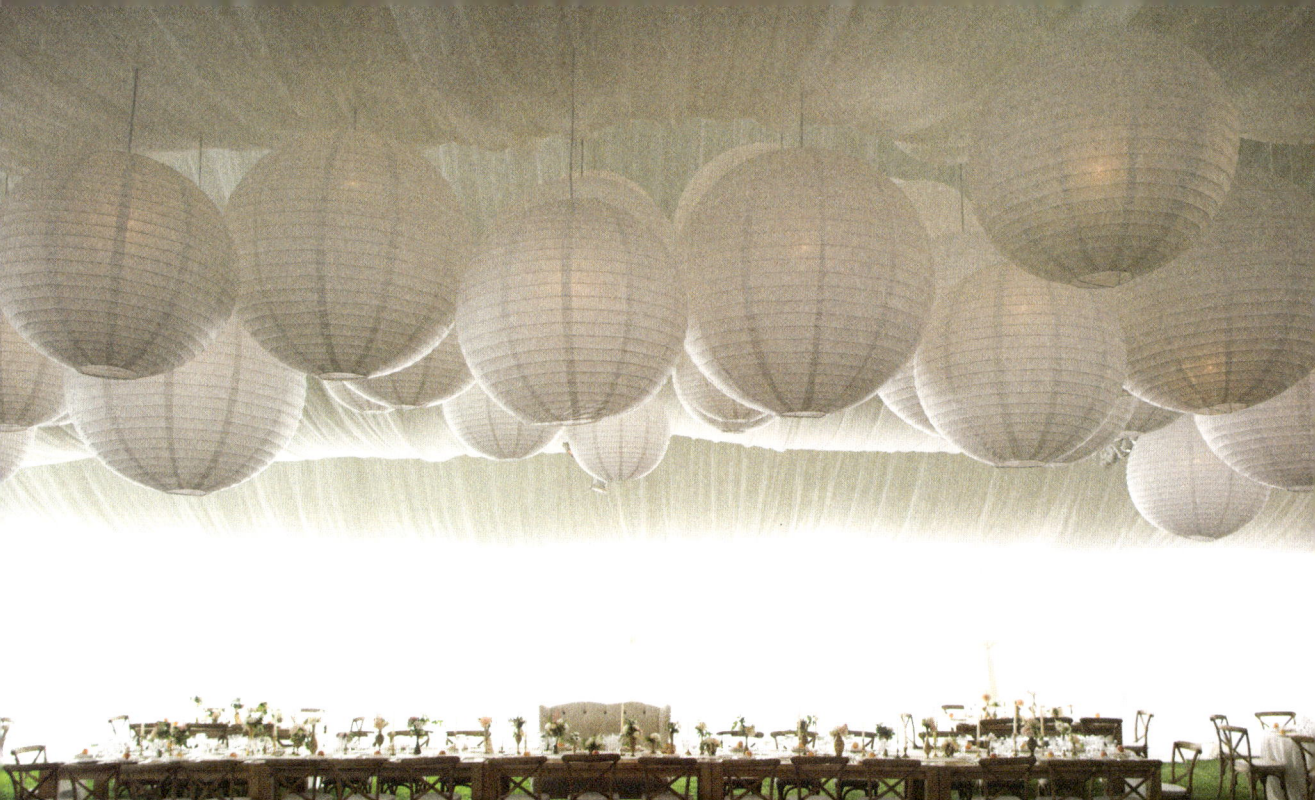

company that curates the most spectacular collection of dishware and china. For our tables, we chose pieces of delicately embossed ironstone and porcelain charges in true white, antique sterling flatware, and cut-crystal goblets in varying designs with a simple Honeycrisp apple resting on a white linen napkin.

I must have looked at a million lights. Chandeliers felt too formal and really expensive. And I ultimately realized I wanted something that disappeared into the tent, so we filled the ceiling with beautiful, oversized white Chinese lanterns. As for the tent itself, when we decided to cover the reception, I started pulling photos. I wanted it to feel light and airy, with curtains that tied. And I wanted it to have the feeling of both an indoor and outdoor event. We ended closing the curtains after dinner to keep in the heat.

To provide additional seating, we had a few seating areas with different vintage couches and upholstered chairs in neutral, washed-out fabrics. We arranged them like a living room so guests could hang out, and the whole thing felt more intimate.

Photographs by Elizabeth Messina

## the entertainment

### band

When it came to the music, I relinquished the reins to William. Being a musician, he had some strong preferences about what he wanted for the entertainment.

For the ceremony, it was all Beatles. The bridal party entered to "Here Comes the Sun" and my father and I walked down the aisle to "In My Life." After the officiant pronounced us husband and wife, the recessional was to "Two of Us."

While a good DJ can be a wonderful wedding option for some, William was intent on live music. He was pretty specific on *what* band, down to the types and amount of instruments he wanted. Before the wedding, he compiled a list of songs we definitely wanted played and a list of songs that, under no circumstances, should be played. I told him I would support all his decisions under one condition: that he join the band for a song. He rarely performs live anymore—and it's one of my absolute favorite things. His performance of "Can't Take My Eyes Off of You" will always be one of my favorite moments from the evening. And because it had long been our song, our first dance was an acoustic version of Queen's "You're My Best Friend."

*Photographs by Elizabeth Messina*

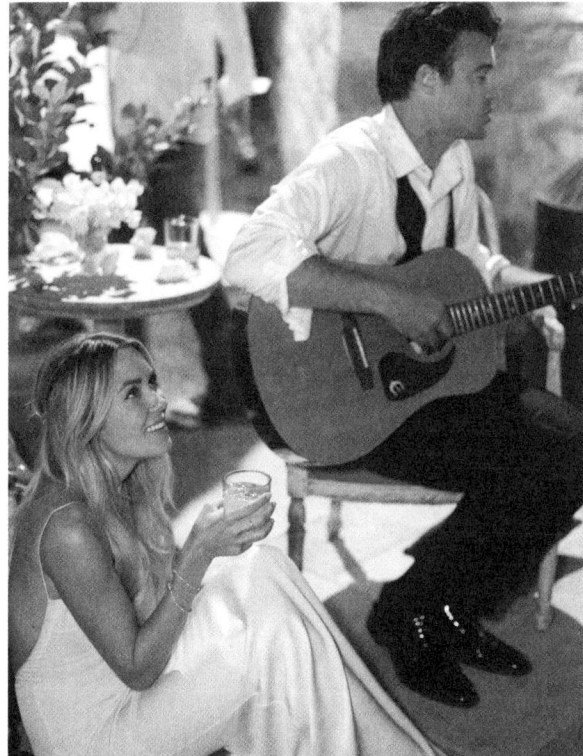
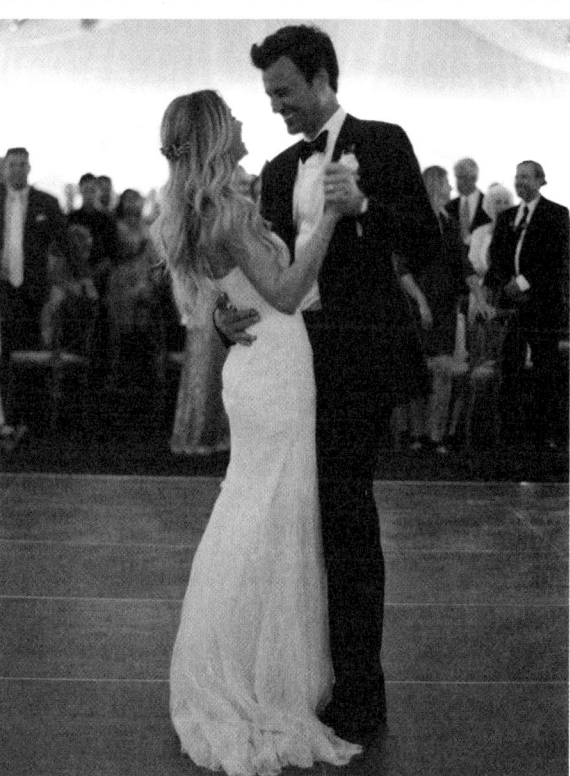

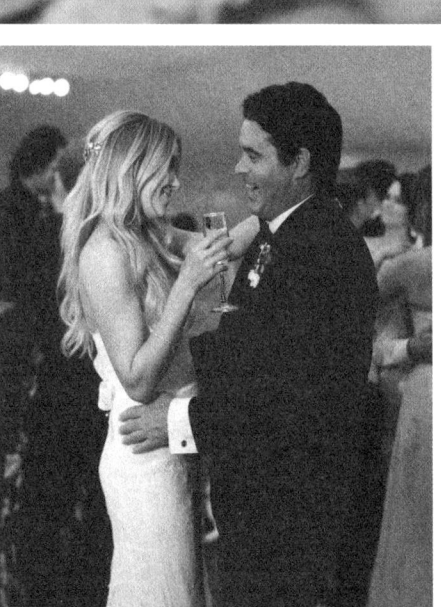

# the details

## the guests

If you have room in your budget, I suggest adding in small details to make your guests comfortable. For our wedding, we were asking people to travel, rent hotel rooms, and take time away from their lives to spend a weekend celebrating with us. We first wanted to offer our guests staying in Santa Ynez some of the amenities of home (which you wouldn't necessarily think to pack), so we put together a Welcome Bag. Our approach was to include things that we would appreciate as guests at a wedding.

We had canvas totes printed with the apple and arrow logo that became the through line over the weekend, which we filled with:

- A welcome program (which included a schedule of wedding events as well as a list of local restaurants and activities)
- A bottle of wine from the vineyard we were getting married at as well as a wine bottle opener with our wedding monogram
- Our favorite snacks: pistachios, snickerdoodle and chocolate chip cookies, gummy bears, and Reese's Pieces
- Boxed water
- Mints
- Burt's Bees Lip Balm
- A sick kit: Pepto-Bismol, Emergen-C, and Advil

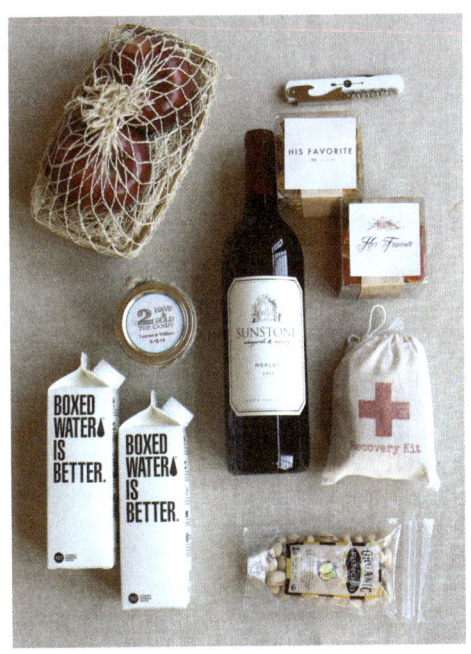

During the cocktail hour, the sun was brightly shining on the vineyard, which created a beautiful visual but made it a bit warm, so we offered a brass cart filled with parasols for guests who wanted a little shade.

Weddings can be long days—and not just for the bride and groom. As the evening

*Photographs by Elizabeth Messina*

turns into night, you want your guests to feel comfortable kicking off their heels to party . . . literally. Around the grounds, we had wooden apple crates filled with flip-flops for people who wanted to rest their feet and stacking baskets with oversized, soft knit blankets so guests would be cozy and warm (we also brought in heat lamps).

For our favors, we worked with Martha Stewart Weddings to create something special for our guests to remember the day. We wanted it to feel really personal, so we decided on a game night–themed favor, consisting of personalized cigar boxes (with our apple and arrow designed emblem) filled with treats and candies; a personalized deck of cards, pencils, and a pad for keeping score; and a personalized pamphlet of our favorite card games (with fun, punny names, obviously) like Go Wish, Crazy in Love Eights, and Gin Yummy.

## the vows

We asked our friend Casey to marry us, because it was important that we be married by someone who knew us as a couple. He's a wonderful husband, and we loved the idea of being married by someone whose marriage has been an inspiration to us.

For our vows, we always knew that we wanted to do our own. Originally we were going to do them separately and surprise each other at the altar, but then we decided to write them together so they would feel balanced and cohesive.

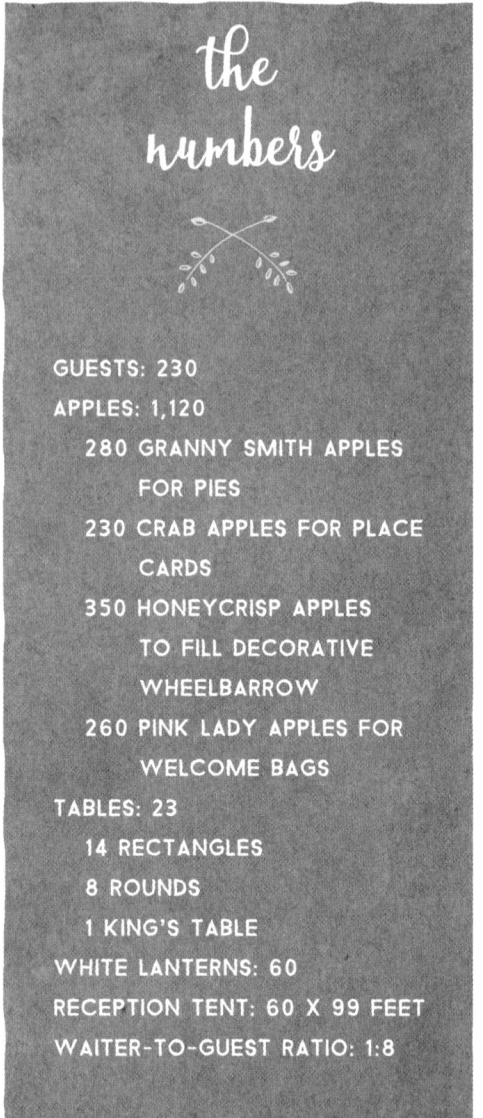

## the numbers

GUESTS: 230
APPLES: 1,120
    280 GRANNY SMITH APPLES FOR PIES
    230 CRAB APPLES FOR PLACE CARDS
    350 HONEYCRISP APPLES TO FILL DECORATIVE WHEELBARROW
    260 PINK LADY APPLES FOR WELCOME BAGS
TABLES: 23
    14 RECTANGLES
    8 ROUNDS
    1 KING'S TABLE
WHITE LANTERNS: 60
RECEPTION TENT: 60 X 99 FEET
WAITER-TO-GUEST RATIO: 1:8

## the look

William is a bit of a romantic, so when it came to my wedding dress he didn't want to know anything about it until the day of the wedding. Like any bride, I really wanted to look beautiful for my husband-to-be, so I, being a bit less traditional, was eager for his opinion . . . but he refused to talk to me about it!

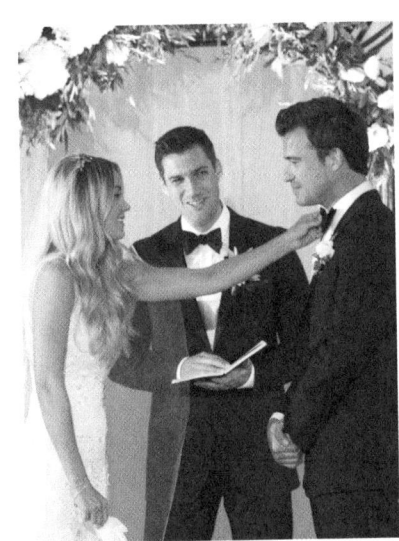

## the ceremony dress

I've always marveled over the world of Bridal. The idea of creating something so intricate that's only meant to be worn once is kind of amazing. It's the dress that someone is choosing to wear on the biggest day of her life—her happiest, most beautiful day. That's a lot of pressure on a piece of lace.

And being a designer, I knew that I wanted to have a hand in creating my wedding dress, but I also knew that I didn't have the expertise to pull off such an impressive feat on my own. Lucky for me, designers Mark Badgley and James Mischka (the wonderful team behind the exquisite fashion house Badgley Mischka, of course) offered to help me execute my dream design. I wanted to work with a designer—or in this case, designers—who shared my same passion for romance and femininity.

A lot of girls have fantasized about their wedding gown—and I had a very clear idea of what I *thought* I wanted: a huge tulle ball gown. I realized rather quickly that I ought to be going in a different direction. When I tried on a gorgeous, showstopping gown, as beautiful as it was, I got totally lost. I looked like a little girl playing dress-up and the dress wasn't particularly flattering on my shape. After that, I decided to try on as many different styles as I could. One by one I ruled out shapes and fabrics, and eventually discovered that I felt most comfortable and most like myself in a more fitted lace dress.

I flew out to New York to meet with the designers and discuss the ideas I had in mind and the general feel I was hoping to achieve. They began showing me examples and inspirations and we went from there! I hadn't imagined any beadwork or embellishments, but James and Mark proposed it in a subtle way that felt organic and dainty (they designed a row of crystal buttons up the back as well). They came up with the idea of

*Photograph by Elizabeth Messina*

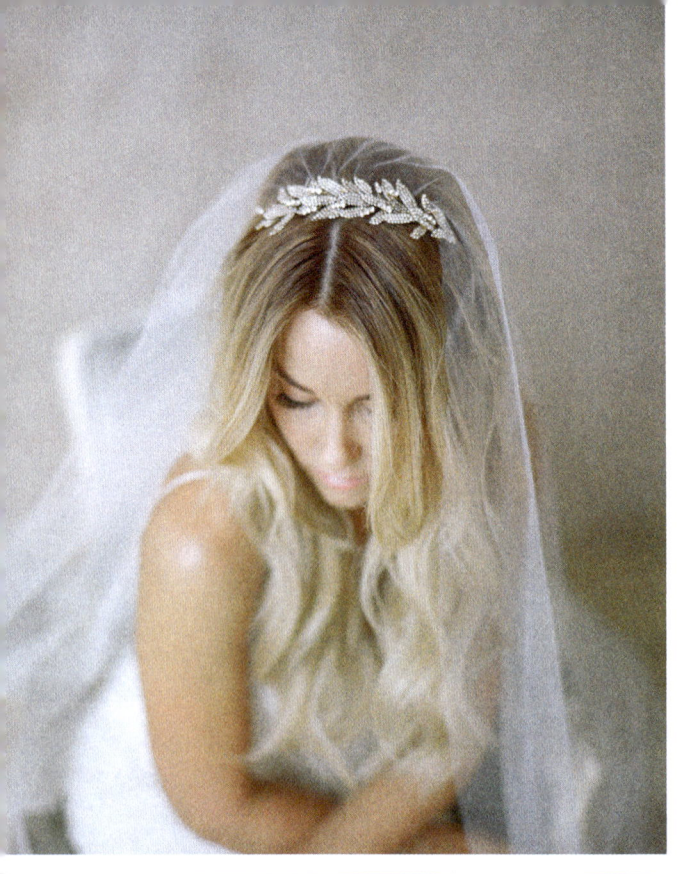

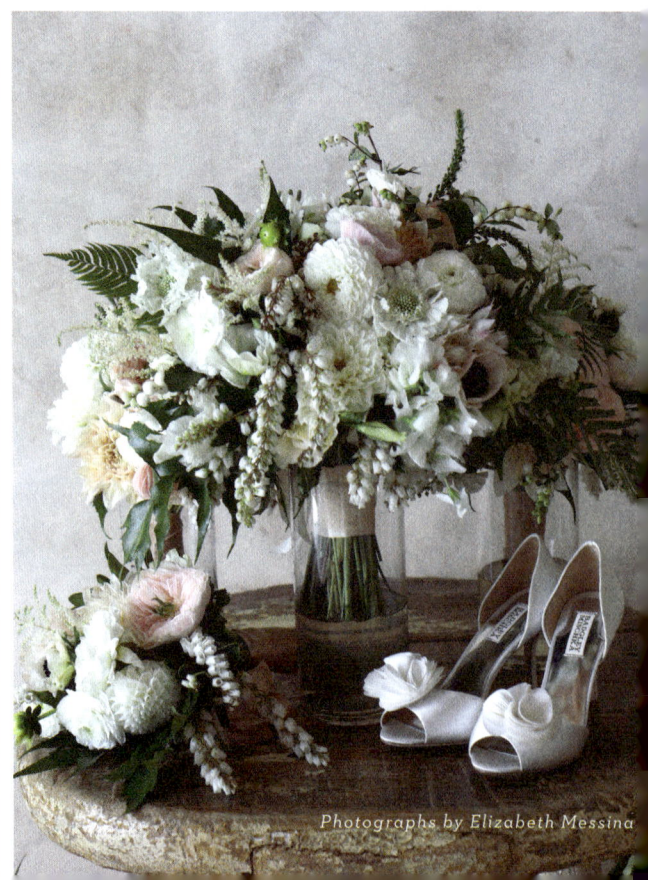

Photographs by Elizabeth Messina

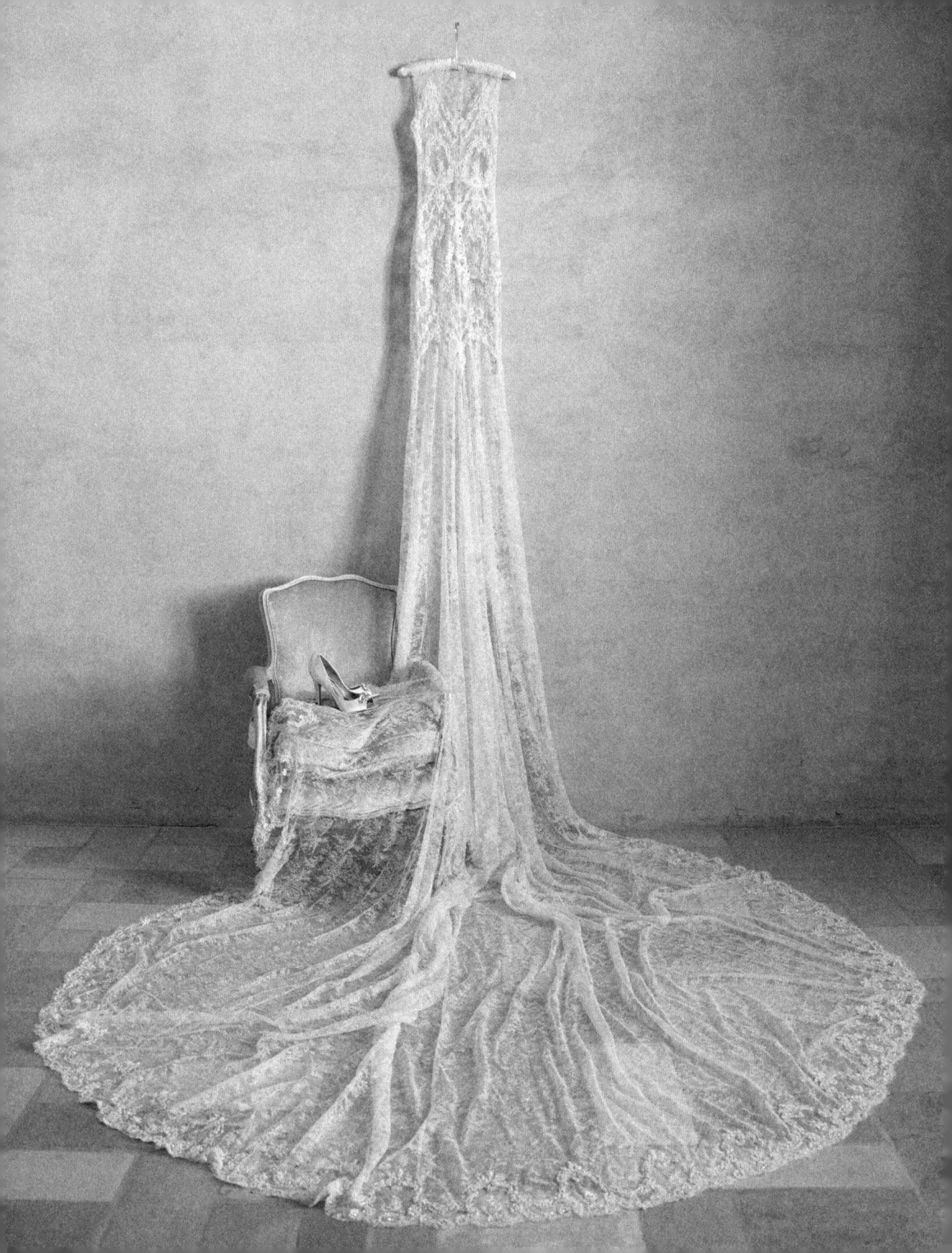

combining two laces: a delicate two-toned Chantilly lace all over paired with a thicker antiqued Alençon lace around the bodice to create the illusion of a pattern, which included a sweetheart neckline.

Under the dual-lace silhouette, they designed a slip because the dress itself was actually completely see-through with a very low back. I always knew I wanted two separate pieces and they designed a slip so beautiful it could have easily been worn as a wedding dress on its own—so much so that I changed into it later in the evening after the band shut down and a bunch of William's friends pulled out their acoustic instruments. Plus, it was time for the comfort food snacks, and the slip was a little less snug than my reception dress.

In the middle of the dress-designing process, I wore a merlot, velvet dress with a giant train for a photo shoot. It felt so special that I couldn't get it out of my head, and I asked James and Mark about the idea of adding a ten-foot train to my dress. They happily agreed! I wanted a very traditional-looking dress, so I initially wanted a sleeve, which James and Mark designed. When the gown arrived two weeks before the wedding, it just felt too serious for me. Plus, the weather was unseasonably warm and sleeves didn't feel appropriate. Either way, something was off, and I needed to fix it . . . and fast.

Before doing anything, I checked with the designers about how they would feel about me taking off the sleeves, and received their blessing. When I was in my final fitting, I turned to the tailor and said, "Remove the sleeves." He looked at me in utter shock . . . he couldn't imagine altering the design, and initially refused, telling me he just couldn't do it. I told him that I understood, but if he wouldn't do it, I was going to use a pair of kitchen scissors and do it myself. Reluctantly, he agreed and it came out perfect. It felt *much* more my style.

I never intended to wear a veil—with the train, it just felt like too much—but a week before the wedding I decided to order one. My amazing photographer, Elizabeth

*Photograph by Elizabeth Messina*

Messina, has shot some stunning veil photos, and I wanted to have it as an option.

My hairstylist brought a jeweled Jennifer Behr hair piece for me to wear at the reception with a half updo. During bridal photos, we started playing around with it and stuck it in my hair, along with the veil for a picture. We liked it so much I decided to wear it down the aisle at the very last moment.

I wanted shoes that virtually disappeared, so I wore very dainty, strappy, mauve Dolce & Gabbana heels.

## the reception dress

Given the enormous train I added to my ceremony dress design, it became a bit impractical for me to wear it during the reception. I wanted something I would feel comfortable in for the party and I would have spent the night terrified I would tear or step on it. For this, I turned to Monique Lhuillier. I knew I wanted a figure-hugging shape with a corset to keep me tucked in, but with enough movement for me to dance! Technically, it was a trumpet shape, but with only one layer of tulle, it felt very subtle. For the ceremony I wanted a more traditional neckline, but for the reception I felt comfortable with something less conservative, like a strapless sweetheart shape. I also wanted a very light Chantilly lace and since it was an outdoor wedding, I wanted to make sure it wouldn't drag on the ground, so I tailored it to perfectly hang around my white, peep-toe Badgley Mischka shoes.

## the beauty

I've been working with my hairstylist Kristin Ess and my makeup artist Amy Nadine for so many years that we didn't really need to do a test run. I wanted to look like myself— and nobody knew how to execute it better than these two. I think there's so much pressure to look the most beautiful you'll ever look on your wedding day that brides can go overboard. I wanted to look like me . . . on a really, really good day. The only thing we took into consideration was making it last through the afternoon and evening (and any possible tears), so we swapped out my normal mascara for a waterproof one. For my hair, I asked William whether he preferred it up or down, and he chose down. So my

*Being a beach girl, I was extra wary of tan lines in the months leading up to the wedding, since I knew I'd be wearing a strapless dress during the reception. Attention all brides-to-be, bandeau bikini tops are your friends. If you can't avoid some inconsistencies, apply some self-tanner or bronzer, but be careful! There's no bigger headache than self-tanner rubbing off on a white dress.*

hairstylist and I opted for a tousled, easy curl that I wore down for the ceremony and we later pulled slightly back for the reception. We added a bit more product than normal (which was really just some hair spray) so it would stay in place. Not to mention, Kristin and Amy were also guests! I wanted them to enjoy themselves and not keep running to the bridal suite with me for touch-ups.

## the jewels

All my jewelry was rose gold, including my engagement ring, wedding band, and two tennis bracelets. To celebrate my new last name, I wore a necklace with a dainty rose gold letter "T." I also wore a beautiful promise ring my father gave my mother when they were just seventeen.

## the bridesmaids

Before the wedding, Maura and I began noticing that people were ordering our Paper Crown dresses for their bridesmaid dresses—and we honestly thought that the idea was genius! We were both engaged at the time, so it felt like a natural progression of the brand. She and I started mocking up designs and soon realized it was big enough to be a collection itself . . . and so it became.

I wanted each girl to feel comfortable, so I gave them twelve styles to choose from. As a designer, and after being in a handful of weddings myself, I know that every body is complemented by a different shape. Although it's a personal choice, I think it can be a bit difficult to ask a group of girls to wear the same dress. Yes, it's

your day, but you want your best friends and family members to feel beautiful too. I offered my bridesmaids a handful of dress designs in varying lengths and fabrics (ranging from chiffon to crepe) in different shades of blush.

One thing brides struggle with is how much is too much to ask your bridesmaids to pay for a dress. As a bride, you should have the wedding you want, but you must be sensitive about what you're asking of your bridal party (multiple events, travel, hotels, etc.). Be mindful of costs already incurred; knowing how much I asked of my bridesmaids, I suggest taking care of yours when possible.

## *the groomsmen*

While I really would prefer to live in a world where all men had a signature, James Bond–quality tuxedo, the truth is most guys just don't feel the need to invest in a tuxedo these days. And I can't say I blame them (although there really is nothing more dapper). Tuxedos are expensive to buy, and we couldn't ask the groomsmen to do that, so we opted to rent them.

Rented tuxes have a bad rap. Sure, there are vendors that offer some really ill-fitting, sad-looking tuxedos, but if you do your research, you can easily find beautiful tuxedos for a reasonable price. We found our vendor after we went to a wedding where the groomsmens suits looked impeccable. When I asked the bride about them, she told me they were rented!

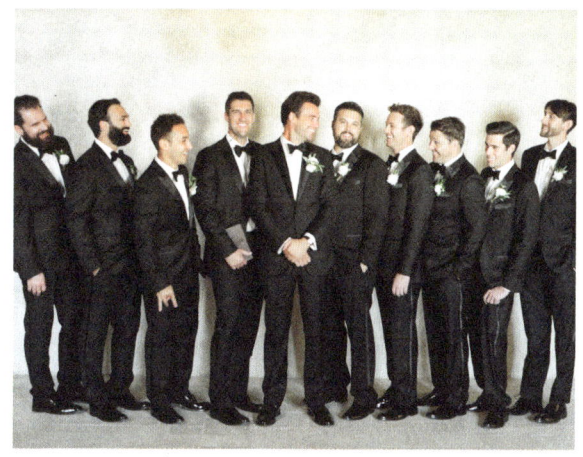

*Photographs by Elizabeth Messina*

## the guests

The rules for appropriate wedding guest attire are pretty simple: pay attention to the dress code and avoid all shades of white—including creams, ivories, and even that ultra-pale yellow. Keep in mind the time of year (spring is perfect for a pastel floral print; winter is great for jewel tones and textures), and always err on the side of caution, especially when navigating tricky dress code labels (like "mountain chic," "island formal," or "creative cocktail"). My opinion is that it's always better to be too dressy than not dressy enough. One note on footwear: Weddings are typically longer celebrations and might require a bit of time on the dance floor, so break in those new stilettos some other day! Finally, while everyone wants to look their best at a wedding, guests shouldn't outshine the bride, so avoid anything too flashy or revealing.

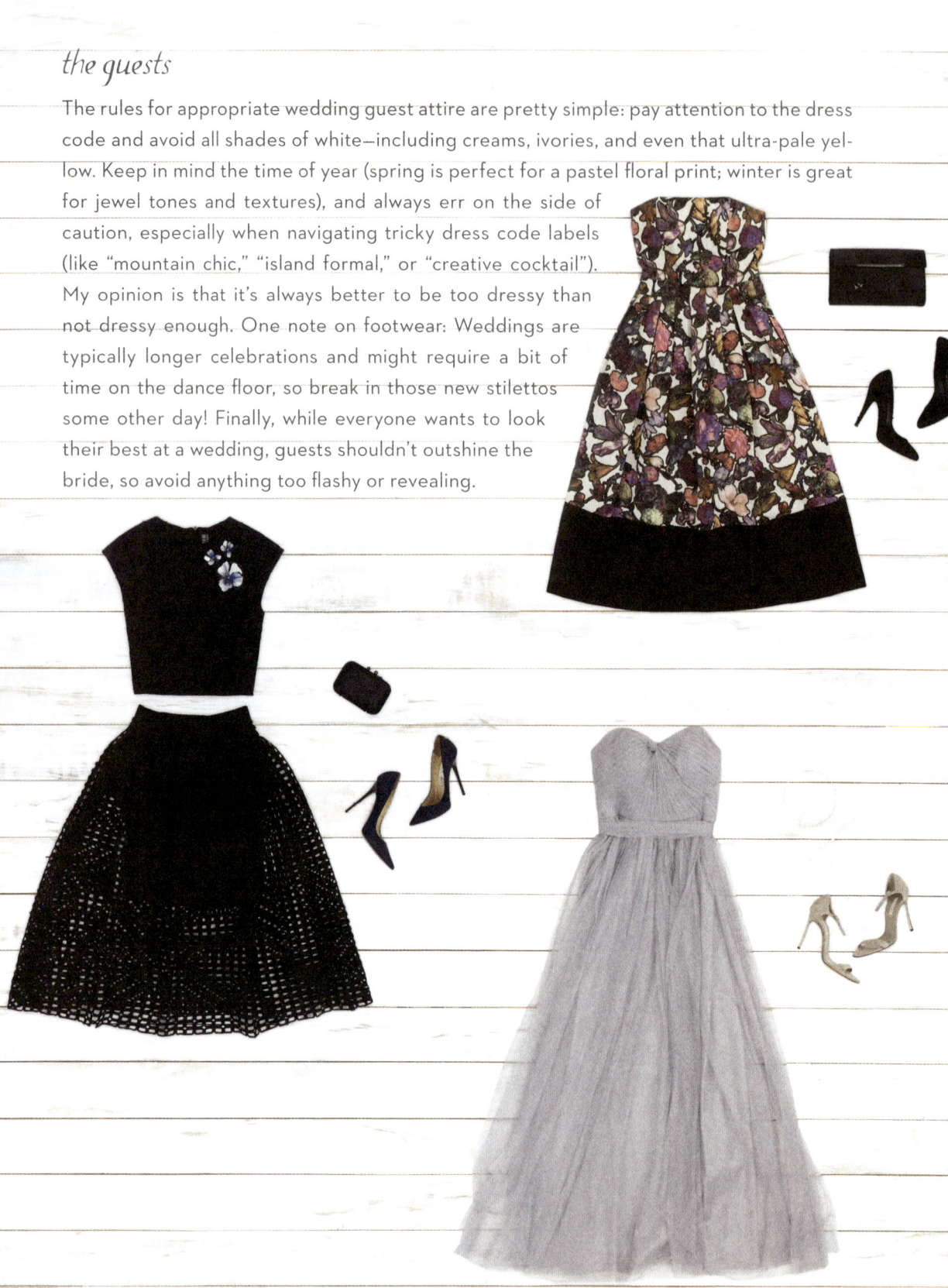

# THE ETIQUETTE
## *being a blissful bride*

It's so easy to get caught up in the *business* of wedding planning that you can quickly forget what the day is truly about. While thoughtful details can take your soiree from enjoyable to *unforgettable*, it's important not to obsess. After all the prepping, Pinterest-ing, and primping has been done, you need to hand over the reins and simply embrace the moment. Despite your very best efforts, chances are that something won't turn out exactly how you imagine it, but I'll let you in on a little secret: nobody will know the difference. Planning your wedding is only the first step, because now your real adventure begins.

*Photograph by Elizabeth Messina*

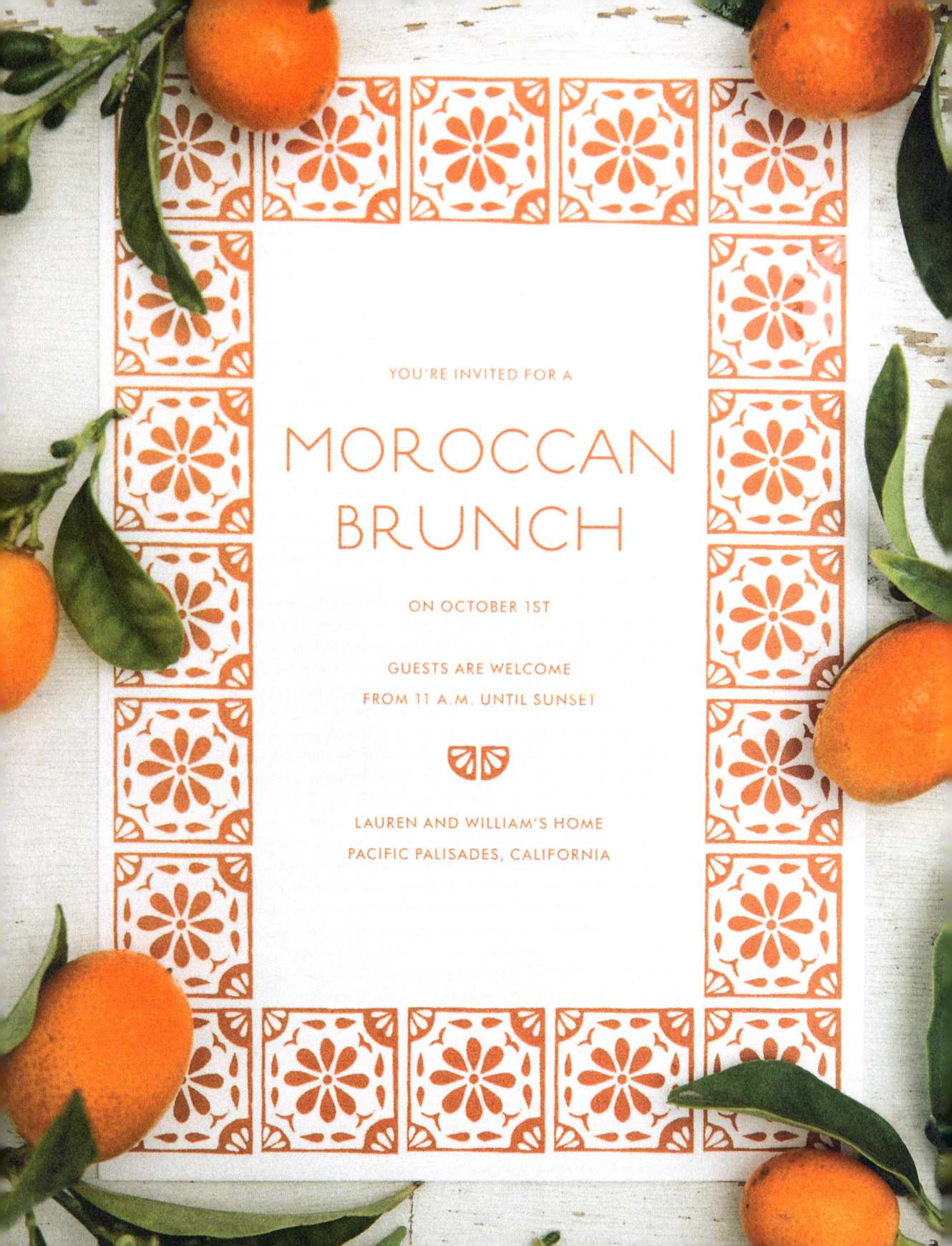

# 15
## the brunch

### the overview

There are a lot of wonderful things about brunch, but isn't it really just an amazing excuse for day drinking? Whether it's celebrating a graduation or an anniversary, or simply just because, it's one of the few socially acceptable reasons to pop the bubbly before noon. I'm particularly partial to autumn brunches, when summer has gone and the days begin to get shorter. Starting your event earlier means more time in the sunshine! And while we're on the topic, I prefer a Sunday brunch. With Monday right around the corner, most people still want to get the most out of their weekend, but also keep a reasonable bedtime. (We're grown-ups now, after all!) Brunch has also become a popular event to host the morning after a wedding. As the bride and groom, it not only gives you the opportunity to connect with guests you may not have been able to chat with the night before, but is also a lovely way to thank everyone for coming to celebrate with you. (It's especially popular for destination weddings.) With the craziness of the wedding day behind you, you can let your hair down and enjoy a wonderful celebration. Chances are, you spent a great deal of time planning the weekend, and now you get to toast all your hard work!

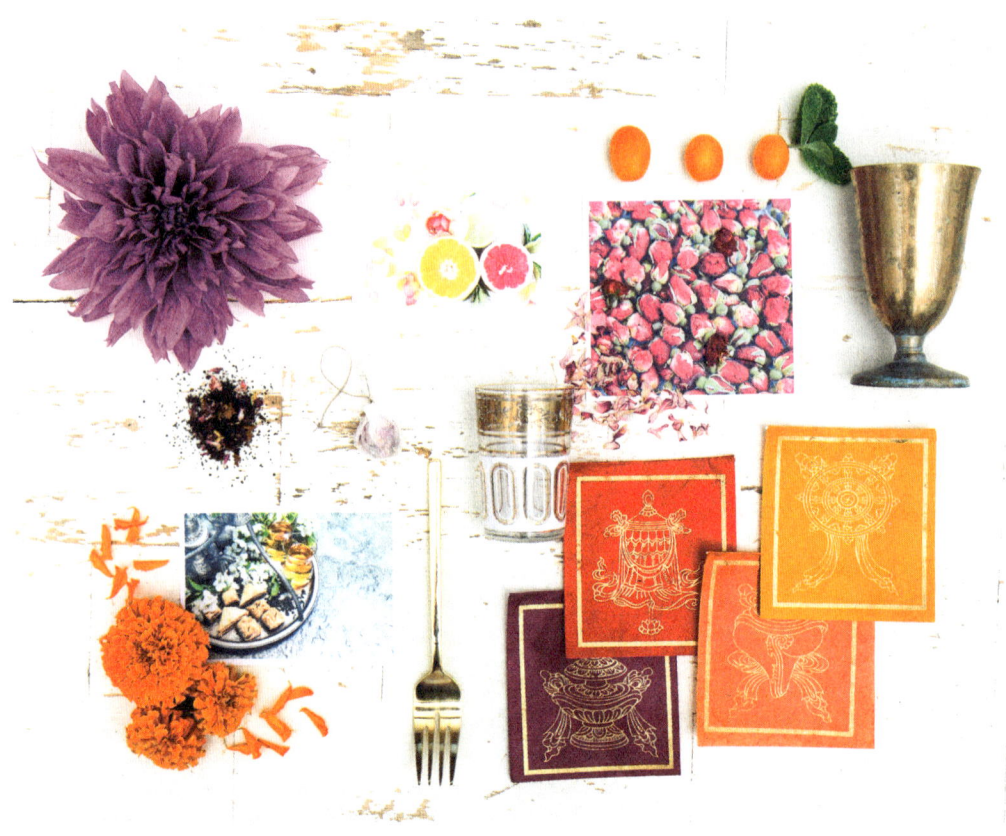

Brunches are a departure from a typical party because they're less structured. There are no hard-and-fast rules. People are welcome to eat, drink, and mingle as they wish; you don't want your guests feeling rushed. It's a more casual gathering, so some guests will come and go, while others will cozy up from late morning to afternoon sipping on champagne cocktails and nibbling savory breakfast fare. To honor that free-spirited vibe, I wanted to create a relaxed, bohemian atmosphere, so I decided on a Moroccan theme for this brunch. For colors, I chose softer, calming tones like Moroccan rust, dusty rose, and soft orange with a sprinkling of mixed metals, such as an aged silver and (of course!) vintage brass.

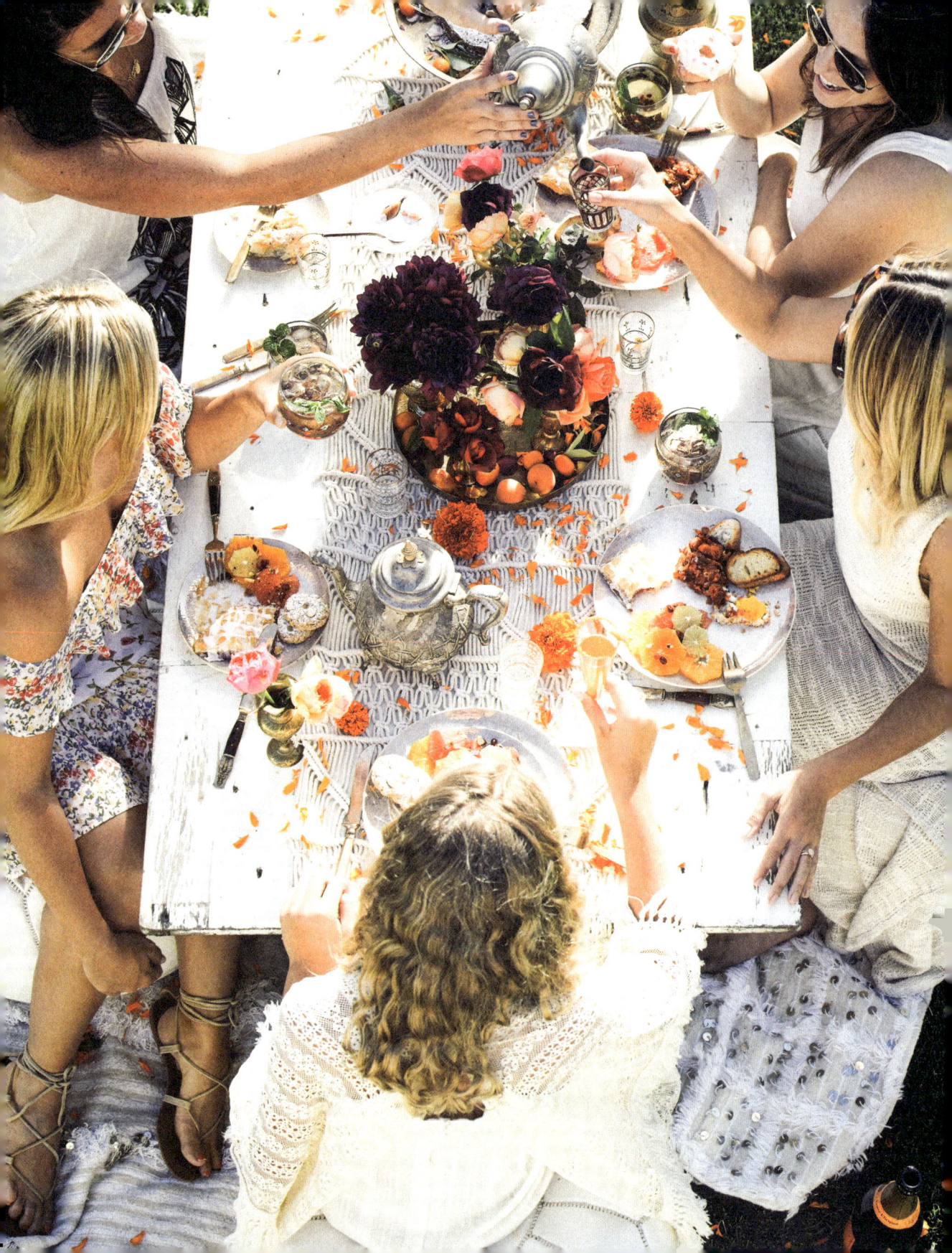

## the menu

When you're having a themed event, it's important not to get too carried away. You want the theme to serve as inspiration rather than dictate every detail. Sometimes less is more. You want to stay in line with the overall mood you're trying to create, but not at the risk of compromising your party!

Since guests would be stopping by throughout the day, I chose to serve the food as a buffet and continued refreshing dishes as needed (using cast-iron skillets, you can prepare the baked egg dishes ahead of time and pop a new one into the oven when you notice you're getting low). I stacked a pile of beautiful vintage Dorothy Thorpe china plates with gold flecks alongside the buffet. For serving trays, I wanted to mix and match hand-painted antiqued wood, aged embellished silver, and crisp white porcelain. The orange cake sat on top of a brass cake stand layered in white parchment paper and covered in kumquats and rose blooms.

*If serving as a seated meal, I suggest combining with a brass or aged silver charger.*

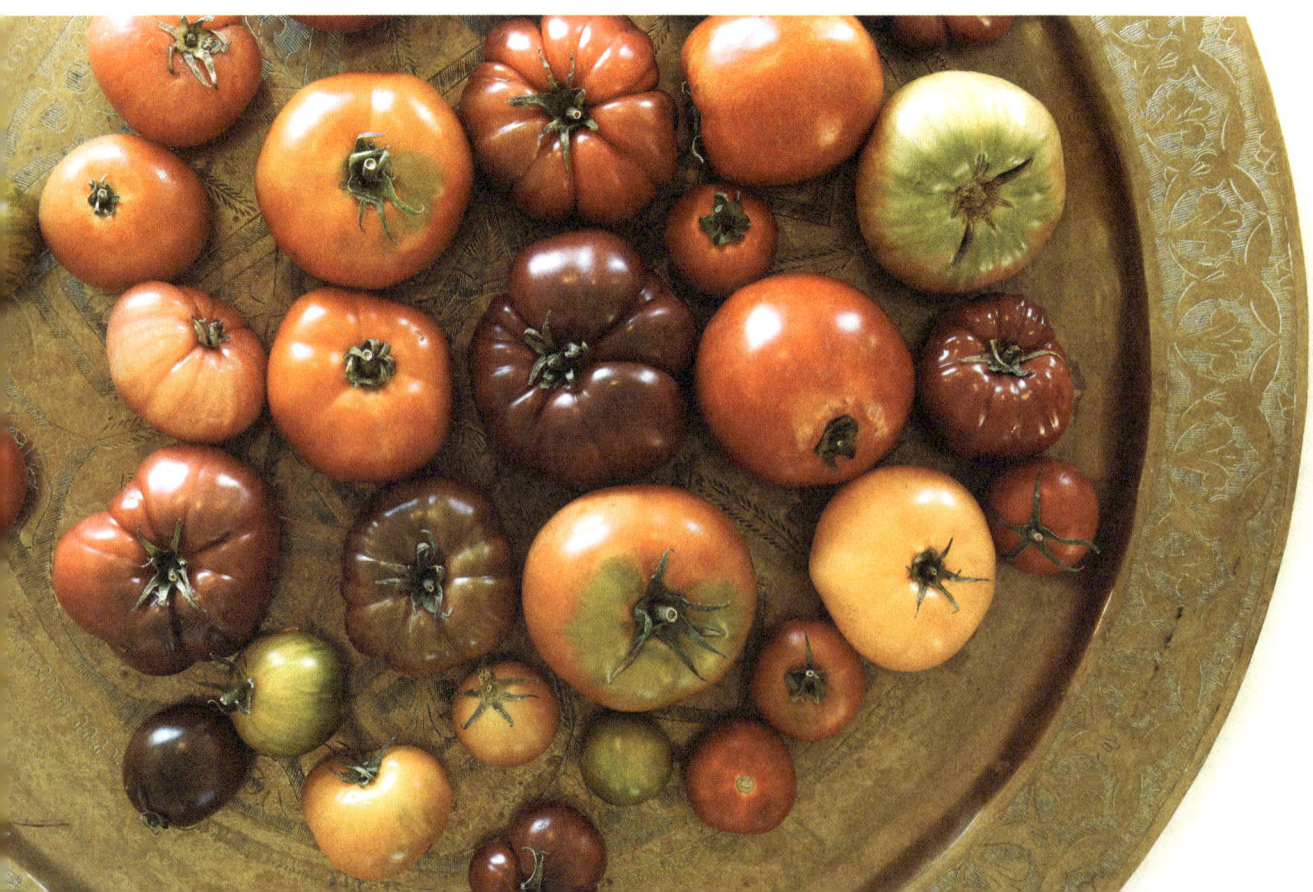

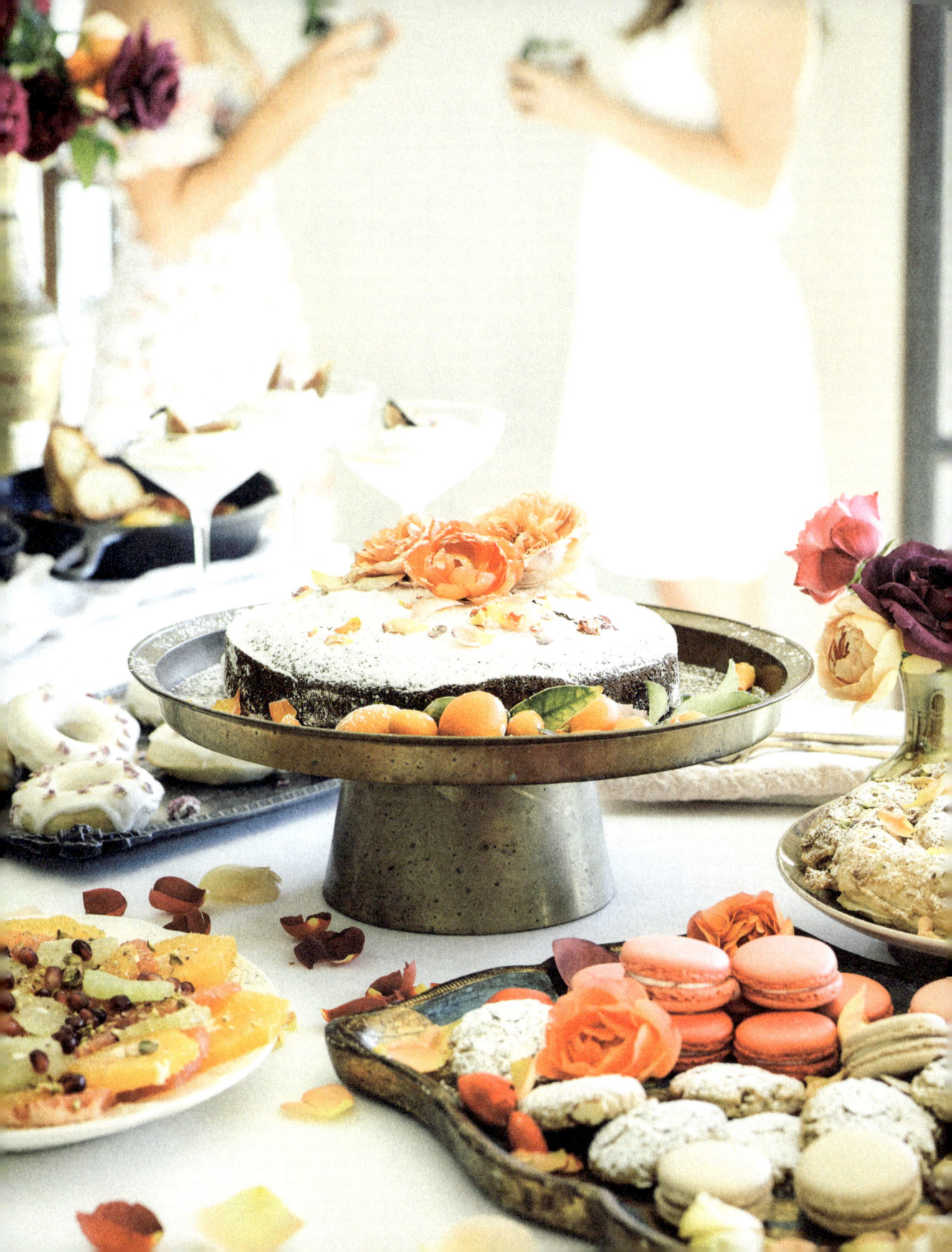

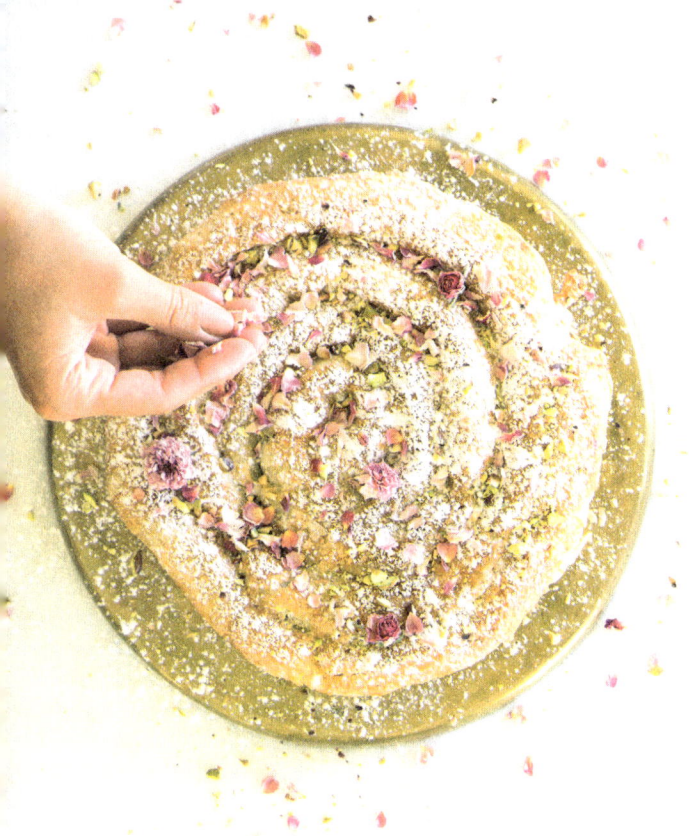

# moroccan brunch menu

Shakshuka (Baked Eggs) with Grilled French Bread

Assortment of Almond Pastries

Yogurt with Honey and Figs

Citrus Salad with Pistachio and Pomegranates

Persian Love Doughnuts Dusted in Rose Petals

Moroccan Snake Cake

Orange Cake with Powdered Sugar

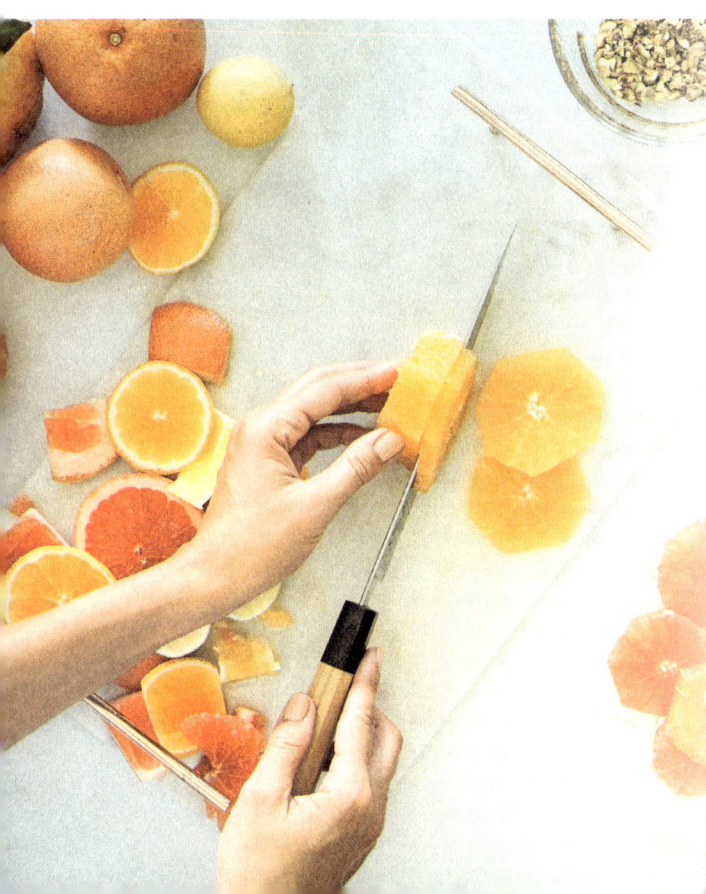

## *the bar*

People come for the food but stay for the drinks. In addition to the champagne, displayed in a floral ice bucket, I also mixed up a Moroccan mint and pomegranate mule served in 1940s lowball glasses. After noon, I offered a few bottles of white wine and beers as well.

Sometimes a little caffeine is necessary for a midday pick-me-up, so I also set up a "Steep Your Own Tea" table. I offered guests a variety of loose-leaf teas—from chamomile citron and ginger lemongrass to chocolate mint and rose oolong—and displayed them in antique finger bowls (along with vanilla-rose-flavored sugar) on a large brass Moroccan platter. Yet another flea market find are the beautiful aged silver teapots I used for the brunch, as well as the traditional Moroccan glass tea glasses with painted gold. For the teabags, I simply used cheesecloth and a bit of butcher's twine. To make the table feel special, we added a hand-painted antique brass vase with dark pink roses and sprinkled petals around.

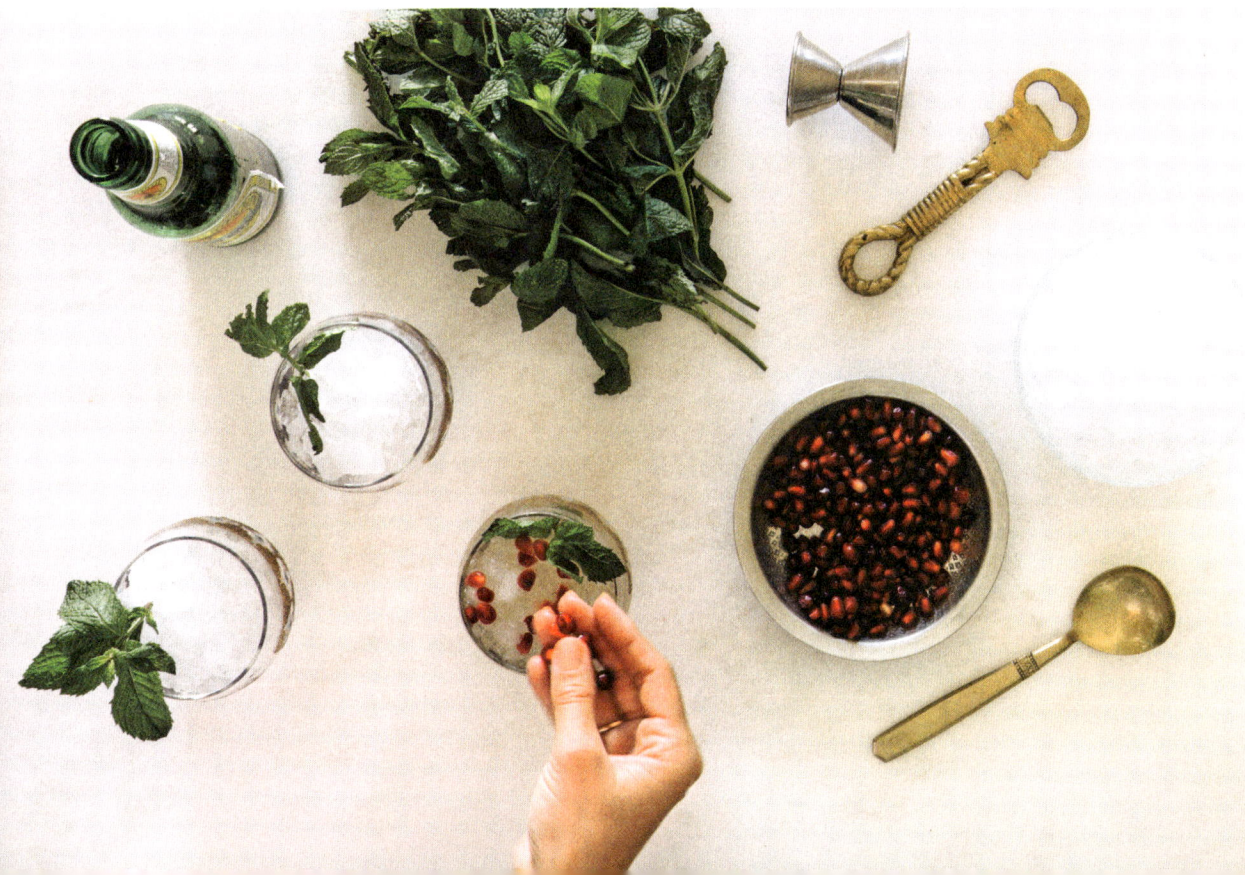

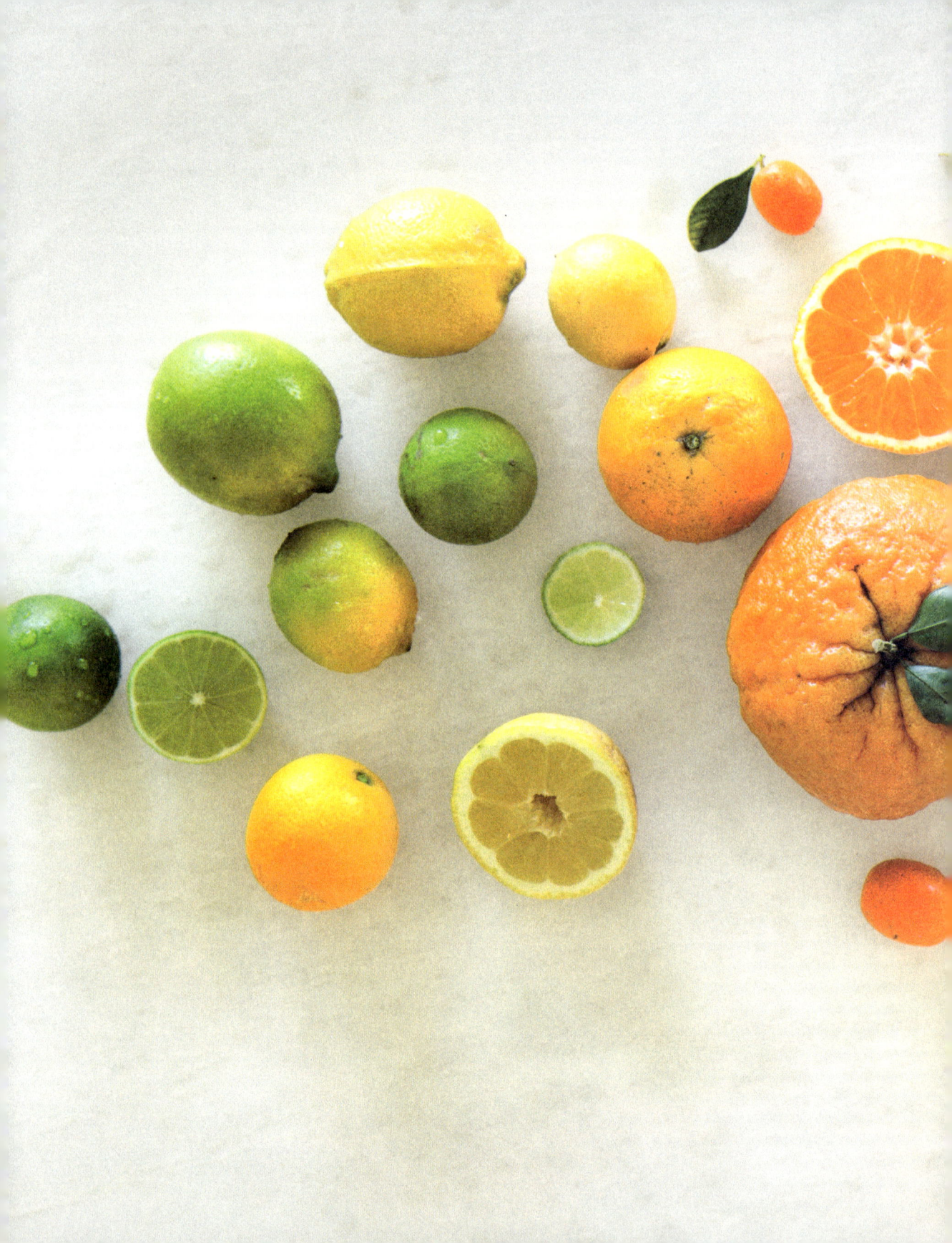

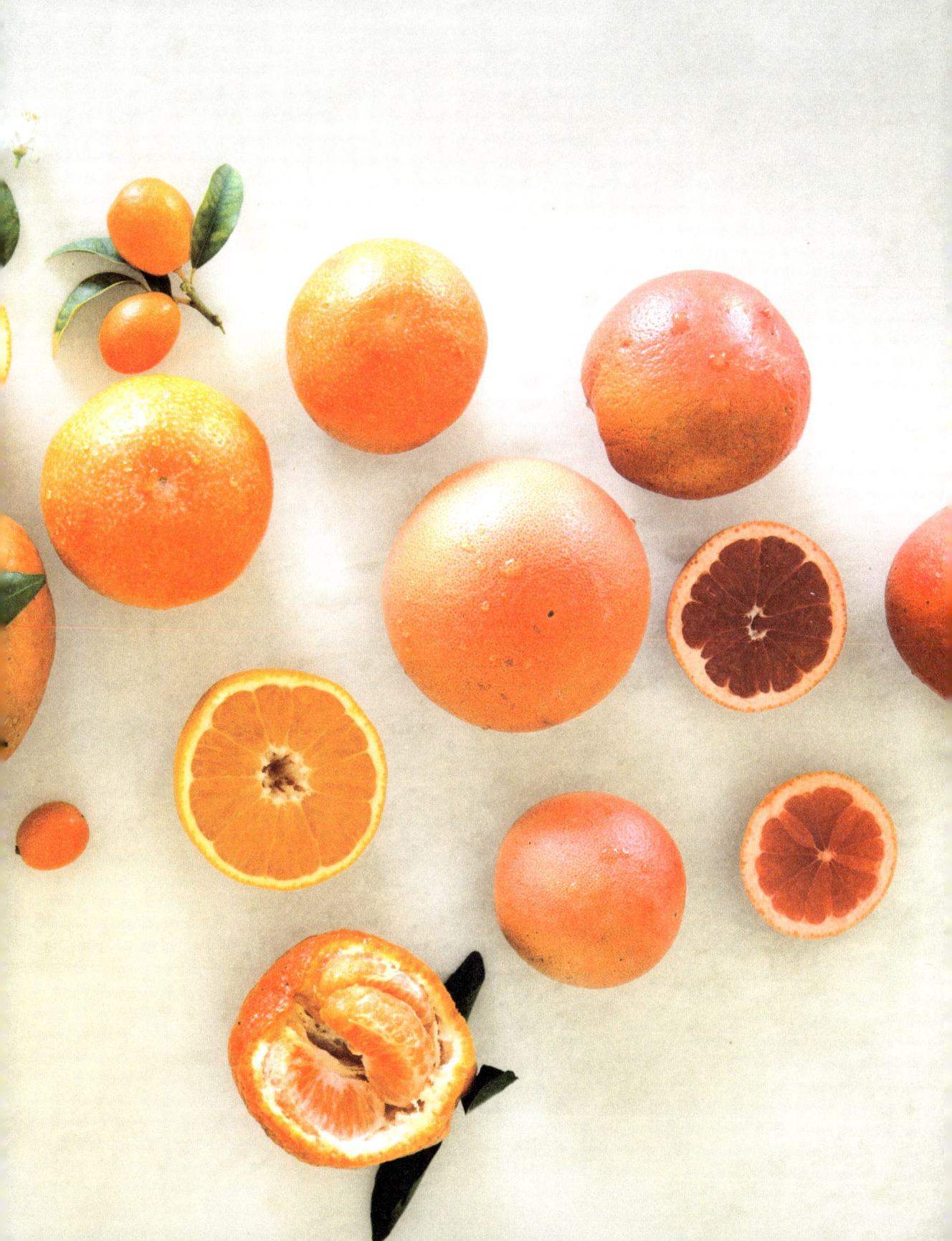

## the décor

Because the event was intended to feel glamorously unpolished, I wanted to create a vibrant tablescape that felt both uncomplicated and layered to capture the harvest qualities and rich tones. On my rustic wood king's table, I laid a macramé cream runner and sprinkled it with bright orange petals. Guests could pull up a white leather Moroccan pouf or lounge on one of the laid-out traditional Moroccan wedding blankets.

For the centerpieces, I chose vintage metal trays and clustered small arrangements of deep red dahlias, as well as peach, coral, and bright pink garden roses in aged brass goblets and vases (see, William, I told you I'd keep using them!). I wanted to mix colors to give the arrangements more depth. Because Morocco is known for its precious metals, I also mixed a variety of silver pieces into the décor. To keep with that easygoing Bohemian vibe, I placed full-bloomed roses and kumquats around both the dining and serving tables.

Word to the wise: Your guests will feel so at home they might never want to leave!

## the details

Since this was a family-friendly event, I wanted to add an unexpected bit of charm and, naturally, a teepee was the perfect option! I found a simple white canvas children's teepee online and, using scissors, enlarged the opening along the seam so grown-ups could enjoy it as well. To create a dreamy vibe, I used vintage lace blankets as an overlay to give it depth and laid out a jewel-toned vintage Moroccan sheet along with wedding blankets. It was a great place for people to relax, drink some tea, or enjoy a cocktail!

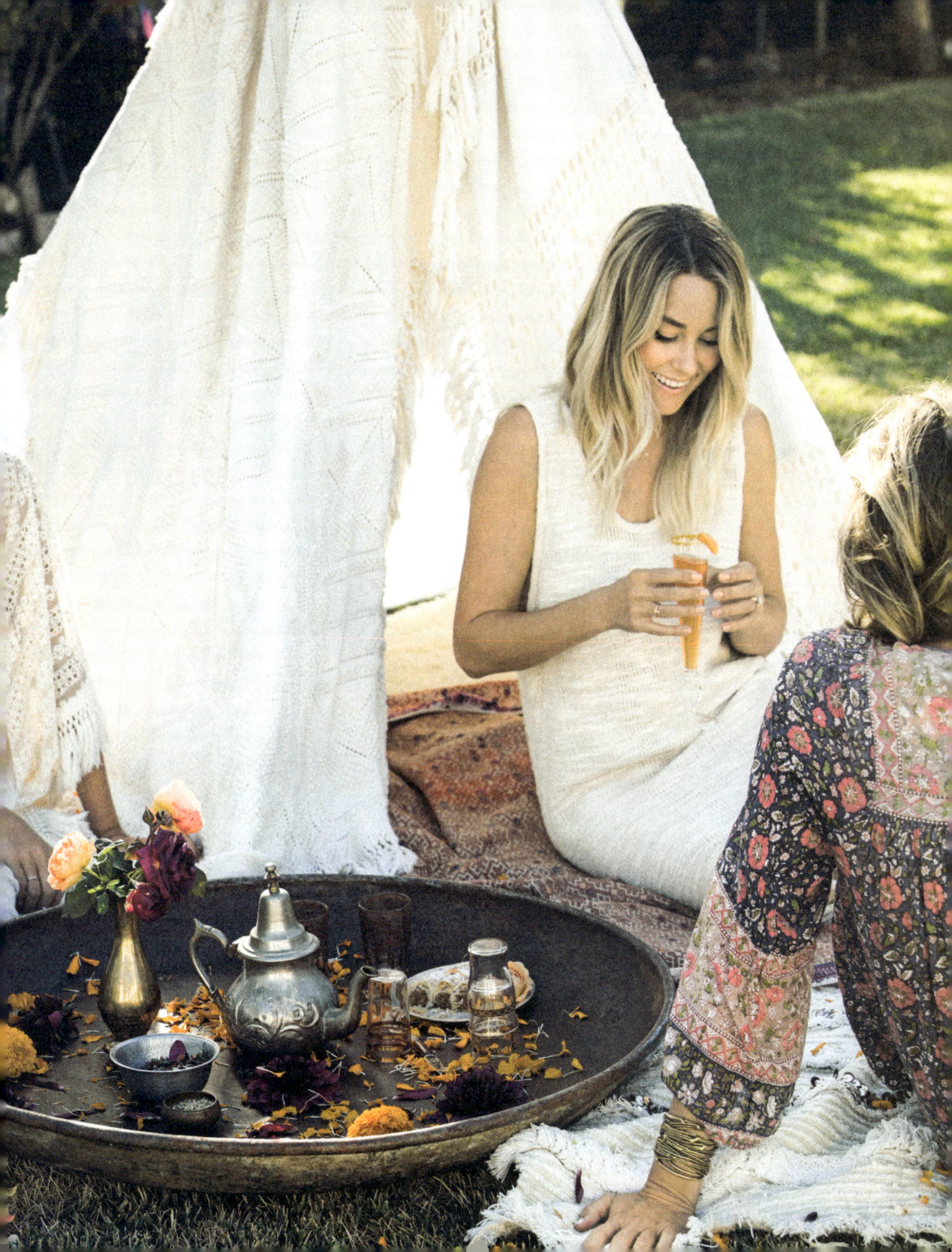

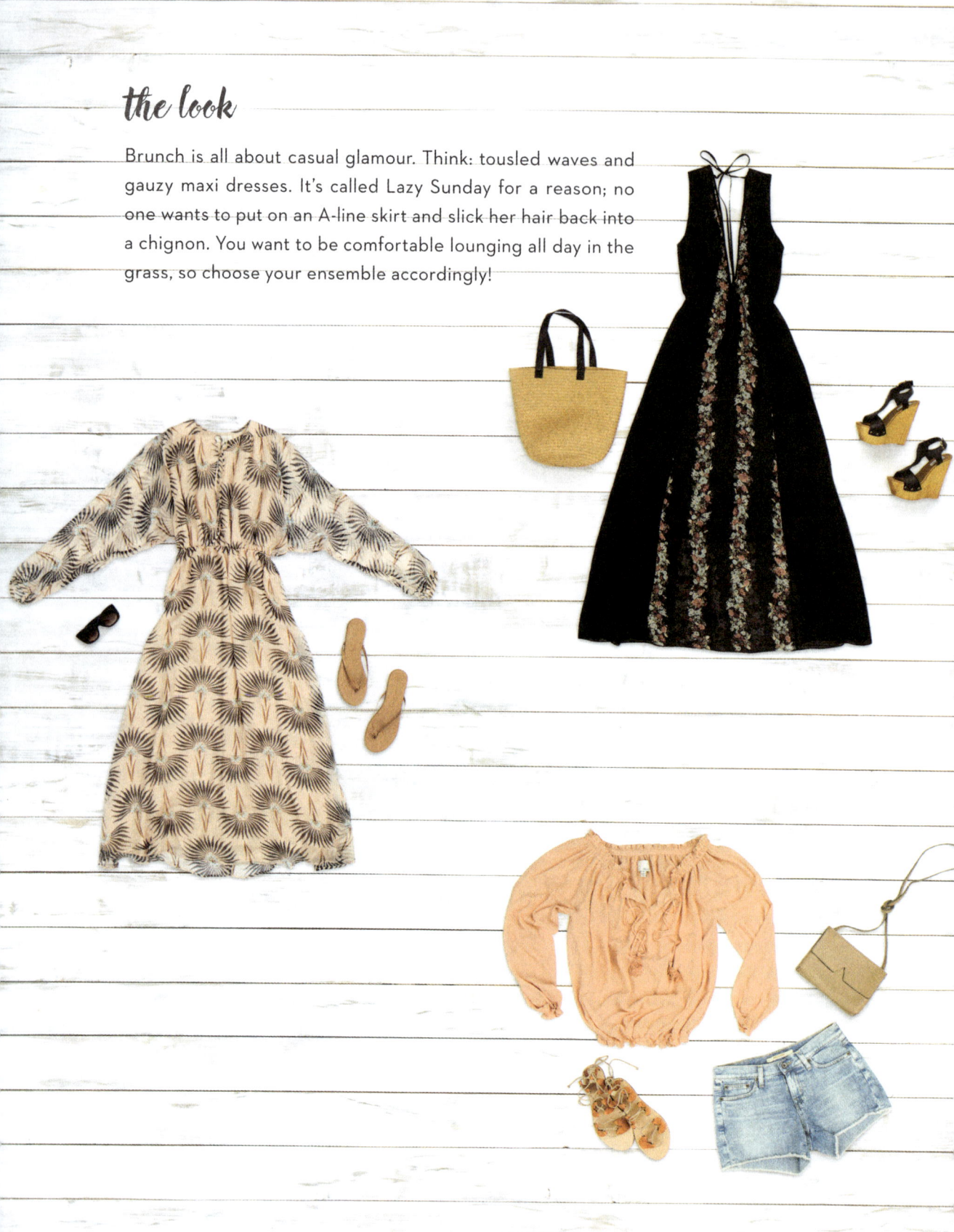

# the look

Brunch is all about casual glamour. Think: tousled waves and gauzy maxi dresses. It's called Lazy Sunday for a reason; no one wants to put on an A-line skirt and slick her hair back into a chignon. You want to be comfortable lounging all day in the grass, so choose your ensemble accordingly!

## THE ETIQUETTE
### the unexpected guest

Earlier we discussed how, as a guest, you are able to determine whether you are invited with a plus one, or whether it's an appropriate event to ask if you may bring a guest. As a habitual hostess, it's inevitable that you'll be faced with this dilemma.

Over the years, I've hosted quite a few events where guests have appeared at my door without RSVPing or a partygoer has arrived with an unexpected plus one. For this reason, I always try to account for a few extra heads when preparing the menu and when stocking the bar (this is when that 20 percent safety buffer comes in handy!).

Your goal should be to handle the situation with grace and discretion. Quietly arrange for another place setting, even if that means getting inventive with seating (an ottoman can make a quick fix, and can usually seat two people at a dining table). If it's a buffet, just put out extra dishes and flatware. In the event that there isn't quite enough food, it's your obligation to serve yourself last and least (and, if needed, nudge your significant other or cohosts to do the same).

I'd suggest keeping the issue quiet and not to bringing it up to the person(s), or to any other partygoers, for that matter. Even something as simple as, "What a surprise! We weren't expecting you," can leave a bad aftertaste. My best advice is to make any necessary accommodations in order to balance out the event, and then forget about it. Letting yourself be bothered by it will take away from the fun you should be having.

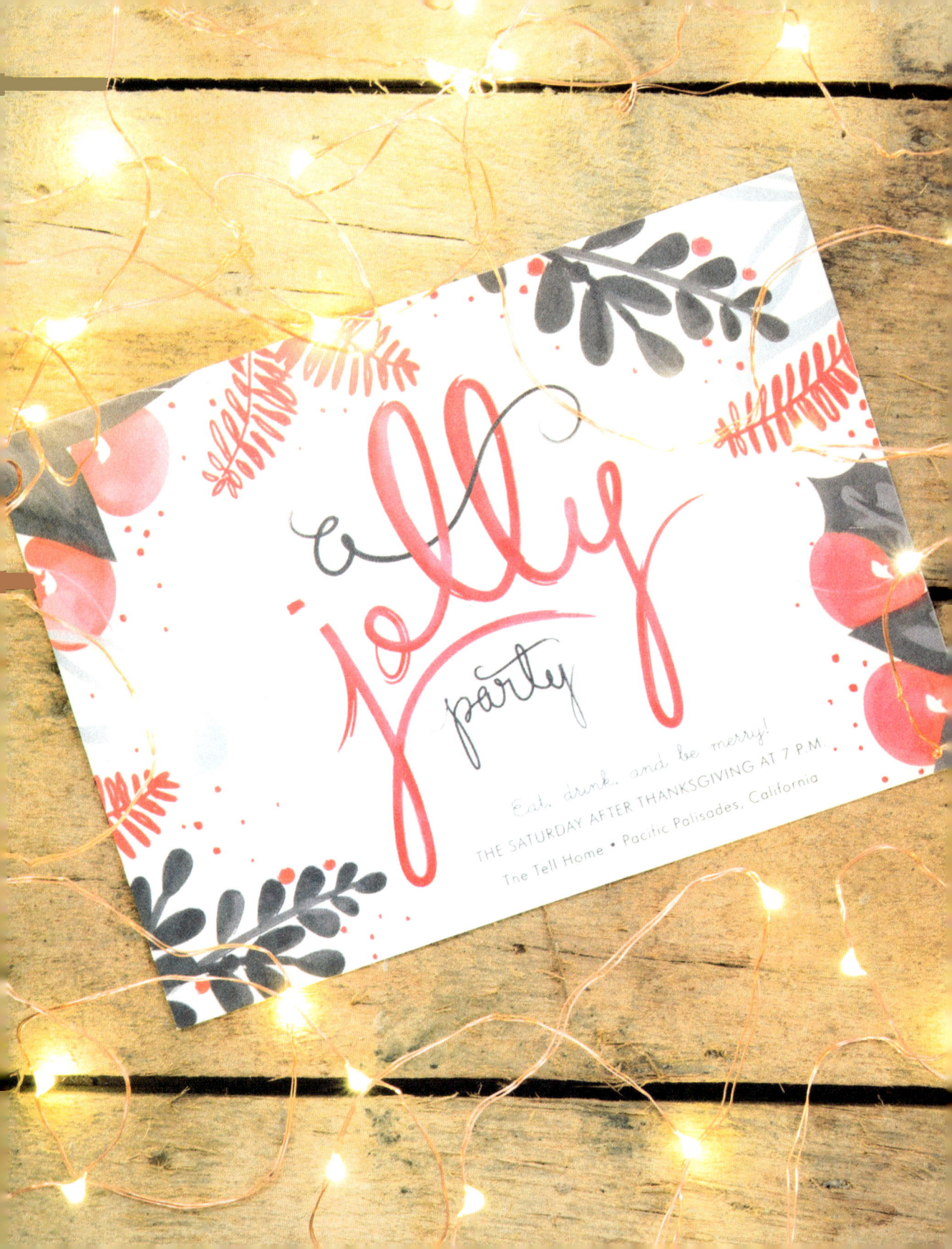

# 16

## the holiday party

### the overview

When I was growing up, nothing quite marked the holidays like my mom's spiced hot apple cider. Every year before my family's annual Christmas Eve celebration, my mom would pull out an oversized stainless steel pot and begin her annual ritual of brewing up the cider. As a little girl, I relished in the sweet, sugary scents of cinnamon, citrus, and cloves drifting through the air, knowing that Santa Claus wasn't far behind. Something about it just *smelled* like Christmas.

As an adult, the holidays are usually the most hectic time of year. We're overprogrammed, overstressed, and, usually, overtired. The hustle and bustle can take away from the true spirit of the season, so we all need a reminder to slow down and have a candy cane. For me, that reminder is hot apple cider. It's a ritual that I've now adopted into William's and my holiday traditions. When that familiar aroma fills our home, all the chaos just seems to melt away. And that's what the holidays are all about: spending time with loved ones, making memories, and celebrating traditions (both old and new).

For the past few years, I've hosted my own holiday party the weekend after

Thanksgiving. It's an occasion to get together with my closest friends before the craziness of the December holidays begin. In the past it was often a larger party, but over the years I've started to appreciate a smaller gathering where I can actually spend quality time with the people closest to me. William and I invited around a dozen friends for hot appetizers, festive cocktails, and good holiday fun!

    I wanted the color palette to reflect the mood I was trying to evoke: warm but also regal (the holidays are fairly formal after all). I chose bright copper; deep, velvety navy; sugarplum; and a few pops of soft icy blue.

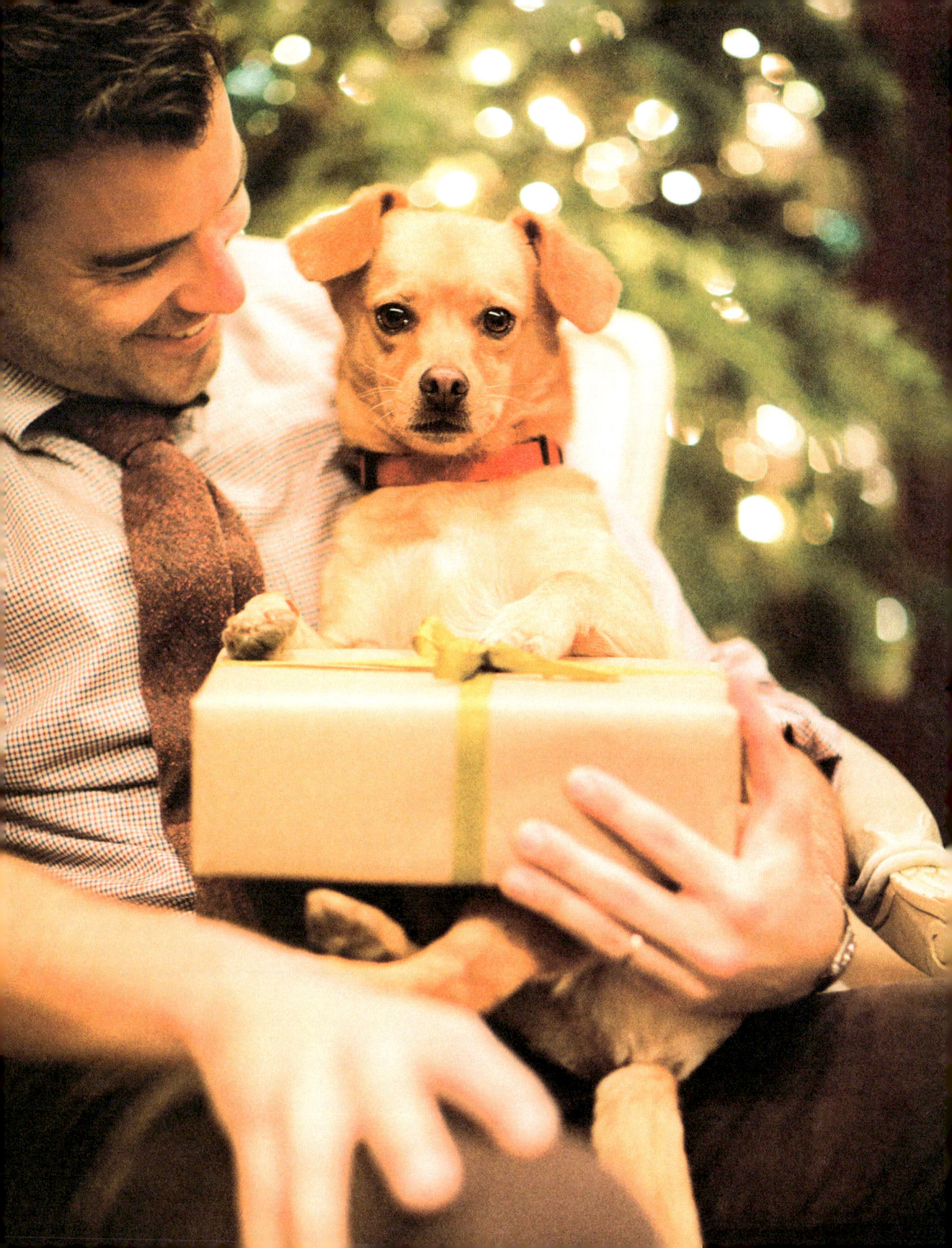

## the menu

The holiday season warrants heartier dishes to warm your tummy. While a holiday party is not a huge festivity, it might have a larger-than-usual guest list and not be practical for a seated meal, so as we've by now seen is often the case, I chose to offer heavy appetizers that could easily be enjoyed standing up or sitting down (think: one hand only!).

We put together a spread of some of our favorite holiday foods—and even put a twist on some holiday classics (like mini turkey potpies!).

For the savory appetizer buffet, I used rustic serving ware and copper flatware and offered up the bites on vintage pizza boards. I chose gray Heath ceramic plates and black crystal glassware to mix in with the other rich elements.

## the bar

The holidays are known to be a beverage-friendly time of year, so I mixed up two specialty cocktails in addition to wine and champagne to make sure all the vintage black goblets were full. Because I'm a sucker for tradition, I've been re-creating my mom's annual apple cider for William's and my holiday parties but giving it my own twist (hint: booze). The first year, I added the liquor directly into the pot (not realizing that the low heat would eventually cook off all the alcohol!). I've since learned to have guests ladle their cider directly from the stove and add the brandy after. We also offered a premade blackberry gin fizz with fresh sprigs of thyme in midcentury glassware.

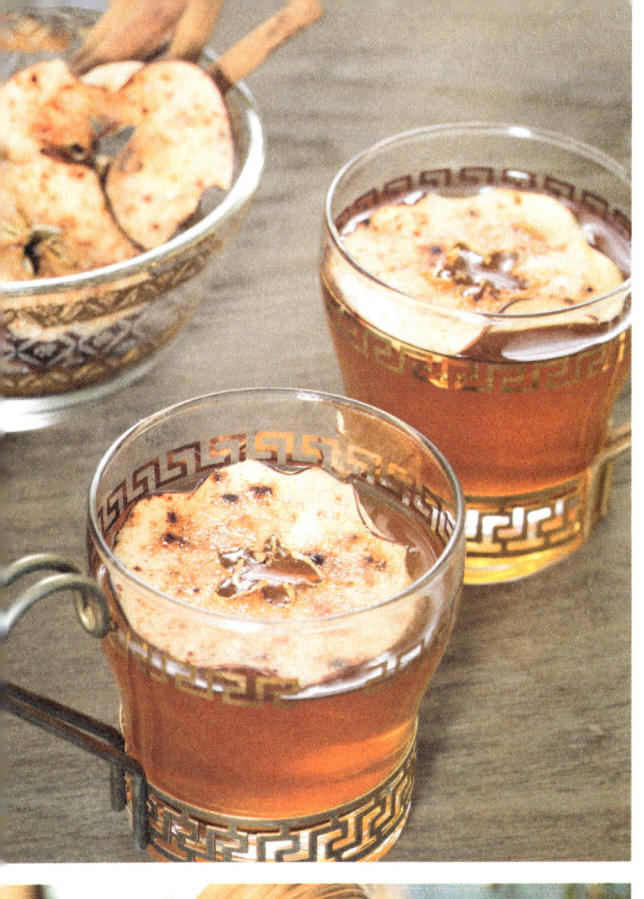

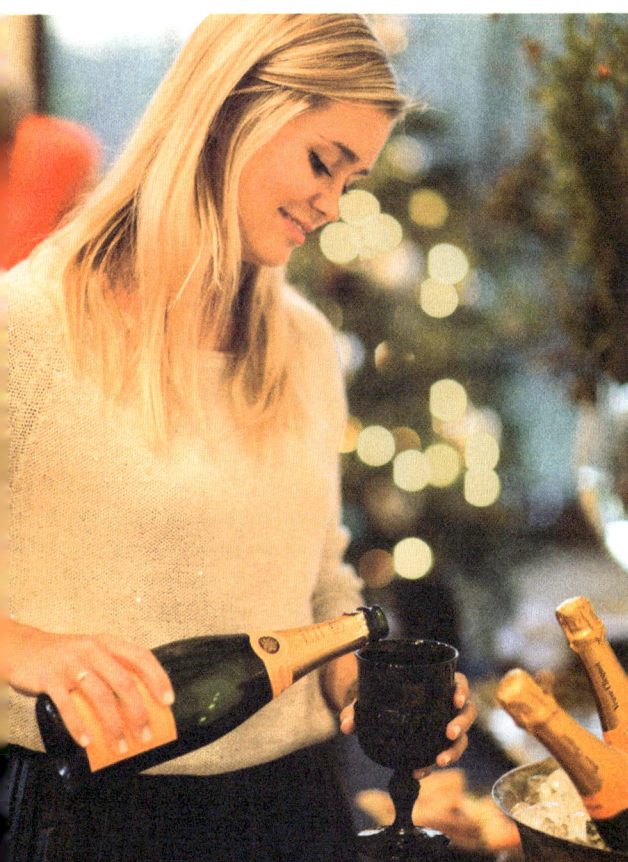

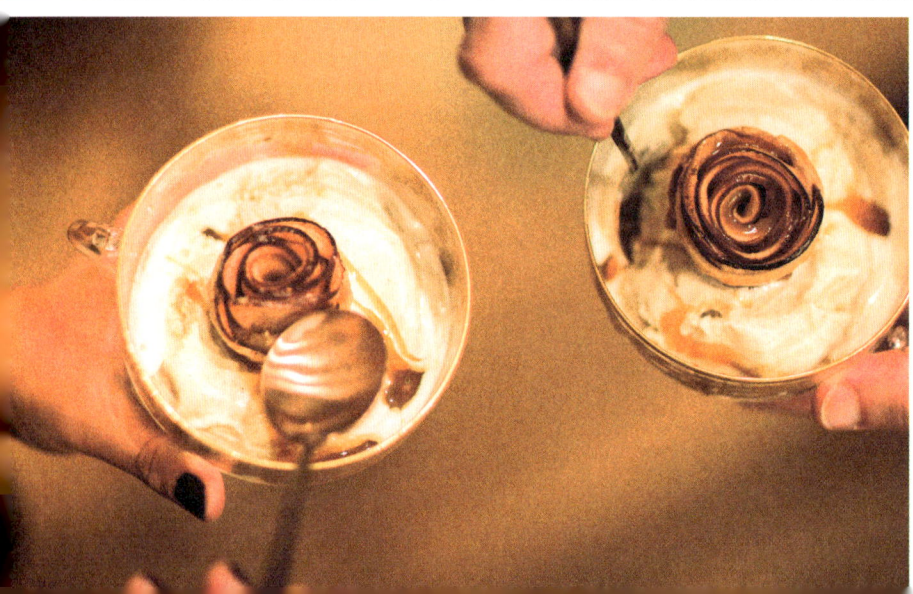

# holiday party menu

Salad Wreath with Fruit and Nuts

Individual Scalloped Potatoes

Mini Turkey Potpies

Caramelized Onion, Pear, and Prosciutto Flatbread

Blackberry, Ricotta, and Basil Flatbread

Blueberry, Arugula, and Goat Cheese Flatbread

Apple Rosette Pie Bites à la Mode

*classic holiday playlist*

"SANTA BABY"
-MADONNA

"WHITE CHRISTMAS"
-BING CROSBY

"BLUE CHRISTMAS"
-ELVIS

"ALL I WANT FOR CHRISTMAS IS YOU"
-MARIAH CAREY

"BABY IT'S COLD OUTSIDE"
-DEAN MARTIN

"HANUKKAH SONG"
-ADAM SANDLER

"MERRY CHRISTMAS BABY"
-BRUCE SPRINGSTEEN

"CHRISTMAS TIME IS HERE"
-VINCE GUARALDI
(CHARLIE BROWN)

"THE CHIPMUNK SONG
(CHRISTMAS DON'T BE LATE)"
-THE CHIPMUNKS

"SILVER BELLS"
-BING CROSBY

"JINGLE BELL ROCK"
-BOBBY HELMS

## the décor

I know that the holiday season means different things to many people. Personally, my family celebrates Christmas, which means a blue spruce and some mistletoe. It's probably my favorite holiday to decorate for, so it's not uncommon to find me pulling out ornaments and garland while the Thanksgiving turkey is still warm. For a tree, I found a potted blue spruce and covered it in tiny white twinkle lights and added a few vintage Shiny Bright ornaments (yes, I collect those too . . . I may have a problem), then topped it with a big, glittering star. To create a warm ambiance, I placed tea lights around the house for a soft glow.

I decorated the fireplace mantel using branches with twinkly lights and some large white garden roses and cranberry bundles woven throughout to create a magical woodland feel.

## the details

Buying gifts for your family and friends can be overwhelming. How many times have we said, "I have no idea what to get so-and-so"? That's why I'm in favor of the White Elephant Gift Exchange! Everyone gets a present to open without all the pressure of finding "the perfect gift." Set the rules beforehand for your guests. For example, no one can spend more than $20. The holidays are all about laughter and good cheer, and what's better than seeing one of your more buttoned-up family members forced to try on a ridiculous hat?

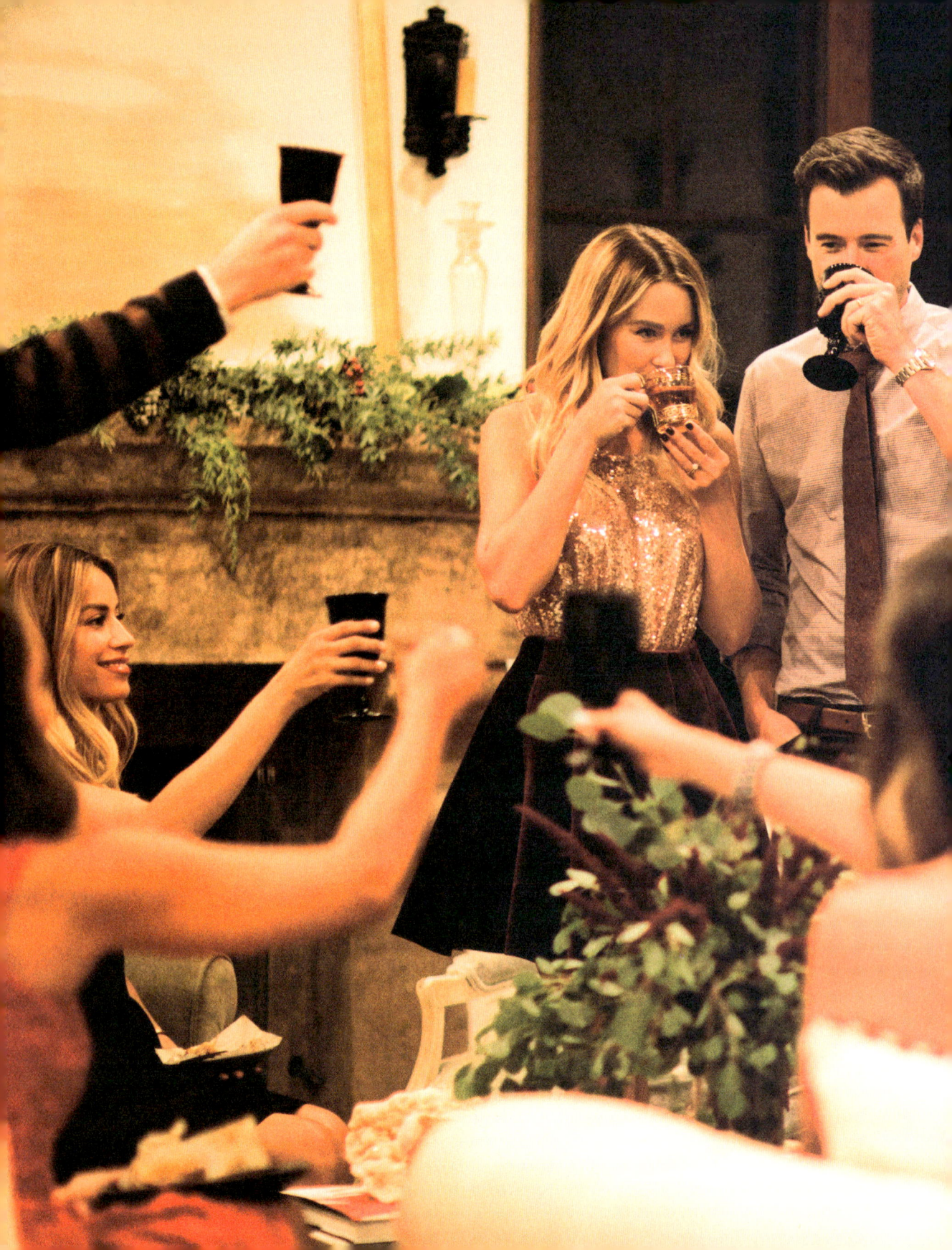

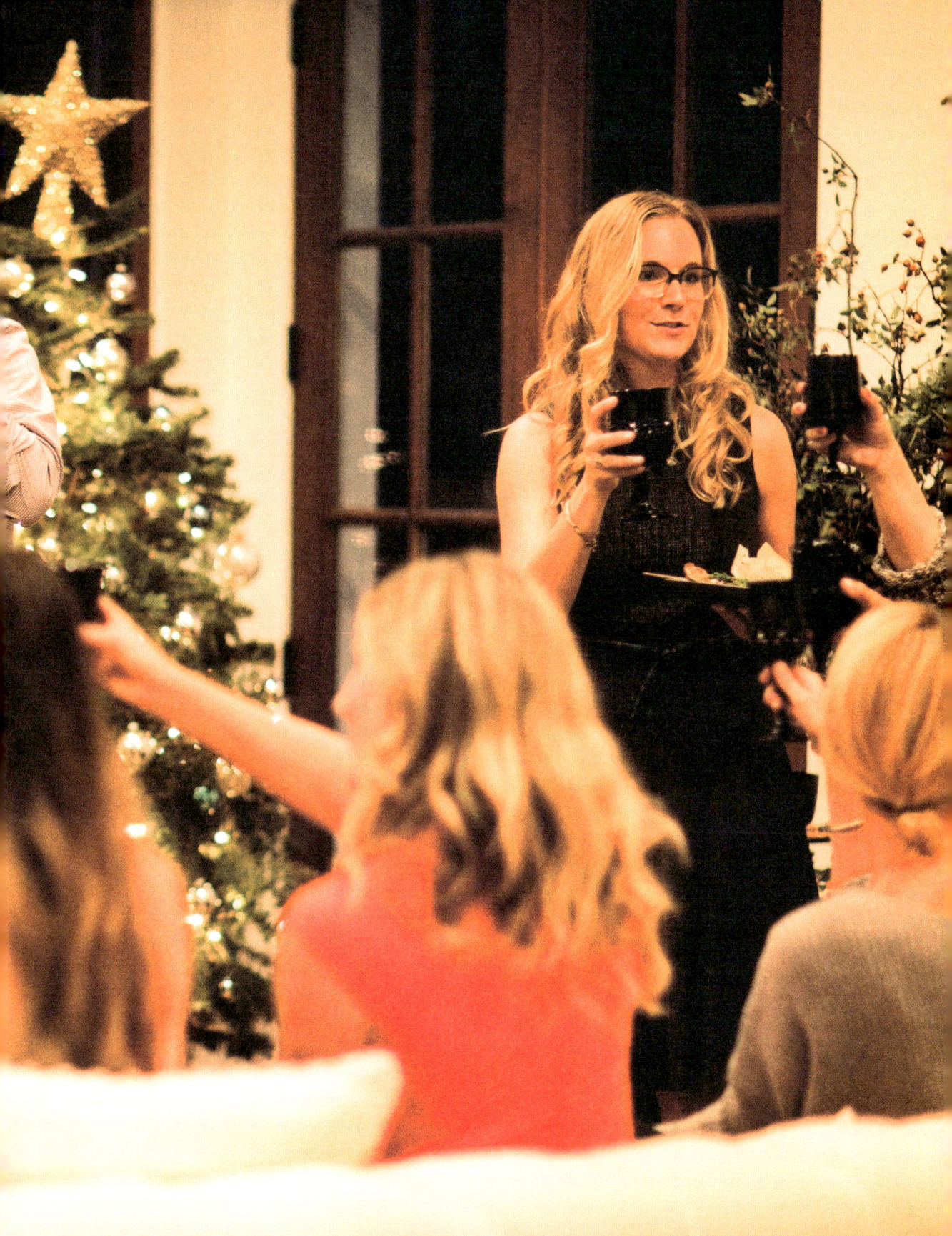

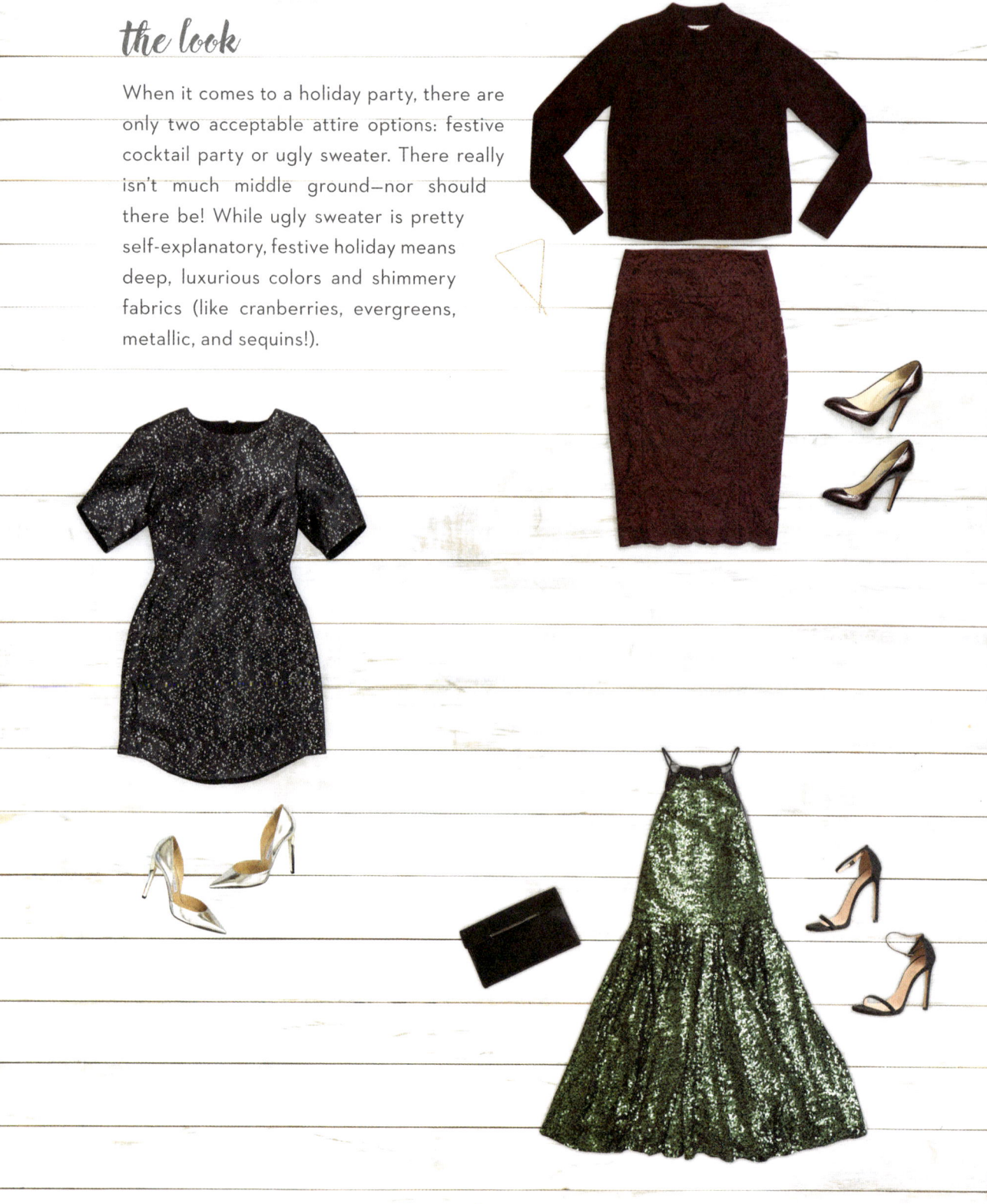

## the look

When it comes to a holiday party, there are only two acceptable attire options: festive cocktail party or ugly sweater. There really isn't much middle ground—nor should there be! While ugly sweater is pretty self-explanatory, festive holiday means deep, luxurious colors and shimmery fabrics (like cranberries, evergreens, metallic, and sequins!).

## THE ETIQUETTE
### the "in case of emergency" present

During the holidays, I always have a few spare gifts laying under the tree, beautifully wrapped and decorated . . . with blank name tags. Whether it's a thoughtful party guest, a considerate neighbor, or a courteous colleague, someone might surprise you with a holiday gift. This is not to be confused with a hostess (or host!) gift, which is a small token meant to thank you for the invitation; this is a proper present (you'll know the difference).

    For that reason, around this time of year I make sure I have a handful of extra gifts that are general enough to be appropriate for different people, but special enough so they don't feel like an afterthought. If in doubt, pick up a few things: a copper wine key, soft knit gloves, a nice candle, or a box of pretty notecards.

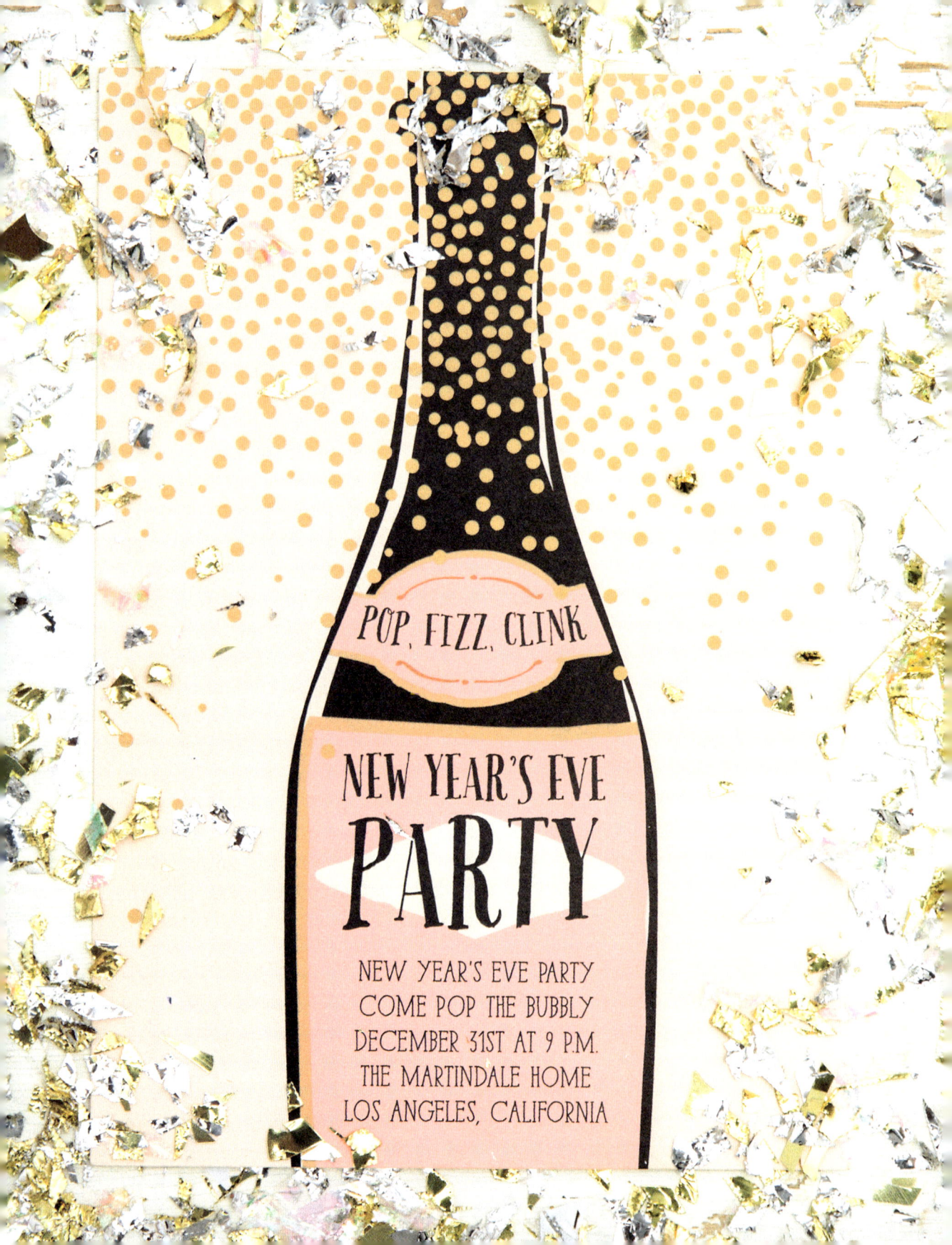

# 17

## the new year's eve party

### the overview

New Year's Eve might be the most stressful holiday. It's the one night of the year where "fun" is obligatory. There is so much pressure to have "the best night ever"—and, more often than not, it ends up being a bit of a letdown. First, you need to decide which overcrowded, overpriced, overhyped party to attend. Next, you have to figure out who you're going with. If you decide to keep your group small, someone will inevitably feel left out. To save yourself the headache, you might just invite all your friends, but good luck finding a large-party dinner reservation or an event that everyone will be happy with. It's just not possible. After all that, maybe you somehow manage to find the greatest party in town, but how do you plan to get there? No one wants to drive on New Year's Eve, and finding an available taxi is like bumping into a unicorn. But if you do happen to find that mythical cab, you'll pay a pretty steep premium. Once you finally get to the party, they're almost always at capacity with a line wrapped around the block. And that's just the start of the many lines you'll be standing in for the rest of the evening. From the bathroom to the bar, you'll spend most of your evening waiting, waiting, and waiting some more. I'm exhausted just thinking about it.

That's why, for the past few years, I've decided to skip all the New Year's Eve madness and host a festive cocktail party. It may not be the most coveted invite in town, but I couldn't imagine being anywhere else. I still get to put on a fabulous party dress, drink champagne, wear silly hats, and ring in the New Year with the people I love most—without all the nonsense. This year, I decided to host it with my close friend Kate at her home in L.A.

We put together a guest list of twenty-five. Keep in mind that your guests might have a few parties to attend, so don't be offended if they only pop in for a short amount of time. Plan to have 50 to 75 percent of your guests in attendance at any given time (which for me means about fifteen to twenty people). We set a 9 P.M. start time. It allows guests the opportunity to enjoy dinner beforehand, as well as a chance to pop by another soiree! We chose colors that felt sophisticated but still festive: bright gold, creamy white, and dusty peach. Kate's home is charming and full of beautiful, antique pieces that we called on to help create a vintage-inspired feel.

## the menu

After a busy holiday season, no host is eager to jump back into the kitchen. Luckily, New Year's Eve is not usually considered a foodie holiday. It is, however, a party ... and like I've said from the beginning, a party isn't complete without a delicious dessert. (If you haven't figured it out by now, I have a soft spot for sweet treats.) We chose to serve a traditional cheesecake because it's Kate's favorite. We wanted to do something a little different to make it feel special, so Kate had the idea of dusting it with flecks of edible gold dust. After all, it's a New Year's Eve party! To serve, we offered guests gold-painted porcelain plates and bright yellow-gold flatware and displayed the cake as part of our bar buffet on a distressed white wood farm table.

## the bar

*Pop! Fizz! Clink!* Nothing says "celebrate" quite like a glass of crisp, cold, bubbly champagne. Set the tone early. Greet your guests with a tray of prefilled champagne flutes near your front door—it's a fun, festive touch. If you are feeling exceptionally daring, you could attempt a champagne tower! It's a gorgeous element if executed correctly, although it could be a bit dangerous if done wrong. As the soiree began taking shape, it started to resemble a vintage, 1920s bash, and since the champagne tower was born during this era, it felt like a natural inclusion—like something from *The Great Gatsby*. The only way to do a proper champagne tower is to use coupes, instead of flutes. Coupes have a wider mouth, which allows you a greater surface area to balance the glasses. For our tower, we used a collection of vintage etched coupe champagne glasses displayed on an aged metal tray. We kept the remaining champagne cold by displaying the bottles in bright gold and white ice buckets.

Since it was a smaller gathering, it wasn't necessary to hire a bartender or any extra help. We set up a basic bar display for our guests to mix their own cocktails, including vodka, gin, and whiskey along with a few options for wine. We arranged some beautiful barware in addition to the coupes: vintage amber glassware and midcentury gold-painted tumblers. Thread a few dozen cocktail stirrers with fresh dark berries for a special added touch.

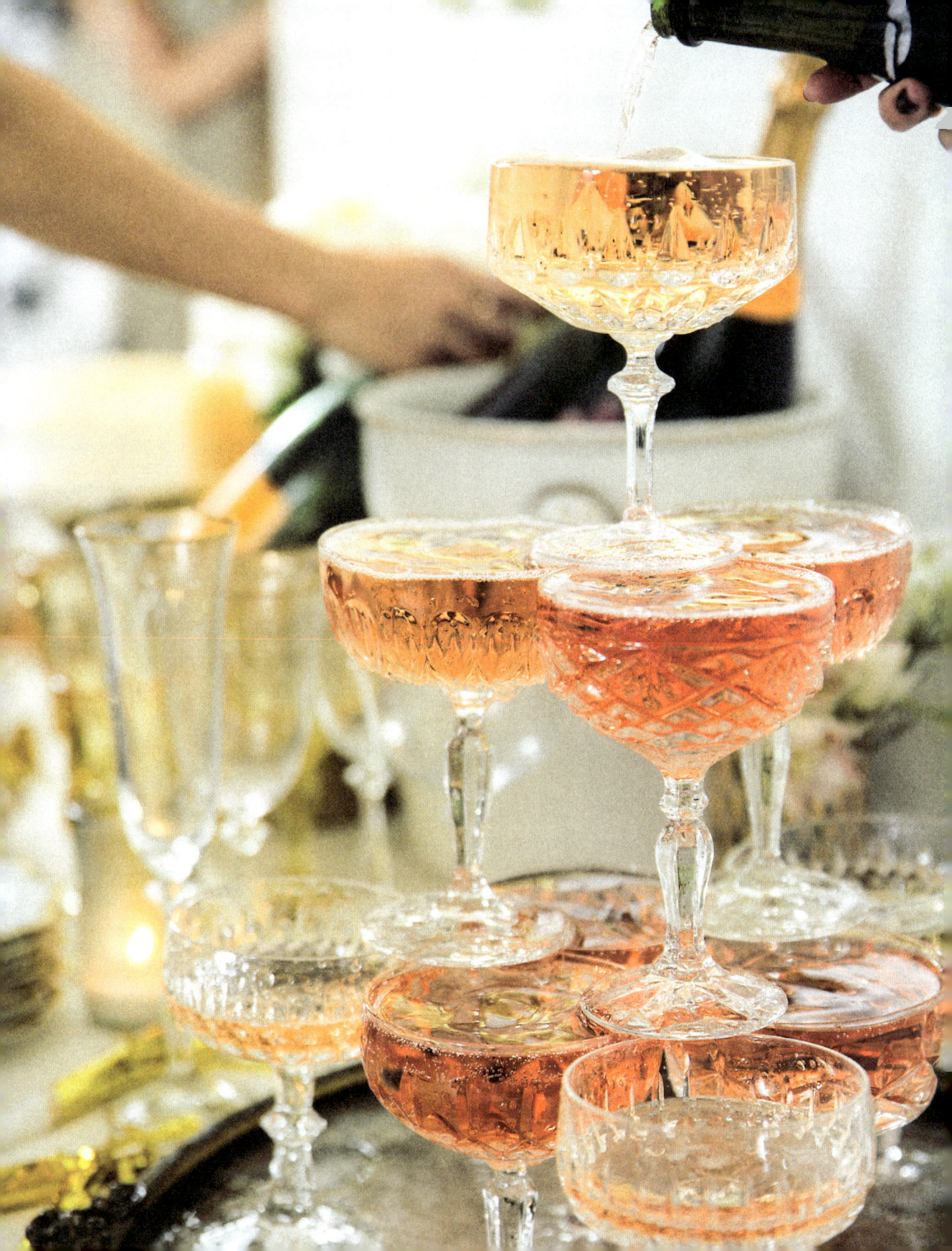

## *the décor*

Top hats! Noisemakers! Balloons! New Year's Eve is one of the few occasions when it's not just acceptable to be a little kitschy, it's basically mandatory. As they are for birthdays, balloons are a natural accoutrement to New Year's Eve, so I decided to fill the room with an assortment of balloons in varying sizes. I wanted guests to feel like they were floating through a cloud of peach and white. We accented the balloons by painting the base of some with bright gold paint and adding shiny gold streamers to others.

This is also a great time to get crafty. For this soiree I had my heart set on creating a sign that said CHEERS! Much as I did for the HAPPY BIRTHDAY sign in chapter 6, I traced the letters and exclamation point on cardboard boxes and cut them out using an X-ACTO knife. With scissors, I cut rows of fringe from bright gold sheets and glued them to the cardboard.

Partygoers love a well-stocked photo booth—and nowadays, it's super easy to pull off! Just set up a smartphone or iPad with a photo booth app, fill a galvanized tub with fun props (like antique lace masquerade masks, tiaras, vintage boas, and top hats!) and let your guests snap away. We hung up some beautiful gold sequined fabric as a backdrop.

The day after the party, you can send your guests a link to the photos so they can relive the fun. Maybe just remind them beforehand that all partygoers will be viewing them!

## the details

Let's talk party games: they're a fantastic way to engage your guests and create some spirited competition! Since some of my friends and Kate's were meeting for the first time, we decided on an ice breaker that's an oldie but a goodie: Twenty Questions (where each partygoer is assigned the name of a famous person, and must ask fellow guests twenty yes-or-no questions to determine who he or she is).

Because New Year's Eve is all about setting intentions and making resolutions, we wanted to honor that spirit. We invited guests to write a "Resolution Reminder" to themselves of hopes they have for the new year. As one of the hostesses, I would keep the pile of preaddressed resolutions and send them to our guests the following month as a reminder to keep their eyes on the prize!

I always look for any excuse to play dress-up. On New Year's Eve, cocktail attire is mandatory: tulle and sequins are completely acceptable for girls, and no one thinks twice when a gentleman works a top hat into an ensemble. (In fact, I own an opera top hat that folds down flat and then dramatically pops open; I wear it every year accompanied with a cocktail dress.) Since New Year's is a more formal event, I kept the color story polished: black, white, and gold.

## THE ETIQUETTE
### a well-executed hostess gift

As we've discussed already in Chapters 2 and 10, I suggest never arriving at a party empty-handed. The gift doesn't need to be lavish or expensive, but when someone is hosting you in his or her home, it's nice to offer a token of your gratitude. Anything from a bottle of wine to a box of delicious gourmet chocolates or even an elegant pack of playing cards will do. I usually err on the side of a gift that the host can enjoy *after* the party. If the host is in the middle of mixing cocktails, proper etiquette suggests that it may not be the best time for him or her to go searching for a vase for fresh flowers (although I would never turn down a beautiful bouquet). My go-to is a homemade pie for the host or hostess to enjoy when everyone has gone home or with a cup of coffee the following morning while celebrating a successful soiree!

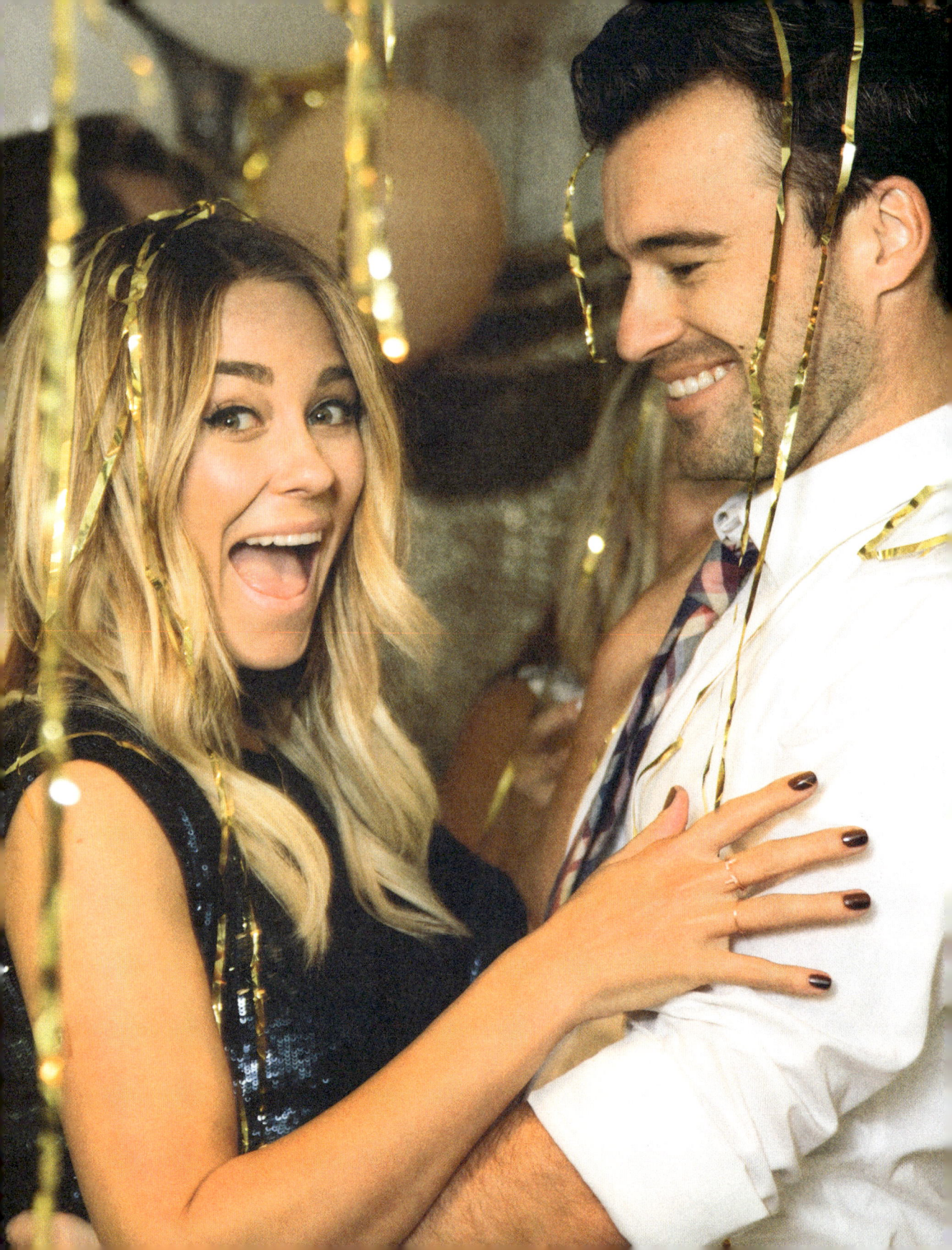

# the cleanup

After the last guest has departed, the floors have been swept, and the sink full of dishes has been washed (finally), there is a calm and quiet throughout the house that just hours before was filled with delicious food, refreshing drinks, good stories, contagious laughter, and, sometimes, a little bit of dancing.

As much fun as inspiration boards and flower arranging can be, at the end of the day these events are really about taking a moment to appreciate the memories you made and the people you made them with. I think about how fortunate I am to have so many wonderful people in my life that I love spending time with. And in that moment I wonder... what will we celebrate next?

Thank you for coming along on this journey with me. See you next time!

xo,
Lauren

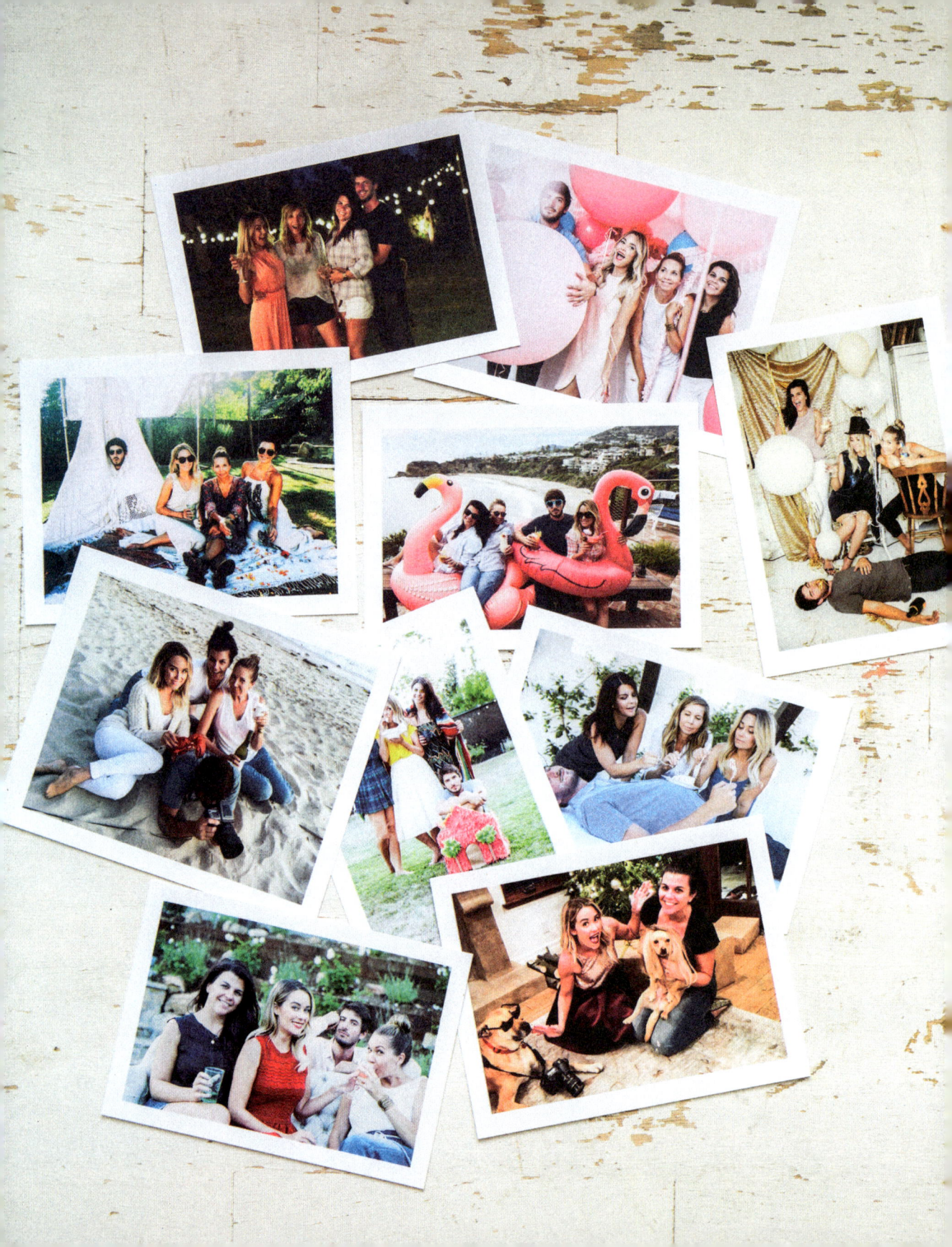

# credits & acknowledgments

**The Writer: LESLIE BRUCE**
Thank you for being such an amazing partner on this project! It was a dream getting to work with such a dear friend. I'm amazed at how incredibly hard you worked to make this book what it is. I hope you aren't upset when you find out there is no actual book and this was all just a ploy to make you hang out with me.

**The Photographer: YONI GOLDBERG**
What good is a book without pictures? It was such a blessing to work on this project with not only a close friend who so passionately shared my vision, but with one whom I could always count on to "fly in" at a moment's notice. Thank you for bringing this book to life in such a beautiful way, and for your dedication to capturing the perfect s'mores shot.

**The Prop Stylist: KATE MARTINDALE**
I'm not quite sure how you do it, but I've never met anyone who can bring vibrancy, elegance, and breath to everything she touches. You are so talented, and I am continually inspired by your creativity. Thank you for being so much fun to work with as well as being a wonderful friend who shares my love for tiny crudité.

**The Fashion Stylists: TARA SWEENEN AND SYDNEY LOPEZ**
You never cease to amaze me. When I call asking for a million looks on a week's notice, I can always count on you to deliver. Thank you for bending over backward and taking the time to do so. I always love working with you guys.

**The Glam: KRISTIN ESS AND AMY NADINE**
If I've said it once, I've said it one hundred times: Thank you, ladies, for always making me feel my best! Love you both. x

**The Publisher: HARPERCOLLINS**
First and foremost, thank you to our thoughtful, dedicated editor, Denise Oswald, not only for working so hard to make this book everything we knew it could be—but also for pretending to not be that sick when basically dying from a cold. Thank you to our interior designer, Suet Chong, for understanding and executing the vision of this book. Thank you to our diligent production editor, Ivy McFadden, for always being totally on point (and even out-punning us). And a big thank-you to the entire HarperCollins team for all your hard work, including Mumtaz Mustafa (cover design), Kendra Newton and Michael Barrs (marketing), Trish Daly (associate editor), and Joseph Papa and Katie Steinberg (publicity).

**The Invitation: MINTED.COM**
Thank you to the entire Minted team for providing us with beautiful invitations to complement our parties. You were an absolute delight to work with as well. Special thanks to the invitations designers: Rebecca Bowen (Birthday), Susan Brown (Engagement), Lori Wemple (Bridal Shower, Wedding, and Holiday), Andres Montano (Housewarming), Bethany Anderson (Dinner Party), Yao Cheng (Baby Shower), Dean Street (Clambake), Olive and Jude (Bachelorette), Katherine Watson (Brunch), Faith Designs (New Year's Eve), and Phrosne Ras (page 21).

**The Tabletop: CASA DE PERRIN**
A big, big thank-you to Diana and everyone at Casa de Perrin. We are beyond thrilled to showcase your exquisite tabletop pieces in this book. Your stunning collections elevate every tablescape they are a part of—including the ones in this book.

**The Furniture: FOUND**
Thank you so much to Lauren and everyone at Found who helped to curate a stunning mix of pieces to help complete our parties. Your inspired collection of vintage wares always brings so much charm to any event, and we were so excited to incorporate them into this book.

**The Baker: LAUREN LOWSTAN, A SWEET SAVORY**
I know that whenever I need four dozen cupcakes and three dozen macarons in 24 hours, you're the best pastry chef for the job. Your delicious creations are such a wonderful

addition to this book, and I am beyond grateful for all your efforts (but I totally blame you for forcing us all to eat a ridiculous amount of sweets). Thank you.

### The Wedding Photographer: ELIZABETH MESSINA
William and I cannot thank you enough for giving us such a special wedding gift: a beautiful way to always remember the best day of our life.

### The Planner: CASSANDRA HERSCHENFELD
Thank you for being such an invaluable resource in the creation of this book, and for sharing all your party-planning expertise with us. Oh... and for giving William and me our dream wedding (and not letting me arrange my own flowers). You're the best!

### The Guest List: MY FAMILY AND FRIENDS
A huge thank-you to all the amazing people in my life who have celebrated with me both on the pages of this book and off. I am so very blessed to have you all. Your support and love mean so much to me—and I can't wait to actually see you all again, now that this book is done!

### The Agent: MAX STUBBLEFIELD
Thank you to my wonderful agent, friend, and professional clambake model (you might really have a future there). As usual, you went above and beyond in the making of this book. Thank you for all you did for this book and for everything else.

### The Book Agent: MATTHEW ELBLONK
Thank you for working so hard to make this book a reality and, frankly, for putting up with me. Your ability to remain calm, cool, and collected under any circumstance is remarkable. If you weren't a literary agent, you could totally be a guidance counselor... or a bartender.

### The Publicist: NICOLE PEREZ
Thank you for continuing to keep me relevant... I have no idea how you are doing it, but keep doing it. x

### The Husband: WILLIAM TELL
Thank you my wonderful husband, for being so supportive of everything I do—even when that means turning our home upside down to shoot party after party and almost always leaving the dishes for the morning. I love you dearly.

# fashion credits

**COVER**
AQ/AQ tank A-line skirt dress; Neil Lane diamond necklace; Willow Roe yellow gold diamond pavé stud; Liv Haley rose gold stud earring

**THE BIRTHDAY PARTY**
1. Tadashi pink lace cocktail; Brian Atwood nude satin shoes; Ann Taylor silver clutch
2. WAYF light pink lace two piece; JustFab nude mule; Phillips House rose gold necklace
3. Alice and Olivia white short-sleeved sweater; BCBG peach wide-leg pant; Louboutin gold pump; Vita Fede yellow gold drop behind earring

**THE ENGAGEMENT PARTY**
1. Green cocktail dress; gold necklace; gold stiletto pumps
2. Noon By Noor gray crop with beading details; Maje black high-waisted trouser with bow; Casadei copper metallic pump; BCBG black satin clutch
3. WAYF burgundy dress; Louboutin gold pumps; Ippolita yellow gold circle necklace; Monica Vinader white and gold drop earrings

**THE BRIDAL SHOWER**
1. BCBG coral ruffle dress; Jerome Rousseau open-toed nude heels; Dana Rebecca yellow gold wrap ring; Rock and Gems yellow gold flat bracelet
2. Equipment light blue tank dress with florals; Pedro Garcia pink patent heel; Melissa Kaye white gold bracelet
3. Camilla and Marc pink and white floral dress; Vince nude leather crossbody bag; Pink Pedro Garcia strappy patent heel

**THE HOUSEWARMING**

1. Aqua pink and white square-print dress; JCrew nude tote; Jimmy Choo red open-toed sandals; Karma El Khalil rose gold/clear crystal ring; Monica Vinader white drop earrings
2. BCBG white long-sleeved blouse with red and blue stripes; Big Star light blue jeans with rips; TKees brown leather "x" sandals
3. Paper Crown pink silk top; Noon By Noor white skirt with red and orange sequins and beads; Louboutin orange patent pump; EF Jewelry white front pavé studs

**THE DINNER PARTY**

1. Zara white sleeveless top; Nicholas blush pencil skirt; Dana Rebecca ring; Willow Roe rose gold double ring; Stuart Weitzman nude nudist sandal
2. Cuyana gray short-sleeve top; Ann Taylor black silk short; Giuseppe Zanotti white lace-up pumps; Neil Lane gold with orange stone necklace
3. Joie floral navy sundress; Steve Madden nude leather wedge; JCrew nude leather tote

**THE BABY SHOWER**

1. Ann Taylor blue and white polka-dot sundress; Aldo nude thick heel peep toe; Monica Vinader silver bracelet
2. Maje red skirt; Rag & Bone white sleeveless top; Cristina Sabatini nude bangle; Cristina Sabatini mother-of-pearl bangle; Louboutin blue pumps
3. WAYF light pink eyelet crop top; Rachel Zoe white wide-leg pant; Lana moonstone and yellow gold earrings; gray lace-up pumps

**THE CLAMBAKE**

1. Charles Henry gray pebbled sweater; Gap white pant; BCBG white and gray sandal; Rag & Bone gray felt hat; Borgioni black spike ring
2. JCrew blue denim short; Talbots light blue button down; Madewell tan/brown tote; Converse white low-top sneaker; Express tan with black fedora
3. Banana Republic white V-neck; Vince crossbody nude bag; Kit scarf; Quay black and white sunglasses; Tkees nude flipflops; gray drawstring trousers

**THE BACHELORETTE PARTY**

1. WAYF tropical romper; Jimmy Choo teal suede envelope clutch; Jimmy Choo seafoam

FASHION CREDITS  293

skin strappy heels; Ippolita gold circle necklace
2. Vitamin A green print bikini top; Blaque Label white shorts; Joie double-strap gold flat sandals; Madewell tan tote
3. Magdalena hot pink lace top and skirt set; Jimmy Choo silver pumps; Dana Rebecca silver choker

### THE BRUNCH
1. BGBG Generation black maxi with floral center; Steve Madden black wedge with wood heel; Vintage tan weave bag with black handle
2. Paul+Joe peach with black-and-tan-patterned dress; LC nude flipflops; LC brown tortoise sunglasses
3. Big Star cut-off shorts; Greylin peach peasant blouse; Vince nude crossbody bag; Cornetti gladiator suede sandal

2. Haney silver sequin three-quarter-sleeve dress; Jimmy Choo metallic silver pump
3. Badgley Mischka green sequin tank dress; Stuart Weitzman black nudist sandal; BCBG black satin clutch

### THE WEDDING
1. Cynthia Rowley strapless floral dress; Casadei black suede pumps; BCBG black satin clutch
2. Sachin and Babi black crop cap sleeve top with floral; Maje sheer skirt with eyelets; Jimmy Choo suede pump; black clutch
3. Gray strapless tulle dress; Casadei gray suede sandal; Harry Kotlar diamond bracelet; Mattia Cielo white gold diamond choker

### THE HOLIDAY PARTY
1. Sandro burgundy long-sleeved knit sweater; Express burgundy lace pencil skirt; Brian Atwood patent burgundy pump; Dana Rebecca gold with diamond thick necklace

### THE NEW YEAR'S EVE PARTY
1. Gold sequin V-neck beaded dress; Vince Camuto gold sandal heels; Rock and Gems flat yellow gold bracelet; Amanda Pearl gold claw wrap ring; Effy yellow gold pavé snake wrap ring
2. DVF long black blazer; Giuseppe Zanotti black shiny pump; Alice and Olivia deep-V bodysuit; Faubourg du Temple gold sequin short; Lauren's own black top hat
3. Ogla long-sleeved black dress with feather skirt; Louboutin silver sparkle pump; Lauren's own black top hat

FASHION CREDITS